Traditional Metalworking
in
Kenya

by Jean Brown

Cambridge Monographs in African Archaeology No. 38
Oxbow Monograph 44
1995

Published by
Oxbow Books, Park End Place, Oxford OX1 1HN

© Oxbow Books 1995

ISBN 0 946897 99 9

This book is available direct from
Oxbow Books, Park End Place, Oxford OX1 1HN
(Phone: 0865–241249; Fax: 0865–794449)

and

The David Brown Book Company
PO Box 511, Oakville, CT 06779
(Phone: 203–945–9329; Fax: 203–945–9468)

Printed in Great Britain by
The Short Run Press, Exeter

Contents

List of Figures

List of Plates

Note: The original thesis (University of Edinburgh 1980) contains eighty pages of photographs.

Ethnographic data can play two basic roles in archaeological investigation, first they serve as resources for testing hypothesis which seek to relate material and behavioural cultural phenomena, second they may often (but need not always) serve as a basis for models of particular social relations which are postulated to have been the context for an observed archaeological structure. In the former case the 'action archaeology' studies are relevant, in the latter model building and testing can be related to ethnographical facts but verification of propositions would remain a problem to be solved by the formulation of hypotheses testable by archaeological data.

Binford 1972:63.

Preface

IN RECENT YEARS archaeologists have shown increased interest in the study of living peoples whose cultures are able to produce data relevant to their work. The use of ethnographic parallels in helping to provide archaeologists with inspiration for possible explanations for their data are more relevant to Kenya than elsewhere for it is one of the few African countries still rich in ethnographic data. Away from the immediate vicinity of the towns the traditional way of life persists and crafts continue to be produced long after the makers and users have taken to wearing European dress.

Until the middle of the last century there was no written history in Kenya so even its more immediate past falls within the realm of prehistory and has to be pieced together from the work of archaeologists, oral historians, linguists and ethnographers. Archaeologists studying the later periods are fortunate that so many Kenya peoples still lead a life little different from that of their forefathers several hundred years ago. There has been relatively little movement of peoples in that time so they are generally living in similar ecological conditions in the same environment, following the same subsistence economy and using the same technology that they have used for centuries. Any ethnographic data used by archaeologists is, therefore, usually closely allied both in time and space with the later prehistoric cultures for which they seek analogies.

Research into the origin of the Bantu and the possible correlation of their expansion with the knowledge and spread of ironworking has resulted in a revival of interest in the secondary source material provided by oral historians, linguists and ethnographers, for archaeologists are left only with the most durable remains of the material culture of a people from which to try to deduce their daily life and activities and this archaeological evidence alone is insufficient to give them the broader picture of the culture that they need.

Although the technological processes involved in the manufacture of crafts and the products themselves have remained virtually unchanged for generations it is generally difficult for archaeologists to find out whether there is any continuity of the pottery or ironworking traditions which they find in archaeological contexts. They generally cannot find out if a particular technique of making or decorating pottery, or making iron artefacts, has been continued into the present because there has been no comprehensive collection or study of present day pottery or ironworking in Kenya.

It was for this reason that I decided to make a study of traditional metal-working while it was still possible to do so. I make no apology for an old-fashioned ethnographical approach because that is what is needed to provide the raw material for analogy for archaeologists; because it is rarely found in the work of recent anthropologists who either treat the once-fashionable study of material culture with indifference or totally ignore it. Information has to be gleaned from the now historical ethnographic descriptions of early colonial administrators, or the casual observations of early European explorers, but these are usually quite inadequate from the archaeologists point of view as they seldom give exact details of the material culture, or of the total background culture which this reflects, and of which it forms so integral a part.

Many articles have been written on African smiths and, ironworking but they are scattered reports from all over the continent.[1] There's no detailed study of the craft from any one area and moreover the studies have concentrated almost entirely on the techniques, rituals, and taboos of smelting to the exclusion of all other aspects. There are, therefore, great gaps in our knowledge. Some are detailed and accurate reports written from careful first-hand observation, but many are, unfortunately, vague and unreliable articles written without adequate knowledge, background or observation, after a hasty visit to a smithy or from information passed on from others.

Kenya is a particularly interesting area in which to study traditional iron-working for several types of bellows and furnaces are used there, the status of smiths ranges from high to low and the attitude towards them is equally ambivalent. Except for the increased reliance on scrap from commercially produced iron which has made smelting virtually obsolete, and a reduction in the number of smiths as a result of the importation of cheap iron goods; external cultural influences, the introduction of commercially produced products and the marketing techniques that go with them and a money economy, have had surprisingly little effect on traditional ironworking in any areas away from the vicinity of towns.

Everywhere there are smiths in traditional smithies still using their traditional tools to produce traditional products by the same age-old techniques of manufacture, and accompanied by the same rituals, taboos and beliefs, which they have used for generations. Their methods of exchange and distribution also remain remarkably unchanged, but with increasing education and a sudden acceleration of improvement in communications all over the country a rapid change is beginning to take place. In many areas, where the influence of education and Christianity is strongest, young men are now less interested in following the craft of their forefathers, and cannot be coerced into doing so because they no longer believe in the ancestral curse which can cause them to be struck down by divine retribution. Where this is happening most of the craftsmen are now middle-aged or old men who will have none to replace them; their craft will, therefore, die with them. In a few years this study will itself become ethno-history.

The work, which covers almost all[2] the tribes in Kenya, was carried out over a period of ten years from 1964–1974. To make it meaningful it was essential to study not only the raw materials used by smiths, their tools, products, and their techniques of manufacture and distribution methods, but also the social status of smiths and the beliefs that surround both them and their iron-working, as well as the modes of livelihood, settlement patterns and organisation of the people with whom they live and work.

I was concerned with setting this on record while it was still possible to do so and with examining ironworking from an archaeological perspective. My first concern was to try to classify the smithies, hearths, furnaces, smith tool kits and products, into types to see if they fell into any distinct groupings or assemblages, and to try to categorise the techniques, rituals, taboos and social status of smiths to see how far they were related and then to relate these to the background culture of the peoples with whom they live and work to see if it was possible to divide ironworking into distinct industries and streams, and to see how far those could, in turn, be correlated with tribe or group of tribes, linguistic group, means of livelihood, social organisation, or environment. Finally it was necessary to examine briefly the archaeological and historical sources, oral traditions and languages, for evidence of related ironworking cultures in adjoining territories, and of the past movements of peoples, to see if they could throw any light on the origins of present-day ironworking industries in Kenya.

While much of the information could be obtained by watching smiths at work and from talking to them and their families, it was equally necessary, especially with regard to the beliefs surrounding them and their craft, to obtain information from the rest of the community.

The study of traditional metalworking in this one country highlights our ignorance of the craft elsewhere in the continent, particularly in the adjacent territories where the closest affinities to Kenya ironworking are to be found. It is to be hoped that similar studies will be carried out in those territories before traditional smiths relinquish their craft for ever.

[1] In 1937 Cline attempted to sum up all the articles written on African metallurgy in his book *mining Metallurgy in Negro Africa*.

[2] I did not manage to visit the Gusii, and was not only too busy to study Kuria smiths when I was in their country, but could not find the time to return there although they had promised to smelt for me.

Peoples of East Africa

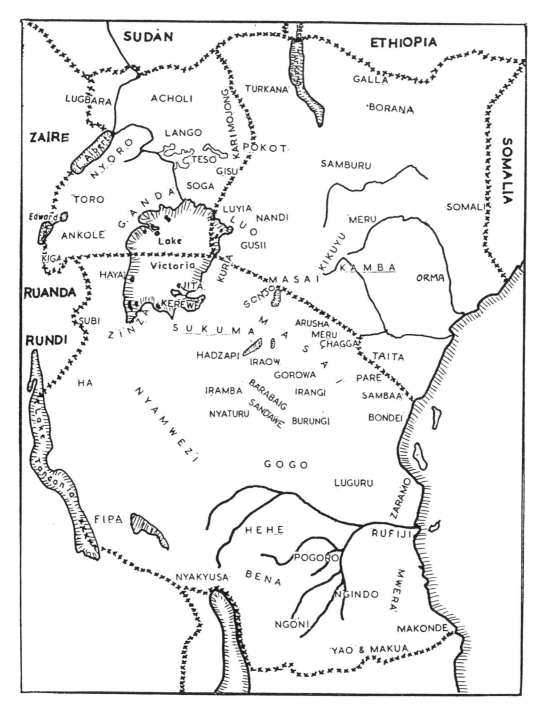

ⵅⵅⵅⵅ Territorial boundary

Peoples of Kenya

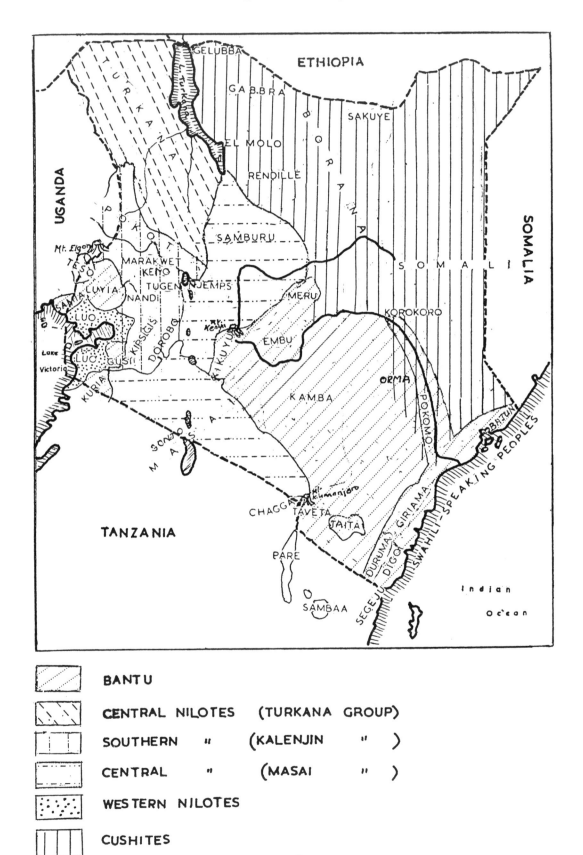

BANTU

CENTRAL NILOTES (TURKANA GROUP)

SOUTHERN " (KALENJIN ")

CENTRAL " (MASAI ")

WESTERN NILOTES

CUSHITES

CHAPTER I

The Smith's Workshop and Tools

THE SMITHY

Smiths carry out their forging in huts and arbours
constructed solely for that purpose, but in eastern and
north-eastern Kenya, where bag bellows and the simple
bowl furnace are used for smelting, the smithy was also
the smelting place[1] except when smelting was done far
from the smithy close to the source of ore. Even then
pig-iron bars were forged in the bowl furnace and
carried back to be worked in a smithy.

With the exception of a Masai smithy no type of
smithy is peculiar to any one tribe or linguistic group-
ing, nor is any one type associated only with one type
of bellows, or with a particular set of tools except in the
broadest sense. The type of smithy erected depends on
the environment and means of livelihood of the people
so that a general type is common to a number of
different cultures.

Smithies are made from the same local materials as
those traditionally used for building. Their design gen-
erally conforms with the house type of the area al-
though smithies are usually more roughly constructed.

There are four basic types of smithy:

A. Rondavel Type

The most common traditional house type in Kenya,
widespread amongst agriculturists and semi-pastoral
agriculturists alike, is a thatched mud and wattle
rondavel. The most common type of smithy is a simi-
larly constructed round hut with low grass-thatched
roof and open sides. It may vary in diameter from three
to six metres depending on the volume of work and the
number of smiths who work there. The apex of the
roof is supported on a thick centre-post while its edge
rests on a circle of stout uprights (Fig. 2 top). Earth
excavated from the floor to a depth of several inches, is
sometimes banked up round the perimeter (Fig. 2 top)
to prevent water running into the smithy during heavy
rain, especially if it is built on the slope of a hill. A

modern square or oblong variation of the rondavel,
which is similarly constructed, is occasionally found
up-country but is not traditional (Fig. 1 bottom).

B. Oblong with a pitched roof

In coastal areas, where the agriculturists build oblong
houses, the smithies too are oblong in shape with pitched
roofs, thatched with coconut leaves, reaching almost to
the ground. They are supported on occasionally two, but
usually three or four centre poles (Fig. 1 top and centre;
Fig. 2 bottom), but these may be off-centre in the few
smithies which have a roof longer on one side than on the
other. One end is usually closed with matting or coconut
thatching against the prevailing wind, but in sheltered
positions both ends are left open.

C. Brushwood enclosures

Kenya pastoral peoples live in low, domed, or flat-roofed,
often flimsy structures of interwoven withies covered
with whatever material is available to them in the
predominantly arid area in which they live. Amongst
these peoples, smithies are even more flimsy than their
houses. Like their enclosures for their homes and cattle
they usually consist of a mere circle of brushwood heaped
against a bush (Fig. 3 bottom), or more rarely placed
under the shade of a tree. This is sometimes open on top
but it is more often covered with additional brushwood
which is supported, if necessary, on a few forked uprights
(Fig. 4 top). It is impossible to stand upright in these
structures which, in some areas,[2] have a low tunnel-like
entrance curved back in the manner of their houses (Fig.
3 bottom). Occasionally this type of smithy is to be found
amongst agriculturists.[3]

The only smithy I came across amongst the pastoral
Turkana, who generally do not have smiths, was iden-
tical with their sleeping huts, being a dome-shaped
structure of bent withies over which grass was securely
lashed. Masai smithies which are likewise completely

1

enclosed, are the only ones in Kenya which bear no resemblance,[4] except in the method of constructing their walls of closely packed thin uprights, to anything that they erect. They are small round huts, with shallow conical roofs roughly thatched with grass, which are in complete contrast to their oblong flat-roofed mud-plastered dwellings. They do, however, bear some resemblance to huts of the neighbouring Kalenjin, and possibly to those of the disbanded Uasin Gishu Masai from whom according to Hollis (Hollis 1909: 36) and Merker (Merker 1910: 111) some of their smiths are said to have originated.

D. Rock shelters

On the steep rocky escarpment of the Kerio branch of the Rift Valley some of the semi-pastoral Kalenjin, who have a tradition of having lived in rock shelters until comparatively recently, often use a large rock or rock shelter as a smithy. Against this they construct a rough wooden structure thatched with grass (Fig. 4 bottom).

Smiths may, nowadays, occasionally work in the open under a tree but only do this when working in their own enclosed homesteads or a market place. In one case the tree was merely a more shady alternative to a brushwood smithy.

Nowadays blacksmiths settling on the outskirts of small towns, where the breakdown of traditional culture has resulted in an increase in thieving, build square or oblong walled-in mud-and-wattle smithies with lockable doors to protect their belongings in their absence and provide them with light and air whilst they work.

In the pastoral groups women are entirely responsible for building both houses and smithies.[5] Amongst the agriculturists it is the men who build the houses although generally the women are left to thatch and daub them. In those communities the smiths construct their own smithies and the women are not permitted to help, although they may be sent to collect the grass for thatching. A newly constructed smithy is dedicated to the smith ancestors at a ceremony at which the hut and the tools are purified and blessed. This usually involves the sacrifice of a goat or chicken,[6] or the pouring of a libation of honey beer.[7]

Smithies of the agricultural people are well designed to suit the environment and the purpose for which they are used for their roofs protect the smiths from rain and sun, while the open sides keep them reasonably cool and provide them with sufficient light. They are usually placed in sheltered positions amidst trees or bushes to protect them from the prevailing wind which is liable to pick up sparks and blow them off to set fire to the surrounding countryside. At the same time they ensure enough breeze to cool the interior, blow away the charcoal fumes, and keep the fire burning well.

Although the risk of the smithy itself catching fire is never given as a reason for building them without walls, this has undoubtedly been considered, the oblong partially-walled type does occasionally get burned down[8] in spite of the belief, held by coastal peoples in particular, that a smithy will not burn even if set alight.[9]

Pastoralist smithies, which are generally of a more primitive type than those of agriculturists, partly because their construction is left entirely to the weaker sex, cannot be said to be either well adapted to their environment or well designed. They are airy enough as even those of the Masai have plenty of cracks in their mud-covered walls, but with the exception of Masai smithies and the only Turkana one that I have found, they give little protection from the tropical sun although they are built in the hottest areas of Kenya. Attempts at providing a little shade are sometimes made by throwing fresh green leaves or a skin over the brushwood, but no pastoralist smithy gives shelter from the admittedly infrequent rain which, when it does come, pours in, extinguishes the fire, and turns the smithy into a quagmire. When this happens some smiths[10] retire to work in their own ill-lit huts. Pastoralist smithies, probably because they are usually attached to homesteads, seem to be constructed with more regard to privacy than to working conditions.

The positioning of smithies is important, the most vital consideration being that they should be strategically placed for trade so that the smiths can count on the maximum custom for their products. They are, therefore, almost always found in the vicinity of much-frequented places like bush markets to which the smith can also take his wares for sale, or near a meeting or crossing of main thoroughfares which make it easy for customers to visit him. Nowadays many of them are in the vicinity of, or on the outskirts of, small bush trading centres which everybody visits.

Amongst the Cushitic speaking pastoralists, smiths are attached to the larger homestead[11] where their dwellings occupy a prestigious position immediately following those of the homestead head who provides them with protection. Their smithies are placed away from the homestead. In contrast amongst the pastoral and semi-pastoral Paranilotic speakers the whole smith group lives in separate homesteads with the smithies built into the outside or just on the outside of the surrounding brushwood enclosure[12] and customers seek out the smiths. It is interesting to note that the old iron-working villages of the semi-pastoral Kalenjin on the steep Rift Valley escarpment, which were placed on the banks of rivers close to the few possible routes down into the valley, have now developed into the largest trading centres in the area.[13]

Agricultural smiths, who do not live in separate communities, carefully isolate their smithies in secluded

places well away from the homesteads of non-smiths. This is done in order to preserve the mystery and secrecy of their craft, to avoid women, and to protect children – who are too young to understand the ironworking taboos – from the misfortunes which they might suffer if they inadvertently break them. In communities where belief in pollution from contact with the smith is strong[14] smithies are kept well away from cultivated land and animals.

Proximity to trees which provide charcoal, and to water, are also specified as requirements when building a smithy. The smiths need water to mix with clay for making tuyeres and furnaces, for panning ironsand where that ore is used, and for quenching. Proximity to ore was also important in some areas but generally smiths were either prepared to travel further afield for their ore, or could obtain pig-iron from smiths working in the ore-bearing areas. For convenience smithies are usually built within easy reach of the smith's own homestead but rarely very close to it.[15]

Once a smithy is established, as long as there is sufficient custom to ensure the smith's livelihood, it remains in the same immediate neighbourhood to be passed on from father to son, and only abandoned if

there is no-one to inherit it who is capable of carrying on the craft. This is true of both pastoralists and agriculturists for smithies are regarded as permanent or semi-permanent workshops by virtue of the nature of the work and its requirements. Only smiths attached to large homesteads of the Cushitic pastoralists have to move with them when they move or they would lose their livelihood.

Even if a smithy has been abandoned for want of a successor it can still be revived many years later if a direct descendant of the deceased owner receives a sign that he must become a smith. In that case he must find the original smithy and start it up again *in situ* or take some cindery soil and a portion of the old anvil from it in order to set it up in his own neighbourhood.

In the case of war, or famine, or if he can no longer make a living in the area, a smith may have to set up a temporary smithy where the demand for his products appears promising, but he is only allowed into that area if he has a close relative or age-set mate there who vouches for his character and the quality of his work. In the first two instances he will almost invariably return to his smithy when conditions permit, but if there is insufficient work for him there and he is prospering where he

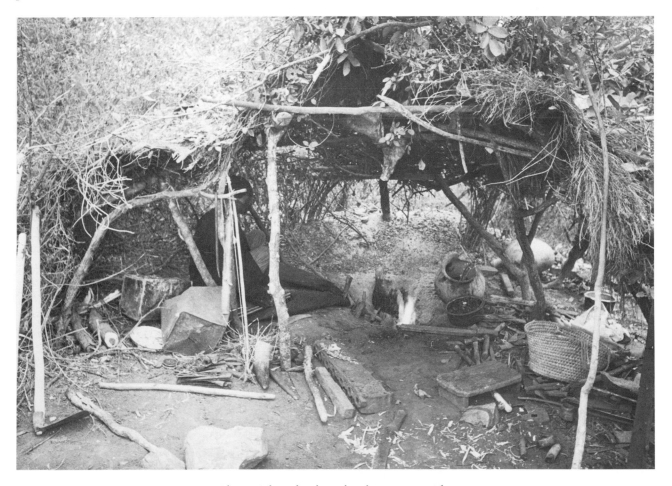

Plate 1. Mbeere brushwood enclosure type smithy.

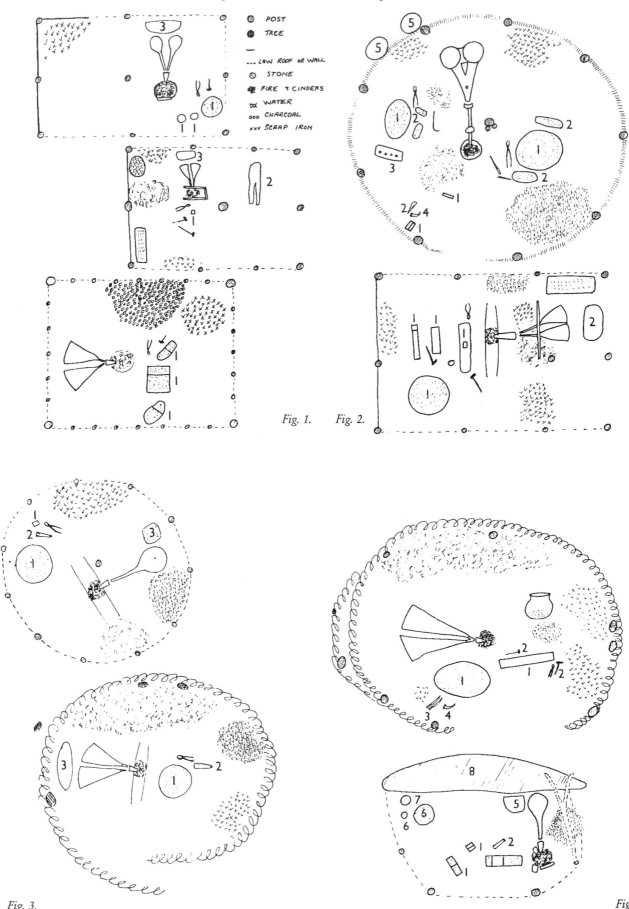

POST
TREE
— LOW ROOF OR WALL
STONE
FIRE + CINDERS
WATER
CHARCOAL
SCRAP IRON

Fig. 1. Fig. 2.

Fig. 3.

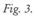

Fig. 4.

Figs. 1–4. *Smithy plans showing internal space arrangements, distribution of artefacts and refuse.*

is he may move his smithy permanently into the new area if the elders allow him to stay. He returns home for his old anvil, the elders bless it in the new smithy, and the old smithy can then be abandoned and ceases to exist. Its abandoned site will, however, be avoided until all memory of it has faded for it was dedicated to the ancestors and imbued with their mystical power which remains there to instil fear into the hearts of all who know of its existence. The actual structure of even the most substantially built smithies does not last more than ten years. They are sometimes re-built a few hundred yards off but are usually rebuilt *in situ*, even if they have been burned down, for they have been blessed and dedicated to the ancestors.

In a round smithy the hearth occupies a central position often very close to the centre-post if there is one (Fig. 2 top, Fig. 3 top). This gives room for the assistant to blow the bellows on one side while the smith works at his anvils on the other. The bellows blower usually works at right angles to the entrance (Fig. 3 bottom, Fig. 4 top) but in larger smithies he may face the doorway in order to leave sufficient space for a set of anvils on either side of the hearth (Fig. 2 top). In oblong smithies the hearth is usually at one end and the bellows blower works facing the side (Fig. 1 top and centre), but in some he may sit facing the end (Fig. 2 bottom).

There are two types of hearth:

A. Bowl-shaped

A.1
A bowl-shaped hollow averaging 30–38cm in diameter and not more than 23cm deep.

A.2
In western Kenya wider and deeper bowl hearths sometimes with stone-lined sides are associated with long pipe-like tuyeres.

B. Trench-shaped

A narrow trench of similar depth to A.1. It is rarely more than 30cm wide and is usually about 75cm long. These are most common amongst the Paranilotic speaking pastoralists[16] but are by no means confined to them, nor are they associated with one type of smithy or bellows.

Both types of hearth may have a stone backing, and three stone uprights (or nowadays large pieces of scrap metal) are occasionally set on the floor around the bowl type if there is too much breeze. A fireshield of stone, clay, scrap metal or even a banana leaf, placed so that the bellows nozzles go under it, is often used by agricultural smiths to protect the bellows blower from the heat.

Occasionally the fire is placed on the floor without digging a hearth, but with daily raking a shallow hollow is soon formed. Except for two instances, both in towns, I have never seen a smithy with more than one hearth even though it may be shared by several smiths.

Smithies are very untidy places. Although some smiths dampen their charcoal and rake it out each evening when they finish work, most hearths, when not in use, are left choked with ashes which are raked out each morning to be left lying around the fire until they get in the way. They are then raked aside to the nearest edge of the smithy where they accumulate in a large heap into which discarded tuyeres and slag may also be thrown. Charcoal, sometimes in a container, but more usually in a spreading heap, lies within easy reach of the fire, and there are usually one or more heaps of scrap iron of every available variety. This scrap may be left all over the smithy until pushed aside to the edges of the hut.

Smiths sometimes carry their tools home with them but more often leave them lying about close to the anvils, while other things like blue-ing horns, used for blackening spear blades, rough wooden handles for holding socketed tools in the fire, and partially finished products, lie scattered around (Figs. 1–4). There is often also a brush for dampening the fire, and a utensil for holding quenching water. From the roof hang spare skins for bellows, and, when not in use, bag bellows, or the diaphragms of bowl bellows, while other small tools not constantly in use, are tucked into the thatch for safe keeping.

Smithies are feared and respected throughout Kenya[17] because of the mystical powers concentrated there.[18] They are carefully avoided by the pastoral peoples while agricultural peoples are deliberately kept out of them.[19] Fear of breaking any of the taboos and incurring the smith's curse makes them generally immune to theft so they are the safest places in Kenya in which to leave things lying around. Amongst the agricultural groups fear of the smithy is mixed with reverence for smithies in general, for they are often regarded as sacred and holy places.[20]

THE HAMMER

The smith's hammer, which is the symbol of his craft,[21] is every-where regarded as his most important tool. Traditional hammers fall into three main types: Unhafted stone hammers,[22] Unhafted iron hammers, Hafted iron hammers.

A. Unhafted stone hammers
A.1
Heavy oblong or oval sledge hammers with slightly convex striking ends. These are found in two sizes. The

samples weighed were 19.25 kilos and 13 kilos in weight (Fig. 5, No. 2).

A.2
Slightly lighter more triangular-shaped hammers with trimmed wedge-shaped striking ends. The samples weighed were just over 9 kilos, and just under 3 kilos in weight (Fig. 5, Nos. 1 and 3).

A.3
Small oval hammer stones usually not more than 10–15cm long, 8–10cm wide, and 6–7cm deep. They rarely weigh more than 1–2 kilos (Fig. 5, No. 4).

Types 1 and 2 are always used together, a smith usually having two of each. They are used only in western Kenya amongst the Interlacustrine Bantu and the Nilotic Luo[23] who use them mainly for pounding iron in the initial stages of forging.

Some of the Highland Bantu,[24] the Paranilotic Kalenjin,[25] and the Cushitic Orma Galla say that they used shaped stone hammers in the past, but the coastal peoples have no tradition of ever having done so.

Type 3 is found in association with types 1 and 2 in western Kenya where it is used mostly for trimming the striking ends of hammers and the heads of anvils, but is also occasionally used in the last stages of forging. It is also sometimes found in the smithies of pastoral tribes,[26] and in those of the northern Highland Bantu. It is most commonly used by non-smiths of the western pastoralists[27] who pick up any nearby stone, of approximately that size and shape, to use to cold-forge iron arrowheads, beads (Fig. 5, No. 3), finger-ring knives (Fig. 67, No. 1) earrings, lip-plugs, and ornaments of brass, copper and aluminium (Fig. 56).

B. Unhafted iron hammers
B.1
A simple iron pounder consisting of an iron bar, rarely more than 25cm long, which is grasped round its middle or closer to one end and used vertically. They are of two types:

B.1 (a) Maul Hammers
A stout looking tool which is either:
i) Round in cross-section throughout (Fig. 6, No. 3)
ii) Round in cross-section at its narrower end, and oval or oblong in cross-section at its wider end (Fig. 6, Nos. 1 and 2).

Smiths who use the first type generally only possess one, but those who use the second type more often have two of them. At the heavy end they are usually 3.5–5cm wide. The heavier and shorter one is usually about 20cm–22cm long. Its oblong end is used for heavy pounding in the initial stages of forging while its rounded end is used for curving the iron of sockets round a mandrel. The lighter and longer one, which is usually about 25cm long, is much more pointed at its round end. It is used, in the final stages of forging, for finer work like making spear mid-ribs, and for making small artefacts.

B.1 (b) Mandrel Hammers
These are also used as mandrels. They show some resemblance to type B.1 (a)(i) but are longer and more delicate tools. Their maximum diameter is less. They are round in cross-section throughout and pointed at one end. A smith normally has two of different sizes, approximately 25 and 30cm long. They are used by smiths in western Kenya, in conjunction with stone hammers and type B.2 iron hammers, for more delicate finishing work in the later stages of forging. They are usually held vertically (Fig. 31, No. 5) but may sometimes be held horizontally so that the side is used for striking (Fig. 31, No. 6).

B.2
An oblong of iron which may either be squared-off or rounded at one end while its other end tapers into a tang which forms its handle (Fig. 6, No. 4). These hammers measure 26–26.5cm long from end to tang, and 7–8cm wide. They are used by the western-most Interlacustrine Bantu in conjunction with stone hammers but for more delicate finishing work. A smith usually has several of them for they have the advantage of being easily manipulated to strike in any direction merely by turning the wrist. Artefacts can be struck with the flat of the hammer, with its end, or with its edge.

With the exception of one tribe east of the Rift Valley,[28] who use type B1 (a)(i) as well as hafted hammers, these unhafted hammers are only found in the north of Kenya and to the west of the Rift Valley where they are used by Paranilotic pastoralists[29] and semi-pastoral agriculturists[30] and by the Interlacustrine Bantu and Nilotic Luo. Type B.1 (b) is generally confined to the latter group and type B.2 to the western-most Interlacustrine Bantu.

C. Hafted iron hammers
C.1
Is basically an unhafted cone-shaped pounder which has a hole punched through its side near the centre (Fig. 7, No. 3) or towards the heavier (Fig. 7, No. 4) or lighter end (Fig. 7, No. 1) for the insertion of a short handle which usually goes right through the head to protrude above. It is sometimes held in position by wedges (Fig. 7, No. 2) or by having the protruding end

of wood hammered so that it splays out round its hole. This type is the typical hammer of the Highland Bantu.

C.1 (a)
A somewhat square cross-sectioned version with a longer handle which is used by the Kamba[31] (Fig. 8, Nos. 4 & 5).

C.1 (b)
A round cross-sectioned version about 25cm long with its short side ending in a sharp point while its long side terminates in a convex bevelled face. The handle, which is never more than 15–20cm long (Fig. 9, Nos. 1 and 2) fits into a hole closer to the pointed end. This hole does

not penetrate through the ridge which goes over its top and round its sides. The handle is never wedged in but rarely detaches itself from the head as it is glued firmly into position. This type is peculiar to the Kikuyu[32] whose smiths usually each have three differently balanced hammers.

The hammers of the Embu (Fig. 7, No. 1) fall halfway between types C.1 (a) and C.1 (b).

C.2
A square or oblong cross-sectioned hammer usually hafted close to its lighter end. The handles are usually long and sometimes very long (Fig. 10, No. 5 and Fig.

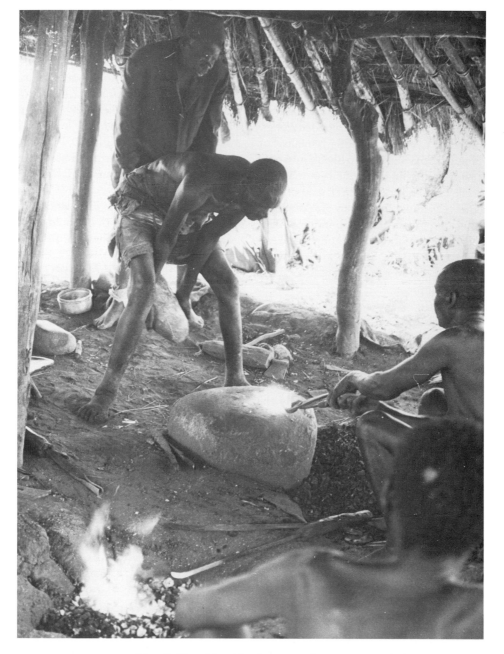

Plate 2. Marachi smith using a stone hammer.

11, No. 5). Each smith may have as many as five or six of these hammers of different sizes and shapes (Fig. 10). They are confined to the coastal peoples.[33]

C.3

Copies of European type hammers introduced within the last 100 years (Fig. 8, Nos. 1, 2, 3; and Fig. 9, No. 3). They are most frequently met with among the eastern-most Interlacustrine Bantu.

There appears to be a logical progression in the development of the hammer from the random choice of any handy hard stone as a hammer-stone, to the careful shaping of a specially chosen stone, then to the manufacture of an iron pounder gripped like a stone, which is later holed for the insertion of a haft, and finally, after much experiment, ends up with different shapes and sizes of head and length of handle. The mandrel hammer is the only dual purpose hammer to be found in Kenya. There are no anvil hammers such as are found in Uganda.

Smiths using stone hammers prefer them because they are poor conductors of heat.[34] For the same reason the smiths using stone hammers also use wooden tongs. They say that the iron they are working remains hot longer, and the hammer does not heat up like an iron one. Except for the few tribes[35] who shape them, stone hammers are used as they are collected. The shaped ones in western Kenya are used almost entirely to break up iron ore before smelting, and for the heavy pounding of red-hot iron in the initial stages of forging, although type A.2 is sometimes used to cut hot iron. Smiths who use stone hammers are the only ones who stand upright to forge for they have to swing the hammer from way down between splayed legs, up over the head, and down again to pound the iron on the downward stroke. Since both hands are required to hold the hammer another smith holds the red-hot iron in tongs, on the anvil with one hand, while he holds an iron rod, with which he points out exactly where the next blow must be struck, in the other. This job is reserved for the oldest smith who is usually the master of the group.

Swinging the hammer requires tremendous exertion for the smith swings from the waist straining his whole body which becomes soaked with sweat in the process. He gasps loudly as he breathes in on the upward stroke and grunts as he breathes out when smashing the hammer onto the iron. Forging with stone hammers is not very efficient as it requires more men, effort and time, than the same operation carried out using iron hammers.[36]

Although the Somali say that a stone hammer must be found near an anvil stone, this is not usual and no Kenya smiths seem to think of a stone hammer as the anvil's child as they do in Uganda.

Smiths using iron hammers of all types (and those using small stone hammers for the finishing process) work in a sitting or in a squatting position sitting on their heels with the soles of their feet flat on the ground. Only one man is necessary for forging as he holds the iron in tongs in his left hand while he pounds it with the hammer held in his right.

Iron pounders, which are remarkably efficient tools, are used by the smiths with extraordinary skill. They are able to make beautiful delicate spearheads with them, and a variety of ornaments requiring fine work. Some smiths manage to do this with only one pounder but the majority possess two. Sometimes the heavier pounder is used to hit the lighter one which is, in turn, hammering the artefact.

Of the hafted hammers it is the heavier ones which are used for pounding in the initial stages of forging. The heavier hammers of the coastal peoples have the longest handles to give them the maximum swing, so that they can be grasped in both hands and swung from the shoulder. Two smiths hammer the metal alternately which speeds up production as they are able to get in more blows before the metal cools and has to be re-heated. Coastal smiths have the greatest variety of well-balanced hammers each kept for a specific type of work. The finer ones (Fig. 10, No. 1; Fig. 11, No. 1) are used in jewellery making. Their short handled hammers, which are used in the later stages of forging are swung from the elbow.

The hammers of the Highland Bantu are only occasionally swung from the shoulder even in the initial stages of forging[37] for their short handles make it difficult to do anything but swing them from the elbow or wrist. The pointed end of type C.1(a) is used to give a direct blow, but its wider end strikes a glancing blow which is delivered merely by flicking the wrist.

Since a hammer is the symbol of the smith's craft and is regarded by smiths as their most important tool[38] it is usually ritually forged and ceremonially presented to a new smith when he is initiated,[39] although sometimes he has to make his own hammer. In many tribes[40] the smith is presented with only one hammer, usually the largest which is referred to as the male, but the smaller is the one presented in tribes which refer to the smaller hammer as the male. Any other hammers that the smith needs will be made subsequently by himself.[41] Other tribes[42] present him with his full complement. Apparently no ceremony accompanies the acquisition of a stone hammer.

The hammer presented to a new smith must be made from iron smelted by traditional methods. Occasionally it is made on the actual day of the ceremony by all the initiated smiths of the area,[43] but more often it is made by the initiate's master well before the ceremony to allow time to forge another if the first forging proves unsuccessful.[44] These hammers sometimes take two days to make. The hole for hafted hammers is made with a mandrel. There is no accompanying ceremony

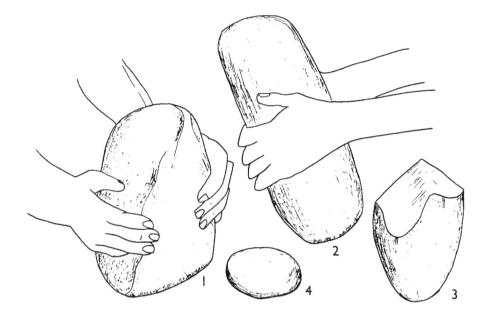

Fig. 5 (1–4). Stone hammers.

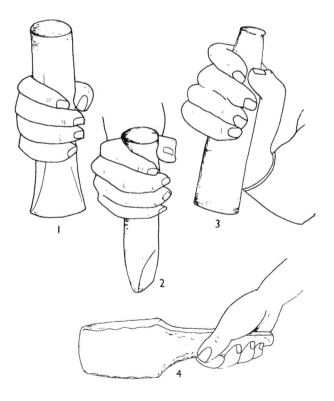

Fig. 6 (1–4). Iron hammers of types B.1. and B.2.

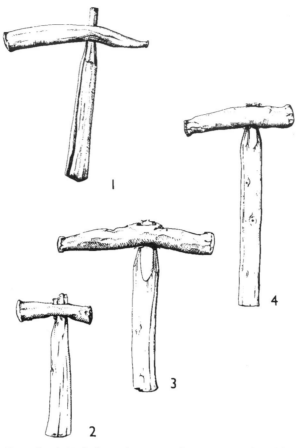

Fig. 7 (1–4). Hafted iron hammers of types C.1. and C.1(b).

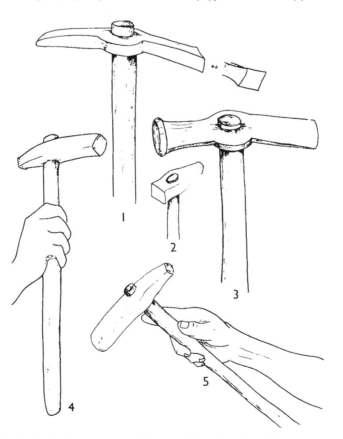

Fig. 8 (1–5). Hafted iron hammers. Types C.1(a) and copies of European hammers.

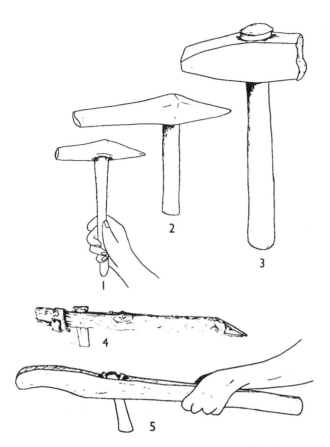

Fig. 9 (1–5). Hafted iron hammers. Types C.1(b) and copy of European hammer. Hafted chisels.

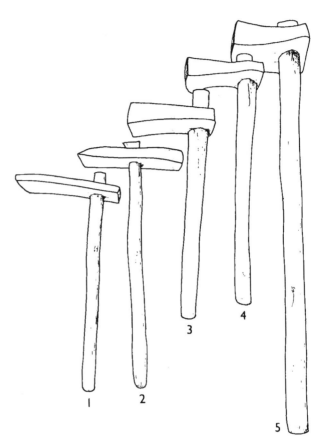

Fig. 10 (1–5). The different hafted iron hammers of a Giriama smith.

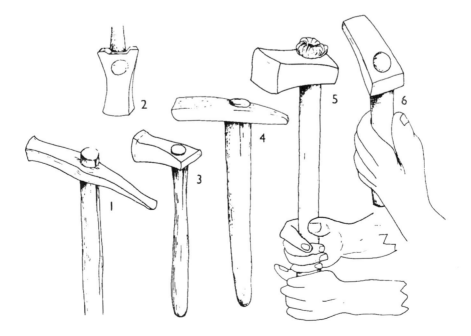

Fig. 11 (1–6). Hafted iron hammers of coastal type.

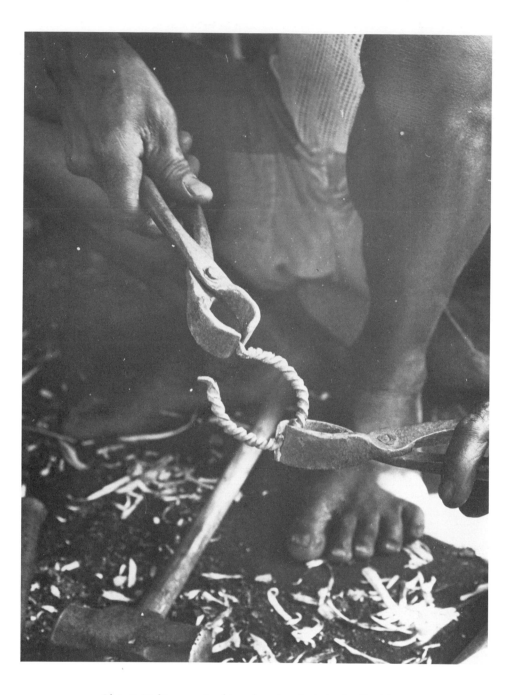

Plate 3. Making a twisted iron bracelet, the insignia of smiths.

other than a short prayer to the ancestors to ask for their help in producing a first class tool which will bring its owner success in his craft. There are usually, however, certain taboos which must be observed before and during production.[45] The smith must be sexually continent and should not have cursed anyone, abused anyone, or drunk to excess. In one case[46] no water is allowed near during the forging.

The hammer is always presented to the smith with great ceremony. Sometimes this ceremony is known as the "wedding of the hammer", and the hammer is regarded as the smith's chief wife.[47] It is purified by being smeared with the chyme of the sacrificed animal provided by the initiate, or sometimes by being smeared with fat,[48] or with a special concoction of medicinal plants. It is then blessed and dedicated to his ancestors. This may be done by placing it overnight on the wet skin of the sacrifice,[49] between the sleeping skins on the bed of the new smith,[50] or by the centrepost of his hut[51] where it is left for a day or two before it can be used.

Smiths may also inherit one or more of their hammers for when a smith dies his tools are divided amongst his smith sons.[52] Many smiths' hammers are therefore very old as they have been passed down to them from their great-grandfathers. Many of these hammers are kept in the smithy but never used. This is because each smith uses his hammer in his own peculiar manner. After years of habitual use by one man a hammer becomes worn on one part of its face only, or it becomes skewed by repeated "drawing" strokes so that other smiths find it difficult to use with precision.

The hammer presented to a smith on his initiation is sometimes[53] buried with him because it is in that particular tool that the mystical power of the ancestors is concentrated and if not buried with him it could cause great harm and misfortune to anyone who came into contact with it. That hammer is also the tool with which a smith most frequently curses,[54] and when he marries it may have to be ritually introduced to his bride[55] for her own protection[56] and in the hope that she will produce a son who will inherit the craft of which it is the symbol.

Touching the smith's hammer is taboo. In many cases this applies even to the wives of smiths,[57] and to their apprentices until they reach a later stage in their training.[58]

As a hammer is such an important tool it is not surprising that many tribes[59] believe it to be an ill-omen if one breaks[60] or slips out of the smith's hand while he is using it.

THE ANVIL

An anvil is another tool vital to smiths. All smiths, with the exception of those of a few coastal tribes who only have iron anvils, use stone anvils although most of them use iron anvils as well. Many prefer stone anvils because when using them there is less heat lost from the artefact they are working and they do not have to return it to the fire as frequently. The Masai group of pastoralists generally use only stone anvils and so do the Highland Bantu group although some of their smiths are beginning to use iron anvils nowadays. They do not, however, make them, but merely use a large piece of scrap iron, the favourite being a short length of train rail.

Several different types of both stone and iron anvil are used:

A. Stone Anvils

These are always made from hard long-lasting volcanic rocks.

A.1

A naturally shaped rock which may be used as it is found but usually has the edges of its working surface

rounded off. This type is found throughout Kenya, occasionally as the only anvil in a smithy,[61] but more often as a second anvil. It is the usual type used by cold forgers. These anvils are usually not very deep and they may just be placed on the ground or sunk in almost level with it. They rarely measure more than 30–40cm long and 25–30cm wide.

A.2 (a)

A square or oblong (occasionally oval) cut stone anvil with a smooth and slightly convex top with no groove in it. Its top edges and corners are rounded or bevelled off by trimming. This type, which is by far the most common in Kenya, is usually set very firmly into its hole so that only about a third of it shows above ground. The tops of such anvils are rarely more than 20cm above ground level and usually less. Three sample measurements are:

1) 29cm long × 28cm wide × 40cm deep, showing 15cm above ground.
2) 31cm long × 21cm wide × 35cm deep, showing 12cm above ground.
3) 28cm long × 18cm wide showing 19cm above ground.

They average about 23–25 kilos in weight. A smithy usually has one of these but a busy smithy in which several smiths work may have two, one for heavy pounding, and the other for lighter work.

A.2 (b)

A square or oblong cut stone anvil with smooth slightly convex top across whose breadth a V or shaped groove is cut in the centre or towards the end (Fig. 13, No. 1: Fig. 15, No. 3). This is for making the midribs of spear, sword and knife blades. The measurements of these are similar to A.2(a) but there is probably a greater proportion of narrower (about 15cm wide) oblong anvils. Such anvils are particularly characteristic of Kikuyu smiths who may have three or four of them (Fig. 1 bottom) with different depths and widths of groove for they use some anvils for making spears and others for making swords. They are also found amongst the Kalenjin group and occasionally amongst the Masai group although their smiths usually manage to make sword and spear mid-ribs without using a grooved anvil.

A.3

A round stone anvil with flat top carefully bevelled round the edge, never grooved, and set deeply into the ground (Fig. 13, No. 2). This is characteristic of the eastern Interlacustrine Bantu, but the western Interlacustrine Bantu sometimes use a shallow variation of this which may just rest on the ground (Fig. 13, No. 3).

B. Iron Anvils

B.1 (a)

Small square anvils tapering slightly towards a flat base which is fitted into a log of hard heavy termite-proof wood sunk flush with the ground or slightly below it (Fig. 14, No. 9). The heads of these anvils, which mushroom over their stems, are 8–10cm square. They stand about 10–12cm high and the log of wood into which they are set is usually 45–60cm long, about 30cm wide and 15–20cm deep. They are very occasionally oblong and may have a hole in the side which is used for bending iron (Fig. 14, No. 2). This is the type of anvil used by Arab immigrants and is virtually confined to the coastal peoples[62] and to the Cushitic pastoralists of the north-east.

B.1 (b)

Ditto B.1(a) but round instead of square. It never has a hole in its side. It is confined to the same groups of peoples but is more usually found amongst the coastal peoples (Fig. 14, No. 1).

B.1 (c)

Ditto B.1 (a) but oblong in shape and usually not more than 12–13cm long. It is used by the southernmost coastal peoples (Fig. 14, No. 6; Fig. 12, No. 4).

B.2

Tiny, tall, square or oblong anvils with (Fig. 14, No. 4) or without (Fig. 14, No. 7) a groove. Those with grooves are usually about 5cm square. Those without are usually oblong about 5cm long × 3½cm wide. Both types stand 12–15cm out of the ground. One was observed to rest on crossed bars of scrap iron, 23cm below ground level, which lay on 8cm of broken stone at the bottom of the hole. They are found only amongst the Kalenjin group.

B.3

Miscellaneous small oblong (Fig. 14, Nos. 3 and 5) occasionally tapering, (Fig. 14, No. 5) iron anvils which are never grooved. They are 6–7.5cm long and only 1–1.5cm wide. They rarely stick out of the ground for more than 5cm and are presumably set in wood or on stone, although these are never visible.

B.4

Anvils of scrap iron of European manufacture (Fig. 12, No. 2). The commonest type are bits of train rail about 45–60cm long (Fig. 12, No. 2) but other heavy bits of iron (Fig. 15, No. 1) such as engine blocks (Fig. 12, No. 3), are also used. These are generally confined to the Highland Bantu and eastern-most Inter-lacustrine Bantu who never developed any iron anvil for themselves.

Anvils appear to fall into a typological sequence from the use of any rough piece of hard rock to the careful shaping of a specially chosen rock, and thence to iron anvils. An important innovation was the cutting of a groove in both stone and iron anvils. I have never seen an anvil with a spiked base in Kenya nor have I seen a hammer used as an anvil.

Stone anvils are always made from very hard durable volcanic rocks for they are subjected to constant pounding and must not crack up. A suitable rock of the right size and shape is always searched for. Several have to be dug out before a suitable one is found. If none is found the anvil has to be cut from a larger rock. A stone or iron hammer and chisel and/or wooden or iron crowbars or wedges are used to split the rock, the smith first marking the line, along which he wishes to cut, with charcoal. The rock is rarely split by firing[63] but when that method is used butter or castor oil is poured along the splitting line and then a fire is built around the rock to crack it.[64]

Stone anvils are usually collected by a small party of smiths. More rarely apprentices[65] collect them, but one tribe[66] has men who specialise in supplying stone anvils to smiths. In exchange for a pair they used to be given a large goat.

Since stone anvils are very heavy they are either rolled home, carried home tied up slung on a pole, or dragged home by oxen,[67] but some smiths[68] get their wives to carry them home for them.

A favourite place to search for rock anvils is a river bed, especially in western Kenya,[69] but they are also obtained from mountain-sides, and at the coast, from the seashore. In central Kenya there are areas so famed for producing long-lasting anvils[70] that smiths will travel long distances to obtain them. These anvils last so well that many of them have been inherited[71] by their present owners. In other areas[72] the rock is less durable so that the life of an anvil is estimated to be only one or two years. Sometimes they crack after only three months use. Some smiths[73] collect them and bring them home at night for they believe that an anvil will crack up, when it is first used, if it has been seen by anyone but the smith before it is consecrated. If three successive anvils crack it is regarded as a very bad omen which is said to indicate that the smith did not remunerate his master sufficiently for his training, or that he was not generous enough in his provision of food and drink for his initiation ceremony.[74]

The heads of stone anvils are rounded off and trimmed with hammer-stones of hard volcanic rock. Sometimes an orange-sized ball of quartzite is made and kept especially for that purpose. An iron hammer is also used occasionally.

Collecting the anvil, or more particularly bringing it back and installing it in the smithy, is attended by considerable ritual amongst most tribes although some[75]

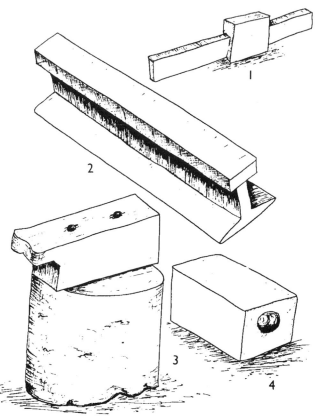

Fig. 12 (1–4). Iron anvils of type (B.1(c) and scrap-iron anvils.

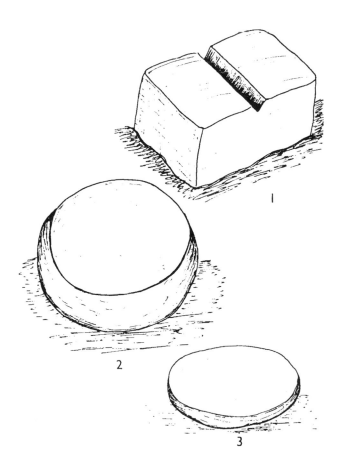

Fig. 13 (1–3). Stone anvils grooved and ungrooved.

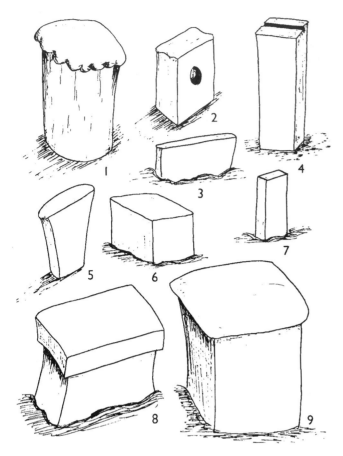

Fig. 14 (1–9). Iron anvils of type B.

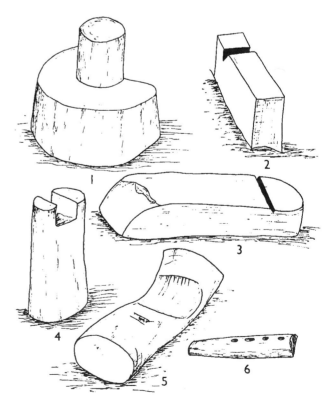

Fig. 15 (1–6). Scrap iron anvil, grooved iron stone and stone anvils, wooden blocks used in smithy and iron tool for bending tool tips.

say that there is no accompanying ceremony. Apparently no libations or offerings are, or were, made to the prospective anvil whilst it was still *in situ* as was the practice in Uganda[76] but prayers[77] are almost always offered for its success.

Amongst some of the Interlacustrine and Coastal Bantu the installation of a new anvil, as amongst some tribes in Uganda,[78] is referred to as a wedding, the smith saying that he is bringing home a new wife. Its installation is almost always accompanied by the sacrifice[79] of a male goat and/ or hen which must be all of one colour[80] and is killed by having its throat cut. Where a goat and hen are sacrificed[81] the goat is killed in the smith's house while the hen is killed the following morning, by the centre-post of the smithy, before any work can be done on the new anvil. Ceremonial foods[82] are eaten at the feast on this occasion, and only ceremonial beer made from honey is drunk. The neighbours are often asked to provide this and are happy to do so as they all benefit from the smith's work. A libation of beer is poured[83] or spat over the anvil when blessing it. The smiths pray for God and the ancestors[84] to protect the anvil from evil so that it will be long lasting and produce sound work.

During the collection and installation of a new anvil all those present must be ritually pure.[85] The smiths must refrain from sexual intercourse, and must not have had any contact with anyone in a state of ritual impurity. This applies particularly to women who might be menstruating. The smith's first wife must be present. The smith usually invites fellow smiths of his family to witness the ceremony and to help him install the anvil in his smithy. The neighbourhood elders are also invited[86] but usually other smiths are deliberately excluded for fear of their sorcery.

The smith's stone anvil is regarded as next in importance to his hammer. In many cases[87] a smithy cannot move, nor can the descendant of a dead smith build another smithy, without consecrating it by bringing the anvil, or a fragment of it, from the ancestral smithy. The ancestral smithy is kept "alive" in this way for the new anvil is "warmed" by the old one.

In many tribes it was customary to place some magical or sacred substance[88] into the hole before lowering the anvil into it, or else on or round the anvil before it was used.[89]

Only in a few instances does a new anvil have to be christened by making a specific artefact[90] on it, and then only when it is installed at the initiation of a new smith. In one case[91] the hoe which has to be made is sold and the money from it is put towards the cost of another ceremony known as "the wedding of the work".

Since iron anvils are more durable and are always inherited some of them are quite old. One coastal smith claimed to be using the anvil made by the first smith in his family several generations ago. When a new anvil does have to be made, usually before the initiation of a new smith, the same ceremonies take place. The smiths of one tribe have to complete the anvil in one day on a specified day of their week.[92] New iron anvils are usually cooled in water into which magical plants have been put.

An apprentice can almost never use his master's anvil. Instead he is provided with a large stone on which he practises until he is initiated as a smith. He may then be given[93] a new anvil by his master who has prepared it beforehand ready for the ceremony. It is usually handed over with a speech of blessing of which a typical example is "This man is now the same as I am and I shall give him a new anvil, and may this anvil be his friend".[94]

It is taboo to sit on an anvil[95] and sometimes on any of the other stones in the smithy for they might be broken anvils. This taboo generally only applies to a stone anvil probably because iron anvils are a relatively recent introduction and generally too small to sit on in comfort. In western Kenya[96] children are taught, from an early age, never to sit on or even touch an anvil in case they become stone deaf or grow up to be dwarfs or cripples. Anyone who does sit on one has to provide a sacrificial goat with which to purify both himself and the anvil.

THE BELLOWS

Both bowl and bag bellows are found in Kenya, the Rift Valley forming a dividing line between the two types. Smiths to the west of it use mainly bowl bellows while to the east they use bag bellows exclusively.

A. Bowl Bellows

Which are invariably made of wood, can be divided into three types:

A.1

A double bellows, usually 60–70cm long, carved from a single log of wood. The two wooden bowls, which are approximately round, usually measure about 25cm in diameter and are joined at the base. A single nozzle containing two separate air passages bifurcates off to each bowl. Without separate air passages the air blown out of one bellow would be sucked back up the other as the bellows have no valves. The bowls have everted rims so that the loose skin diaphragm which covers them can be lashed securely into position on the outside and cannot slip off (Fig. 16, No. 1 and 2). To pump them a vertical stick is pushed through a hole in the centre of the diaphragm and secured to it on the underside but this makes the bellows valveless. These sticks vary in length, some tribes[97] preferring them 105cm

long while others[98] use shorter ones usually about 75cm long. The bellows blower, who always stands to pump the bellows, works them alternately (Fig. 16, No. 1; Fig. 17). When the stick is raised air is sucked into the bowls through the nozzle, and when it is depressed air is pushed out into the tuyere and thence to the fire. The tuyere has to be close to the nozzle, but not too near for if that happens fire instead of fresh air is sucked back in.

This type is restricted to the westernmost Interlacustrine bantu[99] and the Nilotic Luo.

A.2

A single bellows with bowl and nozzle carved in one piece. Its nozzle is sheathed with the tail or legskin of an ox which protrudes over the end so that a detachable, slightly curved clay or wooden tip,[100] 12–15cm long, can be fitted into it. The total length of the bellows is usually 60cm.

The bowls are larger and deeper than in type A.1 and a high proportion of them are oval rather than round. A typical bowl measures 37cm long, 32cm wide, and 20cm deep (Fig. 19, No. 2; Fig. 20).

The loose skin diaphragm which is either fastened both on the inside and outside of the bowl or just on the outside (Fig. 19, No. 2) has a small aperture in its centre which acts as a valve. Each bellows blower works only one bellows[101] which is always placed on his left and worked with that hand. To suck air into the bellows he inserts his thumb into the aperture to pull up the diaphragm (Fig. 20), and then depresses it opening his hand as he does so to cover the hole so that no air escapes. I found the movement rather similar to that used in milking a cow.[102] Smiths using this type of bellows always sit down to work. They are typical of the Kalenjin group and of the Masai.

A.2 (b)

This type is almost identical with A.2 but has a smaller round bowl similar to type A.1 and a very short nozzle cut in one with the bowl. Into it is fitted a crude wooden extension. This type is always used as a pair. They are placed close together in front of their operator who sits on a high stone with his legs splayed awkwardly on either side. This type is confined to the eastern-most Interlacustrine Bantu[103] and is obviously an intermediate form between type A.1 and A.2.

A.3

A single bellows with a deep oval bowl cut in one with its short thick nozzle into which is placed a nozzle extension consisting of a long narrow iron pipe. Its valveless skin diaphragm comes to a peak in the centre and is attached to the rim of the bowl with nails (Fig. 19, No. 1). No tuyere is used. I have seen only one of this type in north western Kenya.[104] The smith sat

down to work pumping the bellows by holding the peak of the diaphragm in his left hand.

B. Bag Bellows

The bags are made from skin. There are two different types which are always used in pairs. Their operator sits down to work holding one in each hand and pumping them alternately.

B.1

A triangular-shaped skin bag with the hair always on the outside (Fig. 21 and Fig. 23, No. 2). The base of the triangle is an open slit which forms the air aperture. This slit is edged with two slats of wood held in the hand of the operator by means of leather thongs. The thong on one side is long enough for the insertion of all the fingers and on the other for the thumb only (Fig. 22). By opening his hand the operator opens the lips of the air aperture so letting in air, and by closing the hand quickly, while at the same time pressing the two lips together and gradually pressing down and collapsing the bag, the air is driven through the pipe or nozzle at the apex of the bag and so into a separate clay tuyere and thence into the charcoal of the fire. One end of the slats edging the air aperture is rested on the ground to give the operator maximum control of the bag. Sometimes[105] the aperture, which is usually about 35cm long, is stitched together for a third or more of its length to prevent the escape of air and provide a more efficient blast. Nozzles may be made of wood, clay,[106] stone[107] or antelope horn.[108] Wooden ones are frequently bifurcated[109] (Figs. 22 and 23, No. 2), but those made of the other materials are always single. This type of bellows is confined to the Highland Bantu[110] and the Samburu and Rendille pastoralists.

B.2

This type is operated in the same way as B.1 but is made from a whole animal skin turned inside out so that the hair is always on the inside (Fig. 23, No. 1). They never have a bifurcated nozzle nor are their apertures ever part sewn up. If the air aperture is at the head end of the skin, which is most usual, the front legs are cut off, but the hind ones, which are cut off at the knee, are stitched up, and the nozzle is tied into the neck hole. In both cases the tail is left on. Both Forbes (1964) and Cline (1937: 102) mention a nozzle tied into a leg but I have never come across this and wonder if the reports stem from careless observation. This type of bellows is restricted to the coastal peoples,[111] and to the Cushitic pastoralists of the north-east.[112]

I was told that one of the Highland Bantu group[113] formerly used a single bag bellows of a different type from either of these but could obtain no more information.

There have been attempts (Foy 1909: I: 185, Klusemann 1924: 120–40) to place the different African bellows types into a typological sequence but in so restricted an area of study this cannot be attempted. It would seem that bag bellows made from a single skin turned inside-out should be the forerunner of carefully cut and stitched triangular bag bellows but this does not appear to be the case as bag bellows made from a single skin are chosen by those industries which have the widest range of tools and use the most advanced technology. Such bellows may be considered preferable because they require less time and work to make. Partially stitching up the air aperture and fitting a bifurcated nozzle to triangular bag bellows is considered an advance in design.

No clay bowl bellows are found in Kenya, only wooden ones. They may be an improvement on clay bellows because they do not break easily but they could equally well indicate a pastoral origin since a pastoral mode of life dictates the use of wood rather than clay utensils.

Except in one tribe,[114] where the smith's bellows were carved for them by expert woodcarvers, the smiths always carve their own bowl bellows from hard durable wood.[115] They are roughed out with an axe, carved with an adze, and then finished off with a knife or sometimes spear. The air passages in the nozzles are alternately burned and scraped out. Some smiths say that they can make type A.2 bellows in three days but they usually take at least a week. Others are said to take as long as two months to make. This includes leaving them for one week covered with cowdung and then rubbing them with fat in order to prevent the wood from cracking.[116]

Smiths regard their bowl bellows as very valuable so great care is taken of them. They are usually hung up after work and the diaphragms of type A.1 are removed when not in use. The diaphragms of type A.2 are usually left on until they, or the cords with which they are tied, need replacing. Bowl bellows are inherited so many of them are sixty to eighty years old and often very worn and much patched.

For both bowl and bag bellows goatskins are preferred, but sheep, antelope and occasionally calf skins are also used. Recently I have even seen one smith use strong paper cement bags for his bag bellows. Only cow skin is used as a sheath on the pipes of type A.2 bowl bellows as it is tougher. With a few exceptions skins of any colour and from either sex are used[117] but since they must, in every case, come from a 'pure' animal[118] they are most often the skins of castrated males. The skins for a smith's first bellows are usually those of the animal(s) slaughtered at the ceremony to initiate him into the craft.

The skins are stretched, pegged out on the ground,

with small sticks, raw side uppermost, and left to dry in the sun. The hair is scraped off with an iron razor or axe-head always in the direction in which it grows to lessen the possibility of damaging the skin by accidentally cutting into it. If the skin is too heavy some of it is scraped away to make it thinner, while if it is too light for the bag bellows the hair is left on. It is then covered with fat[119] and softened by vigorous rubbing in the hands.

Some triangular bag bellows are quite small and can be made from only one skin but others are extra long and require as many as three skins.[120] There are reports of smaller bag bellows being used for forging while larger ones are used for smelting[121] but I have only seen the same ones, irrespective of size, used for both operations. The skin (or skins) is cut into a triangle which is folded over and stitched down one side. An awl is used to pierce the holes which are then threaded through with a fine goatskin thong. The wooden slats are fitted to the aperture either by tacking a thong through holes made in the wood (Fig. 22 and 23, No. 2) or by slotting them into thong loops (Fig. 21, Nos. 1 and 2).

To make the other type of bag bellows either the neck and front legs of the animal are cut off, or a portion at the rear including the hind legs. The remaining legs are always cut off at the knee. The skin is then pulled off inside out, cleaned with water, stuffed with straw, and left to dry for at least three days. After that it is smeared with fat and left for another day before being rubbed to soften it. The legs are then stitched up and the skin on either side of the air aperture is folded outwards over the wooden slats and hemmed to hold them in position (Fig. 23, No. 1).

Generally there are no taboos to be observed when making bag bellows but smiths making bowl bellows are prohibited from having sexual intercourse. Twins, people born with very tiny ear holes, and women who have just fetched water are also forbidden near in some cases.[122] It is believed that if the taboos are broken the bellows will not function properly and the smelting and forging operations will be a failure.

There is generally no ceremony when bellows are made although they are often blessed[123] so that they will function well and produce good artefacts. On the completion of type A.1, the smiths hold a ceremony at which a goat or chicken is slaughtered and its blood is poured into the bowls.

I was told that the diaphragms of bowl bellows last about three months if they are in continuous use. Bag bellows last four to six months under the same conditions but are said to last one to two years if the skins are good. Some smiths say that they have been known to last for four to five years if properly cared for and patched when they first show signs of wear. To prevent the skin wearing out from constant friction with the

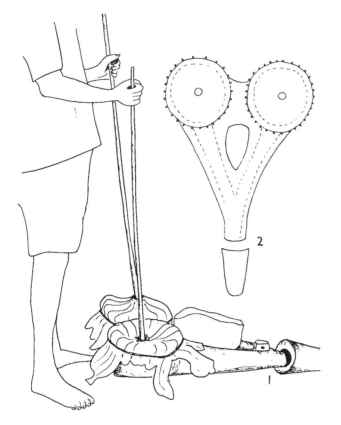

Fig. 16 (-2). Double bowl bellows of type A.1.

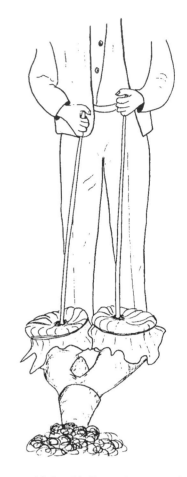

Fig. 17. Double bowl bellows of type A.1. showing method of working.

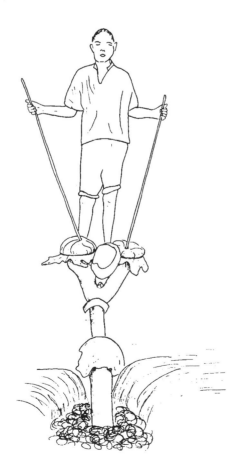

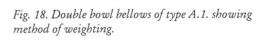

Fig. 18. Double bowl bellows of type A.1. showing method of weighting.

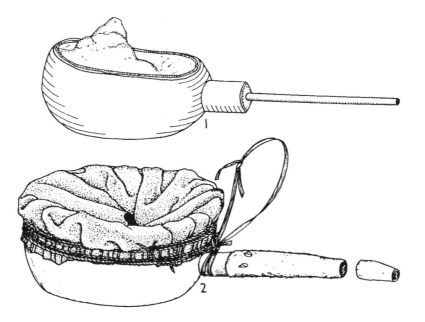

Fig. 19 (1–2). Single bowl bellows of types A.2. and A.3.

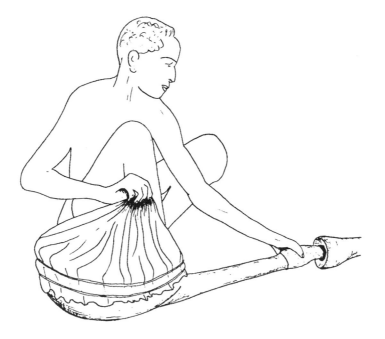

Fig. 20. Single bowl bellows of type A.2. showing method of working.

Fig. 21 (1–2). Triangular bag bellows of type B.1.

Fig. 22 (1–2). 1. Triangular bag bellows of type B.1. showing method of working. 2. Symbol below the bifurcation of a Kikuyu bellows nozzle.

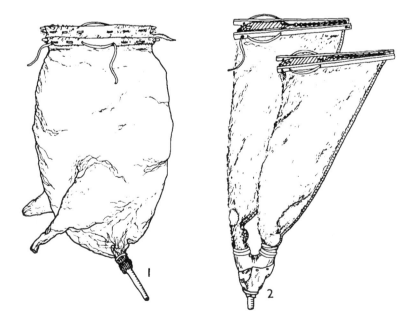

Fig. 23 (1–2). Whole-skin bag bellows of type B.2. and triangular bag bellows of type B.1. with bifurcated nozzle.

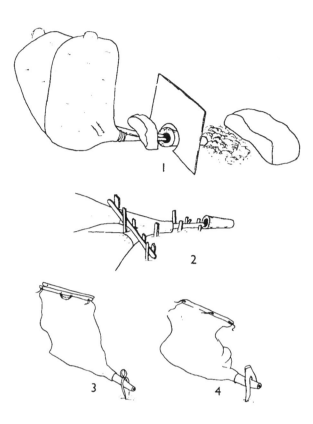

Fig. 24 (1–4). Methods of holding bag bellows in position.

hard ground another skin or an armful of grass is often placed beneath the bellows where the skin is attached to the nozzle.

Since bellows are subject to continuous energetic pumping they are apt to shift position so have to be held in place by various means. Bowl bellows of type A.1 are usually weighted down with a heavy rock (Fig. 16, No. 1) while type A.2 are held in position by the smiths hand during smelting and by his foot during forging. The nozzles of bag bellows are fixed firmly to the ground by forked sticks (Fig. 24, Nos. 3 and 4), or by uprights of stick or metal which are placed on either side of them so that crossbars of wood or metal can be jammed over them (Fig. 24, No. 2). String may also be tied across them and sometimes their nozzles too are weighted down with a stone (Fig. 24, No. 1).

Pumping both bowl and bag bellows requires considerable practice for the speed has to be regulated to keep the fire at the required temperature. It is particularly important that bellows should be operated properly in smelting because if they are not they suck back and block the tuyeres. To pump bag bellows alternately while maintaining an even rhythm is extraordinarily difficult at first. Orde-Browne (1925: 129–30) estimated that they were opened and closed about twenty times a minute, but this rate is speeded up when greater heat is required. Smelters that I timed opened and closed them once a second. When several bag bellows are used together for smelting the blowers pump them rhythmically in unison all pumping the same hand at the same time. Blowers pumping type A.1 bowl bellows become so skilled at keeping up a continuous blast that they often dance whilst working the sticks and pump to irregular drumlike beats which they change frequently to break the monotony.

Pumping bellows for smelting is exhausting work so the blowers change frequently, more frequently for bowl bellows than for bag bellows. When two or more smiths forge together they also take turns at blowing the bellows but a smith working on his own has to pump his bellows and forge alternately he, therefore, takes longer to produce a tool than a smith who has an apprentice or who shares his smithy. It is, however, usually apprentices who pump the bellows and it is the first skill that they learn. They have to become really proficient at it before being taught anything else. Before the onset of menstruation little girls are occasionally allowed to pump bellows[124] but, with the exception of a few tribes, women are generally not allowed near them.[125] Amongst the Samburu I have never seen anyone other than the wives and daughters of smiths pump their bellows, and the wives and daughters of Giriama smiths are taught so that they can take over the operation in the absence of apprentices. There are reports of women from three other tribes[126] blowing bellows but I have never seen them do so.

In some cases[127] bowl bellows may only be used by the smiths for whom they were made, i.e. during their lifetime, for it is believed that they will not function properly for anyone else. Bag bellows, on the other hand, can sometimes be lent to another smith.[128]

The bellows nozzle is often referred to as male for it fits into the tuyere which is referred to as female, and in western Kenya the left hand bowl bellows is referred to as female while the right hand one is male. In some cases the female is made deliberately larger than the male, but I have never come across any tradition of them ever having had male and female symbols on them as was the case in Uganda.[129] Only rarely is male/female symbolism associated with bag bellows. One tribe[130] insist that the skin of the right hand bellows must come from a male goat while that of the left must come from a female.

The only symbol I have seen on bellows anywhere in Kenya was branded immediately below the bifurcation on a Kikuyu bellows nozzle (Fig. 22, No. 2). It was said to be the owner's mark.

THE TUYERE

The tuyere, incorrectly called the nozzle in some litera-

ture, channels air from the bellows nozzle directly into the furnace or fire. In forging it rests on the lip of the hearth, or in a groove running into it, with its nose directed downwards. It is not generally secured to the ground but some smiths may hold it firm by wedging stones into the groove, burying it under soil, fixing it into the ground with clay or embedding it in a clay bank.

Tuyeres are almost invariably made of clay but are occasionally made of stone[131] or nowadays, from a piece of iron pipe. One smith[132] used no tuyeres at all as his valveless bellows had a very long nozzle of iron piping which went directly into the fire.

Smiths of the same tribe generally all use tuyeres of the same shape and roughly the same size but they may vary slightly in length according to the whim of the smith. I have seen a smith who normally makes funnel-shaped tuyeres, suddenly make a batch of straight ones but that rarely happens. Generally the same size of tuyere is used both for smelting and forging but there is a report that in one part of their country one tribe[133] whose tuyeres normally average 30–36cm long, made them three times that length for smelting.

Kenya tuyeres can be divided into three types:

A. Funnel shape

(Fig. 25, No. 2) with round cross-section. This is the most common type and is widespread. The smallest and most delicate of these all measure approximately 13cm long × 4.5cm wide like the sample given at the end, but otherwise they do not vary greatly in size as can be seen from the measured samples in Appendix III.

A.1
Is a variation which looks like a tube narrowing slightly into a sharply everted lip. This type is made by only one tribe.[134]

A.2
An oval cross-sectioned variation (Fig. 25, No. 4) is made by another tribe.[135]

Some smiths[136] produce a short straight pipe which can be classified as a funnel shaped tuyere without the funnel, rather than as type C.

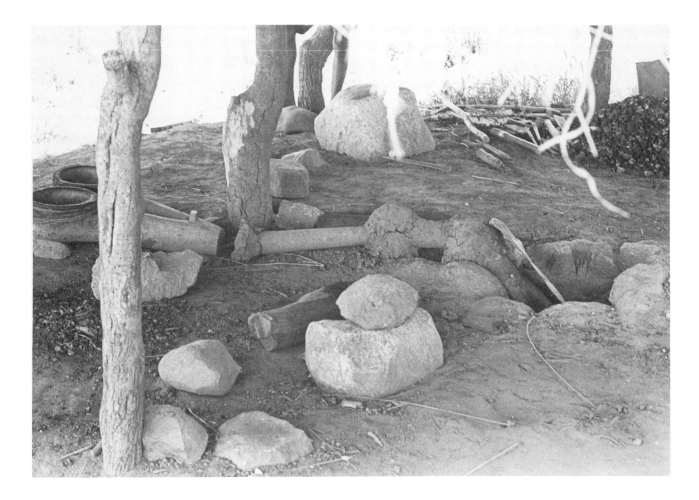

Plate 4. Marachi long straight clay pipe type tuyeres and stone lined hearth.

B. Cone Shape

(Fig.25, No. 3) This is found only amongst the Swahili speaking peoples[137] at the coast. It has not spread to the neighbouring coastal Bantu peoples who make a funnel shape.

C. Long straight Clay Pipe

This is just a long straight clay pipe slightly incurved at both ends (Fig. 25. No. 1). It is confined to the area close to the Uganda border in western Kenya.[138] Two or three of these pipes, usually 50–60cm in length, are joined together by thick rounded humps of clay which raise the pipes off the ground while fixing them firmly to it. These joints also make it easier to slope the whole tuyere gently towards the fire and to angle the last pipe sharply into it (Fig. 48, No. 2). Clay is also used to make the flared mouth into which the air is blown from the bellows nozzle. Since smiths need to replace the clay joints each day, and sometimes several times during the day, they dig their clay from small pits immediately outside the perimeter of their smithies. The closest analogy to this type of tuyere comes from the Karimojong of northern Uganda who also use a similar type of bowl bellows pumped with long sticks.[139] In other respects there is no similarity in culture or language between the two peoples.

In one tribe[140] tuyeres are made by the smith's wives, but elsewhere the smiths themselves make them for it is generally believed that a tuyere made by a woman would cause the smelt to fail and the forged iron to crack. For the same reason smiths generally collect their own clay although in rare instances[141] their wives collect it for them.

Potting clay is commonly used for tuyeres but some smiths are not allowed to use it. Instead they must dig their clay from the same place that they dig their iron ore.[142] This applies particularly to areas which are rich in murram deposits, for murram not only contains iron ore but produces good clay as well. The clay of termite mounds is also used because it is very good clay and has been produced by what are regarded as the most fertile creatures on earth. Some smiths travel considerable distances[143] for their clay which they carry back to their smithies wrapped in bundles of banana leaves or in baskets. Where women carry it they generally use pots.

The dry clay is prepared, as for pottery, by removing any large pieces of stone, grit, or vegetable matter, and then grinding it down on a quern before mixing it with water and kneading it to a dough-like consistency. Some smiths roll it into balls each sufficient for one tuyere. No grass or straw is added to the clay but donkey dung is occasionally added.[144] Sand is added by many smiths if the clay is not already sandy, while ash from the hearth,[145] or grit obtained by grinding down discarded tuyeres, is added by others.[146]

The paste is similar to that of pottery but generally rather coarser although the smiths of one tribe[147] make exceptionally hard tuyeres whose paste is finer than any present day Kenya pottery.

A tuyere usually takes about twenty minutes to make for smiths work surprisingly slowly and laboriously as they do not have the manual dexterity of potters. All tuyeres are moulded by hand around a smooth stick from which the bark has been removed. Sometimes smiths who have long handled hammers may use a handle instead. A stick of 2–3cm in diameter and two to three times the length of the tuyere is usually chosen. One tuyere of 17.5cm long was moulded on a stick 58.75cm long. The wood is sometimes rubbed with ashes[148] to prevent the clay from sticking for it has to be pushed up and partially off the end of the stick in order to flare the funnel. It is then left to dry on the stick for a few hours until it is firm enough to remove without losing its shape. Once removed, it is dried for 2–4 days either in the sun[149] or in the shade of the smithy.[150] Some smiths believe that drying tuyeres can be contaminated by contact with the earth so they place them on ashes from the hearth, on banana leaves or on the leaves of sacred trees.

After drying they may be baked by placing them beside the hearth, or holding them over the fire. Occasionally they are not baked as it is thought that they will get fired in use.[151] Some smiths, however, prefer to fire them properly as it prevents cracking. The very fine hard tuyeres are placed in the hearth with wood shavings and chippings and fired for one hour. Some are fired in the hearth on the normal charcoal fire, while others are fired first in grass and then in firewood. It is possible that these methods may vary in accordance with the type of clay used, but the general tendency is for tuyeres to be fired only in those areas which produce better made and better fired pottery. Some tuyeres are moulded around a pithy stick of millet or wild sisal which is set alight and in burning away fires the tuyere sufficiently to satisfy the smith.

Smiths always make from three to ten tuyeres at a time so that they have enough to last for some while, and spares in case of emergency. For one smelt an Embu smith makes nine tuyeres in case some crack or choke up, for he uses three pairs of bellows and must have enough spares. During a smelt the tuyeres are watched carefully for if the bellows are not pumped with the correct rhythm they tend to suck back causing the smelting iron to fuse around the base of the tuyere and block it. The end of the tuyere also becomes vitrified.

Even in forging the nose of the tuyere becomes fused and vitrified and the colour of the pottery changes

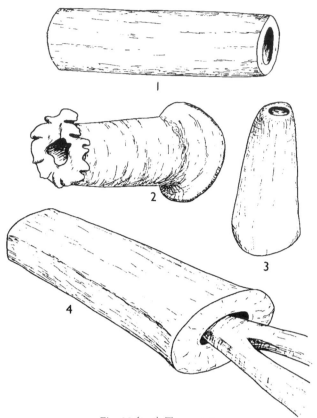

Fig. 25 (1–4). Tuyere types.

unevenly to black and grey, with the heat for it is buried beneath the burning charcoal. Bits of it break off so that it gradually becomes shorter. Tuyeres are usually discarded when they have been reduced to about 11cm in length no matter how long they were when made. Sometimes they crack up when quite new. On average a tuyere in continuous use is said to last two to three months but some smiths say that theirs only last for a week or two. Others[152] say that, if treated carefully and removed from the fire every time that work stops, they can be made to last for a whole year.

Discarded tuyeres are never thrown away or left lying around outside the smithy. Instead they are carefully set aside on the cinder heap at the back where they gradually disintegrate until only the vitrified lumps of their noses remain. There is a report[153] of one such heap measuring ten feet long, three feet wide, and eighteen inches high. The smiths say that to throw them away is tantamount to throwing away their ability to work iron, while to leave them around is dangerous for they are imbued with the mystical power of the smith ancestors which can cause harm[154] to innocent passers-by who inadvertently venture near them. They are also used for magical purposes[155] particularly by the High-

land Bantu whose smiths often hang them on trees to protect their property.[156]

Sometimes,[157] for obvious reasons, the tuyere is referred to as female and the bellows nozzle as male, but this not general. The smiths of one area[158] call the mouth of the tuyere its head, and the nose its legs. One tribe[159] make male and female tuyeres. The male tuyere, which is moulded around a straight stick, is used for forging artefacts such as spears and arrows, which are used exclusively by men, while the female tuyere, which is moulded around a slightly curved stick, is used for making tools like hoes which are used largely by women.

THE TONGS

Tongs are used to hold the hot metal during forging. Those used by Kenya smiths fall into three main types:

A. Tongs made of wood

These are made of a branch of green wood usually 30–40cm long and 3.5–5cm in diameter which is split for half, or a little over half, its length (Fig. 29, No. 1). They are only made from species of trees[160] whose

wood does not burn easily, but smiths who have given up using them say that their main disadvantage was that they caught fire. Smiths who still prefer to use them, because they do not get hot like iron tongs, overcome the burning problem by soaking them for a month before using in a herbal solution.[161] Wooden tongs are still used by the Interlacustrine Bantu[162] and the Nilotic Luo in western Kenya and were used all over Kenya within living memory except by the Cushitic pastoralists of the north-east and by the coastal peoples. The coastal Bantu have a tradition that they used them before they moved from their traditional homeland of Shungwaya, in Somalia, about four hundred years ago.

Instead of a piece of split green wood, two green wood sticks are sometimes used,[163] and occasionally two pieces of green bark.[164]

B. Hinged Iron Tongs

These are made from two pieces of iron bar which each have a hole pierced in them through which an iron rivet is placed to hinge them together. The handles are generally flat so that they are oblong in cross-section except at the end where their round cross-section terminates in a point.[165] One handle is almost always longer than the other to give them a more comfortable grip. They are very similar to the traditional tongs of British blacksmiths. They are made in different sizes, the largest usually being about 40cm long and weighing between half and three quarters of a kilo. The jaws vary

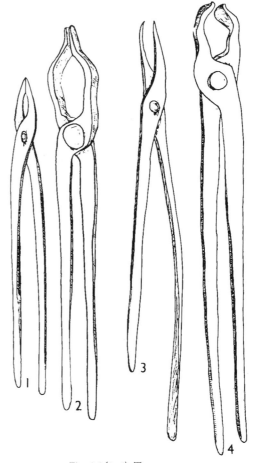

Fig. 26 (1–4). Tong types

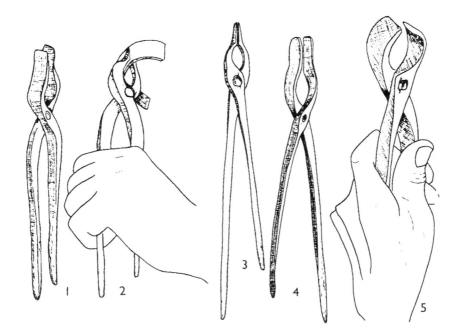

Fig. 27 (1–5). Tong types.

Fig. 28 (1–8). Tong types.

Fig. 29 (1–4). Split green-wood tongs and forceps-type tongs.

in length, the longest usually being about one third the total length. The smallest tongs, commonly used for chain making average about 20cm long with jaws 4.5–5cm long. They weigh approximately an eighth of a kilo. Each smith usually has two pairs of tongs of different sizes.

There are three types:

B.1
With wide jaws which meet only at the mouth for about a fifth to a quarter of their length (Fig. 26, Nos. 1–3; Fig. 27, Nos. 2–4; Fig. 28, Nos. 3–5).

B.2
With wide jaws which meet only at the mouth (Fig. 26, No. 4; Fig. 27, No. 5).

B.3
With jaws which meet right along their length (Fig. 28, Nos. 1–2, 6–8). The smallest of this type, which are not regarded as smith's tongs, are always used by chain smiths and often have a small longitudinal groove at the tip, or a tiny 'parrot beak' on one side, to keep the delicate chain links from slipping.

C. Forceps Type

These consist of a single piece of flexible metal bent until the ends touch. This may be either simply bent over (Fig. 29, Nos. 3–4) or bent round a maul and squeezed to give it a waist so that it has the appearance of sugar tongs (Fig. 29, No. 2; Fig. 41, No. 1). Sometimes it is ringed by one or two metal bands to prevent it opening too wide.[166] This type, which is rare in Kenya, is not an intermediary stage between wooden and hinged tongs. When no other tongs are available they are made for temporary use from any suitable scrap iron.[167] They are the type used by specialist ornament makers who are forbidden to use smith's tongs.

Nowadays no Kenya smiths use only wooden tongs although the westernmost Interlacustrine Bantu still prefer them and use them almost exclusively for holding large lumps of red-hot metal in the initial stages of forging.[168] Iron tongs have, however, only been used in that area since the early 1940s.

Iron tongs may be made for a new smith by his master and given to him when he is initiated into the craft,[169] but usually smiths make their own or sometimes buy them from another smith who specialises in making them. Occasionally tongs are buried with a smith if he has no sons to inherit his craft, but normally they are inherited together with the other tools of the trade.[170] Many of the tongs in use are fifty years old and one smith was using a pair made in 1898.

THE SMITH'S OTHER TOOLS

The foregoing tools are those most essential to a smith but smiths also use a variety of other tools of which cutting irons or chisels and mandrels are perhaps the most important.

Stone chisels were used in the past particularly in western Kenya.[171] Nowadays most smiths have a number of iron chisels of different sizes and lengths with both wide and narrow cutting edges. The longest, which are usually also the narrowest, are basically iron bars with a cutting edge at one end. Except for the cutting edge they are round in cross-section (Fig. 30, No. 1) or are flattened on two sides which may occasionally be flanged (Fig. 30, No. 3, 4 and 5). On average they range from 1–4cm wide and from 6–15cm in length, although some are as much as 23cm long. They are always held directly in the hand and never hafted. The wider variety are short wedge-shaped tools (Fig. 30, Nos. 5, 6, 8) which are oblong in cross-section. They may have developed from an axe as they are often regarded as an axe without a handle, and some of them are actually made from old axe blades. They are rarely more than 8cm wide. The narrower ones are held directly in the hand while the wider ones, used for cutting heavy bits of red-hot metal, are put into horizontal hafts, about 40cm long, so that the smith's hand is not burned by the heat rising from the hot iron.

The chisel is inserted about 1/4–1/3 of the way along these hafts which are usually rough pieces of tree branch. The branch is either split at one end for the insertion of the chisel, which is kept firmly in position by binding the split with a strip of metal (Fig. 9, No. 4) or a hole is made through it for the chisel which is held in position by small wooden wedges (Fig. 9, No. 5). In both cases the head of the chisel protrudes some way out of its haft so that it can be easily hammered. As a result of repeated hammering the heads of most chisels are well burred over. They are often re-hardened at intervals by heating them in the fire and then quenching them in cold water. This is done twice before the chisel is considered ready to use again.

Mandrels (Fig. 31, Nos. 1–6) are cones of iron which vary in length and diameter according to the purpose for which they are used. They too were made of stone in western Kenya until comparatively recently.[172] Metal rings are placed on them for trueing up and they are inserted into bells or beads (Fig. 31, No. 4) when they are being worked. Smiths rarely make holes in iron, but when they do, as when making the hole in a hammerhead, they use mandrels. Smaller holes are also made with mandrels or with any piece of scrap iron roughly shaped into a spike (Fig. 32, No. 2), while tiny holes, such as those pierced through bells, are made

with a short blunt-nosed awl (Fig. 32, No. 3). The most important use for mandrels is for making sockets.

The sockets of spear butts and heads are shaped around long thin mandrels while tools such as knives requiring shorter sockets are shaped around shorter thicker mandrels. In length they vary from 30cm to 5cm, but are rarely more than 3.5cm in diameter. Some acquire slightly burred tops from being tapped constantly by the hammer. In Western Kenya[173] long mandrels are used both as mandrels and hammers (Fig. 31, Nos. 5 and 6).

Roughly made wooden mandrels are frequently used for making coarser sockets, for shaping bells, and for trueing up bracelets but when a socket requires a smooth and perfectly finished interior, as in spear making, they are only used in the initial stages of the work. Smiths make these wooden mandrels as they are required and discard them after a few days when they begin to crumble from burning.

During the initial stages of forging a tool smiths use their tongs to hold the hot iron but in the later stages, when only part of the artefact is heated at a time, it is held in a temporary handle of wood or iron. Smiths have a variety of these lying around their forges. Most are of wood, roughly made, and average 15–20cm long. Some, which resemble a wooden mandrel and are sometimes used as such, are pointed at one end to fit into a socketed artefact (Fig. 33, Nos. 2 and 3) while others look like wooden tongs as they are merely pieces of branch split up to hold the tang of the tool in process of manufacture. The tang, however, is firmly hammered into the holder and left there until forging is completed (Fig. 33, No. 5).

Metal handles, which are used only for holding tanged tools, are more common in western Kenya.[174] They consist of a rough socket, perhaps more correctly described as a flanged bar, which may be used alone (Fig. 33, No. 1), or may itself have a wooden handle fixed into its other end (Fig. 33, No. 4).

Files were not used traditionally by Kenya smiths and are still not often seen in smithies.

Very few smiths have iron pokers (Fig. 34, No. 2) as they poke their fires with green sticks. They sometimes also use rakes which are found throughout Kenya. These are unhafted slim iron bars curved and sometimes flattened (Fig. 34, Nos. 3, 4) at the working end while the other is curled over to form a handle.

An iron pointer, which is burned into a short wooden handle (Fig. 34, No. 5) is used only by smiths who pound their red-hot iron with heavy stone hammers. Some smiths have a small heavy piece of iron, often scrap, with a hole or holes in it (Fig. 15, No. 6) over which objects are placed to have holes pierced into them, or which is used for straightening out or bending

tips of objects, or working the back of pointed objects whose points are placed in the holes.

Most smiths have a utensil for holding water for quenching and for dampening down the fire. An old pot is usually used but some smiths have a well-made wooden trough (Fig. 35, No. 1). Brushes, which are roughly made from fibres or twigs (Fig. 36, Nos. 1 and 2) are used for sprinkling on the water to dampen down and contain the fire and conserve the charcoal.

In most smithies there is a horizontal log of wood on which blades are leaned for sharpening and polishing (Fig. 15, No. 4). A banana tree stem is often favoured for this work and the blades are either pegged down or held in position with the foot. Occasionally a short stump, with its top notched to hold the blade, is set upright in the smithy for the same purpose[175] (Fig. 15, No. 4). Nearby are several sharpening, burnishing and polishing stones usually of quartzite or volcanic rock and a horn or two used for 'blueing' (i.e. blackening) the heads of spears.

Although wire is no longer made many smiths used to make it in the past and still have their wire drawplates and clamps. If they did not themselves make wire they made the drawplates and clamps for wire and chainmaking specialists who still use them for reducing the thickness of trade wire when they are unable to obtain the required gauge. The drawplates average 15–20cm long,[176] 3.25–4.5cm wide and vary in depth from 1.25–2.5cm.[177] They are boat-shaped with a slightly concave top through which a line of countersunk holes of different sizes are pierced[178] (Fig. 37, Nos. 2–3). The clamp used to hold the wire consists of a split rod, into which the wire is placed. It is closed by a metal ring held firmly in position by the insertion of a small wedge.[179] (Fig. 37, No. 1). Another tool used to hold the wire[180] consists of an angle of iron with a hole in its short arm through which the wire is pushed and fastened by being bent back and twisted round itself (Fig. 38, Nos. 1–2). Notched and forked posts, about 1.12 metres high, set firmly in the ground, are also used for drawing wire. The drawplate is held against the forked post so that the wire is drawn through the fork (Fig. 38, Nos. 1–2). It may be wound round a second post some distance away or, then be pulled through the notch of a second post (Fig. 38, No. 3) and wound directly onto a coiler (Fig. 38, No. 3).

A different type of wire drawing apparatus is used by coastal silversmiths. It consists of a stepped heavy plank of wood 1.5 metres long, 18–20cm wide and 12–13cm deep with a draw-plate at one end through which the wire is pulled by a pair of pincers attached to a wooden upright which is worked along the plank step by step (Fig. 39). The drawplate is a narrow brass plate with numerous rows of different sized small holes. It is

typical of those used by Islamic silversmiths from Morocco to India.

Wire is used almost exclusively for ornament. So is the fine chain made from it, not by the smiths, but by specialist chain-makers. They use three different types of tool for coiling the wire. The simplest is just a thin wire rod in a wooden handle. The wire is attached to the rod, through a hole in its handle, and carefully wound round it (Fig. 37, No. 4). In this method the rod is always thicker than the wire being coiled. Chain-makers producing simple link chain (Fig. 37, No. 5) almost always use this method.

In the second type of tool the ends of a horizontal of thick wire are stuck through the tops of two vertical sticks. The left hand stick, in which both thick and thin wires are wedged, is held firm while the right hand one is turned in order to coil one wire around the other.[181] The most sophisticated tool, which works on the same principle, consists of an oblong of rhinoceros hide about 7–8cm long and 4–5cm wide, into which is fitted a long right angled stick which serves as a handle, and a shorter one which wedges into position an upright wire and the wire to be coiled around it (Fig. 40. No. 1). By holding the upright wire in the left hand, using a small leather guard to protect the finger, and turning the handle in the right hand, one wire is spiralled around the other. Sometimes there is no second hole in the rhinoceros hide as the handle itself is used to wedge in the two wires (Fig. 83, Nos. 1–4). A long coil can be produced in the tool merely by pulling the finished portion down through the hole.[182]

Chain-makers using more advanced methods[183] also use a hard-wood pedestal (Fig. 40, No. 2) with a spiked base on which the links are shaped by means of two awls (Fig. 40, No. 3). The finished links are kept in a narrow bamboo tube and are then joined and squeezed together with a pair of pincers (Fig. 40. No. 4).

Traditionally smiths restricted themselves to making iron ornaments for protective purposes, and many, like those still using stone hammers, still do.[184] Many smiths, however, will make ornaments of brass, copper, or aluminium if *heat forging* is involved,[185] but others regard such objects as being purely for pleasure. As such they can be made by any apprentice but once a man is initiated a smith he has to stop making ornaments of any metal other than iron[186] unless he *heat forges* them. Where this applies highly skilled specialist ornament makers are to be found who can cast and forge other metals but never iron.[187]

For these reasons few smiths have special tools for making and decorating non-iron ornaments. Nowadays the metal most commonly used for making ornaments is aluminium which is melted down and cast. An old tin is used for melting the metal which is usually cast into a groove in the floor of the smithy or into a piece of old angle-iron if that is available. Clay moulds are occasionally made by both smiths and ornament makers. There is only one instance of *cire perdue* casting.[188]

The most common method of decorating aluminium, brass and copper ornaments is the simplest. Patterns are incised, or more rarely punched, into them. For incising patterns knife tips, and a variety of tracers in the form of hafted awls, which may have pointed, splayed, or chisel-like tips, are used (Fig. 42, Nos. 5–7). Occasionally one looks like an engraving tool (Fig. 32, No. 4) but it is usually only used as a tracer for it is rare for any metal to be removed. These tools are never hit with a hammer. Punches are rarer tools which are never hafted and are hit directly with a hammer. The most common type has a grooved tip which produces a pair of small holes (Fig. 30. No. 7).[189]

Only smiths of one coastal tribe[190] use dies which are of two types. A long narrow block of iron 20cm long, just over 1cm wide and 3/4cm deep, which is entirely covered with indented patterns (Fig. 44, No. 9), and a heavier rectangular type, usually 6cm long, 5cm wide and 1.5cm deep, with two or three patterns indented across its width (Fig. 44, No. 4). They also have the tools for making these. The patterns in the first type are made by hammering a tiny chisel, and a tiny blunt-nosed tool, both 3cm high and 1.5cm wide (Fig. 44, Nos. 10–11). into the iron, while the second type is made by hammering a positive die into it. The positive die is made by cutting patterns into a piece of shop-bought steel bar, or into a steel file (Fig. 44, Nos. 2–3) which has previously been filed smooth. A very small chisel 7cm high, with a cutting edge 1.5cm wide (Fig. 44, No. 1) is also used by these smiths. The ornament is always hammered into the die, never vice versa.

This technique has obviously been acquired from contact with coastal silversmiths of Arab extraction who use the tools and techniques of silversmiths throughout the Islamic world. Only they do fluting using small brass blocks with the desired delicate flutes carved into them. For making bosses they use a punch and dapping die of brass 5cm square with hollows of various sizes on each face (Fig. 34, No. 1).

Most blacksmiths who make jewellery also have wooden blocks on which to work it.[191] Most are small logs which may (Fig. 43, No. 3; Fig. 41, No. 3) or may not have a hole in them, and are sometimes accompanied by a wooden roller-cum-mallet (Fig. 35, No. 2). Some are larger horizontal pieces of tree trunk which also have a hollow and/or hole in them (Fig. 15, No. 5), while others, like the strange 45cm high peg-shaped tool of a Giriama smith (Fig. 45) are used vertically.

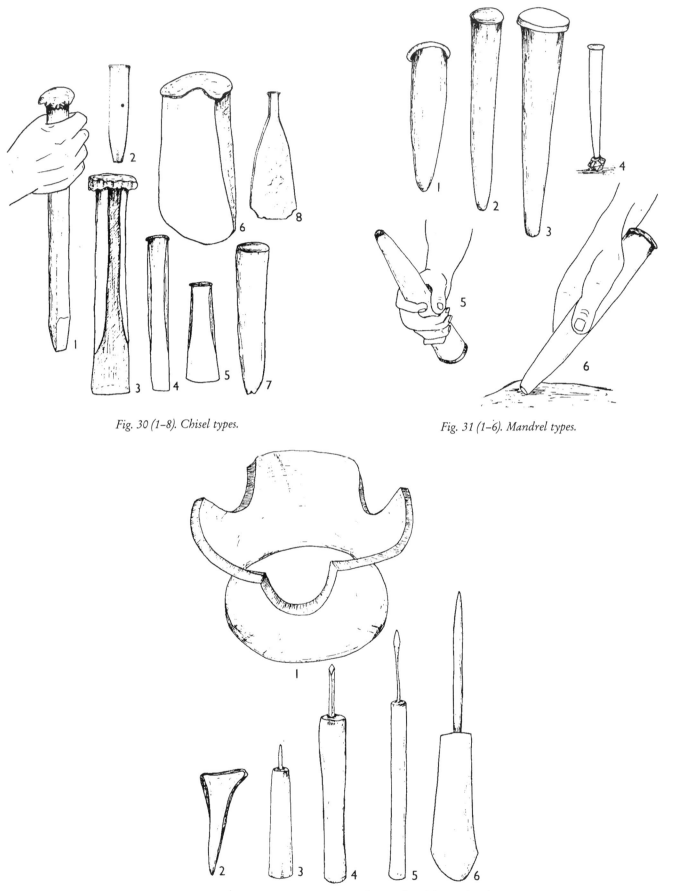

Fig. 30 (1–8). Chisel types.

Fig. 31 (1–6). Mandrel types.

Fig. 32 (1–6). Pot-half used for the second part of smelting and awl types.

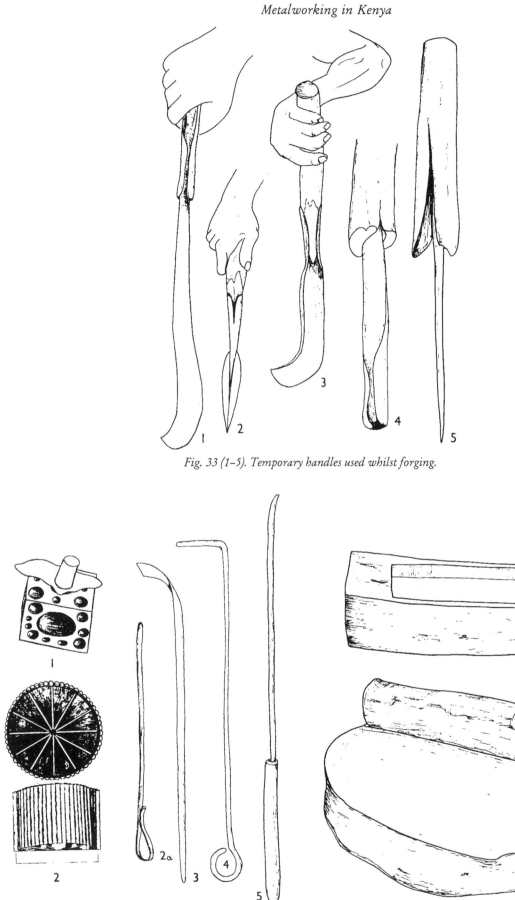

Fig. 33 (1–5). *Temporary handles used whilst forging.*

Fig. 34 (1–5). *Dapping die, rakes, iron pointer and ground plan*
of the reconstruction of an extinct type of Keiyo furnace.

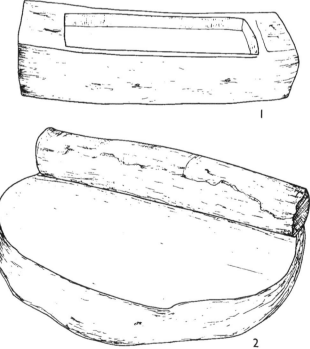

Fig. 35 (1–2). *Wooden trough for quenching water and*
ornament maker's wooden block.

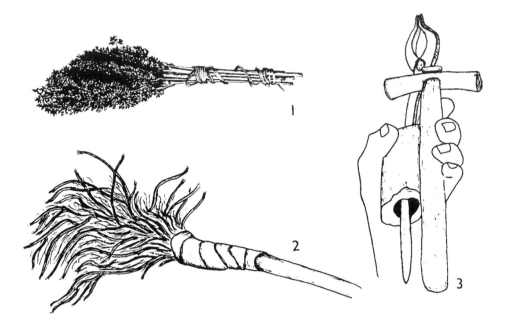

Fig. 36 (1–3). Smiths' brushes and assemblage of tools held by an Mbeere smith when cursing.

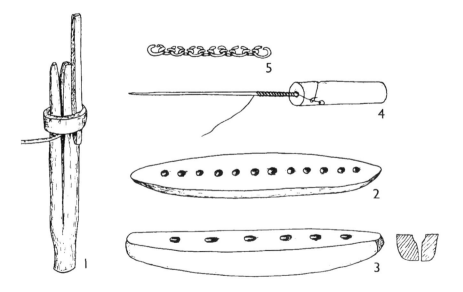

Fig. 37 (1–5). Wire draw-plates, wire drawers clamp, wire coiler and simple-link chain.

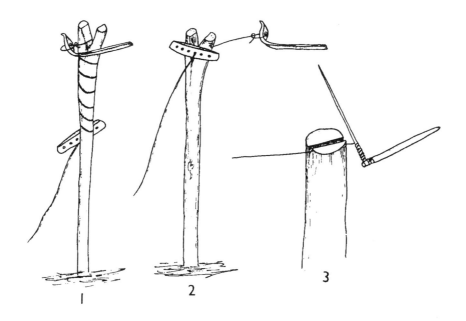

Fig. 38 (1–3). Wire-drawing methods using a forked upright post.

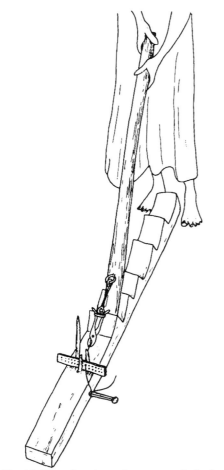

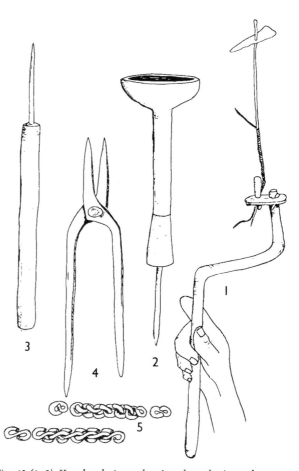

Fig. 39. Wire drawing using a stepped plank.

Fig. 40 (1–5). Kamba chain-makers' tools and triangular cross-sectioned chain.

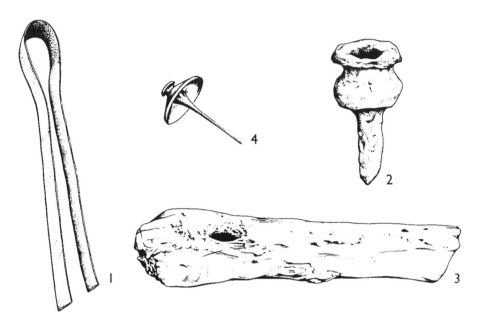

Fig. 41 (1–4). Giriama one-piece clay mould, earring and tools used in casting it.

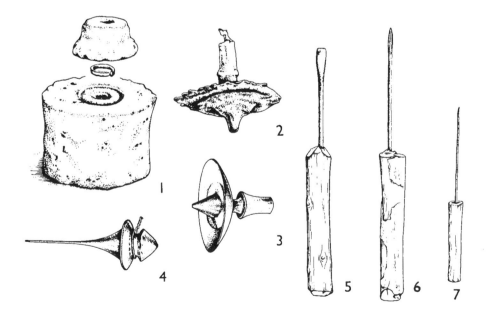

Fig. 42 (1–7). Kamba two-piece clay mould, earrings and awls used for decorating jewellery.

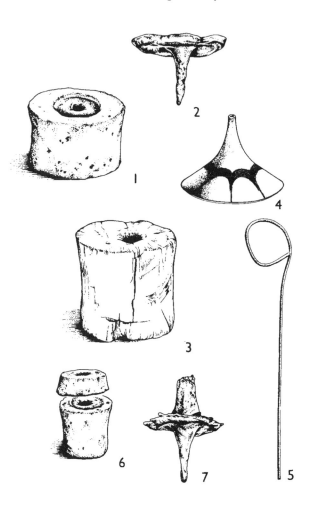

Fig. 43 (1–7). Kamba one-piece and two-piece clay moulds, the ornaments produced from them and the tools used to make them.

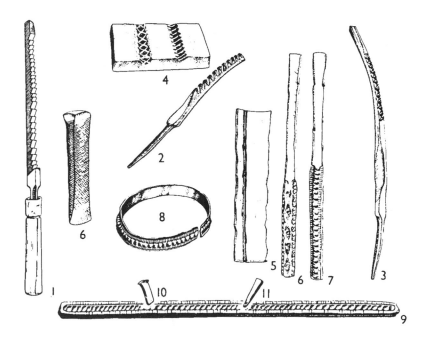

Fig. 44 (1–11). Method and tools used by Bajun smiths to make bracelets for the Orma.

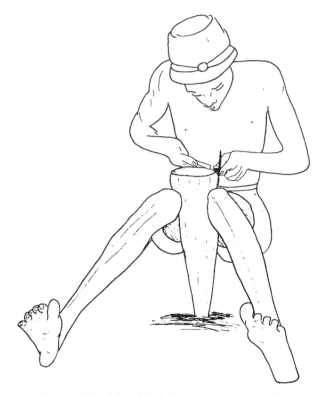

Fig. 45. "Work-bench" of Giriama ornament maker.

Notes

1 Leakey (1977: 307) mentions that this was so amongst the southern Kikuyu, but some of the northern Kikuyu used separate furnaces. The Embu also had separate furnaces but other tribes related to the Kikuyu such as the Mbeere, Tharaka and Igembe used the same place for both operations.

2 Particularly the Samburu.

3 I have seen it amongst the Isukha (Luyia), Interlacustrine Bantu of western Kenya and the Mbeere (Embu) of the Highland Bantu group, but in both cases the smiths were lazy and constantly drunk. Usually when found amongst agriculturists this type of smithy is a second temporary one in which the smith's partner can work nearby if there is a lot of work to be done.

4 I did come across one smithy with a flat mud and dung covered roof but it was still round.

5 A Masai smith's wife constructs the smithy but is not allowed to enter it later, but wives of the related Samburu can enter the smithy freely.

6 The Interlacustrine Bantu and the coastal Miji Kenda Bantu groups often use a chicken but the Highland Bantu had a fowl taboo.

7 The Kamba do this. The neighbouring elders perform the ceremony and the smith's first wife must be present. When brewing beer a Kamba smith must always brew a double quantity, one for the hut and one for his smithy as he is regarded as being two people.

8 I have seen both a Bajun smithy at the coast and an Isukha one in western Kenya burned down.

9 Smiths are also supposed to be immune to burns from sparks from the forge and from hot iron.

10 The Samburu do this.

11 This applies to the Borana, Gabbra, Somali and Rendille. According to Anders Grum (personal communication) Rendille

smiths would not be attached to a homestead of less than 100–130 houses. They lived thus until 1969 but nowadays the smiths of all these peoples are gradually setting up their smithies on the outskirts of the small trading centres.

12 This is particularly true of the Masai and Samburu and was true of some of the Kalenjin.

13 This applies particularly to the Keiyo (information from Michael Guillibrand). the Marakwet and Endo and also to the Nandi on the plateau above.

14 This applies to the semi-pastoral agricultural Kalenjin tribes and to the northern Meru agricultural tribes.

15 They may sometimes be as near as 200 yards or as far as a mile away. They are never built within a homestead because of the danger from and to menstruating women in particular.

16 Samburu and Masai smiths prefer this type but I have also seen them used by Turkana, Pokot, Swahili and Rendille.

17 The only exception I have come across are the Pokomo of the Tana river who did not have smiths traditionally so have no fear of smiths or smithies. The Bajun who have set up their smithies there find their constant visitors so distracting that one of them imported a snake to his smithy. The people believed it to be his familiar and kept outside!

18 See Chapter on the Status of Smiths and the attitude towards them.

19 ditto.

20 The Interlacustrine Bantu and Highland Bantu in particular regard them in this light, but the coastal peoples are not so reverential.

21 Even the word for smith sometimes comes from the word to beat or to hammer and is often onomatopoeic, e.g. Tumtu and Tumal of the Borana and Somali.

22 There are no hafted stone hammers in Kenya. In Tanzania Krootz Kretschmer (1926: 138) says that the Safwa made bored stone hammers, and Foran (1937: 200) mentions stone hammers with two loops of rope used as handles.

23 They are now used by the westernmost tribes of the Abaluyia Interlacustrine Bantu, e.g. The Wanga, Marachi, Samia, but some of the eastern tribes, the Isukha, Idakho and Logoli and the Bukusu, say that they also used to use them. In 1887 Thompson (1887: 291) mentions seeing the Samia use them. Foran (1937) mentions stone hammers with two loops of rope.

24 Particularly the Embu and southern Meru.

25 The Kipsigis say that they used them and the Tugen used them until quite recently.

26 I know of a Masai smith who still uses them regularly.

27 The Turkana and Pokot. Even the women use them for cold forging ornaments.

28 The Kikuyu.

29 The Masai and Samburu.

30 The Kalenjin group of tribes.

31 And occasionally by their neighbours the Mbeere. The Kamba have long had contact with the coastal peoples and these hammers show definite coastal influence.

32 Routledge (1910: 7) gives a very detailed description of these hammers. De Maret (1984: 132–134) points out that the hammers found in the collection of smith's tools at Ingombe Ilede (Fagan et al 1969) closely resemble this type but have one end chisel-shaped. A hammer identical to those at Ingombe Ilede is illustrated by Smith and Dale (1920: Vol.I.212 and photos 211–213).

33 The Miji Kenda group of tribes, the Bajun and the Swahili.

34 Jeffreys (1948: 7) says that Bamenda smiths give the same reason for using them.

35 The western Luyia group Samia, Wanga, Marachi, Banyala; the Tugen, Tharaka and Somali.

36 I watched one slasher being made by Wanga using stone hammers and another by the Bukusu using iron hammers throughout. The former took almost a third as long.

37 The Kamba sometimes do this but others of the group rarely do so.

38 Embu smiths have a song which they sing whilst working which says that once a man owns a hammer, i.e. has been initiated as a smith, he has the means to get whatever he wants.

Umi uuuu nie ningiverua naki,
Ningiverua naki, kiriva kiri gwetu,
Gia gutuura, ni ngiverua naki.

Literally:

Oh how can I be prevented from getting what I want, While the smith's hammer is at ours, For (the hammer) i.e. as a blacksmith, how can I be prevented from getting what I want.

Quoting Mwaniki (1974: 76).

39 Wagner (1949: II: 9) says that as a Logoli smith hands his apprentice the smith's hammer he says *"Enyuli Yeiwe exale"* 'the hammer is ours from long ago'.

40 For example, Tugen, Marakwet, Kikuyu, Tharaka, Masai, Samburu.

41 For example, the Kikuyu make their own hammers themselves and hold a ceremony when making each one. The Tharaka say that they do not have a ceremony.

42 e.g. Somali, Luo, Bukusu.

43 e.g. The Marakwet.

44 If a hammer breaks or cracks the Tharaka have to make a sacrifice and smear it with blood to avert misfortune, but otherwise they do not smear a new hammer.

45 Only the Somali say that they do not observe any taboos when making a hammer.

46 Bukusu.

47 The Marakwet and Luo refer to the ceremony as the "wedding of the hammer", the Marakwet calling the hammer the smith's chief wife.

48 The Samburu smear fat on it when blessing it, but this *must* be wiped off before the new smith can touch it.

49 e.g. Samia, Marachi, Wanga.

50 Tugen.

51 Marakwet. It is important that the centre-post should be made of bamboo, a tree whose trunk the Marakwet use as an artefact to cast out evil.

52 More rarely they are inherited by the eldest son. If the smith has no sons they are passed on to the smith sons of a brother.

53 The Bukusu and Tugen. The Bukusu say that the hammer must be buried on the smith's right.

54 See Chapter on Curse.

55 A Samburu bride has it placed on her back. Guttmann (1912: 82) says that amongst the Chagga of Tanzania, many of whose smiths are of Masai descent, the hammer was likewise handed to a new bride.

56 Against the mystical power of the Smith's ancestors.

57 Somali, Bukusu, Luo, Pokot and Tharaka smiths' wives are allowed to touch the hammer, those of the Tharaka can do so even if they are in a state of ritual impurity (i.e. when menstruating, or pregnant, or after they have given birth). It is thought by some tribes, e.g. the Isukha, that anyone touching a smith's hammer will become deranged.

58 See Heredity and Training.

59 e.g. Marakwet, Tugen, Tharaka, Luo. The Bukusu and Somali think nothing of it. The Luo believe that it shows that the smith has broken the taboo on having intercourse the night before forging.

60 If a smith's hammer breaks it is thought to be a sign that misfortune will fall on the smith. The Marakwet regard it as so serious that they hold a big ceremony of purification attended by all the smiths of the neighbourhood.

61 Many smiths of the Masai group (and here I include the Samburu) have this type as the only anvil in their smithies.

62 The Swahili, the Miji Kenda group and the Bajun.

63 Only Samburu and Embu smiths say that they use this method.

64 Roscoe (1923: 233) says that this method was also used in Uganda where smiths put butter or egg-white on the rock.

65 The apprentices of Mbeere smiths collect them.

66 Routledge (1910: 89) gives this information for the Kikuyu.

67 The Luyia tribes use oxen.

68 e.g. Samburu smiths whose wives are the only ones in Kenya who regularly blow bellows.

69 The Luo, Luyia, Kalenjin and Mbeere usually search in river beds.

70 The Embu area was particularly famous, the anvils being obtained from a hill called Karue. The Ithanga area was also a very well known place for anvil stones.

71 Routledge (1910: 89) says that the Kikuyu anvils are inherited. The Pokot believe that anvils are the most important tool to inherit. One old Kikuyu smith said that his anvil had, so far, lasted him for twenty years.

72 Particularly in the region in western Kenya inhabited by the Luyia.

73 Isukha.

74 The Marakwet say this.

75 e.g. the Kikuyu and Pokot.

76 Amongst the Bakitara according to Roscoe (1923: 222). Informants who are not smiths would not know what takes place since these rituals are secrets of the smiths.

77 Before a Tharaka smith cuts an anvil he says *"Iga ririega riaguturirwa nikenda ritura migwi yakuraga nyamu; ciakarere nthaka igura mauka aciara twari Murungu Tharima, iga iriri ritwike o uu muthitari ukari."* Translated this is 'This stone is for working on, so that arrows will be made on it, the arrows will kill animals which will feed young men so that they may marry and bear girls and boys. God bless it as I cut along this line'. Prayers are usually made to God, see Note 24.

78 The Bakitara, Roscoe (1923: 224).

79 The Kikuyu, Somali and Tharaka say that they do not sacrifice.

80 The Interlacustrine Bantu insist that the sacrifice must be black.

The coastal people prefer it to be red (brown), while some of the Highland Bantu say that it must be all white.

81 As amongst the Luyia.

82 Millet porridge is a ceremonial food for most Kenya peoples, and honey beer is a ceremonial drink.

83 e.g. the Marakwet, Samburu, Embu, Kamba, Tharaka.

84 Some pray directly to God, e.g. the Embu who might remember the ancestors but pray directly to God, *Mwene Njeru* (meaning "the owner of the sun") to bless the anvil, and others, e.g. the Tharaka and Kamba, to the ancestors.

85 The Bukusu did not even allow the newly married near for fear that they *might* have had sexual intercourse.

86 e.g. by the Highland Bantu. Amongst the Kikuyu and Embu, the lineage elders of the smith's ridge were invited. In their country each steep ridge between rivers was occupied exclusively by one clan.

87 e.g. the Kamba and Embu and Mbeere. Probably also the rest of the Highland Bantu.

88 The Marakwet put sacred *seretion* grass (a creeping grass – *Cynodon nlemfuensis vanderyst var. nlemfuensis*) into the hole. The Somali put an unspecified magical substance in the hole. The Bukusu put a mixture of chyme, from the sacrificial animal, and ore, plus special herbs into the hole.

89 The Mbeere put four pieces of *Mukenyia* bush *(Lantana trifolia* L.) under the sides of the anvil with the tips of the twigs facing each other. The Tharaka place *Kamma* plants on it.

90 e.g. The Mbeere have to make a circumcision knife or an awl; the Embu a twisted iron protective necklace for the new smith's wife and then a protective bracelet for himself; the Kisa and Giriama a hoe; and the Rendille a hammer.

91 Giriama.

92 The Giriama, whose week has only four days, have to make the anvil on the fourth day.

93 A new Tugen smith has to obtain his own anvil, so does a Luo smith who gets it after he has been given the other tools.

94 Kamba (Hobley 1922: 174).

95 This has also been mentioned by Weeks (1914: 249).

96 Amongst the Luyia.

97 e.g. The Samia, Wanga, Marachi.

98 e.g. The Kisa and Luo.

99 Johnston (1904: 11: 745), Hobley (1902: 19), Thomson (1885: 492) and Ansorge (1899: 77, 89) describe this type of bellows at the turn of the century.

100 In his frontispiece, Hollis (1909) illustrates a Nandi bellows with a detachable clay tip, but I have only seen them made of wood. The Marakwet always remove the tip when they finish work and replace it before starting next time. They lick all round it before pushing it in so that it holds in place.

101 Unless he is left handed when he works it with his right hand.

102 The Embu, who use bag bellows, refer to their bellows as "the tree which is milked", as can be seen in the following smith's song:

Mue mugaga mwici ki,
Mugaga mwici ki-
Mutaneci muti uria ukamagwa iria.
Mugaga mwici ki?

Translated:

You, what do you say that you know,
What do you say that you know-
You do not know the tree that is milked of milk
What do you say that you know?

Minagira ngamwa
" " , Nyama ino
lgukamwa na miangu ithathu,
Minagira Ngamwa.

Translated:

I sing in praise of the milked
I sing in praise of the milked, the animal

Which is milked from three openings
I sing in praise of the milked.

(Mwaniki 1974: 75)

103 e.g. Logoli, Isukha, Kisa.

104 Used by the only Turkana smith I came across. The Turkana normally do not have smiths.

105 e.g. by the Embu and Meru tribes but generally not by the related Kikuyu.

106 Those of the Samburu and Rendille might be mistaken for tuyeres, see measurements of Samburu ones at end of Appendix III.

107 The Borana use stone ones.

108 The Tharaka, Rendille, Somali and Borana still use antelope horn.

109 The Embu and Meru use bifurcated ones often made from the wood of a *Lantana* species. The Kikuyu rarely use bifurcated nozzles.

110 The same type was described from there earlier by Routledge (1910: 85–86), Orde-Browne (1925: 129–30) and Champion (1912: 79).

111 The Swahili, Miji Kenda group and Bajun.

112 The Borana, Galla and Somali.

113 The Mbeere. Konso smiths in their Ethiopian homeland use one single large square bag bellows pumped with the right hand. The specimen collected is in the British Museum (Museum of Mankind).

114 Logoli.

115 The Bukusu use *kumurembe*, the Isukha *mukomare*, the Samia, Wanga and Marachi *omubele-Albizia coraria* Oliv. *(Mimosaceae)*, the Hayo *nandere*, the Luo *ng'owo-Ficus* sp. *(Moraceae)*, the Marakwet *koroba* and the Turkana *echote*.

116 Merker (1910: 114) says that Masai smiths covered theirs with clay to make them durable, but it may well have been a mixture of clay and dung.

117 A few tribes, e.g. Marakwet, insist on the diaphragms being made from castrated male goat skins, while the Embu always use nanny goat skins for their bag bellows because they are lighter and softer than billy goat skins which are said to be difficult to soften up.

118 A "pure" animal is one which must have been slaughtered preferably for a sacrifice (no animal which dies a natural death is ever 'pure'). It must be completely whole and without blemish and must never have been scratched, or even touched by a wild animal. Since only infertile, fat, male animals are slaughtered and the smiths in any case own mostly male animals, which are given in exchange for their products, the bellows skins are mostly from castrated males.

119 The fat used is very often the residue left over from making castor oil which is made by frying the seeds, and then grinding them on a quern before boiling them in water. The residue is the gritty stuff left over when the oil is decanted into a gourd (fat sheep fat is also used).

120 The Embu liken such bellows to a woman, married to a rich man, who says that she needs more than one skin for her skirt! The following is a blacksmith's song about this:

Wonirue nu, no we kiura mukwa ngatha?
Mukwa Ngatha, utangikomanwa ni ruo rumwe?
Kiwa mukwa ngatha.

Translated:

Who showed you *Kiura* (= the smith's Y sticks to hold the bellows down), the wife of a rich man?
The wife of a rich man who can be dressed in one skin? *Kiura*, the wife of a rich man.

(Mwaniki 1974: 75)

121 Routledge (1910: 91) reports this for the Kikuyu, and in Tanzania the South Pare were said (*Tanzania Zamani* 1969: 22) to use smaller ones for forging.

122 e.g. Bukusu.

123 e.g. The Somali recite some verses of the Koran over them.

124 e.g. The Kisa allow them to do this.

125 Marakwet women are never allowed to pump them but may carry them home for their husbands up the steep escarpment.

126 Arkell Hardwick (1903: 238) mentions that the wives of Tharaka smiths blow their bellows, and Merker (1910: 114) says that Masai women also blow them. Hobley (1910: 51) says that Kamba women sometimes blow them but the Kamba themselves deny this saying that if they did so the ironworking would fail.

127 e.g. By Luo, Marakwet.

128 The Taita lend theirs quite happily and ask nothing in return.

129 Lanning (1954: 167) reports this from the Bunyoro, Buganda and Bajulunga.

130 The Mbeere.

131 Used by a Konso (an Ethiopian tribe) smith working for the Borana in Marsabit.

132 Turkana.

133 Routledge (1910: 91) reported that the northern Kikuyu did this.

134 The Kisa (Luyia).

135 Tharaka.

136 e.g. the Pokot.

137 The Swahili and Bajun.

138 They are used by the western-most Luyia tribes particularly the Samia, Marachi, Wanga and Bukusu. Ansorge (1899: 69) mentions having seen them probably in Bukusu.

139 They are, however, made of clay and not wood (Wayland 1931: 199–200). From Wyckaert's illustration (1914: 371) Fipa (Tanzania) tuyeres appear to be similar too.

140 The Samburu.

141 Particularly the western Luyia, peoples famous for their pottery, but Marakwet women may also do so.

142 The Tharaka and Marakwet do this.

143 The smiths on Lamu island, for instance, have to cross the sea to Manda island for their clay, while Wanga and Marachi smiths travel to the territory of the neighbouring Samia tribe for theirs.

144 By the Samburu.

145 By the Rendille.

146 e.g. The Samia, Marachi and Wanga.

147 The Kisa (Luyia).

148 According to Barnes (1926: 192) the Ba-ushi also do this.

149 The Rendille, Embu, Tharaka, and Samburu, dry theirs in the sun.

150 The Bajun, Mbeere, Giriama and Marakwet dry theirs in the shade.

151 The Embu and Rendille do not fire them.

152 The Kisa who made especially hard tuyeres.

153 By Orde-Browne (1925: 129–131) for the Chuka (a Meru tribe).

154 Often in the form of paralysis.

155 See Chapter on the Status of Smiths and the attitude towards them.

156 Both Orde-Browne (1925: 129–131) and Routledge (1910: 91) mention this and Routledge gives an illustration (plate LVIII).

157 According to Hollis (1909: 37) the Nandi do this and so do the Masai.

158 The Marakwet.

159 The Marakwet.

160 The Samia, Wanga and Marachi use *olurianyi* (an *Acacia* species). The Luo use *bandhi*. The Isukha use *imbafi*. The Kikuyu say that they use *muringa* but the bark only.

161 I have also seen tongs placed over the fire to heat or smoke them before use so that they are less likely to catch fire.

162 Particularly by the Samia, Wanga and Marachi.

163 By the Mbeere.

164 By the Kikuyu.

165 Routledge (1910: 91) says that the pointed ends of Kikuyu tongs were used for making and enlarging holes, though he does not say in what, but 1 have never seen them used in this way. They are, however, sometimes used instead of a maul when making artefacts like tiny bells.

166 Hinde (1901: 86–90) describes this for the Masai, but I have never seen any with these bands.

167 The most usual scrap used is steel strip for binding boxes.

168 The Samia, Wanga and Marachi.

169 e.g. The Bukusu, Marakwet and Luo do this.

170 A Marakwet smith's tongs are always inherited by his last-born son. If the smith has no sons they are either buried with him or handed over to a brother's son if he is a smith.

171 By the same people in western Kenya who use stone hammers.

172 I have seen a Kisa (Luyia) smith using one.

173 Particularly amongst the western Luyia tribes who use stone hammers. I have seen the Wanga, Marachi and Samia using them.

174 The Samia, Marachi and Wanga use them a lot.

175 Orde-Browne (1925: 129–131) mentions this for the Chuka.

176 Merker (1910: 116, Fig. 26a and b) reported that the Masai used drawplates one foot in length.

177 Some of the thickest I have seen were Kikuyu, but they vary with individual smiths.

178 Five to six holes seems to be the average but some (e.g. Fig. 37, No. 2) have more and some less. I saw Giriama using drawplates with only three holes. The holes are at the base of cup shaped depressions which penetrate 1/ 3–1/ 2 way through the bar.

179 Routledge (1910: 94) describes and illustrates (Plate LIX) this from the Kikuyu.

180 This type seems to be preferred by the Kamba, who now use any suitable scrap iron with a hole in it.

181 This type is used by the Miji Kenda group, particularly the Giriama who are noted chainsmiths.

182 This tool is used by the Kamba and is described from there by Lindblom (1920: 531).

183 Particularly the Kamba who are the main users of this tool.

184 The Luyia and Luo smiths never seem to have worked in any metal other than iron, nor did they have specialist ornament makers according to my information.

185 The smiths of all the pastoralist groups are ornament makers as there are no specialist ornament makers. In the north west other metal ornaments which can be cold forged are made by the wearers of both sexes.

186 This applies particularly to Kamba smiths.

187 They developed amongst the Miji Kenda, particularly the Giriama, and the Kamba but did not generally extend into the Kikuyu and Meru groups although they had specialist chainmakers.

188 It is used by Konso smiths who have emigrated from Ethiopia to work for the Borana and Gabbra (Galla) in Kenya and they only seem to use the process for making phallic ornaments.

189 This tool is used exclusively by Konso smiths working for the Borana and by Somali and Giriama smiths.

190 The Bajun smiths working on the Tana river, but they are now teaching a few Pokomo to use them. Dies are otherwise restricted to Arab/ Swahili silversmiths but theirs are much more delicate.

191 Such wooden tools are found almost exclusively in eastern Kenya where jewellery making techniques are more advanced.

Manufacture and Techniques

THE CHARCOAL *(see also Appendix IV, Trees used by Smiths for making Charcoal)*

Ironworking has to be carried on in an area where there is a plentiful supply of wood for making charcoal, and the trees have to be the right species for smiths are very particular about the type of charcoal that they use. In each ecological zone they select trees which produce the slowest burning charcoal which gives the greatest possible heat. In addition in western Kenya[1] it is important that the charcoal does not give off sparks because in that area sparking charcoal is considered to be a very bad omen.

In well forested areas the pencil cedar (*Juniperus procera*) is one of the trees most commonly used, while in savanna country an *Acacia* species is usually chosen. In coastal areas the Doum Palm (*Hyphaene coriacea gaertn*) is used almost exclusively, although one smith makes charcoal from coconut shells because they give a fiercer heat.

The same charcoal is generally used for both smelting and forging. Smiths do not like to mix two types of charcoal but in cases where a slower burning charcoal takes much more blowing to get burning, another charcoal might be used to start with. In smelting in a bowl furnace two types are, however, sometimes used.[2]

Amongst the Highland Bantu,[3] it used to be a common practice for the customer to supply the smith with charcoal, so no taboos were observed in collecting the wood or in making it into charcoal. It could be collected by anyone, even women, and anyone could make it although if the smith himself did so he usually put some magical plants with it to ensure the success of his ironworking.

In the coastal area there is no objection to obtaining it from charcoal burners but elsewhere in Kenya only the smith, or more usually his apprentices, could collect the wood and make it. The Kalenjin do not allow women to collect it although some tribes allow them to carry it home.[4] Some smiths have to cut the wood very early in the morning and make sure that no wind is blowing the trees when they do so.[5] It is taboo for anyone, even the smiths in some cases,[6] to step over the wood or the charcoal for it is regarded as 'sacred'. If anyone does so it is believed that the smelting or forging will not be successful and the transgressor might go mad. It is also considered dangerous for anyone but the smiths themselves to use any charcoal made especially for iron-working, or to use any charcoal taken from a smithy unless it is used charcoal which has been deliberately dampened to put out the fire before raking it from the hearth. Once that has happened it is regarded as being like ordinary domestic charcoal over which anyone can step or sit on.

Scarcity of suitable trees in their immediate neighbourhood and a government ban on charcoal burning in certain areas has nowadays forced many smiths in the densely populated agricultural areas to buy their charcoal from licensed traders, but the fear of using charcoal from a smithy remains.

Although some smiths start their fires with a small amount of wood and then pile on charcoal, it is more usual to light the charcoal directly by pushing into it a smouldering ember from the domestic hearth and fanning it with air from the bellows.

In forging, and also in smelting in a bowl furnace, the burning charcoal is often damped down by sprinkling it with water to keep it at an even heat,[7] and some smiths[8] soak the charcoal in water before forging newly smelted iron into pig iron bars, although they do not do this when forging artefacts.

IRON ORE

There is no oral tradition of meteoric iron[9] ever having been used in Kenya but iron ore, in several forms, is found in great abundance throughout the country (see Appendix V), except in the lower Tana River Valley

where none exists. West of the Great Rift Valley haematite and limonite are the most commonly used ores although some ironsand is found there and occasionally used. To its east magnetite is used almost exclusively except in those areas which have none where murram is used instead.

Murram or pisolitic iron, which is very widespread, is found in the once forested areas, and in clearings and on the edges of existing forests in the central highlands, the Mau, and the Uasin Gishu plateau. It lies beneath a covering of red clay where it forms a layer which varies in thickness from a few inches to a few feet. Its presence is usually taken to indicate deforestation as it is thought to form as the result of denudation of the soil. Once the forest covering has gone heavy tropical rains carry the iron oxide in the red clay further down into the ground in solution where it is later subjected to intense solar evaporation. Constant repetition of this process during alternate wet and dry seasons gradually causes it to be re-deposited as a hard layer like iron pan.

The richest ore deposits in Kenya, which are haematite, are located in Samia district in Western Kenya, where the iron occurs, in the hills to the north of Port Victoria,[10] in pockets about twenty feet thick.

Magnetite or ironsand, the ore with a bright metallic lustre, is also available throughout the country but is more plentiful in northern and eastern Kenya. It is found in large quantities on the lower slopes of Mount Kenya[11] and in the surrounding plains,[12] in the Kamba[13] and Taita Hills and on the coast to the north of Malindi.[14] As it is richer in iron[15] and contains far less gangue than haematite and limonite it is preferred to other ores. Magnetite washes out in stream beds, gulleys and pathways in many areas after heavy rains, where it may be collected often without the necessity of panning it. Where it occurs as a constituent of river and stream sands in flowing water it usually has to be panned in situ.

Some tribes[16] regard iron ore as the earth's excreta, and believe that it multiplies in the soil. Some[17] think that it comes about as the result of volcanic activity, while others[18] think that murram results from burning red clay. Most say that they have no idea how it originated but believe that it was given by God.

Smiths never had to do a great deal of prospecting for most deposits of haematite and limonite are well-known and have been used for generations, and ironsand is usually very easy to see especially after the rains when it lies in black glittering patches in the dry streambeds having been panned naturally by the flow of the stream during the rains. It is the glitter which has always attracted smiths to it especially when it is under water in permanently flowing streams. In addition they look for black coloured sand and then weigh it in the hand to check if it is heavier than ordinary sand.

When smiths did have to prospect for ores they looked for surface signs which indicated that ore could be found below. Red clay was the sign to look for when searching for murram, and when found it was investigated to see if it contained rich red nodules of murram for the reddest murram was considered to be the best quality ore.

In the Samia hills in Western Kenya, where the haematite is not always obvious, smiths carefully study each small change in soil, flora and fauna, as they walk over the ground in search of ore. They look for the presence of one species of grass, for stagnant pools of water which remain when other surface water has long since dried up, for hares and a species of rat which prefer to make their burrows in soils where the ore is to be found, and for a reddish dung beetle[19] which also prefers to live in that soil. Gravel and small stones, which are brought to the surface in the scrapes of these animals are examined carefully. They are weighed in the hand to see how heavy they are, tapped to see if they give out a metallic sound, banged to see if they are difficult to break, and cracked open to see if there are any streaks of iron in them.

Iron ore is usually obtained from common land[20] but in densely populated agricultural districts the land on which ore is found is more likely to have an owner or owners whose permission must be sought before any ore can be removed. Permission is usually granted willingly because, as ore is considered to have been given by God, it does not belong to the owner of the land and he cannot sell it. Most people also find it judicious to keep on the right side of smiths, and look forward to receiving the present of tools or pig-iron[21] which they are invariably given. Sometimes, however, the question of rights over ore became a vexed one[22] as smiths of an ore-bearing neighbourhood tried to monopolise the supply.[23] In some cases only a selected few knew where the rich deposits were and they carefully guarded the secret as they did not want their rivals to make use of them.[24] Smiths gravitated towards the ore-bearing areas in order to be close to their supply but this was not always possible as many could not move far from where they were readily able to market their products, and if they could smiths already living there were jealous of allowing them access to the ore. In some cases they had to travel as much as thirty miles to obtain ore[25] although most of them had a supply within ten to fifteen miles of their smithies. Sometimes smiths living in the rich ore-bearing areas took the opportunity to mass produce pig-iron during the smelting season so that they could sell it to smiths elsewhere who had difficulty in obtaining ore.

Generally only smiths and their apprentices collected ore, but in the case of ironsand, which was easily found and could be obtained without digging, custom-

ers often collected their own. In exchange for the tool that they needed they were required to supply the smith with enough ore for its manufacture and sufficient over to pay for his labour and the cost of the charcoal he used.[26] If a customer collected more than this they might give him a leg of goat, or a protective iron ornament as well.[27] During wartime all able-bodied men were sent ore-collecting and occasionally young men who had no need of tools collected ore as they found that by going further afield they could exchange the tools they received for animals which they required for their bridewealth.[28]

In Kenya there was no need to dig shafts when collecting ore as ironsand was picked up on the surface and other ores were obtained from open workings, usually from an exposed bank or from a hillside where the excavation was rarely more than three to four metres deep. When the ore had to be dug the smiths and their apprentices worked in groups under the direction of the oldest man who was always the master smith.

Smiths from a number of different tribes[29] collected their ore from the Samia Hills in Western Kenya. The hillside to which I went with a group of Marachi smiths comprising the master smith and his son, his two cousins and one of their sons, had obviously had ore dug from it for generations for the surface was a rash of slight humps and shallow hollows. Small pieces of ironstone, which were much heavier than other stones, were lying all over the surface but were pronounced to be of poor quality. After walking over the area carefully, examining it by eye, and weighing stones and cracking them open, the master smith decided to dig into a bank which was obviously the edge of a previous excavation.

A pick-axe and hoes were used for digging. At a depth of 45–60cm below the surface the smiths began to examine every piece of stone in great detail often cracking them open to do so. They divided them into poor and good quality stones which they threw onto the bank in separate piles. The poor quality stones, which were coarse-grained and had obvious streaks of haematite crystals in them, were discarded as being decayed and not good enough to smelt. The good quality ore was in small pieces rarely more than 3.5–5cm long, 1–1.5cm wide and 1–2cm deep, which were of a consistent bluish/purplish colour throughout, heavier and denser than the poor quality material. Analysis[30] showed that both samples contained about the same amount of iron, the good quality containing 58.4% while the poor quality contained 59.75%. The difference in quality was presumed to be due to the difference in silica content between the two samples which held 8.11% and 2.26% respectively.

Half a sackfull of this ore, which was so heavy that four of the men had great difficulty in carrying it to my vehicle, took five men and myself four hours to collect. Normally it is carried home in baskets or wrapped in banana leaves where it is prepared for smelting by hammering it up smaller.

In southern Kikuyuland iron ore in the form of murram, was also obtained by open quarrying into banks.[31] The smith's apprentices were responsible for this work which they did by cracking the murram with a small iron crowbar and then levering blocks of it from the bank by means of a wooden digging stick. Each apprentice prepared his own ore. This was done by breaking up the lumps with a heavy hammer[32] to extract pieces rich in ore and then hammering them down into a fine powder[33] which was wrapped in bundles of banana fibre ready for smelting. In western Kenya murram was treated in a similar manner but the ground-down ore was often washed in water containing leaves of a tree[34] thought to have special cleansing properties, or sieved to rid it of impurities. Sometimes it was both sieved and washed.

Immediately after rain ironsand can be collected in such pure form that there is often no need to pan it[35] although it is always winnowed. Panning is, however, usually necessary as goats and wild animals tend to travel along the stream-beds trampling the separated ironsand back into the sand below.

As soon as streams stop flowing smiths and their apprentices, or their potential customers in need of ore, walk along the sandy beds in search of heavy concentrations of black ironsand. The sand is scooped up with the hands or with a half-gourd and put into a leather bag, or closely woven basket, or bound up in banana leaves, and carried back to the home where it is winnowed in an ordinary shallow flat-bottomed winnowing basket. This work is done by women who shake the basket with a circular movement until the heavier black ironsand separates from the lighter silica sand which is thrown away.

Further separation is done by panning, a task sometimes performed by women but usually by men. The ironsand is placed in a half gourd which is shaken while water is poured into it. The light sand and debris float to the top and are poured off, while the heavier ironsand sinks to the bottom. The process is repeated until only clean pure ironsand remains. This wet material is dried in the sun on banana leaves which are specially cured beforehand, by smoking them over a fire, so that they will not split and spill the ore. Analysis of one sample of ironsand showed it to contain 89.28% of ferrous oxide.[36]

If water is available where the ironsand is collected it is winnowed and panned in the streambed, the smith's whole family taking part in the operation.[37] If the streambed is partially rocky the smiths look for a natural hollowed stone which they use for panning

instead of a gourd. This is left in situ while the ironsand is poured into it and stirred as the stream flows over it.

In areas such as Gaturi in the Ithanga Hills[38] which are famous for supplying ironsand, large open workings developed beside rivers and streams as their banks were gradually excavated further and further back in the search for ore.[39] In the central highlands women usually carried the ore back to the smelting place but donkeys were occasionally used to transport it.[40]

Iron ore could only be collected in the dry season, except at the coast where it could be collected at any time of the year. The best time was immediately after the long and short rains when the floods had subsided for then the dried-up streambeds were rich in ironsand and erosion had also exposed the other types of ores so that they too were easy to see and collect.

Restricting ore collection to that season gave the smiths in agricultural communities the opportunity to repair their houses and fences and to prepare their own small fields, and prevented people, in those communities where customers collected their own ore, from neglecting their fields in favour of ore collecting. The Highland Bantu, amongst whom this custom is prevalent, are most emphatic that iron ore could never be collected until the land was 'black',[41] i.e. until it was green with growing crops, and it could only be smelted in the short dry season before the short rains, not in the long dry season because if smelting was done then 'it would chase the rain away'.[42] That was the time for preparing the fields and for forging.

Before setting off to collect ore it was usual for smiths to offer a prayer asking their ancestors to intercede with God so that their journey would be fruitful.[43] Where ironsand was to be collected they also prayed for sufficient wind to be able to winnow it properly.[44]

At the beginning of the ore-collecting season the Luyia and Kalenjin groups[45] in western Kenya usually held a ceremony at where they were to collect the ore. They sacrificed a goat or hen[46] to purify the land, praised the ancestors and prayed to God that they might be blessed with an abundance of good quality ore which would produce first-class iron.[47] This ceremony, which took place at dawn, was usually led by the master smith but occasionally a medicine man/holy man was called in to conduct it.[48]

Very few taboos have to be observed when collecting ore and omens are rarely looked for. Women could collect ore in many tribes[49] except in western Kenya[50] where it was believed that if a woman did so the smelt would be a failure. In some cases, for the same reason, women could not be greeted by ore collectors,[51] and they could not even walk on the ground from which the ore was obtained,[52] while in others they were allowed to carry the ore home if they were not in a state of ritual impurity.[53]

The most common prohibition was that iron ore must not be referred to either as iron or as iron ore. To do so before it was successfully smelted was considered to be tempting providence. It was either not mentioned at all[54] or referred to indirectly by another name such as 'cooking stones',[55] or the name of a personal ornament.[56]

It was also only in western Kenya that omens were looked for when collecting ore. One tribe[57] returned home immediately if they heard a woodpecker calling as they were journeying to collect it, while others believed that their smelt would fail if they looked behind them[58] or if they met anyone as they travelled home with it.[59]

Sometimes different sized ores were referred to as male and female, or husband and wife,[60] and in one case,[61] iron ore is thought of as feminine while iron itself is regarded as masculine.

SMELTING

Iron smelting was practised regularly in Kenya until about fifty years ago and even later in some areas. Now I know of only one smith, surprisingly living within one hundred miles of the modern capital city of Nairobi, who smelts regularly. Most of the older smiths, however, still know how to smelt and in many areas still ritually smelt the hammer which is presented to an apprentice when he is initiated as a smith.

Smelting declined when a much more easily procurable source of iron became available as a result of culture contact. Arab and European trading caravans travelling up country brought with them trade wire which was welded together and forged into tools. Then came the building of the Uganda Railway which provided an unbelievably rich source of iron which was pilfered by the smiths and their customers with monotonous regularity.[62] The advent of European settlers brought an increase in supply for, in the words of one smith, "they threw away what they thought was useless iron"; broken hoes, bits of ploughs and other desirable things. The smiths were quick to take advantage of such wastefulness for it allowed them to abandon the exhausting and time-consuming tasks of ore collecting and smelting in favour of increased forging activity which brought them quicker returns.

Both hearth or bowl furnaces and shaft or dome furnaces are used in Kenya. There are no draught furnaces as bellows are always used to supply the draught. The two types can be further sub-divided as follows:

A. Hearth or Bowl Furnaces
1.
The most common type is a simple round hole in the ground which is rarely more than 30–35cm in diameter and 20–30cm deep (Fig. 46, Nos. 1 and 3). It is fre-

quently, though by no means always, clay lined. Scooped out of its circumference at regular intervals are hollows for the insertion of tuyeres. Draught for this type of furnace, which is found throughout northern and eastern Kenya east of the Rift Valley, is always provided by one to four pairs of bag bellows (Fig. 46, No. 1).

2.

A variation of this type is a clay-lined oval about 60cm long, 30cm wide in the centre and 45cm deep with a hollow at each end for the insertion of tuyeres. The clay lining is extended up and over the edge of the two long sides to form a rim about 5cm thick. Two pairs of bag bellows are used to provide the draught for this furnace which seems to have been peculiar to the Kikuyu tribe[63] (Fig. 46, No. 2).

3.

This type of bowl furnace is completely different from the other two as it consists of a clay lined bowl in front of a low wall with a trench behind it.

A round hole under the wall connects the trench with the bottom of the bowl (Fig. 47). The tuyere, which consists of three sections of straight clay pipe (tuyere type C), enters the bowl opposite the trench. Draught for this furnace, which is found only in the extreme west of Kenya, is provided by one bowl bellows of the double chambered type (Type A.l) (Fig. 47).

B. Shaft or Dome Furnace
B.1
This type of furnace consists of a shallow hollow round which is constructed a circular wattle and clay daub structure approximately 75cm in diameter and 100cm high. It tapers slightly towards its top which is entirely roofed over with the same material. At the base of the wall are two or more holes for the insertion of tuyeres which are slanted downwards into the hollow. Two or more single bowl bellows[64] pump air into this type of furnace (Fig. 48, No. 1).

B.2
This type consisted of a low flat cylindrical foundation of baked clay divided into two or more segments by means of clay partitions[65] which radiated out from the centre. Over this was built the furnace which rose to a height of 60cm. Each segment had a hole in its outer wall for the insertion of a tuyere. The number of segments was regulated by the number of smelters as each man took the portion of iron which sank into his compartment.

B.3
This type is open topped. It is said to be usually approximately 3–3.65 metres in diameter and 1.22–1.75

metres high with walls inclining inwards towards the top. Around the base of the wall were holes about 30cm apart for the insertion of tuyeres. Draught was provided, depending on the furnace size, by ten to fifteen men who pumped single bowl bellows.[66]

All these dome furnaces were pumped by single wooden bowl bellows with valves. The first two types were used by the Kalenjin group of tribes and the third by the Masai. A further type of furnace used by the Kalenjin group was described to Galloway (1934: 501) by a Nandi. It consisted of a series of clay pipes four inches in diameter set vertically on a radially sectioned foundation so that each touched its neighbour. Each pipe was so placed on the foundation that one half of its base was free (Fig. 34, No. 2A). I have not included this as a type because I have not come across it, and the description may not be correct as I have found that smiths can never give an accurate description of their furnaces, tools, or techniques.[67] It is essential to see for oneself.

Dome furnaces are confined to the west of the Rift Valley, while to its east only bowl furnaces are found. Type A.3 bowl furnaces, which are found in the extreme west, are obviously of different derivation from those east of the Rift, but they do seem to be used for the same reason. Generally there seems to be some relation between the type of furnace and the type of ore used, or the way in which that ore is prepared for use, for with one exception[68] the bowl furnace is found only where ore is richer and less bulky. Thus it is used in eastern Kenya where the predominant ore is ironsand, and in the extreme west where solid small lumps of haematite are used. Both of these ores contain less gangue than others so less slag remains after smelting and there is less iron remaining in that slag.[69] Where large quantities of murram[70] are used without further preparation the same furnace is found. Although murram is also sometimes used in bowl furnaces[71] it is always reduced in bulk before smelting by carefully selecting only the richest pieces and then grinding them to powder. It is often washed and sieved as well.

None of the Kenya furnaces, except type A.3, have any provision for slag tapping, and the trench of A.3 seems to be used as an air-hole and overflow for cinders as the slag is extracted through the bowl.

Furnaces are almost always charged with charcoal of the same type as used for forging, but in some dome furnaces wood was occasionally used on its own[72] in which case it was placed on top of the ore and constantly replenished, or in conjunction with charcoal. Usually successive layers of charcoal, ore, wood and charcoal, were built up to the top of the furnace.[73] *Juniperus procera* (the pencil cedar) seems to have been the only wood used for this purpose. Wood is very rarely used in bowl furnaces.[74]

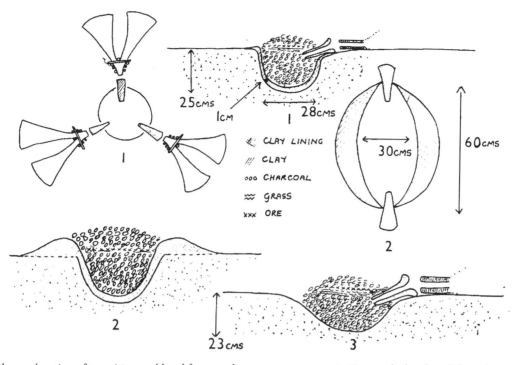

Fig. 46. 1. *Plan and section of type A1 round bowl furnace, the most common type in Kenya which is found throughout northern and eastern Kenya east of the Rift Valley. Draught is provided by 1–4 pairs of bag bellows. This Embu one is clay-lined. 2. Plan and section of type A2 bowl furnace, a clay-lined oval with a thick clay rim, which seems to have been peculiar to the Kikuyu. Two pairs of bellows, set at either end of the oval, provide the draught. 3. Section through a Mbeere bowl furnace of type A1 which is not clay-lined.*

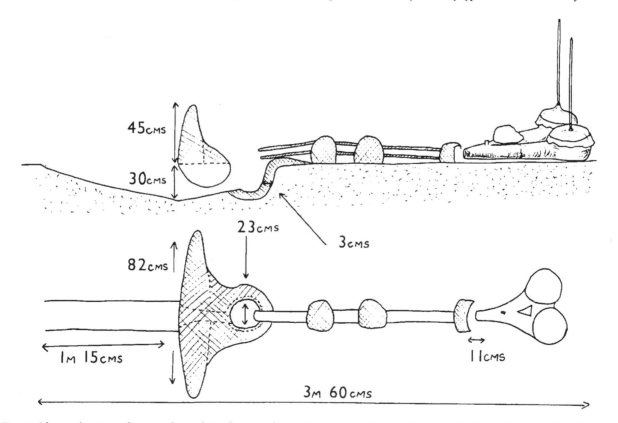

Fig. 47. *Plan and section of a marachi smelting furnace of type A3. It consists of a clay-lined bowl in front of a low wall with a trench behind it. A hole under the wall connects the trench with the bottom of the bowl. The tuyere, of type C, consists of three sections of straight clay pipe joined together by three rounded humps of clay. Draught is provided by double bowl bellows of type A1.*

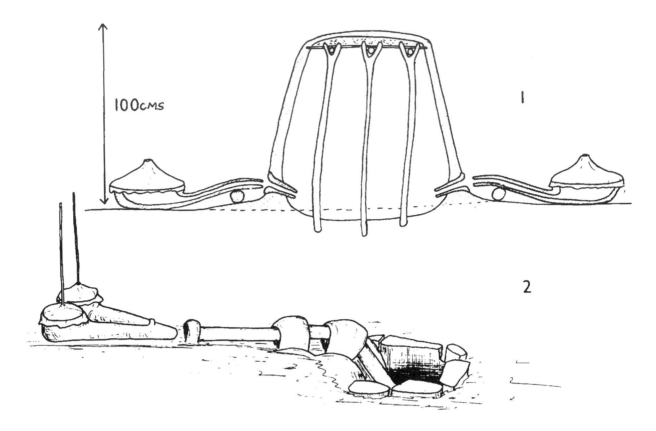

Fig. 48. 1. Section through a Pokot dome furnace. 2. Marachi smith's bellows, tuyere, and stone-lined hearth.

A bowl furnace is always filled with charcoal which is brought to white-heat before the ore is placed on top. Frequently the charcoal covering it is from a different species of tree.[75] In bowl furnaces ironsand is very often separated from the charcoal below by a thick bundle of grass,[76] while powdered murram or the sticky residue resulting from boiling it with water until all the water steams away is tied up thickly in grass or banana leaves before being placed in the furnace.[77] Other smiths[78] coat the ore thickly with clay or cowdung because they say that gives a good colour to the iron as well as ensuring that it will be of good quality.

There are many reports from the Highland and Coastal Bantu[79] of ironsand being placed on the furnace in a piece of broken cooking pot. On hearing this for the first time I was very sceptical, assuming that the smiths must either be referring to the reheating process for which they definitely use a pot[80] or to the actual furnace which is commonly referred to as a 'pot',[81] but as many smiths reported this and were most emphatic about it I can only assume that they did actually use one.[82] The explanation given for separating the ore from the charcoal in these various ways is always that they wish to keep the fine ore from percolating downwards through the charcoal. By keeping it together a large lump of iron is produced instead of a lot of little

pieces. They may also be attempting[83] to prevent it becoming too carburised and, therefore, too brittle.

Generally no flux is added to iron ore, but one of the Highland Bantu group[84] does add lime in the form of ground-down *Achatina* or *Limicolaria* shell, the powder being placed on top of the ironsand in the furnace. Very little slag is produced when this is used. Other things such as clay,[85] soil from termite mounds,[86] iron dust and flakes left on the anvil when forging,[87] concoctions of leaves pounded in water, and various magical plants with a sticky juice[88] are also added to the ore mostly for magical purposes to ensure that the ore produces good iron.

There was no differentiation between smelters and forgers as no man could be initiated as a smith until he was skilled in both smelting and forging. Since forging required more training and more skill it was regarded as the more important work. Smelting, with its hours of non-stop bellows blowing was an exhausting task which was left to apprentices and younger smiths, but they always worked under the direction of a master smith, usually the oldest man present. It was he who gave orders as to how the furnace should be constructed and charged, supervised the attendant rituals, directed the bellows blowers so that they produced the correct amount of draught, checked the tuyeres at

intervals to see that they were not blocked, and examined the ore from time to time, if that was possible, to see how it was progressing.

In the rich ore-bearing areas of Samia, Guisii and Kikuyu, as the demand for iron products increased smiths began to specialise so that some of them concentrated more on smelting and forging pig-iron for sale, while others, who bought it, concentrated on forging artefacts from it. This specialisation allowed smiths to move further afield into areas which had hitherto lacked smiths because they were so far from sources of ore. These smiths had to concentrate entirely on forging[89] unless they were lucky enough to find some sort of ore in their new area, but it seems that smelters never concentrated on smelting to the exclusion of forging, for everywhere there are reports of them forging artefacts, as well as pig-iron bars, and in any case, ore-collecting and smelting were seasonal activities almost everywhere.

The smelting season was generally a short one. Amongst the agricultural and semi-pastoral agricultural peoples smelting could not be done until the crops were safely harvested.[90] If smelting took place during the growing season[91] it was believed that not only would the crops be ruined[92] but people and animals would suffer a terrible epidemic.[93] This is because iron ore is part of the soil which is considered to be 'Mother Earth'. Whilst growing the crops are said to be feeding from her, and if ore, which can be collected from her only at this time, is also smelted then the crops will fail. Once the crops are ripe the land is 'mature' and just as people can then eat the crops, so can iron ore then be 'eaten' or made 'mature' by smelting it. It could be smelted until the short rains but never during the long dry season from January to March when the smiths concentrated on forging.[94] Pastoral smiths, however, were apparently able to smelt at any time.

Where dome furnaces, which require more labour to construct and more bellows blowers, are used smiths generally smelted in family groups from two or three neighbouring smithies.[95] The same applied to those who used the more complicated type of bowl furnace found in western Kenya, but was less true of smiths east of the Rift Valley who used bowl furnaces, as in most cases smelting took place in their smithies in the same hearth that they used for forging. It was only in those areas[96] where they lived close to their ore supply and concentrated on producing pig-iron for sale that they worked in large family groups. Some of them often smelted with the help of only one apprentice.

Clay from termite mounds[97] is generally preferred for building dome furnaces and for lining bowl furnaces, partly because it is consistently fine and often the only available clay, but mainly because termites are regarded as the most fertile creatures on earth and their clay is thought to ensure the fertility of the ore and the successful outcome of the smelt.

Sometimes a family group of smiths abandoned their smithies during the smelting season and moved temporarily close to their source of ore where they stayed until they had smelted enough to keep them supplied until the next smelting season, but this happened only in rare instances when smiths lived far from their source of ore. Usually they preferred to carry the ore home to work in the ancestoral smelting places where it was easier to ensure freedom from pollution and because it was not often that agricultural smiths could be certain that they were safe from the attack of enemies when in strange territory.

Smelting furnaces, like smithies, are carefully hidden away in secluded places in the bush, often without paths leading to them. When smelting is done in a smithy, as it generally is to the east of the Rift, the furnaces are usually permanent but when they are specially built as they are to the west of the Rift they almost never last beyond the one to three month smelting season. This is because, in that area, dome furnaces predominate and they are built completely in the open, while the bowl furnaces are provided only with the flimsiest of roofs which are unable to withstand rain. During the following wet season they disintegrate rapidly because the clay crumbles and wattle walls are ravaged by termites. It is rare, therefore, for sufficient to be left standing to make it worthwhile repairing for the next smelting season.[98]

Because of the heat and the danger of setting fire to their clothing smelters preferred to work naked[99] or with just a bunch of leaves over the genitalia.[100] Sometimes they oiled their bodies,[101] and occasionally they protected themselves by wearing special thick skin garments.[102]

Before starting to smelt some smiths watched for good and bad omens. If the omens were bad all work ceased for that day. It is a bad omen for owls, woodpeckers[103] and hyaenas,[104] all regarded as harbingers of death and therefore likely to impart impurity, to be seen or heard near smelting, for anyone to sneeze whilst smelting,[105] and for the furnace fire to go out soon after it is lit.[106] Some regard it as bad if they wake up to find that the hut fire died during the night,[107] while others will not smelt if any of the chosen smelters fail to turn up on the appointed day.[108] Some think that to strike a left foot with a stone is a very bad sign but to strike the right foot in the same way is a highly favourable one.[109] Sighting certain species of birds is also regarded as favourable.[110] Some smiths could smelt only on propitious days of the week[111] and considered it particularly disastrous for the smelt if someone died in the nearby village whilst smelting was in progress.

As when collecting and preparing ore it is often

looked on as tempting fate to refer to either iron or ore by its correct name, while some smiths may not even mention the words 'skin', 'potters clay', or chainmakers 'pincers' at this time because they are considered to be an indirect reference to the bellows, tuyere and smith's tongs respectively.[112] Sometimes the fire can only be alluded to as the 'fierce one'[113] while the master smith is occasionally referred to as a medicine man during smelting.[114] For similar reasons it is sometimes forbidden to forge all the iron from the previous smelting season until a new smelting season has commenced.[115]

Before smelting a small ceremony usually took place at which a libation of honey beer[116] and sometimes a sacrifice[117] was made to the ancestors, and the master smith blessed the participants and prayed to God and the ancestors for a successful smelt, and for protection against harm.[118] As well as giving protection these prayers were occasionally considered to purify the smelters, but they were also sometimes purified by being smeared with chyme from the sacrificed animal, and washed with water containing sacred herbs.[119] Some were painted with coloured earth,[120] and all wore their protective iron ornaments. To make doubly sure that no jealous fellow smiths could harm the smelting or themselves some smiths engaged in elaborate anti-sorcery rituals.[121] It is interesting to note that these are unnecessary when the smith has no rivals.[122]

During smelting the blast has to be kept up non-stop by relays of bellows blowers who change more frequently when pumping valveless bowl bellows with sticks than they do when blowing single bowl bellows with valves, or bag bellows[123] whose operators sometimes blow for the entire smelt. The master smith is the one who carefully watches the condition of the fire, directs the bellows to be pumped faster or slower as required and adds more ore and charcoal from time to time. He checks to see that the tuyeres are not becoming blocked and pokes the smelting mass into the centre of the furnace from time to time.[124]

The first part of smelting is carried on in anxious silence for the smelters are afraid that they might have inadvertently offended the ancestors in some way which will make them want to retaliate by causing the smelt to fail. When they see that the ore is forming into large lumps there is great rejoicing for they then know that the ancestors are pleased. They break into raucous songs in praise of them[125] and jig around as they complete the smelting.

Many smiths prefer to work at night[126] because it is cooler and there are fewer people about to stumble on their secret processes. They also say that they are able to see how the smelting is progressing better in the dark. They cease work at dawn and while the furnace cools go to sleep until the afternoon when they remove the lumps of iron. Other smiths smelt during the day,

usually starting at dawn and going on well into the afternoon or until dusk. The minimum time for a smelt is said to be three to four hours. In bowl furnaces iron may be taken from the furnace almost immediately and it is sometimes sprinkled with water to cool it,[127] or it may be left for about an hour,[128] or overnight,[129] before being removed. It is left to cool in dome furnaces for much longer, sometimes for only one day[130] but usually two or three.[131] The fire must be left to die out naturally. It must never be put out for fear that some misfortune will befall the smelters.[132] A smelt in a bowl furnace was always completed in one day for the furnaces were too small to hold much ore. Amongst the Highland Bantu it was forbidden for the ore belonging to two men to be smelted on the same day.[133] When the iron was removed the furnace was cleaned out and recharged for smelting the next man's ore the following day. A smelt in a dome furnace was also usually completed in one day but occasionally it was carried on continuously for as long as four days.[134]

When the iron from a successful smelt was removed from the furnace, and sometimes before it could be removed, an animal was sacrificed close to the furnace in thanksgiving to the ancestors and all the smelters feasted on it. Smiths of the Highland Bantu group were usually content to pour a libation of honey beer over and around the furnace, bellows and tuyere before they removed the iron. The smith and his assistants then drank the rest of the beer. At this stage the smelt is regarded as complete: the ore has been transformed into metal and is everywhere regarded as iron but to make it workable it must always be re-heated.

The material removed from the furnace is either a large spongy core consisting of a mass of coalesced iron, slag, charcoal, and unreduced ore, or a number of smaller pieces of the same matter. To extract the nodules of iron it has to be knocked to pieces, with a hammer (usually an iron maul) or hammer-stones, to remove the unwanted substances. Where smiths smelted as a group these blooms were usually divided out amongst the participants who took them off to their own individual smithies. In some cases apprentices were entitled to a share.[135]

The blooms are always re-heated, in the hearth of the smithy, to refine, weld and consolidate them. When doing this a flux, in the form of crushed shells, is occasionally used.[136] Sometimes, also the bottomless top half of a domestic cooking pot is placed in the hearth to hold the charcoal and iron blooms during the refining process.[137] The smiths consider that the bloom is ready to remove when typical long-tailed sparks are given off to the accompaniment of loud crackling noises. The iron is extracted and placed on the anvil where it is beaten with a hammer to test if it is ready. If not quite ready it is returned to the fire, but if ready the remain-

ing small amount of slag is separated from it and it is then repeatedly heated to red heat and hammered into pig-iron bars of the sizes traditionally required for making different artefacts. These bars, which were used for trading, seem have averaged about one and three quarter to two pounds in weight[138] and were sufficient to make two large artefacts. In western Kenya they were shaped like a long triangular axe-head 25–30cm in length.[139] A Kenya furnace rarely produced more than a kilogramme of iron in a day and it usually produced less.

Smiths who smelted in bowl furnaces both in eastern and in western Kenya rarely threw their slag away[140] but stored it in pots for future use in making the rougher personal ornaments, chains, rough bells for hanging around the necks of hunting dogs[141] and bell-clangers. It was also hung on smith's bags for decoration and to identify them as belonging to a smith.[142] Amongst the Highland Bantu group slag was often handed over to an ornament and chainmaker,[143] usually the brother of the master smith. On the rare occasions when a smelt failed the part-fused mass was thrown away and never resmelted.[144]

The utilisation of slag by bowl furnace users and the fact that they used a purer form of ore may explain why iron slag is so rarely found lying around either in eastern or extreme western Kenya where bowl furnaces are used, whereas in areas such as the Uasin Gishu plateau, where dome furnaces were used, it is fairly common,[145] for users of dome furnaces do not seem to have made use of their larger amount of slag in any way other than to read omens in it.[146] Non-smiths also carefully avoided areas where slag was to be found and still make a sacrifice to purify a field if they happen to dig up a piece of slag there. Many tribes regard slag in their fields as bad because it indicates the presence of a former smelting site which is always avoided as long as memory of it lasts.

At this point it is best to give exact details of four different smelting processes as I observed them.

Embu Smelting

The Embu, who belong to the Highland Bantu group, live on the southern slopes of Mount Kenya. They obtain most of their ore, in the form of ironsand, from the lower hot dry country of the closely-related Mbeere sub-tribe to the south of them, from whom the Embu claim to have originally learned the art of ironworking. Embu country being high is also cold and wet for much of the year. This is said to make the smelting of iron difficult there and to result in a poor quality product. Because of this very little smelting was actually carried out in Embu. Instead it was customary for smiths collecting ore in Mbeere to set up their furnaces in the bush and smelt their ore there in situ. The cores were carried back to Embu. During the smelting period, which extended from August to December, the smiths had to smelt intensively so as to produce enough iron to satisfy the artefact requirements of the tribe for the rest of the year.

The smelting described here took place in Embu. Ore was collected from the dry bed of the small Ceciono River, a few miles beyond Ishiara, on the lower Embu to Meru road. Directed by the smith the apprentice collected it from where it lay in thick black patches in the streambed. It was carried back to the smith's homestead where it was winnowed by his wife and then panned by the apprentice. Ironsand was collected and prepared not only by smiths but by anyone who wanted an article manufactured by the smith and who did not possess sufficient scrap-iron (*Ituika*) for re-forging. Analysis of the ironsand collected proved it to contain 89.28% ferrous oxide.[147]

In preparation for the smelt the smith made nine tuyeres and three new pairs of bag bellows. Smelting was carried out in the bush close to his homestead. The smith himself dug the hole for the bowl furnace using a large knife. He first dug it in the shape of a cone with a top diameter of 30cm but later scooped out the bottom so that it was 25cm deep with fairly straight sides and a flat bottom (Fig. 46, No. 1). Three small sloping hollows 3.5–5cm deep at their lower ends were scooped out of its circumference at regular intervals to allow for the insertion of the clay tuyeres. Clay of the same type as that used to make the tuyeres was ground into powder in a bowl quern, mixed with water and worked to a soft dough-like consistency. Sand was then added to make it hold together[148] and it was used to line the entire hollow to a thickness of approximately 1cm. The furnace was then left for a day for the clay to set.

The next day at 1.30 p.m. the three funnel-shaped tuyeres, 13cm in length with bores of 2cm in diameter, were placed in the clay-lined hollows provided for them and angled downwards so that they extended about 5cm over the edge of the pit. Behind each tuyere a pair of triangular bag bellows was positioned with their bifurcated wooden nozzle leading into the tuyere but placed about 1.5cm away from its mouth (Fig. 46, No. 1).

The nozzles were held firmly in position by means of a series of sticks hammered into the earth on either side of the Y-shaped nozzle. One was placed in the fork of the Y whilst three were placed on either side of the Y with a further stick lying horizontally across the nozzles to lock them into position.

It was explained that the furnace must first be dried out completely, by burning the fire for a time, before smelting could begin. A small amount of charcoal made from the wood of the *muthigira* (*Acacia mellifera*

Vahl; Benth. ssp. *mellifera* Family *Mimosaceae*) tree was placed in the furnace. Before lighting it with a smouldering piece of charcoal from a domestic fire, the smith carefully positioned the tuyeres and tested them for maximum air flow by blowing the bellows a little. No special ceremony took place and no libations were made when first starting the fire in a new furnace.

The three bellows operators took their places and blew the fire gently to get it going. It was then piled with more charcoal. Each pair of bellows, one held in each hand was pumped alternately by its operator. Raising each bag, opening its aperture to let in the air, and then slowly and rhythmically collapsing it took approximately one second for a pair of bellows, so that the fire was receiving approximately six blasts of air per second. The smith gave instructions that the bellows operators must work in unison, all pumping their right hand bellows at the same time, and then all their left hand ones. The smith listened to see if the passage of air in the tuyeres was audible.

Only then was he satisfied that the bellows were being properly worked. If one bellows momentarily stopped working fire was driven back up its tuyere from time to time but when the master smith noticed

this he told the blowers that to prevent it and stop the tuyere from getting blocked they must blow evenly so that one bellows was always blowing air through the tuyere while the other was sucking it in.

An hour after lighting the fire the smith considered the furnace ready for smelting so he ordered some extra rapid blowing to bring the charcoal in the centre to white-heat. He removed some charcoal from the cooler periphery of the fire to put on its centre. On top of that he placed a round flattish bundle of green grass (*nyaki* - *Hyparrhenia anamesa* Clayton) of about 15–20cm in diameter and about 5cm in thickness, which had previously been made flexible by rubbing it in the hand to break the fibres. This was done to form the grass into a dense mass so that the ironsand, which was then placed on top of it, would be unable to trickle through into the fire below.

Two handfuls of ironsand were heaped over this green and slow-burning grass almost covering it to a depth of 2.5–5cm. The tuyeres entered the fire below so that the blast of air percolated upwards through the grass to the ironsand. Fresh charcoal made from the wood of the *muthura* tree, which is considered to give a fiercer heat than that of the charcoal first used, was

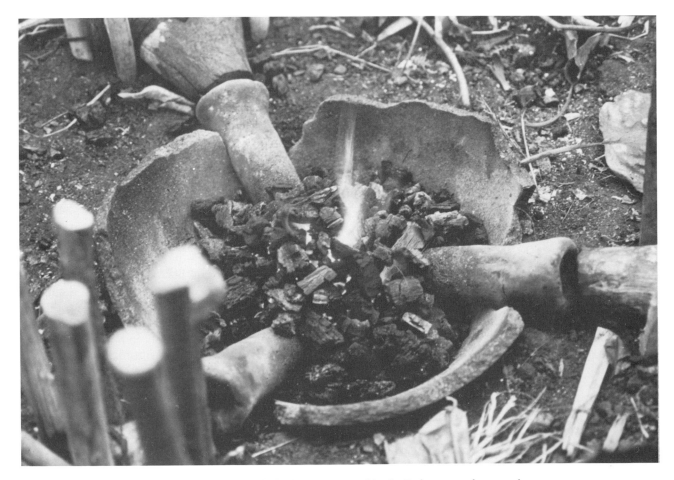

Plate 5. Broken top half of a domestic pot used by the Embu to complete a smelt.

ringed around the grass and ironsand and then heaped up over it to a height of 2.5–5cm. The bellows blowers were told to reduce their speed to approximately one cycle of the bellows every two seconds, but in five to ten minutes the fire had again become red-hot and they were ordered to double their speed. An hour after placing the ironsand in the furnace the smith poked around in the fire to examine its progress. Finding it satisfactory he placed more grass on the fire and more ironsand on top of that, covering it, as previously, with charcoal made from the *muthura* tree. This second lot of ironsand was examined after three quarters of an hour but although bright red had not yet fused.

Two and a quarter hours after placing the first quantity of ironsand in the furnace and three and a quarter hours after the bellows blowers, who had not changed or rested, first started blowing the fire, the iron was again examined and found to have fused into several black irregular-shaped lumps which had come to rest quite high up in the furnace; only 2.5–5cm below the level of the tuyeres.

The cores consisting of iron, slag and adhering charcoal, were removed from the fire by means of tongs. The tuyeres were removed and examined to see if they had become partially blocked and the furnace was stoked up with charcoal before being abandoned until the following day. This preliminary smelt was said to have been done in order to dry out the furnace and the surrounding ground sufficiently for the real smelt to take place next day.

Because of the damp ground conditions of this first smelt the ironsand had taken longer than usual to fuse[149] and the resultant core was of very poor quality. The furnace fire remained alight all night so that it was still hot at 10 a.m. the following morning when the smith started work. As on the previous day the smith spent some time preparing the bellows and stoking the furnace to well above ground level with charcoal made from *Muthigira* wood. The bellows were worked until the topmost charcoal in the fire was red-hot when the same procedure as on the previous day was followed except that the iron core already produced was placed on the grass and the ironsand was added on top of that.

Half an hour after the start, the smith examined its progress and found that the ore was fusing satisfactorily. Forty minutes later he added a second lot of grass and ironsand. In between he had replenished the fire with charcoal four times to ensure that the ore was covered.

An hour later he examined the result, and finding that a core (*kigera*) had been produced he raked it from the furnace. While still red-hot the slag and charcoal was hammered away from the iron. The furnace was recharged with charcoal made from *muthura* wood, which was blown to a red almost white-heat. The lumps of iron were then placed on top, without grass, and cov-

ered with more charcoal. The furnace was refuelled several times always using charcoal made from the same wood. Forty minutes later the core was removed from the furnace and left to cool.

For the next part of the process the broken top-half of a domestic cooking pot was placed rim downwards into the furnace hollow. Three U-shaped notches had been cut into the upper edge at equidistant intervals to allow for the entry of the three tuyeres, as three pairs of bellows are also used at this stage although only one pair is used for forging. It was explained that the fire was built in this pot as it protected it from the coldness and dampness of the Embu ground and served to contain the product.

The pot was filled with charcoal made only from *muthuru* wood which gives the greatest heat. It was set alight by a piece of burning charcoal from the domestic hearth. The core had already been broken up to remove the slag and the resultant twenty to thirty small pieces of iron weighing approximately a kilo to a kilo and a half, were placed on top of the charcoal which had been fired to red-heat. When the fire was red but almost white-hot more charcoal was heaped on and around it and replenished when needed. The bellows blowers again maintained a steady heat, pumping fast so that both bellows of the pair completed the pumping cycle in one second. In order to protect themselves from the heat, which they had not done in the earlier operations, they improvised fire shields from banana leaves by placing them into the upright sticks which held the bellows nozzles in place.

From time to time the blacksmith checked on the iron by probing the fire with an iron rod. Approximately thirty minutes after placing the iron in the fire it began to give off typical long-tailed explosive red sparks and to make crackling noises indicating that it was almost ready. The smith attributed the crackling noises to the iron losing water. Further probing then produced a molten piece of iron adhering to the end of the rod. This was tested by placing it on the anvil and beating it with a hammer. Finding it satisfactory because it did not break from the rod, he soon after used his tongs to draw a large lump from the fire, but on hammering it he found it to be still friable as it broke up into small pieces and had to be returned to the fire which was by then white-hot. More charcoal was added and pumping continued.

Later the rod was again used to probe the fire. This time when tested the mass of iron adhered to it firmly and was declared to be ready. It was placed on the anvil held in the tongs while the smith broke away a few final pieces of impurity. He then hammered it into a lump and finally into a rectangular bar which could be traded or which he could use himself to forge into artefacts. No water was used at any stage during these operations although the smith used it for quenching during forging.

Each time the ore was put onto the fire, when the *Muthuru* charcoal was first added, when the iron was put on for re-smelting, and when the pieces were finally being welded together, the smith and his bellows blowers sang songs about the work, about themselves and about the people who brought them ironsand to smelt.[150] When things were going well the smith relaxed by drinking honey beer from a cowhorn but he never once poured a libation.

When smelting the smiths used to work naked. They could not take part in smelting after having had sexual intercourse or if their wives were menstruating or otherwise in a state of ritual impurity. No rituals seem to have taken place before or during smelting and no good or bad omens were looked for. It was, however, strictly taboo for an Embu smith to have sexual intercourse for one month after smelting.[151] It was also taboo for a smith to smelt until after the crops were ripe for harvesting. This was generally taken to be after the harvesting of the traditional food, bullrush millet, which was cut in August. Smelting could continue until after the next rains. It was strictly prohibited to smelt when the crops were growing, i.e. when the land was 'black'.[152]

Smelting was carried out in the bush well away from people for visitors might be impure and, therefore, a danger to the smelting process. No other smiths were allowed near for they might be jealous and resort to sorcery in order to prevent the ore from producing good iron. When smelting did take place in Embu it was usually done in the smithy which was built in a secluded position for the same reasons.

Mbeere Smelting

To the south of the Embu, in dry bush country near the Tana river, live the Mbeere, who have a long tradition of ironworking. They maintain that they first carried on ironworking in the Ithanga Hills to the west, and that it was they who taught the craft to the Kikuyu, Embu and Masai.

In the southern part of Mbeere district lives one of the few Kenya smiths who still smelts regularly. He says that he continues to do so because scrap iron is difficult to come by in the area and buying it from a town is too expensive for him. I observed him smelting on a number of occasions.

The iron ore that he uses is most frequently ironsand *(Ithiga)* which is found all over the district but is particularly rich beyond Mwea. He also uses iron-bearing rocks *(Igero)*. He searches for iron-bearing veins amongst the quartzite rocks in the vicinity of Kiambere Hill.

As in Embu customers can collect their own ore, but at the beginning of the smelting season they have to wait for it to be smelted until the smith has first completed two smelts for himself. The smelting season is the same as that in Embu and the same taboos apply. Ironsand can only be gathered for a short period after the rains. It is prepared in the same way as by the Embu. A medium sized crockery kitchen mixing bowl of ironsand collected in Mbeere produced only half a 35mm film canister of 'pure' ironsand after preparation, but sometimes it produces much more.

Smelting is done in the smithy in a simple bowl furnace. In the past it was done by groups of smiths who produced sufficient iron to supply requirements until the next season. Four pairs of bellows were said to be used. Work started early in the morning and finished at noon. Nowadays, with little demand for his tools, the smith smelts only for his own immediate requirements. He works alone but for his apprentices and uses only one pair of triangular bag bellows with bifurcated nozzles.[153]

His father's smithy, in which I first saw him smelt, had a roughly circular furnace/hearth 23cm deep and 35–37cm in diameter. The smithy to which he moved, about fifty yards away, was of brushwood type with a furnace/hearth which when originally dug was about 30cm deep and 45cm in diameter, but it soon became much shallower. The hole had to be dug using a wooden digging stick of the type used in cultivation. A 'pure' young girl and a 'pure' boy were then called to carry away the earth which had been removed.

Into the hole was placed some honey and a liquid made from *Mugwata Ngondu*.[154] In the area of Mbeere the earth is said to be so hard and compact that it is unnecessary to clay-line the hole as is done in Embu and Kikuyu country. A little water is, however, poured into it and rubbed around the sides to seal them.

Before a fire is started in the hole, powdered *Achatina* shell *(Nyonga)* is put in the bottom of the hole together with some *Kirathangi* grass which is set on fire. The hole is then ready to be used as a furnace and the fire is started in it using charcoal made from the wood of a tree of the Acacia species *(Mugaa)*.

Before smelting the smith must observe certain taboos. Most important is the taboo on sexual intercourse on the night before a smelt and on any person in a state of ritual impurity being in the vicinity of the smelting. This applies particularly to women for they might be menstruating or have recently given birth.

The night before a smelt a goat is killed in the smithy for consumption by the smith and his helpers. This is for purification and to bless the work. It must all be eaten in the smithy as a safeguard against any of the meat being eaten by menstruating women, for should that happen it is believed that the ironsand would never fuse together.

Because of his ability to curse a smith has little to fear from anyone other than a fellow smith. When

smelting, therefore, an Mbeere smith regards the presence of another smith in the vicinity with the gravest suspicion for he might be lingering there with the intent to bury some object for sorcery near the smithy. The presence of a snake around the smithy is equally bad for it indicates that another smith is seeking to harm the work by magical means.

To make doubly sure that any possible sorcery will be counteracted the smith takes elaborate preventive measures in the form of the following ritual:

First he collects a small twig of *Karundu* (*Jasminium fluminense, Vell*). Then puts some white diatomaceous powder *Ira*,[155] commonly used by medicine men, onto the palm of one hand and rubs it into his finger tips. He passes his hands round the anvil seven times. Then back and forth over the anvil with the fists first turned downwards and then upwards, and finishes with both hands flat on the anvil so that the magical power is transferred directly from his hands to the anvil. With his fingers he then rubs *Ira* onto his toes, onto his hammer and onto the small twig of jasmine.

He then turns his attention exclusively to himself. He rubs *Ira* around the outer edge of his eyes putting a small spot by the inner edge as well, and a larger spot on either side of the end of his nose. More is put between the first and second toes of each of his feet, on his toe joints, along the outer edge of his feet and finally under his heel. Some is rubbed on his right elbow, more put on the back of his wrist and on the knuckles of each of his fingers while the prints of his fingers are re-coated with it. He makes a white line with it on his upper lip and over his eyebrows and then puts some under the soles of his feet.

Ira is then rubbed onto the drinking horn, onto the nozzles of the bellows before they bifurcate, onto the tuyere, onto the lower part of the belly and the lip of the pot containing the quenching water, onto the tip and handle of the millet brush used for sprinkling water to dampen the furnace and finally again onto the *Karundu* twig which is then dipped into the quenching water. Using the small millet brush some of the quenching water is sprinkled over the furnace.

The *Karundu* twig is then broken up into small pieces. A fragment is put into the furnace fire, some pieces are put under and around the anvil, while more are placed on top of it so that the smith can crush them into the anvil with his hammer.

At this point he fills his drinking horn with honey beer, pours a libation of it onto the crushed *Karundu* on the anvil, around the anvil and onto the remaining piece of *Karundu* twig, drinks some, and then takes a mouthful which he spits into the furnace.

He rubs the remaining piece of *Karundu* twig onto the tuyere, then still holding it he circles the furnace with his arm before dipping it into the quenching water.

At this point the *Karundu* may either be thrown into the furnace or placed in the half-gourd containing the ironsand waiting to be smelted, which has previously been wetted with the treated quenching water.

This is all done in silence. The details of the ritual may vary slightly each time that it is performed but basically it is always the same. Smelting can then proceed without risk of harm from sorcery, for every item to be used has been treated.

While this is taking place the bellows blower is pumping the bellows alternately to provide the blast of air necessary to keep the fire going. Then onto the glowing charcoal is placed a thick wad of *ndathango* grass (*Cynoden aethiopicus*, Clayton and Harlan) which is very slow-burning. Further libations are offered.

Some honey, honey beer (*njohi*), and water are placed in a drinking horn. Some of the contents are dripped in a circle around the furnace and into the pot of quenching water. The smith takes a mouthful and spits small amounts onto the waiting iron ore, onto the anvil, tuyere, bellows and bellows nozzle in that order. Without these libations, which are said to make the ore easier to smelt, it is thought that the resultant iron would be no good. Whilst pouring these libations the smith calls on his ancestors to bless his work and to help him to produce good iron.

The smith then sips some of the contents of the horn himself before passing it to his son who is his assistant, then to the two bellows blowers, then to his tiny grandson (to ensure that he too will one day become a smith) and finally to any other male member of his family allowed to be present.

When the wad of grass on top of the charcoal has completely burned to thick ash, a little more is added. The waiting ironsand (or previously crushed iron-bearing rock) is sprinkled with quenching water and a large fistful of it is placed on top of the ash and grass. On top of that is placed powdered *Achatina* shell (*Nyonga*) which had been ground down beforehand on a grinding stone. The smith is emphatic that it is the use of this powdered shell which causes the iron ore to fuse into iron. Mbeere smiths are said have discovered for themselves the use of *Achatina* shell as a flux[156] and to have used it as far back as anyone can remember.

The iron ore plus its flux is again sprinkled with water before more charcoal, this time made from the *Muraci* tree (*Lannea atuhlmannii. Engl.*) – a tree said to be especially good for smelting as it burns slowly and gives off considerable heat, is added on top. On top of that is placed a layer of chips of the hard heartwood of the *Muraci* tree, to which is added some leaves of the *mugondu* creeper and some crushed up pieces of an even more powerful magic plant, a small succulent called *kavuri* (*Caralluma subterranea*, E.A. Bruce and Bally., *Asclepiadaceae* or *Portulaca foliosa* L. *Portulacacea*;

both are given the same name and either may be used). Some *mugondu* leaves are also placed in the quenching water and the juice of *kavuri* is dripped in a circle around the furnace.

It is said that *mugondu* leaves are used because they exude a sticky substance to which birds stick if by chance they perch on them. A plant sticky enough for a bird to adhere to is believed to be equally efficacious in fusing iron ore. It is also believed that adding it to the quenching water makes doubly sure that the product will be successful.

Onto all this is added a final layer of charcoal made from *muraci* wood, whilst further libations are poured in a circle around the furnace, onto the bellows nozzle before it divides, and onto the smith's own wrists. This latter action is done to protect the smith and his work only if he is not wearing his *muthiore*, the traditional twisted iron bracelet of the blacksmiths.

The bellows blower then begins pumping the bellows in real earnest. Pumping is fast and continuous in order to produce an even draught. The bellows blowers were very young and when one became tired another took over. The blast was kept up continuously for thirty to forty minutes.

At intervals throughout the smelting, water from the quenching pot is sprinkled onto the fire. This is said to make the charcoal 'stronger' to make it last longer and to concentrate the heat. At intervals the smith continues to pour libations onto the fire, onto the bellows nozzle and onto his own wrists. No further libations are poured onto the tuyere. Whilst working the smith continuously chews leaves of *miraa* (*Catha edulis*, the Khat of the Arabs) to keep himself awake and fully in command of his work.

Thirty to forty minutes after the ironsand is put on, the smith pokes the fire with his tongs and takes out the core to see how it is progressing. On the various occasions on which I watched this smith smelting he invariably replaced the lump of iron for a further ten minutes during which the fire was once more sprinkled with water.

The core of iron, which is fairly low down in the furnace, is then removed with iron tongs which were introduced into Mbeere during the smith's lifetime. Previously two pieces of green wood were used. Probably because the ore is prepared so carefully very little slag is produced but what there is is knocked off with a hammer and the pieces of iron are replaced in the furnace so that they will weld together. This smith never added more ironsand to the original quantity he placed in the furnace.

The iron is considered nearly ready when sparks with long whitish tails crackle out of the fire. The consolidated iron is removed from the furnace, any rubbish adhering is knocked from it and it is repeatedly heated and hammered into a small bar. The large fistful

of ironsand which was smelted produces sufficient iron to make a black-smiths twisted iron bracelet, a razor or a large arrowhead.

Instead of using iron ore the smith sometimes re-smelts either the solidified end of old tuyeres to which a lot of slag has adhered (*nganga*) or the produce of first smelts (*kigera*) which he obtains from the site of his dead father's smithy. In both cases the material is ground down before smelting.

Marachi Iron Smelting

The Marachi, who live close to the Uganda border in western Kenya, belong to the Luyia group of Interlacustrine Bantu. To the east of them are the Wanga and to the west the Samia. All three peoples are well-known for their iron-working and share common ironworking techniques, but the Samia are particularly famous as smiths as one of the richest sources of iron in Kenya is in the Samia Hills. All these smiths use heavy stone hammers and split green-wood tongs and still know how to smelt.

The groups of smiths, whose smelting operation is described, consisted of a master smith (whose father had not been a smith), his son, his two cousins and one of their sons, who shared two smithies a few miles from Sangala.

On this occasion they dug their ore,[157] a heavy fine-grained haematite,[158] from Ageng'a Hill in Budongo sub-location of Samia location, but they also obtain ore from Namenya Hill and from Mumbaka Hill on the road to Port Victoria. All these ore sources are ten to fifteen miles from their smithies.

The ore was sorted into good and bad quality during collection. Only the good quality was taken home so no further sorting was necessary but it was hammered up into smaller pieces before smelting.

After returning with the ore the smiths built a hut in which to smelt. This was to shelter them from the sun and to delineate the working area so that onlookers would not cross the boundary. It is only used for the smelting season and then abandoned. The hut, a substantial structure approximately 4 metres in diameter, took the men a whole morning to build as a considerable amount of work was involved in cutting and preparing the poles, clearing and levelling the floor and digging the post-holes.

Twelve stout uprights with forked tops were placed in the circle of post holes with a taller thicker forked pole in the centre. Horizontal roof supports, resting in the forks, were placed between every two uprights. A thick log about 45cm long was then placed horizontally into the fork of the centre post to support the apex. Roof pole ends were rested on this and tied one above the other, while their other ends were tied to the

horizontals resting on the uprights. Circular bands of pliable withies were tied on the top of this at about 20cm intervals, and onto them were thrown a few green banana leaves and an armful or two of grass, a mere gesture towards providing shade. As they dried up others were added.

The smiths then began to build the furnace. Two four-gallon paraffin cans full of clay from a termite mound were tipped onto a hut floor which had been paddled smooth with dung. Two more full of clay dug from a nearby hillside were added and the lot was pounded with a stone hammer to reduce it to powder. Water, brought by a woman from a river half a mile away, was poured on and the clay mixed to a dough-like consistency. It was emphasised that the two sorts of clay could not be mixed on the loose dirt floor of the smelting hut because if soil became mixed with the clay the furnace would crack during use.

In the hut where the furnace was to be built the floor was smoothed with a hoe and with the feet. The light red/brown wet clay was tipped onto the ground near the edge of the hut. From it the smiths began to build a wall. Starting with a base 82cm long three of them, directed by the master smith, very slowly and painstak-

ingly added thick rolls of clay, one on another, to build up a structure 45cm high which sloped down at either end. Beside them stood a bowl of water into which they dipped their hands.[159] Only their thumbs were used to smooth the clay.

When this was complete one smith dug a furnace bowl 30cm wide and 30cm deep immediately in front of the wall on the side facing into the smithy, while another dug a trench 1 metre 15cm long on the other side. This extended beyond the hut circle and sloped downwards towards the wall where it was 30cm deep. A hole was then very carefully made under the wall to join the furnace bowl to the trench. The trench was apparently used not for slag but for ash.

The furnace bowl was then lined with clay about 3cm thick. This was built up and over the hole to form a thick raised rim which was banked steeply up towards the wall on that side. The finished furnace was left to dry until the following day. Its internal diameter was now reduced to 23cm and it resembled a bowl-shaped pot (Fig. 47).

The furnace was prepared soon after noon. Three sections of straight clay pipe tuyere, first a long one, then a short one, then another long one which rested on the lip of the bowl furnace, were joined together by

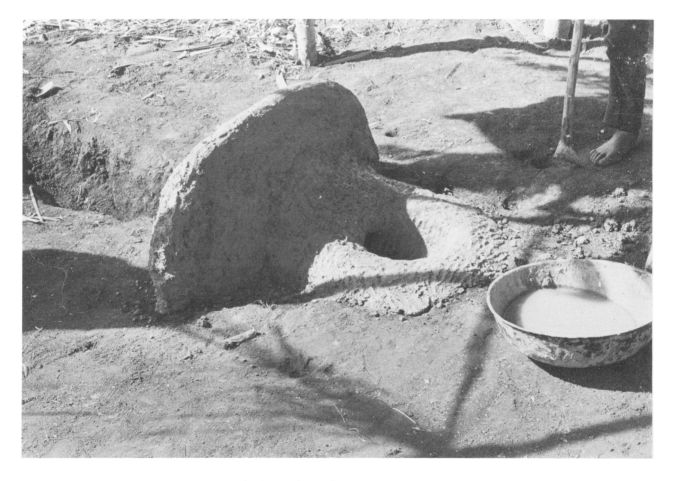

Plate 6. Marachi clay lined bowl furnace with wall and trench behind.

thick rounded lumps of clay which also raised them off the ground (Fig. 47). A flared clay mouth was fashioned for the first one to channel the blast of air into it from the bellows. The double wooden bowl bellows were then placed in position, their diaphragms tied on and their sticks fixed in ready for use.

Next the furnace was charged. Finely ground charcoal, which spilled out into the trench was placed in the bottom of the furnace with normal sized charcoal over it.[160] On top of that, close to the end of the tuyere, was put a piece of smouldering wood which was piled high with more charcoal. This covered the end of the tuyere and reached almost to the top of the wall. The fire was started at 1 p.m. by fanning the smouldering wood with air from the bellows. As soon as the charcoal began to glow the whole half sack of ore was piled all round the *outside* of the charcoal but not on top of it, and the bellows blower started pumping in earnest.

As the charcoal burned away in the centre more was placed on top of it but it was never put over the surrounding ore which extended to the edges of the wall and spread slightly beyond it. At frequent intervals during the smelting the ore round the periphery was scraped up towards the hot charcoal in the centre.

One and a quarter hours after lighting the furnace the hole to the trench became so choked with ash that it had to be poked clear with a stick and the ash left in the trench. This exposed several masses of ore which appeared to be fusing. Ten minutes later the nose of the tuyere became blocked. In order to unblock it without disturbing the furnace they broke up the clay hump joining the first and second sections, removed the first section and pushed a long stick through the last two. Half an hour later the furnace was again probed with wooden sticks to locate the forming iron core. By this time the charcoal and ore were fairly well mixed in the centre of the furnace.

Forty minutes after its first blockage the tuyere again became blocked and was cleared in the same way. Air was also leaking from the diaphragm of one of the bellows bowls so it was tied on more securely while the blast was kept going by the other bowl. Throughout the smelting operation the bellows were pumped very fast by three young men who changed over on average every twenty minutes. The bellows blowing sounded like drumming as it was done to a similar rhythm. The blower frequently danced to it as he worked. The rhythm was changed every quarter to half a minute

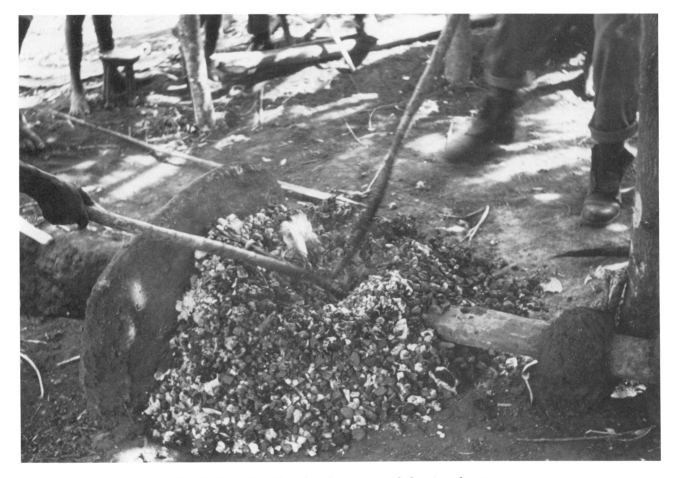

Plate 7. Marachi smith probing for cores to push them into the centre.

except when songs were being sung when they pumped to the rhythm of the song.

Twenty minutes later they probed around in the furnace for the cores of iron and pushed them together into the hot centre of the furnace. Some of them were adhering to the end of the tuyere. They were broken off and the tuyere end was cleared by pushing a stick up it. Charcoal was then piled high on the centre of the furnace.

Three hours and forty minutes after lighhting the furnace they again probed and decided that the iron was ready. Six to eight loosely joined cores were removed form high up in the furnace on a level with the tuyere, and left on the ground alongside to cool.

The joyous singing[161] and dancing of the smiths brought the women to the hut to join in. Half and hour later an all-black male goat[162] was sacrificed in the hut to the right of the furnace. It was killed by cutting its throat with a sharp knife. The blood was caught in a cooking pot. It was skinned and its skin given to the master smith and it was then butchered *in situ* on banana leaves. That evening it was roasted and eaten.

When cool the cores were hammered with a stone to remove the most obvious slag. The half sack of ore had produced a cooking pot, 10 inches in diameter, full of iron bloooms but at least a third of the ore remained unsmelted round the periphery of the furnace.

In preparation for reheating and welding the blooms the next day a small amount of charcoal was soaked in water. Fifty metres from the smelting hut a hole, approximately 30cm in diameter and 20cm deep, was dug in the ground. Charcoal was piled into it and water poured on top. When it was thoroughly soaked it was removed and placed in a container. The smiths could give no explanation for soaking this small quantity, other than saying that 'it was customary'. The rest of the charcoal was used normally.

The second part of the operation took place in the smithy at noon the following day. Further slag was removed from the cores by hitting them with the biggest piece. The fire in the hearth was started with wood. The iron was placed directly onto it. As he put it there the smith spat three times onto the iron and said "I put this iron on with a whole (pure) heart. Let what we want be produced". He then covered it with charcoal, threw on three handfuls of soil[163] taken from the entrance and the sides of the hut saying "This is the work of my ancestors. I, too am doing it with a good heart. Let the result be satisfactory" and placed some green grass on top to protect the operation from possible sorcery. Finally he covered the lot with the soaked charcoal prepared the previous evening.

When the iron had formed into a lump it was alternately heated and hammered using only heavy hammers, until it was formed into a long triangular-shaped bar of pig-iron measuring 25cm long, 7½cm

wide at its base and 3½cm thick, and weighing 520grms.[164] This took three hours to produce. During the final hammering its tip, weighing 2½ozs., broke off. This was said to be because the fire was too hot. There were also several cracks in it. This ingot was of the same size and shape as those traded throughout Luyia and Luo country and eastern Uganda until thirty years ago. It was sufficient to make two large slashers, or three spearheads.

Once the blooms were seen to be producing a good iron bar women brought beer into the smithy and great rejoicing took place whilst the bar was being finished. Everyone, except those actually hammering the bar who could only sing, danced and sang songs praising the ancestors and the craft of ironworking.[165] Only the men drank the beer.

In order to ensure the successful outcome of the smelt several taboos have to be observed. The smiths must be pure so they must not have sexual intercourse either immediately before or during smelting, and women are not allowed into the hut until the work is seen to be successful. During the actual smelting no-one but the people who were present when the furnace was lit are allowed into the hut until iron has been produced. Both in the smelting hut and smithy everyone, including the smiths, has to be careful not to step over the bellows, tuyere, furnace or hearth. In the smithy no-one may sit on the stone anvils or hammers, and people who are twins or who have born twins, can only enter if they throw charcoal onto the fire three times.[166] If this is not done it is believed that the iron will spill whilst being pounded.

Agricultural Pokot Smelting

The Pokot occupy an extensive area in north-west Kenya which embraces both high mountains and low-lying semi-desert. They are the only tribe in Kenya which is split into two sections each following its own distinct mode of livelihood. The section in the plains are nomadic pastoralists while the hill-dwellers are agriculturalists. They are a Paranilotic people speaking a language closely related to the Nandi group of Kalenjin from whom they may have been an early offshoot. The Pastoralists have no smiths so have to rely for their iron goods on the neighbouring agriculturalists. As the area they occupy remains remote, smelting was carried on there until comparatively recently and the older smiths still know how to smelt.

The smiths who smelted for me lived and worked on the Weiwei river near Sigor close to the Marich Pass. Their smithy was beside the river but the smelting furnace was constructed about half a mile away, across the river, in deep bush and about a quarter of a mile from the river.

The wattle walls were built first. A rough circle 75cm in diameter was scuffed on the ground by foot, close to a shady bush. Into this, upright withies were stuck at intervals of 15–20cm. Two lots of encircling bands of withies, one lot on the outside and the other opposite them on the inside, were placed horizontally round the uprights at intervals of about 14cm and tied to them with strips from *Sansevieria rahillii*. The higher bands decreased in diameter so that the stucture was tapered slightly towards the top.

When this was complete the smith, the smith's son and two of his brother's sons walked to a higher area of dry sandy soil about a mile away where they searched for a suitable tall termite chimney. Having found one they hacked at its base with a hoe until it toppled. Placing the smaller fragments into sacks and carrying the rest on their shoulders they reurned to base where they tipped the soil into the wattle structure just built.

While one man went to the river to fetch water the other toppled a nearby tall termite mound by thumping its upper half with long stout sticks. Being near the river it was composed of rich reddish clay. This was carried back and tipped into the wattle structure, on top of the sandy soil from the first termite mound, where it was broken up with a hammer and hoe. Water was added to it and one man got inside to mix it by trampling it with his bare feet. More clay, collected from the second termite mound, was dumped alongside the structure, broken up with hammers, mixed with water, and trampled in the same way.

When the clay was mixed to the right consistency, the man inside applied the clay, (from inside the structure) thickly to the inside walls, while the men outside applied the clay from the outside heap to the outside walls. It was thrown at the walls and then pushed firmly home.

When the whole structure was thickly covered with clay, both inside and outside, it was smeared by the smiths who dipped their hands constantly into water. In mixing the clay inside the structure some of the ground soil was incorporated so that the floor was hollowed out to a depth of 10–12cm. This was with clay like the walls.

When the lip of the structure was neatly smoothed

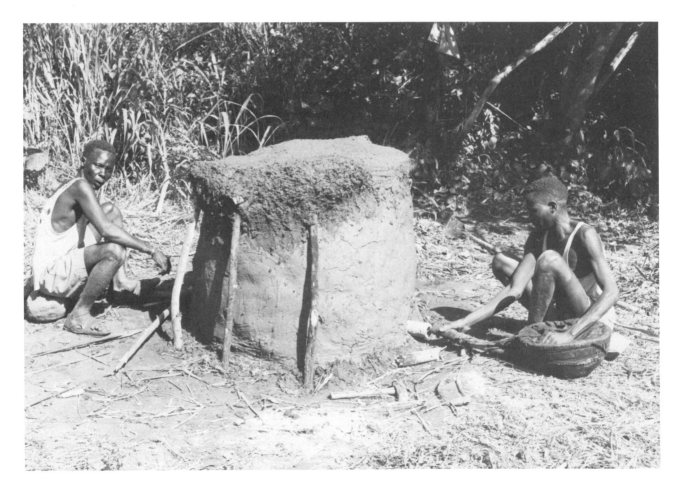

Plate 8. Agricultural Pokot smiths blowing their dome furnace

over, two holes were made opposite each other, about 5cms above itas base, for the insertion of the tuyeres. To form the holes a stout pole, angled downwards, was pushed through the wall. The holes were smoothed inside by hand. The tuyeres were inserted, slightly countersunk, fixed in firmly with clay, and the surround smoothed off.

By 1 p.m. this first stage of the furnace was completed having taken five hours to construct. It was then left to dry out for a day.

The following morning it was charged and its roof was put on. On either side of the furnace, not occupied by tuyeres, three stout poles with forked tops were fixed into the ground close to the walls. The ore was broken up with a hammer and the furnace charged nearly half-full with alternate layers of charcoal and ore, placed on top of some dry grass and twigs.

Three stout sticks were laid horizontally over the open top of the furnace, their ends resting in the forks of the uprights. On top of these and at right angles to them, small thin sticks were packed close together and covered thickly with wide-leafed river grass. The whole was covered about 5cm deep in wet clay. A knife was used to trim the protruding grass ends off flush with the wall. The joint between the top and the wall was sealed with clay. The smiths then completed the furnace top by smoothing it wth hands dipped frequently in water.

The following morning, after leaving the top to dry for a day, the smelting began. The smiths first offered a prayer for the successful outcome of the smelt and blessed their ancestors for handing the craft on to them. The furnace was then ignited by removing the tuyeres, thrusting a smouldering stick in through the holes, and then blowing down them by mouth. When the dry grass and twigs inside caught fire they removed the sticks, replaced the tuyeres, and started to blow the bellows at first placing the nozzles almost into the mouths of the tuyeres. Soon afterwards the bellows nozzles were placed approximately 5cm from the tuyeres mouths while one man raised up the tip by resting it on a piece of tree branch placed on the ground immediately in front of the tuyere. They continued to pump the bellows slowly and rhythmically for the next six hours changing bellows blowers, from time to time, as they became tired.

Once the furnace fire was well established a considerable amount of flame, and some ash, was sucked back out through the tuyeres and a small amount of smoke escaped through tiny cracks which developed where the roof joined the walls.

The furnace is normally left to cool off until the third day when knives are used to dig the clay from the roof amd from where the roof joins the walls until the lower cross-beams are exposed sufficiently to be grasped in the hands, The whole roof is then lifted off and tipped over to one side of the furnace and the smiths delve over the edge to remove the iron inside.

The smiths removed the tuyers from the furnace and carried both of them and the iron back to the smithy. There the adhering slag was hammered from the blooms which were re-heated and beaten into two iron bars. It was estimated that these would produce four spearheads and four long spear butts.

The smelting operations have to be kept pure; no women are allowed near and the smiths must also be in a pure state. For example they must not have sexual intercourse the night before starting to build the furnace; whilst building it, or whilst smelting and they must not smelt if their wives have just given birth of if they themselves have been in close contact with death. During smelting they must take care not to step over the bellows, and must, on no account, comment on the work in any way.

This type of furnace was also used by the neighbouring Markwet who may have taught the Pokot how to work iron. New roofs had to be put on for each smelt so furnaces were never used for long. Some were said to be used only for one smelt while none lasted beyond one short smelting season.

SMELTING TABOOS

Blacksmiths consider the strict observation of taboos as necessary to the successful outcome of a smelt as they do the actual techniques of smelting. These taboos are said to have been instituted long ago by the ancestral smiths in order to ensure success by keeping the whole process ritually pure and free from pollution. Thus the taboos aim to keep away from smelting anyone who is (or might inadvertently be) in a state of ritual impurity for if impurity is allowed to creep in, the smelt would fail.

It is, therefore, necessary to exclude everyone but the smiths and their apprentices from the scene of pocreation, for there is no means of knowing who is or is not in a state of ritual impurity. Nor is it possible to tell whether or not an onlooker might harm the work by sorcery or the evil eye.

While ironworking has to be kept "pure", it is, itself, polluting so that people also have to be kept away from it for their own good for they are in great danger from the mystical power of the smiths and their ancestral curse.

The presence of women is especially taboo for they are regarded as creatures who are frequently in a state of impurity. They are thus a source of great danger to the ironworing as well as to themselves for there is a general belief that if they go near ironworking they will become sterile. A few tribes[167] do allow women to approach but even those societies which permit them

to act as bellow blowers during forging absolutely forbid them to do so for smelting.

No smiths or apprentices in a state of ritual impurity[168] are allowed to take part in smelting, while all those who do take part are generally purified before starting in case they have become polluted. The tools and everything else involved are also purified. The operation itself, however, is usually regarded as an unclean and impure process. Fire is the purifying agent, but it can only purify the iron ore (by turning it into iron) with the assistance of the smiths' mystical powers which are inherited from their ancestors. For those powers to function properly the smiths must adhere strictly to the prohibitions for if the ancestors are displeased they will cause the smith's power to lessen, the furnace to become barren, and the smelt to fail.

Ritual impurity can be brought about in a number of ways all of which are deviations, in one way or another, from the normal rules and customs of a society which seeks to recognise and maintain its established order and structure. It is incurred by: breaking any rule of avoidance or taboo; doing something contrary to the customary behaviour of society such as infringement of marriage and sex regulations; committing a bloody crime or otherwise being in contact with human blood; being closely associated with the crises of life e.g. birth, initiation, death; being involved with some abnormal event or phenomena, such as being a twin, or being closely connected with someone struck by lightning.

People who temporarily fall into this state of ritual impurity, whether as the automatic result of an act which they have deliberately committed, or as the result of one in which they have unknowingly been involved, are regarded as being possessed by a mystical power which is highly dangerous to themselves and to anyone else with whom they come into contact, and in certain circumstances only to those people. They are feared and avoided, not because it is thought that they will intentionally use this dangerous power to inflict harm on others, but because they cannot help doing so, for they involuntarily transmit their impurity to those people and objects with whom they come into contact, thereby exposing them to the same danger to which they themselves are exposed.

Smelters must therefore avoid any act which will cause them ritual impurity; and avoid contact with any person in a state of ritual impurity who might transmit that impurity to them.

As elsewhere in Africa[169] it is most important for smelters to avoid sexual intercourse for those who have recently indulged in sex are automatically considered to be impure and liable to cause the smelt to fail. This taboo applies to the night before smelting and for the duration of the smelt. Sometimes[170] it is taboo for one month afterwards, that is for the normal period of seclusion and

sexual abstinence which follows a birth for, in the minds of most Kenyans, smelting is regarded as the birth of iron[171] and the furnace as female although it is not often spoken of as such.[172] It is, however, rare for the furnace to be thought of as the smelter's wife as it sometimes is in other parts of Africa.[173] Eliade (1962: 57) had likened the furnace to "an artificial uterus where the ore completes its gestation", an idea which is widely prevalent in Kenya although, again, the furnace is rarely spoken of as a womb. When it is, it may at the same time be referred to as a tomb[174] presumably because in it the ore dies to be reborn again as iron. Smelting is alos occasionally referred to as a wedding rather than a birth.[175]

Smiths who have committed adultery,[176] or who have deliberately or accidentally killed anyone,[177] are not allowed to smelt until they have been purified, for they are in a state of ritual impurity. A smith whose wife is still in seclusion after childbirth also cannot take part until after the purification ceremony which marks the end of her periods of seclusion for her impurity may have been transmitted to[178] him. In many tribes,[179] smiths whose wives are menstruating are likewise prohibited. A smith who has been in contact with death, especially if he has helped to bury the body, must avoid smelting until the period of mourning is over for he is in a state of pollution.[180] There is no taboo on a smith who is a twin, or the son or father of twins, taking part but he must be sure to perform a small ritual so that his presence will not adversely affect the smelt.[181]

Since a smelt is usually of such short duration the taboo on smiths returning home during smelting[182] is not a very common one, but in some tribes smiths could not return home at this time for fear that they might incur ritual impurity, and because until they had actually produced "pure" iron they themselves were liable to pollute their families.[183] Prohibitions on washing, which have been recorded elsewhere in Africa,[184] are also found in Kenya although the smelters of many tribes could wash whenever they wished, and some did so whenever a spark landed on them.[185]

Food taboos, which have been recorded from neighbouring Uganda and other parts of Africa,[186] are not common in Kenya. The smiths of one tribe,[187] however, are not allowed to eat at all whilst smelting or forging, whilst those of another may not eat mutton before a smelt.[188] The drinking of alcohol beforehand is also sometimes forbidden.[189] There is a general taboo on food being cooked in both furnaces and forges. A few tribes, however, do allow it but restrict the cooking to one or two traditional ceremonial foods which must only be roasted by the smiths and their apprentices.[190] Women generally took food to the smelters but left it some distance from the scene of operations calling out to attract the attention of an apprentice who went to fetch it.

FORGING

Heat Forging by Smiths

Some smiths, in the few areas of intensive ironworking and in those areas where ore was not available, concentrated solely on forging but this was not usual and they always had to know how to smelt as well. They forged with iron which they themselves produced or which they obtained from other smiths, and with scrap iron brought to them by their customers.

Since only wrought iron could be produced, iron was never cast, although casting of other metals was and is practised. Steel was not produced but by constant heating and reheating in a charcoal fire the iron presumably took up a small amount of carbon. Quenching is practised widely but many artefacts are poorly hardened with the result that spears, in particular, frequently become so bent after piercing an animal that the hunters have to spend the next hour hammering them back into shape between two stones.[191]

For a time smiths used trade wire for forging, twisting lengths of it together,[192] heating it, and then welding it into a mass by pounding it on the anvil. Only the Masai are reported to have used a flux (Merker 1910: 115) in the form of crushed shells, in this process.

Smelting has now almost ceased. Scrap iron, usually from mass-produced goods but often still from worn-out broken traditionally smelted articles, is used almost exclusively. With this plentiful supply there is no longer any need to smelt or to weld together iron wire.

Smiths often forge in groups under the direction of a master smith. Sometimes brothers work together, or a father and his sons, but the majority of smiths work alone. All smiths, however, must have one assistant to blow the bellows. This is usually an apprentice who is almost always the smith's son. Occasionally a smith may have to both forge and work his own bellows for a time; this slows down his work considerably.

The same simple tools are used for forging throughout Kenya although they differ slightly from one part of the country to another. Smiths in some areas may also have a greater variety of them than in others. The techniques are likewise remarkably homogenous.

Before starting to forge smiths usually clean out the hearth. Generally the same charcoal is used both for smelting and forging but occasionally a different type is used for forging. For magical reasons this is sometimes poured into the hearth over the tuyere. It is lit, usually just in front of the tuyere, by bringing fire from the smith's own hut. Often an old maize cob core or some equally easily ignited material is placed on the fire to help it to kindle. The bellows are not pumped properly until the fire is well alight but are merely used to give a gentle puff from time to time. During forging the bellows are blown gently to give a low even blast. They are only pumped when iron requires heating, otherwise the fire is allowed to lie dormant.

The fire-place is rarely filled with charcoal. Often there is only a small heap around the tuyere. The fire is controlled by raking it together from time to time. Many smiths also use a brush (Fig. 36, 1 and 2). This is dipped in quenching water which is sprinkled over the fire if it becomes too hot and sends out sparks. This is said to be done to prevent the charcoal from breaking up into tiny pieces and to stop the sparks flying for they might burn someone.

While working it, the iron is kept hot by repeatedly reheating it between hammerings. The smiths recognise the different degrees of heat necessary for different operations. For welding they wait until the iron is white-hot and emits characteristic long-tailed explosive sparks. When cutting iron, punching holes in it, jumping it,[193] or drawing it, they bring it almost to the same heat, but for most other processes they are content to make it red-hot. They continue to work on it until it blackens. A very large lump of iron is often worked early in the morning for then it can be put at the bottom of the hearth and have the fire lit over it so that it heats through gradually.

Welding by hammering is general but is used mostly for welding blooms together after smelting. In a few areas it is also used for repairs, particularly to hoes. The edges, which are to be welded together, are heated, thickened by jumping them on the anvil and then thinned out. They are re-heated until long-tailed sparks appear and then placed one on top of the other and hammered to weld them together to the required thickness. I have never seen bracelet ends welded together, nor have I seen weapons welded. Since pastoral smiths no longer smelt, and have no tools to repair, it is very unusual to see them welding.

Rivetting is equally rare except that it is always used for tongs. It is not, apparently, a traditional technique but appears to have been introduced by Islamic silversmiths as it is used in north-east Kenya[194] and at the coast,[195] almost entirely for rivetting ornaments. In western Kenya its introduction is even more recent. There the smiths repair blades oi factory-produced hoes, which break easily, by trimming them back usually to a triangular shape onto which they rivet a new blade of their own manufacture.

For pounding, in the early stages of forging, the heaviest hammer is used on the largest anvil. In later stages of forging, the smallest hammer is used on a small anvil. Iron is cut with a chisel which is quenched frequently. Chisels used for cutting larger pieces are hafted to keep the smith from being burned (Fig. 9, Nos. 4 and 5). They are always given an initial heavy blow to cut the iron, followed by a more gentle one to sever it. In the rare event of iron being decorated[196] chisels are used to cut patterns into it when hot.

Mandrels are commonly used for making sockets, wood mandrels being used for sockets which need only rough work and for bells. Making tanged and socketed artefacts is simplified by making the tang or socket first and then fitting it with a temporary rough wooden handle with which it is held while the rest of the artefact is hammered out. Before this is done it is held in the tongs. I have seen smiths use their hands to remove hot iron from the fire but they always cool the protruding end with water first. This is most frequently done when twisting a bar. It is held in the left hand while the hot end is picked up with tongs. The cool end is then transferred from the hand to another pair of tongs. Twisting is the only method, apart from the rare instance mentioned above, of ornamenting iron.

Twisted iron bracelets (Fig. 77, No. 3; Fig. 78, Nos. 8–9) and neckrings (Fig. 80) which are the insignia of smiths and their families and are used by non-smiths as protective devices are made by drawing out a piece of iron into a long thin bar. The finer gauge neckrings are sometimes made from thick wire. Nowadays the wire is bought from a shop, but used to be made by the smiths themselves using a drawplate. The bar is hammered into a square cross-section and cut to the required length. Some smiths guess the length but others measure the customers wrists with a piece of fibre or twine which is then placed alongside the bar for size. The cut end is hammered smooth and the bar re-heated. Then holding each end in a pair of tongs the smith twists it. Some smiths[197] hold the bar steady in the left hand while twisting only with the right, others[198] twist both hands back and forth, at the same time, in opposite directions. A few[199] hold one end down on the anvil with the hammer while twisting the other in the tongs.

Bracelets need two or three re-heatings to complete the twisting, but the longer neckrings require more, for they have to be heated and twisted section by section. In between twists the tongs have to be cooled off for they become so hot that the smiths have to protect their hands with pieces of leather. The twisting is always irregular so that by examining a twisted neckring for the beginning of each new twist it is possible to count the number of twists required to complete it. The twisted bar often develops a wave which has to be hammered out. Many smiths make a loop (Fig. 77, No. 3), and sometimes several loops (Fig. 80), in the centre of a bracelet or necklet, often hafting one end of it while they do so.

The terminals are flattened with a hammer and the bracelet is then bent into shape. Bending is always done on top of the anvil, never over its rounded edge. Holding down one end with the hammer the other is slightly bent by the tongs. Holding it in the left hand with the tongs, the smith then bends it around a mandrel in a slight curve. He removes the mandrel and uses it to hammer the inside of the curve very gently. Some smiths use only a hammer and tongs for curving. When the smith has achieved the desired curve he holds down the bracelet with the mandrel, hammers it flat, and then taps it again gently with the mandrel (Fig. 53, Nos. 9–10). Then, holding it is his left hand with one pair of tongs, he bends the terminals back onto the outside of the bracelet using a second pair of tongs held in his right hand. Placing it flat on the anvil, he completes it by hammering the terminals so that they do not extend beyond the width of the bracelet. A neckring has to be bent into a wider circle which is achieved by hammering it over the groove in the anvil to begin with. Anvils without grooves sometimes have slight hollows in them for this purpose, but more often a hollowed log is used.

Iron and copper are sometimes[200] twisted together, and imitation twisting, done by filing in the twists, is found on aluminium bracelets in certain areas.[201]

Nails are only made at the coast where they are used in boat-building.[202] They are amongst coastal smiths' best selling products. Bajun smiths are skilled in this work, unlike some smiths of the Bantu who did not make them traditionally and are very slow. To make them, a small rod is heated and hammered to a square cross-section then cut with a chisel to the required length. It is heated again, pushed by tongs through a hole in a piece of iron often the valve-hole of an old car wheel, and hammered over to produce the head. To get it out again it has to be hammered from underneath, a process which, more often than not, results in the nail getting bent, sometimes so badly that it has to be discarded. All nails are square in cross-section right down to their points.

Bells of different shapes and sizes are made. There are two types of tall bells, both usually reserved for animal use. The first, with closed sides (Fig. 75, Nos. 1 and 4), is made by hammering out a rectangle of iron through which two holes are punched across the centre. The second, with open sides (Fig. 75, Nos. 2 and 3) is made by hammering the iron into a flat hour-glass shape. Both shapes are then doubled over and hammered around a rough wooden mandrel. These mandrels have to be replaced constantly as they rapidly become singed and burn away. Iron mandrels are not used as smiths never have any wide enough for making bells. Any piece of iron heated and hammered into a round cross-section, which is bent over at the top to form a loop, is used for a clanger. The clanger is attached to an iron ring which goes through the holes of the closed-in bell or round the waist of the hour-glass shape of the open one. Wide shallow bells, worn as personal ornaments (Fig. 76), are made from flat circles or ovals of iron which are dished slightly by hammering. Two holes are pierced in line horizontally near the centre by placing the metal over a hole in a piece of iron

and hammering it with a punch or awl. It is then partially bent over. Small pellets, made by hammering tiny bits of iron cut from a heated rod, are inserted and the bell is gently hammered almost shut. It is, of course, always struck beyond the fulcrum.

Most smiths are highly skilled craftsmen who, with their simple tools and techniques, are able to produce beautifully made and finished artefacts. They usually work on several items at once so that no time is lost in waiting for the iron to heat up. The artefacts, which may be of different types, or all of the same type, are usually at different stages of production. Where two or three smiths work together they may have as many as eight to ten partially-made artefacts in the fire at any one time. It is, therefore, often difficult to gauge how long an artefact takes to make. The average time taken to make a short-bladed spearhead without its final burnishing and polishing is two hours, but longer bladed spears can take double that time.[203] Some smiths are much slower workers than others, and the pace of most slows down as they get older (see Appendix VllI).

Spear Making

Spears are the most beautifully made of all artefacts. They are well-balanced, of elegant proportions, and poise well. They have to be, for the customers are connoisseurs who demand both efficiency in use and perfection of line. Blacksmiths, who live close to the larger towns, have found that the mild steel reinforcing rods used in building construction, are ideal for making spears. A few traders, therefore, specialise in obtaining discarded rods which they straighten out for sale to smiths.[204]

The bars average 60cm long by about 2cm in diameter. To make a long-bladed Masai type spear the end of the rod is first thickened for about 13–15cm of its length. This is done by repeatedly jumping it upright onto the anvil to drive it back onto itself, then hammering it to true it (Fig. 49, 1–2). The heaviest hammer is employed for this work. If it is a maul then the oblong heavier end is used. The thickened rod end is then flattened into a well balanced fan-shape by repeatedly heating and hammering it (Fig. 49, 3–5). The smith is extremely careful to work it symmetrically so that it is of even thickness. At this point the edges of the flattened socket are trimmed off with a chisel, if necessary, and hammered to remove the sharpness of the edges. The socket is then rested against the anvil while the smith holds the other end firmly in position on the ground with his left foot while he smooths the edges with a shop-bought file or rubbing stone. Once the socket is roughed out a tapered mandrel is inserted so that the socket can be hammered closely around it to bring its edges together in a straight line (Fig. 49, No. 6). Smiths who only have maul hammers use the rounded

end of the larger hammer for this work. When the mandrel is removed some smiths hammer the socket delicately to close up the slit. The socket is then flared gracefully into the rod (Fig. 49, No. 7), a process which usually involves repeated heating because the iron is often buckled at that point as the result of the earlier work.

If a shorter old mans spear is desired an estimation is made of the amount of iron necessary, the rod is marked at that point and the rest is cut off with a chisel.

Turning to the rest of the bar, starting just above the socket, the smith successively heats and beats it flat, bit by bit, for the rest of its length, into a rectangular cross-section measuring 1cm by 2cm. Using a grooved anvil of stone or iron, and frequently one to supplement the other, he places the bar over the groove, and between reheatings, hammers it just off-centre with the utmost precision, so that its underside sinks into the groove while its upperside is thinned only along its edge. This produces a mid-rib on both sides (Fig. 50, 2–4). The heavy maul is the hammer most frequently used for this work. To produce a straight and true rib the blows must never vary. Such work is done only by the most skilled smiths for if one blow reaches beyond the centre of the bar the mid-rib is obliterated.

Shaping the rest of the blade is a matter of beating all the edges thinner and thinner while turning the blade first onto one side and then onto the other. Every blow is carefully planned for the smith must keep the overall shape straight and true. Every few drawing and thinning blows are followed by sighting along its length and giving a corrective tap or two.

Long Masai-type spear-blades (Fig. 58, Nos. 3, 6 and 8) require a lot of work for they are gracefully incurved. The blade has to be drawn out thinner and wider just below its tip[205] and then narrowed slightly to within 5cm of the socket where the edges are again splayed out to form its base. In drawing and thinning it the smith may first use a handled hammer (Fig. 50, Nos. 2, 3) but those smiths who have maul hammers invariably use them for the final touches,[206] especially for smoothing out the hammer marks along the mid-ribs and for removing the slight wavering of the cutting edges (Fig. 50, No. 4).

Making a spear butt is not as laborious as it does not require such careful shaping. Its socket is made in the same way. Immediately above the socket a Masai-type spear is fullered to produce a smaller "waist". This is done by hammering it while it rests against the rounded edge of the anvil (Fig. 50, No. 6). The next part of the rod is beaten for 10cm of its length, to square it off. It is then fullered again to produce a second ring indentation. The rest of the rod is thin drawn to reduce its diameter. This is done by successively heating and hammering it section by section, first into a square cross-section and then back

into a smaller diameter round cross-section by hammering-in the edges of the square. The majority of spear butts are gradually tapered to a point in this way, but the butt of most Masai spears is hammered square 8–10cm from its end, and drawn into a square cross-sectioned point. Occasionally[207] a smith will point the end of the piece of iron intended for a spear butt then burn it into a temporary rough wooden handle. He then jumps the socket end on the anvil by hammering the top of the handle. This method makes it easier to hold while the socket is worked.

Since mild steel rods are not available to most smiths they heat and hammer any available scrap iron into a suitably sized oblong bar. For making the typical delicate spear (Fig. 58, No. 1) of north-western Kenya[208] with its small leaf-shaped blade (about 15cm long) tapering into a long delicate shaft, a block of iron (length 4cm, width 2.5cm and breadth just over 1cm) is heated and hammered to draw it out into a long narrow bar. Having made the socket a crude wooden handle, with suitably tapered pointed end, is fitted into it so that it can be held easily while removing it from the fire and working it. These are used while working any socketed tool. Occasionally, when the smith wants his hand further from the fierce heat, the socketed handle is itself held in a second wooden handle (Fig. 33, No. 4). There are usually one or two wooden handles lying around the smithy but if not, the smith or his assistant quickly make one. After drawing out the rod further by hammering it square and rounding it off, the smith and his assistant confer to assess how much iron is required for the blade and then cut off the remaining unwanted square cross-sectioned portion at the end.

The blade of such spears is roughed-out by first forming the mid-ribs. This is done, as with a Masai spear, by placing it over the groove in the anvil and beating it with the lighter pointed end of the maul hammer, but it is turned first to one side and then to the other.

The rest of the blade is formed by thinning the edges. The edge to be thinned is placed on the extreme edge of the anvil so that the mid-rib hangs over the side. It is hammered with the heavier oblong end of the maul which is especially roughened beforehand with a grinding stone or sometimes a shop-bought file. Doing that is said to produce a better edge.[209] From time to time the forming blade is placed upright on its side in the groove while its cutting edge is tapped to true it. Finishing touches are given to the surface of the blade by using the pointed end of the maul.

Some smiths,[210] who do not have grooved anvils, still succeed in making excellent spearheads with mid-ribs by hammering them along the extreme edge of the anvil which is kept especially sharp for that purpose. This technique requires even more skill so it is not surprising to find that in western and north-eastern Kenya, where smiths generally do not have grooved anvils, ogee or flat bladed spears predominate.[211] Mid-ribs may be very pronounced or barely discernable. They may run from the tip of the blade to its base. In some cases they may even be distinguished on the neck or the socket or they may start at the base and disappear halfway to the tip.

Other artefacts with mid-ribs, such as swords and digging knives, are made in the same way but they, especially the latter, are not so carefully made. They are tanged (Fig. 61, Nos. 1 and 2, Fig. 65, No. 6) not socketed, so it is necessary to make the tang first and haft it roughly before the blade can be worked.

Many spear blades and some knife blades are "blued" (blackened) all over. Their cutting edges are then burnished bright in contrast. Ogee blades usually have their concave halves blackened while their convex halves are burnished. Blackening is done with a cow or goat horn which must come from a sacrificed usually castrated animal. Since only a "pure" animal can be sacrificed, its horns are also pure and using them will bless the spear. The horn is either rubbed onto the hot spear or is, itself, heated and rubbed onto the cold spear. This is done several times so that the blade is thickly coated. If necessary the smith cools the blade by blowing a mouthful of water over it. Its edges are then given a preliminary sharpening by hammering them delicately with the smaller maul.

The following method is typical of that used to smooth and sharpen spears. The smith gathers a handful of iron flakes which lie on and around the anvil as a result of forging, spits water onto them and mixes them in his palm. He then rubs them vigorously on the edges of the blade several times while spitting water onto it in between to clean it and examine his progress. Many smiths retain so much water in their mouths during this operation that they appear to have a cheek pouch.

The spearhead is then handed to the apprentice who holds it vertically on the anvil while sharpening the edges of the blade with a tiny piece of rough quartzite. This is a most delicate operation. Next its shaft is rubbed down with rotting quartzite rock which has been crushed and ground on the stone anvil by the apprentice. It is then placed against the notched top of a wooden block, set upright into the ground (Fig. 15, No. 4), so that its blade projects beyond the notch while its socket rests on the ground held firmly by the left foot of the apprentice. This is the best position for putting the finishing touches to the mid-ribs and cutting edges which are filed and polished with a shop-bought file whose serrations have been filled in with charcoal. The shaft of the spearhead receives the same treatment. When it is shining brightly it is usually rubbed with mutton fat.

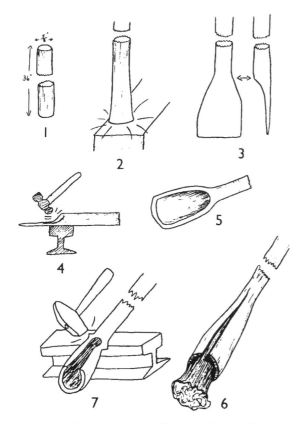

Fig. 49 (1–7). Method used by Kikuyu smith when forging a Masai spear from a mild-steel reinforcing rod.

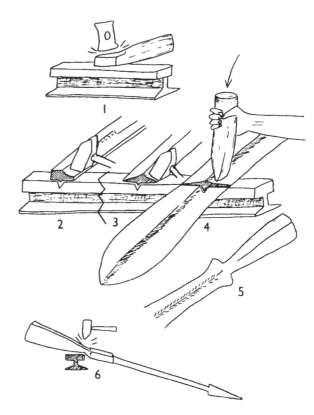

Fig. 50 (1–6). Method used by Kikuyu smith when forging a Masai spear from a mild-steel reinforcing rod.

Some smiths burnish their spears with sand or other abrasive earth[212] or with ground-down slag,[213] while others use the leaves of the "sand-paper tree" (*Cordia ovalis*). Spear blades are generally sharpened all round but are sometimes sharpened only at the tip. Ogee blades are frequently sharpened only on the convex side.

Other blades requiring smoothing and sharpening are first burnished with a series of small stone balls and then given a good cutting edge by rubbing them on a sharpening stone which is sometimes sprinkled with water. A sharpening stone is often set into the floor of the smithy alongside the log of wood on which the artefacts are rested for burnishing. To make the task easier the pliant branch, on which short tools are rested for burnishing, is also leaned into the notch of the wooden upright if the smith has one.

Burnishing is such long laborious work, that with the exception of spears, swords and some arrowheads, few products are normally burnished. Customers wishing for a burnished tool may sometimes have to pay extra for it.[214]

Making flat-faced artefacts
Flat-faced tools are much easier to make. The simplest of these is probably the small triangular razor made by the Highland Bantu (Fig. 53, No. 2). A tiny piece of

scrap iron or a piece of newly smelted iron[215] is hammered into an oblong. With repeated heating and hammering always holding the iron in tongs held in the left hand the splayed end is drawn out using the wide heavy end of the hammer. Sometimes a longitudinal ridge appears but it is later pounded out. The razor is hammered flat most of the time but if it becomes slightly misshapen it is turned upright onto its side and hammered on end. Once the desired shape has been achieved it is beaten at alternate ends, by the smaller hammer, to add the finishing touches. The point is then hammered over onto the blade, the razor quenched, and its cutting edge sharpened on a stone.

A simple flat leaf-shaped arrowhead (Fig. 63, No. 5, 8, 9) is made in the same way. The end of an iron bar is held in the tongs while its extremity is hammered flat. It is hammered further to draw out its end into a tang. Then holding it in the tongs by the tang, the rest of the iron bar is cut off. The tang is then heated and burned (Fig. 63, Nos. 1–3) into a small wooden handle in which it is held while the blade is completed. The blade of a barbed arrow is made first by hammering the end of an iron bar into a thin flat oblong, then cutting away, between the barbs and tang, with a chisel. The tang is them hammered to a round cross-section and pointed so that it can be hafted for the finishing process. Most

hunters cold-forge their own arrowheads, especially the flat leaf-shaped ones, but those from the smith are considered superior.

Hoe blades (Figs. 68–70) are made in the same way but some of them are slightly dished. Once the basic shape of a coastal hoe has been achieved by heavy pounding, the tang is bent slightly towards the blade. The blade is dished by hammering it on the anvil. Holding it almost upright on the ground, its working edge is then hammered to bend it slightly inwards.

Making slashers or Bill-hooks

Slashers or bill-hooks, (Fig. 71) used only in western Kenya, are crudely made. Apart from hoes, they are the largest and heaviest tools made by Kenya smiths. Making them is heavy, slow and laborious work especially when stone hammers are used. Scrap iron is usually prepared into comparatively large almost square lumps for slashers. A lump is alternately heated red-hot and pounded with a stone hammer to draw it out into a flattened rectangle. This is further drawn into a slightly curved long triangle which has a thick base for that is later hammered out to form the curved tip of the slasher. During this process the master smith holds it in his left hand in green split-wood tongs or heavy iron ones. In his right hand he holds an iron rod with which he points out, to his partner wielding the stone hammer, exactly where each successive blow must fall. The tang of the slasher is made first by drawing out the apex of the triangle. It is then pushed into an iron socket whose tang is set in a wooden handle. It is held in this for the rest of the operation.

To curve the slasher it is placed on edge, at the correct angle, over the rounded edge of the large stone anvil and pounded with a stone hammer. When the final curve has been achieved the slasher is transferred to a smaller lower stone anvil for the intermediate work for which an iron hammer of type B2 is used. Holding the slasher vertically on the anvil, its curved tip is tapped with the flat of the hammer. It is then laid flat and tapped with the side of the hammer.

Slashers are also made from scrap iron which has not first been prepared into a set shape.[216] Since commercially-produced hoes with haft holes are sold in quantity and wear out quickly they are the favourite form of scrap used. The worn-out hoe is heated. A long narrow chisel is used to cut off the blade on both sides leaving the mid-rib which later becomes the tang of the slasher. The stub or heel of the hoe is then cut off using a short wide chisel (Fig. 51, Nos. 1–2). The long narrow chisel is used to hot-cut through the wall of the haft-hole (Fig. 51, No. 3) which is then partially opened out (Fig. 51, No. 4). After more heating and hammering the shoulder is hammered out and the whole thing roughly straightened (Fig. 51, No. 5).

The cutting edge is then thinned and the back of the blade hammered to an even thickness of 0.75cm (Fig. 51, No. 6). The thinning continues from the tang to the dotted line (Fig. 51, No. 7) using a two pound straight pein hammer to make the diagonal dents which thin the blade still more. These hammer marks are left in deliberately to show up the dirt left by a lazy owner who does not wash his tool after use.[217] The end (beyond the dotted line shown in Fig. 51, No. 8) is left

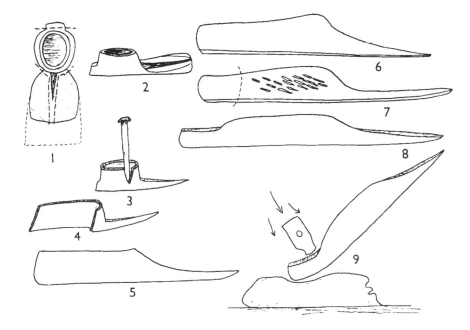

Fig. 51 (1–9) Method used by a Kisa smith when making a slasher (bill-hook) from a worn-out commercially-produced haft-hole hoe.

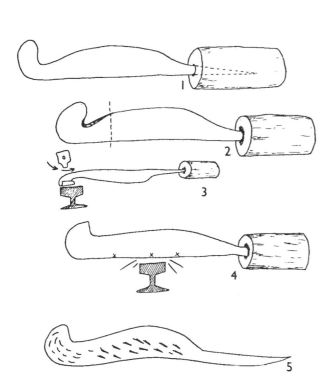

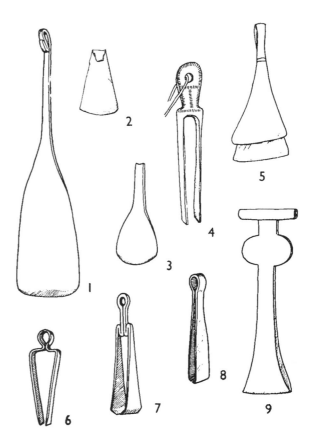

Fig. 52 (1–5) Method used by a Kisa smith when making a slasher (bill-hook) from a worn-out commercially-produced haft-hole hoe.

Fig. 53 (1–9). Razor and tweezer types.

0.75cm thick. Up to this stage the work is done on an iron anvil made from a piece of railway line.

The smith then starts to form the curved tip of the slasher. To do this he works on a stone anvil in which there is a hollow (Fig. 51, No. 9). The smith inserts the tang into a rough wooden handle until he completes the slasher (Fig. 52, No. 1). At this point he raps the end of the heated slasher against the anvil to increase the curve. When he considers the curve sufficient, the end beyond the dotted line (Fig. 52, No. 2) is thinned by drawing it with the hammer. This dishes the inner curve from the spine to the inner edge and removes the radius in the neck. Finishing touches are made to the tip whilst holding it at different angles on the iron anvil (Fig. 52, No. 3). The blade is then up-turned on the anvil and rapped smartly at several points (Fig. 52, No. 4) to give it the desired reverse arc (Fig. 52, No. 5). It is then fitted with its handle and sharpened.

Smiths have to make handles for almost all their tanged tools which range from tiny awls to large slashers. A slasher handle is carved by one of the smiths who is not forging at that particular moment. The green wood,[218] complete with its bark, is first placed across the fire to smoke it. The bark is then peeled off and the handle shaped with a knife. To pierce the hole for the

insertion of the tang, a large awl (in a handle) is heated red-hot and held upright on the anvil while the head of the slasher handle is forced down onto it. The awl is pulled out, reheated and pushed into the hole again while the handle is held horizontally. This is repeated a second time. The tang is then tried in the hole to test it for fit. If satisfactory it is heated and held upright on the anvil while the handle is forced down into it. It is removed, reheated, and the operation repeated. This time it is forced in further in the horizontal position as the handle lies on the anvil, and is then held blade-down and jumped on the anvil. The blade is removed, reheated, and the operation performed twice more before the blade is removed for the last time. A glob of dried tree gum[219] is crushed on the anvil; the pieces are then dropped into the tang-hole and rammed home using the cold tang. The tang is re-heated again and forced into the tang-hole while the handle is held vertically on the anvil. This causes the gum to bubble out all round as the tang is turned and pulled in and out to distribute the gum evenly in the hole. Still in the vertical position the slasher is upturned, jumped on the anvil, and hammered home by hitting the end of the handle. The gum soon dries holding the head firmly in position. Throughout the operation the smith holds

the handle in his left hand and the red-hot blade, in split-wood or iron tongs in his right hand.

Sometimes soot may be added to the tree gum. Bees propolis is occasionally used as a substitute. Recently some smiths have discovered that broken bits of gramaphone records work equally well. Sword handles are fitted in the same way but the handles of small slashers, bill-hooks, sickles and knives are merely burned in. Sometimes a hole is not pierced in the handle first, but tangs are burned in directly.

Some of these peoples[220] also make socketed slashers with handles held firmly in position by hammering a nail through both socket and handle. This is done on a wooden block (Fig. 15, No. 5). To make the slashers the iron is initially pounded into rectangular, rather than triangular, shape. The sockets, like those of many spears, are made round a wooden mandrel.

End-hafted tools subject to a lot of strain, such as iron bladed digging sticks, may have an iron band fitted round the base of the long thin handles for they are liable to split where the tang is burned in. To make the band for a digging stick with a small leaf-shaped blade (Plate 58 *in original thesis* shows the whole process), a small piece of scrap iron is hammered into a narrow flat rectangle which is cut to size using a chisel. Holding one end of the iron in his tongs the smith curves it by hammering it on the inside, then, holding it in the middle, he curves both ends round by hammering them on the outside. Finally he hammers both ends so that the iron forms a hoop with the ends almost touching. Making the hoop red-hot he then burns it round the top of the haft and squeezes it on tightly with his tongs. Holding the haft upright on the anvil he uses his tongs to burn the red-hot tang into its hole for the second and last time.

When making tang-holes in the side of a handle, it is usual for the red-hot awl or other hot iron tool to be hammered into the haft from above. Sometimes a smaller awl is hammered in first to guide the larger one. Tangs of smaller end-hafted tools like awls and knives are generally fitted permanently when first pushed and hammered in, but those of larger tools are usually taken out again so that they can be burned in more deeply a second time. Tongs are used initially to force the red-hot iron tang into its hole. It is then hammered home by placing the hafted tool vertically blade-downwards on the anvil and hitting the top of its handle.

The customer almost invariably has to supply his own hafts for socketed tools and weapons, for arrows and for tanged artefacts which are wedged into or tied onto their handles. Thus smiths supply handles for axes if they are burned into them, but not if they are wedged in (Fig. 72, No. 2). For the same reason smiths rarely supply handles for hoes except for those with a tang which goes through a hole in the handle and is then bent back onto it[221] (Fig. 68, No. 2), for bending

requires heating the iron. The smith or his apprentice carves the hoe-haft using a knife and reduces it to the correct length by chopping off the top with an adze. The hoe-head is then burned into its haft and taken out again. This is repeated after bending its tang inwards to an angle of 45°. The tang-hole is stuffed full of coconut fibre and then the haft is held horizontally on the anvil, so that its tang-hole is just over the anvil edge, while the tang is rammed into position. The fibre, which has been displaced, is cut away with a knife. The haft is held upright while the protruding tang, which has been heated, rests on the anvil so that it can be hammered. It is then turned so that the tang can be hammered back onto itself towards the haft-head not, as might be expected, towards the lower part of the handle. All that then remains to be done is to sharpen the working edge of the hoe-blade.

If they take them to market to sell, smiths in western Kenya usually make handles for the European shaft-hole hoes which they repair. If asked to do so smiths will sometimes make handles for tools which they do not normally haft, but, in that case, they sell the handle as a separate item. A few smiths,[222] however, do supply spear and arrow shafts but this work is usually passed to a smith too old to work iron or to a non-smith brother. These men sit whittling away in a corner of the smithy.

The majority of smiths are thus always skilled in woodworking as well as in metalworking. In western Kenya, smiths who use bowl bellows usually carve their own and occasionally branch out into making stools, eating bowls and mortars.[223] In central Kenya, Highland Bantu smiths make digging sticks and elders' walking sticks[224] which both incorporate iron.

Smiths make their own bag bellows and diaphrams for their bowl bellows but otherwise engage in leatherworking only in those tribes which look on leatherworking as a despised craft;[225] and then they only supply sheaths for swords, knives and other items requiring them. Smiths who make ironwork for other tribes who despise leatherworkers seem to have no objection to making sheaths for them although they will not do so for their fellow tribesmen[226] who are expected to make their own.

To make a sheath, a goatskin is prepared in the usual way but is scraped down extra thin and cut into strips of the required size. These are soaked in water to make them soft and pliable so that they will stretch easily over the wooden sheath and dry firmly in position thus ensuring a tight fit. The smith puts a strip across his knees, places the weapon between its two wooden slats onto it and starts stitching at the base of the blade. Only the leather holds the slats together so after the first few stitches an assistant has to hold the slats until the stitching is complete. The leather is pulled to-

gether, pierced with an awl and joined over the centre of one slat with a fine running stitch. To give an extra strong join two threads, which may be of wild sisal string or nuchal ligament, are used. The leather is sewn right over the tip, cut off and then stitched round the tip with a leather thong which is chewed to moisten and soften it. Sometimes a metal tip[227] is inserted to prevent the blade from penetrating the leather. Sheaths are usually stained[228] red and, in the north-east, are beautifully tooled with geometric patterns. A very small awl-sized chisel with a wooden handle is used for this work.

Smiths in north-eastern[229] Kenya also make ornamental knife handles of horn, bone, ivory, ebony, aluminium and brass. In non-metal handles, the tang-hole is bored by twirling a long-handled splay-tipped awl between the palms.

Some smiths perform a small ritual each morning before starting to forge. This usually takes the form of a prayer to the ancestors, praising them and asking them for their help in producing good artefacts and in keeping away all evil influences. It may, or may not, be accompanied by a specific action.[230] Occasionally smiths also perform an evening ritual when they finish work.[231]

Forging Taboos
As with smelting, the observance of taboos is believed to be just as important to the successful production of tools as the actual process of forging. Protecting the work from all impurity and harm ensures its success. If the taboos are broken it is thought that the result will be poor quality tools which will crack during manufacture or soon after they are used.

To keep their mystical powers intact, and thus ensure the successful production of artefacts, the smiths must observe the same prohibitions as for smelting. A smith who breaks a taboo can only avert the consequences by making a sacrifice to purify himself and the smithy. Fellow smiths gather to bless the transgressor, to invoke the ancestral smiths to forgive him, and to feast on his goat.

Smiths must not be in a state of impurity whilst forging therefore they should not have had sexual intercourse the previous night,[232] nor should they have committed adultery, killed anyone, helped to bury anyone, or be in mourning. In many cases[233] they cannot forge if their wives are still in seclusion after childbirth, and occasionally if their wives are menstruating.[234] Smiths of one tribe[235] cannot send any of that day's products to market if they have inadvertently touched a menstruating woman. They believe that if they did so they would sicken and die. A newly initiated smith is generally not permitted to work for a short period after his initiation. This usually corresponds to the period of total seclusion undergone by

initiates into adulthood while their wounds are healing or to the period of seclusion after birth.[236]

There is also a general taboo on food being cooked in a smithy but, as with smelting, some tribes may cook certain foods there.[237] Generally, however, food is not permitted[238] in a smithy except during special smith ceremonies and then it is cooked on the domestic hearth. No food taken to a smithy may be eaten elsewhere; the guests who are generally[239] all from smith families, have either to stay there until it is consumed or have to leave the remains for eating the following day.

More important than the taboos which the smiths themselves have to observe are those which non-smiths must observe. Smithies everywhere are regarded with fear for it is in them that the mystical power of the smith ancestors is believed to be concentrated. They are, therefore, regarded either as sources of possible pollution and carefully avoided or as sacred and holy places from which non-smiths are, if possible, excluded, as they are liable to be impure and could therefore pollute the ironworking. To protect the work the smith ancestors imposed a series of taboos designed to instil such fear in non-smiths that they prefer to keep away. Breaking these taboos brings ritual impurity which can cause harm to the ironworking and sometimes to the smith,[240] but causes far greater harm to those who break them; contact with the mystical powers in the smithy exposes interlopers to the greatest danger of all which comes from the smiths ancestral curse. This danger which may take the form of continued misfortune, illness or death, can only be averted by the payment of an animal for sacrifice for the use of its chyme to purify the smithy and purify and bless the transgressor. The cost involved in breaking a taboo, therefore, acts as an added deterrent.

Unlike smelting, which was a seasonal activity undertaken with as much secrecy as possible, forging is a much more public affair. It is an almost year-round activity which is carried on closer to centres of population in order to attract the maximum number of customers. The taboos connected with forging are, therefore, understandably more numerous than those connected with smelting; now that smelting with very rare exceptions is no longer practised, non-smiths need to concern themselves only with forging taboos which are, surprisingly, still adhered to strictly all over the country.

The most common taboo everywhere is that forbidding the presence of women of childbearing age in a smithy both when forging is in progress[241] and even when the smithy is empty. The fear is that not only will the work be harmed but that the women will become sterile or lose their children.[242] There is generally no objection to the presence of women past the meno-

pause[243] or to little girls before the onset of menstruation,[244] although the latter are often kept away in case they might become infertile later or have difficulty in conceiving or in parturition.[245]

In some cases this taboo applies to the wives and daughters of smiths as well but they are generally allowed in the smithy if they are bearing messages or have been asked to bring or collect something. In one case[246] the wives of smiths regularly act as their husband's bellows-blowers and in a few other rare cases help out as bellows-blowers when no male is available.[247] They do, however, usually have to be protected by wearing the smith's special protective iron ornaments.[248] With rare exceptions[249] they are never allowed to enter when they are in a state of impurity; menstruating women, women in seclusion after childbirth or initiation, and sometimes pregnant women[250] have to keep away. Adulteresses[251] and widows[252] must also keep away.

Access to forging is also taboo to any men who are in a state of ritual impurity. Smiths are usually aware of those who have killed a person; who have committed adultery and not yet been purified; of new initiates into adulthood[253] and those whose wives have recently given birth. They have, however, no means of knowing who has had sexual intercourse the previous night nor can they know if a visitor has the evil eye[254] or intends to harm the work by sorcery. Therefore they try to exclude all those who have not been given personal permission to enter, and take defensive measures to counteract any possible harm from sorcery or from the evil eye[255] (which can be possessed by those who are unaware of having this power). In many cases people passing by a smithy demonstrate their good intentions by throwing a stick or a piece of charcoal on the fire.[256]

In addition to the more usual causes of ritual impurity already mentioned there are a wide variety of minor conditions and situations which bring it about including unusual happenings and unavoidable freaks of nature. Those in the former category rarely endanger forging since they are able to get themselves purified immediately, but those in the second category can do so for they suffer impurity all their lives. Some tribes consider the danger from these people great. Others, who consider them not so dangerous, allow them to come providing that they do something to counteract the effects of their presence.[257] Into this category come those born in multiple births, those who have had a breach birth and those born with very tiny earholes.[258] The prohibition on twins and triplets is most common in Western Kenya[259] and applies even to the smiths themselves who if one of a twin, born of a twin, or have fathered twins, must take counter-measures.[260]

There are also taboos concerning the use of water for quenching. In many areas it is taboo to use anything but fresh water straight the well, for stale water is believed to cause the products to crack.[261] The women who fetch the water must do so well before forging starts and may then not come near for fear of harming both the ironworking and themselves.[262]

Amongst many tribes it is taboo to question the smith on his work,[263] to pass remarks about it,[264] or to exclaim in fright if a spark suddenly explodes or a piece of red-hot iron flies off the anvil.[265] Sometimes it is taboo[266] for the smith himself to remove a spark which falls on him, or even to rub himself directly where it fell; sparks are thought by many people to be the life-blood of iron and smiths are supposed to be immune to their burns. Further taboos are whistling,[267] pointing at a smith or pointing smiths' tools at anyone,[268] for pointing is always regarded with suspicion it being one of the commonest methods used to harm people. Pointing with the smiths tools is especially dangerous for the tools are regarded as being imbued with the same mystical powers as the smith himself. For the same reason some people forbid the throwing of weapons in the vicinity of ironworking. Doing any of these things is liable to cause the iron to crack and sometimes to harm the smith. In some smithies[269] an onlooker cannot touch his mouth for that is regarded as an indication of the evil eye.

Those tribes who look for omens during smelting, look for the same omens when forging. In addition it is generally considered a bad omen if the smith's hammer breaks[270] or slips from his hand whilst forging,[271] if a piece of iron being forged breaks up and hits an onlooker[272] and if an apparently dead piece of charcoal suddenly flares into flame.[273]

Since the mystical power of the ancestral smiths, concentrated in the smithy, is strongest in the smiths' tools, and it is with them that the smith creates his products, they too must be kept "pure". It is therefore taboo for anyone allowed in the smithy to touch them for if touched their functioning is so impaired that only poor quality artefacts will be produced. Anyone breaking this taboo is doomed to die from the effects of the smiths' ancestral curse[274] unless an animal is quicky provided for sacrifice and purification.

Most important is that no-one steps over the hearth, bellows, tuyere, or anvil, for these are most essential to the procreative process and stepping over them is liable to affect their fertility.[275] This taboo applies to the apprentices as well[276] and often also the smiths themselves but their smith bracelets protect them from the effects of inadvertently breaking this prohibition.[277] It is also taboo for anyone, except the smith in certain circumstances, to blow the fire by mouth. The smiths of a few tribes allow their wives and daughters and other people to pump the bellows but even they must be careful not to touch any of the other tools, especially the tuyeres which are particularly dangerous.[278]

These taboos are so numerous that it appears that no-one dares to go near a smithy. That is often the case as generally only smiths and their apprentices can enter unless invited. Some people[279] say that anyone else doing so, or even trying to peep in, will be cursed unless he provides a goat for sacrifice and purification. It is also usual for anyone having tools made by those smiths to wait a considerable distance from the smithy while they are being made. The only time that customers are allowed in is when the smith invites them to shelter from the rain and then they are warned not to move about, touch anything, ask questions, or make remarks.

This attitude, however, varies from tribe to tribe, and from one time to another for, like most rules, they are not always strictly enforced. If a smith has not fined anyone for coming uninvited into his smithy for some time, more and more people take advantage of his laxity and creep in to watch until one day some of his products crack or someone gets an inexplicable illness which is diagnosed as being caused by breaking a smith's taboo. The smithy will then be deserted until such time as the incident is forgotten.

A smith can pick-and-choose those whom he wishes to see in his smithy. He may invite in customers, or he may sometimes have a few trusted cronies of his own age-set who wander in to gossip from time to time, or (alas most infrequently nowadays) a few boys or young men with the right ancestry who are fascinated by the craft and who are being encouraged in the hope that they will be interested enough to become apprentices. If they displease the smith or his work is not successful then the taboos are reinforced.

Heat-Forging Iron by non-Smiths

Amongst the E1 Molo, a small group of people who lost their original means of livelihood and now eke out a meagre existence by fishing on the western shores of Lake Turkana (Rudolf), most men heat-forge their own few tools. They are the only non-smiths in Kenya who regularly heat-forge iron. This is a recent development which started after a small bush-shop, selling large nails, opened in the vicinity. Their products are confined almost entirely to crude knives and harpoons.

Like ornament-makers they do not use smiths' tools. The iron is heated in a donkey-dung fire placed anywhere in the village. Any available rough stone is used as an anvil. Another stone is used as a hammer unless the maker has been fortunate enough to obtain a European-style hammer. No tongs are used. The object is hafted at one end and bound round tightly with string. It is held in the fire to heat it. If a knife is being made its other end is hammered flat. Occasionally it is given a mid-rib of sorts. It is hammered both on the flat of the

blade and, near the tip, on the blade edge so as to form the point. There are no taboos or rituals in connection with this work.

Occasionally one group of hunter-gatherers[280] will also heat and cut down an old shop-bought panga (machete) to make it into a crude tanged spear head when they cannot affort to obtain one from smiths of the neighbouring tribe. No taboos are observed and no omens looked for when heat forging is done by non smiths.

Cold-Forging Iron

Cold-forging of iron is widespread in Kenya. The technique is used mainly by hunters who forge their own arrowheads, by livestock owners who forge stopped arrowheads (Fig. 62, No. 1) with which they bleed their animals and by men making tweezers and awls (Fig. 53, Nos. 4–9; Fig. 32, No. 6). The pastoralists of the northwest,[281] who do not have their own smiths, also use it for making finger-ring knives and other small knives (Fig. 67, Nos. 1, 3, 4) and for making iron beads (Fig. 55, No. 3). Amongst these pastoralists, women also cold-forge beads but elsewhere cold forging is done entirely by men.

Iron for cold-forging is obtained almost exclusively from shop-bought nails of various sizes and from heavy gauge iron wire. If available, the metal strips for binding bales are also used.

In the north-west any hard stones to hand are picked up for use as anvil and hammer stones and discarded when the object has been made. The artefact is usually shaped entirely by hammering; no chisels are available to cut it to shape unless someone has a discarded axe-head.[282] Stones are also used elsewhere in Kenya, but the maker is more likely to have access to a commercially-produced hammer and chisel and a piece of heavy scrap iron which can be used as an anvil.

The arrowheads most frequently cold-forged are leaf-shaped as they are the simplest to make. A man with a chisel will make triangular-shaped arrowheads with or without tangs or barbs (Fig. 62, Nos. 2–4). A man making arrowheads from old metal strips from packing cases[283] placed a strip on a stone, hammered it flat with a European hammer, (using the hammer on the edge of its face as he would a traditional one) and then cut out a triangle using a chisel. He placed that on an anvil of scrap-iron to hammer the cutting edges thin. Then, returning it to the stone, he made two vertical cuts with the chisel from the base of the triangle. Two further cuts were made from the top of those to the two corners of the base of the triangle so that he was left with a tanged arrowhead with barbs. The tang was hammered to make it round in cross-section, and the arrowhead sharpened with a file as it

lay, first flat on the iron anvil and then at an angle over its edge.

This man made arrowheads for other hunters and provided the shafts for them as well. He notched the bow end and fletched it, attaching the strips of vulture feathers with nuchal ligament. Then, holding an awl with a flattened tip upright between his feet, he placed the other end of the arrow-shaft onto it and twirled it rapidly in his hands to make the tang-hole. The tang was placed into it and bound tightly with damp nuchal ligament.

JEWELLERY-MAKING TECHNIQUES

Before the mass importation of trade beads around the turn of the century, metalwork was the most sought after form of personal ornament and is still very popular in many areas.

Wire-drawing and chain-making

Although smiths made short lengths of near-wire which they made into anklets, armlets and necklets, wire proper does not seem to have been made until after its introduction from the coast.[284] Even the making of wire by using drawplates does not seem to have penetrated into the extreme west of Kenya with the result that the smiths there, imitating imported trade wire, could only produce short lengths which were square in cross-section.[285]

Wire was produced by repeatedly heating and hammering a piece of iron to draw it out into a long, narrow, square cross-sectioned bar. One end was often pointed and hafted to make it easier to work. At the coast and in the central highlands, the coastal and Highland Bantu[286] hammered it into a round cross-section and lengthened it by welding on another piece before pulling it through a drawplate.

When necessary the drawplate holes are hammered[287] on the underside before use so as to close them partially. They are then opened up to the correct size by piercing them with an awl. One end of the roughly made wire is hammered to a point, rubbed down to the right size on a sharpening stone, and pushed through a hole in the drawplate. This start to wire-drawing is often the most difficult part of the operation as sufficient wire has to be coaxed through the hole to enable it to be fastened to a clamp, or similar device, on the other side. This is usually accomplished by pushing from one side and tugging from the other with the help of tongs or chain-makers pincers. Once it has penetrated and been attached the wire is drawn through the plate with a steady pulling movement. If fine wire is desired it is pulled through several successively smaller holes until the required gauge is achieved.

This operation generally requires two men, one holding the draw-plate and one the clamp, but one man can

draw short lengths of fine wire by sitting down, holding the drawplate firmly against the soles of his feet, or in notches in two short sticks set upright in the ground a few inches from each other, and pulling the clamp towards him.[288] At the Kenya coast, Swahili silversmiths are also able to draw wire single-handed using the more sophisticated method of levering the wire through the drawplate by means of a vertical bar to which a pair of pliers are attached. The drawplate is held firmly between small uprights on a horizontal stepped beam while the vertical bar, with the wire clamped in the jaws of the pliers, is levered backwards along the beam step by step (Fig. 39). This method has not penetrated inland.

There the drawplate itself may occasionally be pulled, once sufficient wire has been drawn for fastening firmly to a tree or upright post. It may also be levered around a forked upright coiling the wire round after it as it progresses down the pole (Fig. 38, No. 1). The more usual method is for one man to hold the drawplate firmly against a forked upright, a little over a metre in height, while the other holds the clamp and pulls it backwards (Fig. 38, No. 2). The wire may be finely coiled in the same operation by passing it through a notch in a second upright of the same height, about five metres away from the first, and attaching it to a coiling tool which consists of a thick wire set at right angles into a wooden handle to which the newly drawn wire is fixed. By rotating the handle the wire is coiled around the thick wire, which is held against the top of the post (Fig. 38, No. 3).

Some wire coilers prefer to use this more direct method of coiling as they can straighten any twisted wire at the same time by passing it through the drawplate. Others use it when longer coils are required[289] for it produces long coils more easily and more quickly.

I have never seen wire oiled or heated before being put through a drawplate, but one old man[290] told me that he used to heat brass wire before drawing it.

The smiths of some tribes[291] never made wire at all and with the mass importation of trade wire there was no longer any need for the others to do so.[292] Although they formerly made drawplates and drew iron wire that they themselves made, once commercially-produced iron wire was introduced they rarely drew iron wire and did not draw that made of copper, brass or aluminium.

In the coastal areas and in the central highlands, as a result of the introduction of non-ferrous metals and of fine chainmaking and its popularity as ornament worn for decorative rather than for protective purposes two groups of specialists, wire-drawer/chain-makers, and non-ferrous ornament makers, came into being. Sometimes men were skilled in both crafts.

Since only heavy gauge wire was available the craftsmen were kept busy drawing it into thinner gauges.[293]

In those areas where wire-drawing was most practised there is now little demand for it as commercially-produced fine gauge wire is available quite cheaply; the demand for wire ornaments has also dropped off considerably with the adoption of European dress. Nevertheless, a number of old men still carry on the craft but use their drawplates nowadays mainly for straightening, rather than thinning, wire.

Wire and chain were, and still are, favourite forms of metal ornament. Heavy gauge wire was wound around necks, arms and legs. Finer gauge wire was coiled and used in that form for necklets, bandoliers and waist belts, but was more usually made into chain. The methods used for coiling wire have already been described.

The simplest wire coiler (Fig. 37, No. 4) is always used by chain-makers producing simple-link chain (Fig. 37, No. 5). Once the wire has been coiled around the rod by rolling the handle on the thigh with the hand, the rod is removed from its handle and laid flat on a stone. Holding it firmly between the feet a longitudinal cut is made, with a chisel, down the length of the coil. Sometimes a few coils may be cut through at a time. These form simple circular links which have one end slightly higher than the other. They are hammered flat individually with the head of the chisel.

A fine piece of string, firmly secured to a vertical log about 6cm in diameter, is attached to the first link. The links are hooked together by means of the fingers. As the chain grows it is wound around the log to provide the slight strain necessary to prevent the links from falling apart.

When there is enough chain the log roller is placed flat on the ground behind a stone so that the chain can be drawn gradually over the far edge of the stone. The unclosed circular links are placed on this edge, opening uppermost, and hit with the chisel or any other suitable piece of iron, to close them and make them oval in shape.[294]

The more sophisticated coilers, with a handle that is turned, can use wires which are both of the same fine gauge so that a very fine chain can be achieved. They are always used to produce chain with a triangular cross-section which is composed of S-shaped links. These are obtained by using an awl to prise two coils at a time from the end of the coil of wire. They are placed on the shallow top of a hard-wood pedestal. This is spiked into the ground between the knees of the craftsman who sits on a small stool. Two awls are used to manipulate the coils into a series of S-shaped links with their two cut ends lying in different planes. The links are not flattened as with the simple type of chain. Each link is then joined to the previous link in the growing chain and squeezed tight with a pair of pincers usually fitted with an oblique groove to enable the links to be held securely.

Simple-link chain was made by many Kenya tribes,

but triangular cross-sectioned chain was only made by the coastal Bantu[295] and the eastern-most Highland Bantu.[296] Some peoples never made chain.[297] In western Kenya, where no fine chain was made, the smiths forged heavy chain for use as waistbelts, but only after they had seen chain brought up-country by early travellers.

Craftsmen making simple chain say that they produce between 100 and 150cm a day. Skilled smiths making the more complicated triangular cross-sectioned chain can make 300cm in a day. A fine triangular cross-sectioned chain has sixteen links to 25mm, but even finer ones are to be found. Everyday simple link chain has 7–10 links to 25mm (Routledge 1910: 97).

Chain was used entirely for personal ornament; for every form of jewellery and for hanging objects such as snuff boxes.

Some chain makers[298] pour a libation of beer on the ground before they start work, and occasionally[299] a goat is slaughtered for the teacher by a chainmaker who has just learned the craft, but generally there are no taboos or rituals to be observed when chainmaking.

Non-ferrous ornament-making techniques

The specialist ornament-makers, often known locally as white-smiths, who developed amongst the Coastal and Highland Bantu are allowed to heat and cast non-ferrous metals but never iron. In those areas qualified smiths can only engage in non-ferrous ornament-making if the metal has to be *heat-forged*. Usually they are so busy with ironwork that few of them have time for this, but if they have, and ornament making is remunerative, they will do it.[300]

Ornament-makers are frequently the non-smith sons or brothers of practising smiths. They may also be men who have been instructed in ornament making by a smith or his apprentice, because they are close friends or neighbours who showed great interest in learning ironworking but were unable to do so because they lacked smith ancestry. They live near smiths and obtain the iron tools necessary for their work from smiths but they can never use the traditional tools of smiths, nor can they use bellows to provide the draught for their fires, or even charcoal to make those fires. Instead they have to make their fires of wood or dung and fan them with any suitable object.

These metalworkers were, and are, regarded as being quite distinct from smiths because they are not initiated as smiths and therefore cannot heat-forge *iron* and their products are not useful but made solely for pleasure. They are not allowed to have a *permanent* workshop like a smith or even a permanent open workplace. They must move from place to place each day, even if only for a few feet, and, unlike smiths, can engage in their craft within a house compound.[301]

Elsewhere in Kenya, except in the extreme west[302] where non-ferrous metals do not seem to have become popular, smiths make all the non-ferrous metal ornaments provided that they have to be heat forged. Cold forged ornaments are made by the wearers, but some men become more expert than others and supply their fellows. They cannot, however, be described as specialists.

Casting and forging of non-ferrous metal

Lindblom (1920: 34), who provides the only reference to casting in Kenya, states that tin for armlets was melted and poured into a mould either cut in wood or formed in sand. The shape of the mould is not specified. In the southern Sudan (Stafford 1955: 206) brass, from melted down cartridge cases, was cast into a groove in a rock. Brass, obtained from the same source and from trade wire, was also melted and cast in Kenya but there is no record of the method used. I have never seen or heard of metal being cast into a groove in a rock, but have been told that some craftsmen[303] formerly cast into wood, and one man told me that armlets were cast by pouring metal between two small concentric clay circles laid on the ground.[304]

It seems likely that the most usual method was to cast the metal into a simple groove in the ground, as this is still the most common method of casting in Kenya. Until recently it was used for casting copper for earrings,[305] but nowadays it is used, almost exclusively, for the casting of aluminium, for that is the most popular metal for ornaments.

Aluminium, a white metal resembling silver, is easily worked. It is very malleable and ductile, and may easily be beaten and worked with a knife or file into whatever shape is desired, or into thin sheets and then cut to shape. Not only is it easier to work than tin or brass, but, in appearance, it resembles silver, yet is regarded as better than silver in the eyes of inland peoples for it is very much cheaper and does not tarnish. It has therefore come to be regarded as the poor man's silver. It is used for a variety of ornaments and for decorative objects such as knife handles and large ceremonial staffs (Fig. 57, No. 3).

The aluminium is obtained from old cooking pots[306] which are either cut up with a panga or, more generally, just hammered up into a compact shape and then put into an old tin can for melting. Formerly, a small clay pot was used and melting took longer. *Smiths* melt the aluminium in the container on top of a charcoal fire blown by bellows. Hot charcoal may also be put on top of the aluminium in the tin. Instead of charcoal, *ornament-makers* use logs of a tree known to produce a good heat, and less frequently dung. Once the log fire has been lit and the aluminium put on for melting, more logs are placed on top so that the tin containing the aluminium is

often hidden from view. No bellows are used, the fire being fanned instead. The aluminium melts in 10–15 minutes. It is then cast into a bar. The usual method of doing this is to scrape a shallow and usually narrow groove, 15 to 23cm long, in the ground beside the fire, and to pour the molten metal into this. The residue, which resembles dirty silver paper, is quickly scooped out of the groove. Ornament-makers leave the metal until cool, judging this to be when it will no longer singe a piece of dry grass. The many I have observed have always cold-forged the ornament from then on, but I have not verified if this is always the case.

Smiths start working the metal as soon as it solidifies and then usually heat-forge it in the same way as iron. Heavy bracelets (Fig. 57, Nos. 1 and 2), necklets, earrings and beads are made in this way. To make the typical drop earrings (Fig. 56, No. 10) worn by many Kenya elders[307] the smith heats and hammers the bar into a long rod. He cuts sufficient off its end to make the earring, narrows it in the centre and thickens it at either end by hammering it, with incredible precision, with a large maul/hammer; he then bends it in the middle with his tongs while it rests on the anvil. Into the middle he inserts a narrow iron mandrel around which he curves the top of the earring. Just above the drop, on either side, he then forms a neck by placing a nail beside the mandrel but on the outside of the earring and hammering it. The completed earring is then smoothed with sand or a file if he has one.

To make the beautifully facetted aluminium beads of the Galla group, a smith hammers the cast metal into a bar approximately 18cm long, 1cm deep, and 2cm wide. From this he cuts bead-sized cubes, hammers a hole in each with a nail-like maul, inserts the maul, turns it rapidly on the anvil hammering in facets at each turn, inserts the maul from the opposite end and repeats the process, and then files it smooth. Four beads a minute are made in this way. It takes 12 seconds to do the work and 3 seconds to get hold of the next one. The smith usually produces five 60cm lengths of beads a day between other work.

Some smiths[308] pour the molten metal into a piece of scrap angle-iron, if they can obtain it, as they believe that it is an improvement on the former method of pouring it into a groove in the ground. To make flat decorated bracelets, the resultant bar is placed on the anvil and flattened by being hammered alternately by the smith and his apprentice. A chisel is then used to cut it first into horizontal and then into vertical strips the length and width of a bracelet (Fig. 44, No. 5). After further hammering and trimming these are decorated by being hammered into a mould placed on the anvil. A bracelet is placed on a log. A hole is hammered into each end with a punch which is then used to hammer

the edges of the holes flat. Using the punch followed by the most delicate of his hammers, the smith very skilfully curves the bracelet into a circle. Placing it back on the anvil he joins its ends by hammering a rivet through the holes, squeezes the rivet tight with the tongs, smooths and rounds it off by hammering it, and then slips it onto a large wooden cone where he taps it gently to perfect its curve.

The more complicated form of casting, into a mould in the shape of the object, is rare. The silversmiths of Pate Island (off the coast) use a two-piece mould of cuttlefish bone to cast silver rings. An existing ring is pressed into the soft cuttlefish to obtain the shape. Bantu smiths[309] of the coastal hinterland use a one-piece clay mould for casting the spiked earrings typical of the area (Fig. 41, No. 4). The mould (Fig. 41, No. 2) is made from potters clay which the smith forms in his hands and then dries beside the fire. For use it is placed

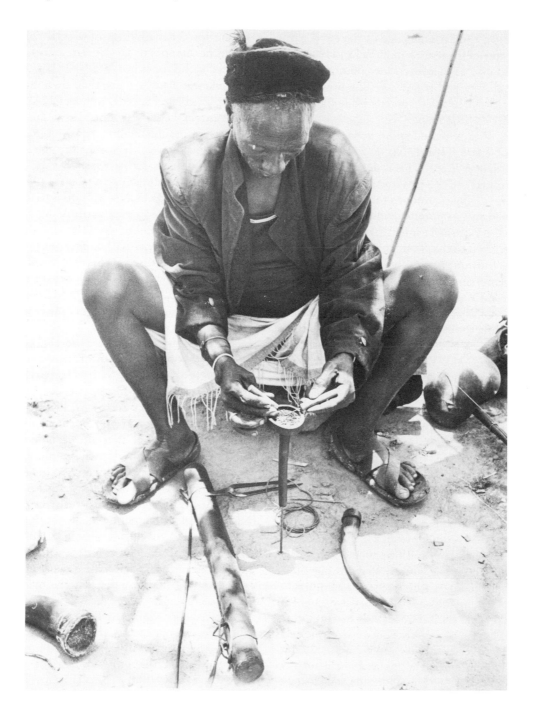

Plate 9. A Kamba chainmaker using two awls on top of his special hardwood pedestal to manipulate coils of wire into S-shaped links for triangular cross-sectioned chain.

upright in a small hole in the ground and, in case it cracks, is heated by having some hot charcoal placed on it. The molten metal is poured into the mould and allowed to set. The mould is then removed from the ground and broken away from the casting with a hammer. The casting is dipped into water to cool it. As the mould has only one opening the aluminium sometimes bubbles back and cannot be poured into the mould. The process then has to be repeated. The earring is placed on the anvil while the back portion (which protrudes through the ear) is trimmed with a chisel. It is then placed on the extreme edge of the anvil while both its back and its front are hammered and filed. The front is formed into a square-sectioned point. The back is filed again and its end is cut off. The point is put through a small hole in a flat iron bar while the back is hammered into its final shape.

The earring is then placed spike uppermost into a hole in a log of wood (Fig. 41, No. 3) while its front is worked into a saucer shape. This is done by using first the sharply pointed end of a small hammer and then the wider end. The earring is removed to the anvil where it is further dished and its point is hammered to a round cross-section. It is returned for further work first to the wooden block, then to the anvil, and finally to the iron bar, before the finishing process begins. This consists of filing the earring smooth, scraping the saucer shape deeper with a knife and, finally, pouring a little coconut oil and some ash into it and polishing it. At one point during filing the earring is placed on top of a large peg-shaped piece of wood held upright between the smith's knees (Fig. 45). Large aluminium neck-rings also are shaped around this wooden tool. When finished the hollow of the earring is so smooth that it looks as though it has been machine turned. One earring takes six hours to make.

Another smith of the same tribe uses a different method to make the same type of earring. He places his aluminium directly onto the fire. It melts and falls to the bottom of the hearth from where it is scooped out with an old spoon and poured into a groove in the ground. When the bar sets hard it is dipped in water, then heated and hammered into a rectangle from which is cut enough to make the earring. The smith heats and hammers it before scraping and filing it into shape using fifteen different tools including a whole series of hammers.

One-piece clay moulds are also used by Highland Bantu ornament-makers.[310] For making earrings in the form of a simple round cross-sectioned bar, a thick clay mould with narrow central hole is placed directly onto the ground. The molten metal, poured in through the hole, splays out a little on the underside and has to be cut off later (plate 80, Nos. 3–16 and the accompanying captions *in the original thesis* show and explain the process of making these earrings).

A similar one-piece clay mould is also used for casting the conical-shaped head-pieces worn by young men on ceremonial occasions (Fig. 43, Nos. 1–2, 4). These are gummed onto the hair and topped by a feather. The shape imitates the top end of a conus shell. Such shells, obtained from the coast, were previously used by young men in the same manner.

The only two-piece clay moulds found in Kenya are made by the same craftsmen. They are used for casting spiked earrings similar to those made in one-piece clay moulds at the coast (Fig. 43, Nos. 6 and 7; Fig. 42, No. 4), and for other earrings of coastal derivation which might be described as circular shield-shapes with a reduced spike for a boss (Fig. 42, Nos. 2 and 3). The craftsmen, as always, make their own moulds (plate 77, Nos. 1–24; Plate 78, Nos. 1–9, and 21–22, and captions in the *original thesis* demonstrate and explain the making of these moulds). Before the molten metal is poured in through a hole in the top half of the mould, the two halves are sealed together with wet clay. Further refinement is added by placing an iron ring into the top half of the mould (Fig. 43, No. 1). This is to form the groove at the back of the earring for holding it in the hole in the lobe of the ear.

There are no records of cire perdue (lost wax) casting ever having been used in Kenya. Metal workers deny all knowledge of the technique or of any traditions of its use. Nowadays, however, a few Konso smiths from Ethiopia, who have settled in the extreme north of Kenya to do metalworking for the Borana, use the technique. Ethiopian crosses are cast by the lost wax process[311] but there is no information on its use in the manufacture of other metal artefacts anywhere in Ethiopia.

Although Konso smiths working in northern Kenya make a wide variety of metal ornaments, mainly from aluminium, only the special ceremonial phallic ornament *Kalaca*, is cast by the cire perdue method.

This aluminium ornament is a penis-like (Fig. 54, No. 5), or very realistic penis-shaped (Fig. 54, No. 6), object worn almost vertically on the forehead.[312] Its base is fitted with a loop which goes through a circular aluminium disc base-plate. Through this loop is threaded the thong with which the *kalaca* is bound to the head. In the distant past *kalaca* were made of ivory, clay or wood, while the base-plates were made of ivory or conus shell ends.

The present smiths, who have lived in Kenya for about seventy years, say that the Konso have used the cire perdue method of casting metal for as long as they can remember, but only for making *kalaca*, not for other objects.

A prototype of the aluminium *kalaca* is made in wax. The wax is obtained from a beekeeper as the blacksmith himself does not keep bees.

The wax, which is placed in an old tin can on the hot charcoal fire of the forge, melts down in a few minutes. It is then poured into a container of cold water the resultant lump being kneaded in the hands to soften it and make it easily workable.

When firm, but not hard in consistency, it is rolled in the hands into a fat sausage-shape which is then cut roughly to phallic shape by using an old razor-blade. While doing this the blacksmith constantly wets his hands.

A tanged knife-blade (Fig. 54, No. 1), held in tongs, is then heated in the fire. This blade is used to melt and smooth the surface of the wax *kalaca* in order to remove the ridges left when carving it with the razor-blade. The process of carving with the razor-blade and then melting and smoothing with the hot knife is repeated until the desired phallic shape is perfected. Special attention is paid to the shaping of the tip.

While this work is in progress, the forming wax *kalaca* is held over the container of cold water so that wax which melts as a result of contact with the hot knife-blade will drip into the water, solidify and not be wasted. The basic phallic shape of the *kalaca* is often elaborated by the addition of small cones around the middle of the tip.

These cones appear to be a later development as they are not carved out of the original wax sausage, which would presumably be the simplest and quickest method, but are made by melting-in holes at regular intervals round the middle of the tip with the hot tang of the knife-blade. Tiny sausages of wax, rolled in the hands, are then pushed into these sockets so that they protrude like tiny cones (Fig. 54, No. 2).

Two more holes are melted into the base of the phallus in a similar manner and a small roll of wax is then curved over and fitted into them (Fig. 54, No. 2). This will form the loop through which goes the thong used for binding the phallus to the forehead. Once in position this wax loop is widened and smoothed by the heated knife-blade tang which is passed through and over it. Thus completed the wax image is set aside (Fig. 54, No. 3).

The blacksmith then prepares the clay mould. Ordinary earth, taken from just outside the smithy, is placed on a skin, water is added to it and it is kneaded to the right consistency. A grass called *buyo* is then kneaded into it.

The resultant mixture is plastered over the wax *kalaca* leaving the basal loop exposed. A small sausage of the clay mixture, rolled in the hands, is placed through the wax loop (Fig. 54, No. 4) and the whole wax *kalaca* is then completely plastered over to a depth of just over a centimetre. The part of the clay mould which covers the tip of the *kalaca* is then scraped flat and a tiny hole made in the clay until the wax is felt.

This hole forms the funnel through which the molten aluminium is poured into the mould. Depending on the whim of the maker, the funnel is sometimes counter-sunk in a concave hollow.

Whilst making the clay mould the blacksmith, like a potter, constantly dips his hands in water to smooth the outside of the mould. The mould is set aside to dry overnight.

The following day the blacksmith takes the mould, wets his hands with water and plasters *buyo* grass around the outside. This is said to prevent the mould cracking when it is heated to remove the wax. The mould is then left at the edge of the fire to dry for a few minutes before being placed on the red-hot charcoal of the fire, hole-downwards, so that the wax gradually drips out into the fire.

Meanwhile pieces of old aluminium cooking pot (*sufuria*) are cut or hammered up and placed in a tin on the fire. The aluminium melts in ten to fifteen minutes.

Using a grass stalk the smith probes down the funnel of the clay mould to ensure that all the wax has melted out before pouring the molten aluminium very carefully into the mould.

Very often, as might be expected with so narrow a funnel or vent, the molten aluminium bubbles back when poured in, and the cast is incomplete because of trapped air. It rarely works successfully the first time. This bubbling back is believed to be caused by someone, who does not wish the work to succeed, deliberately employing sorcery in order to try to harm the result.

Making a *kalaca* is considered to be very special and secret work; no onlookers are allowed in case any of them have the "Evil Eye" which could be as harmful to the result as sorcery.

Immediately the molten aluminium is poured in successfully the blacksmith begins to break off the clay mould. Holding it in the tongs, he breaks it open by hitting it first with an iron chisel and then with a wooden stick, until the aluminium *kalaca* emerges cleaned of adhering mould.

When cool enough to hold in the hands the *Kalaca* is finished off by being scraped and filed smooth with a shop-bought steel file.

The circular base-plate is made by melting down old aluminium cooking-pots and pouring the molten metal into a piece of old angle-iron. The size of the resultant bar is regulated by placing two handfuls of earth in the angle-iron to stem the flow of molten metal. A piece of the bar is cut off with a chisel and hammered flat on the iron anvil. It is then cut to shape with a chisel, which is also used to cut the central hole through which the *kalaca* loop goes, and finally finished off by being smoothed by a shop-bought steel file (Fig. 54, Nos. 5 and 6).

The *kalaca* loop is put through the hole in the base

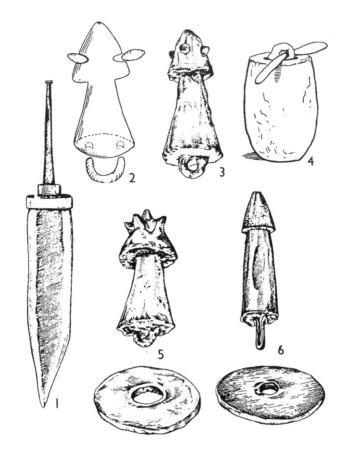

Fig. 54 (1–6). Casting an aluminium phallic ornament by the cire perdue process.

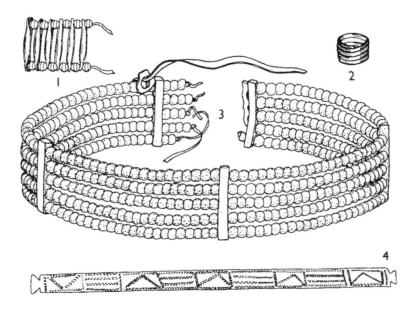

Fig. 55 (1–4). Aluminium bead belts and aluminium bracelet.

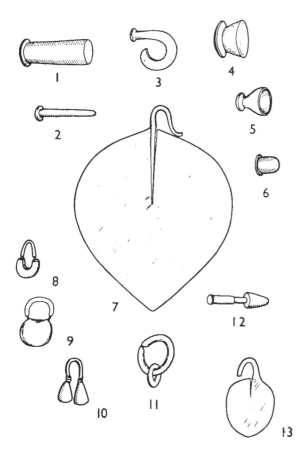

Fig. 56 (1–12). Earrings, lip-plugs and nose ornament mostly of aluminium.

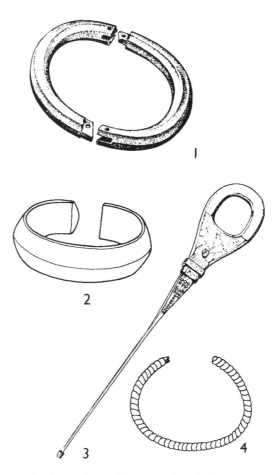

Fig. 57 (1–4). Bracelets and ceremonial staff of aluminium.

plate and threaded with a temporary piece of fibre. The *kalaca* is then ready for use.

Amongst the north-western pastoralist groups[313] who have no specialist ornament-makers to cast aluminium, and often no smiths, both sexes make their own aluminium earrings (Fig. 56, Nos. 8, 9, 12, 13), lip-plugs (labrets) (Fig. 56, Nos. 1–6), nose ornaments (Fig. 56, No. 7), beads (Fig. 55, No. 3) and bars for belts (Fig. 55, No. 1). One man told me that tiny round holes are sometimes made in the ground, a piece of old aluminium cooking pot being placed above, and a fire being built on top so that the metal will melt into the holes below, but I have only seen cold forging used.

This is the only area in Kenya where women engage in metalworking, but the craft is still predominantly in the hands of men who generally make ornaments for their wives and daughters as well as for themselves. Some men become so expert at making specific ornaments that their neighbours, wanting only the best, go to them to have theirs made.

Techniques for decorating non-ferrous metals

The shape of many Kenya aluminium, brass and copper ornaments and the designs with which they are decorated, are very reminiscent of those of Bronze Age Europe. The designs are almost always geometric. By far the most common technique is to incise the designs into the metal. Simple straight lines alone may be used, but zig-zag ones (Fig. 55, No. 4; Fig. 57, No. 3) are preferred all over the country. Occasionally straight lines are used for the outline which is completely in-filled, or alternately in-filled, with zig-zag lines. The most usual method of making straight lines is by incising them with a knife-tip or awl which is first used to scratch a rough-out of the design on the object. The zig-zag lines are obtained by slightly wobbling the awl to and fro in the hand as the design is traced. This technique sounds simple but requires considerable practice to perfect.

Occasionally a tiny chisel, hit with a hammer, is used to cut in a pattern, but this technique is generally

reserved for ornaments made of brass. Punched decoration is also comparatively rare. It is confined to the coast and the north-east of the country where a punch with grooved tip, which produces a pair of small holes, is used repeatedly.

The technique of stamping on a design has, so far, only penetrated part way up the Tana river from the coast. This technique, which is used only by smiths and only for decorating bracelets is quite complicated because the moulds into which the bracelets are hammered have first to be made. The methods of making the two types in use have already been described. Using the long narrow type (Fig. 44, No. 9) a whole bracelet can be ornamented in one effort, but only half a bracelet at a time can be hammered into the small rectangular ones (Fig. 44, Nos. 4, 6, 7), so it is usually possible to see where the two lengths of pattern join. With constant use the first type of mould tends to become worn and does not produce a clear stamp. Instead of making a new one the smith gives it a new lease of life by deepening the design using the special very tiny tools (Fig. 44, Nos. 10, 11) used to make it in the first place.

Inlay work has been done at the coast for a very long time. Otherwise it is confined to the easternmost Highland Bantu[314] and to the Cushitic peoples of the north-east who use the technique less frequently. Aluminium may be inlaid with copper, brass, or ebony. Sometimes a disc ornament or an earring may be made of concentric circles of different materials. Ebony ornaments may themselves be inlaid with metal pins.

A new type of inlay is now being done in the north-east.[315] Bracelet terminals and rings are inlaid with plastic. Any plastic is used but that most readily obtainable comes from ball-point pens, old sandals and buckets. The preferred colours are red and blue. The hollow for the inlay is hammered-in with a small punch/mandrel. The portion of the object to be inlaid is then held in the fire to heat it. When removed from the fire the smith drops a small piece of plastic onto the prepared hollow and then pushes it in with a small chisel. The plastic sizzles, becomes molten and fills the hollow. The residue, which spills from the hollow, is scraped away as soon as it cools and solidifies. The finishing touches are then added by filing it smooth.

Over most of eastern Kenya, metal ornaments are kept polished by rubbing with sand or ash, the fruit of the Baobab (*Adansonia digitata*) tree, the pulp of the Tamarind (Tamarindus *lndica*) fruit, an *Oxalis* species or a *Rumex* species. In the north they are simply rubbed with ash, fine sandy earth, or a piece of leather.

Specialist ornament-makers, like chainmakers, will sometimes pour a libation to the ancestors before starting work but otherwise no taboos or rituals are observed.

Notes

1 Some of the Kalenjin and Abaluyia tribes avoid sparking charcoal.
2 See details of Mbeere smelting.
3 But not amongst the Embu and Mbeere.
4 e.g. The Marakwet.
5 Bukusu.
6 e.g. The Tugen.
7 Orde-Browne (1925: 130) mentions this for the Chuka.
8 e.g. of the Samia, Wanga and Marachi. See details of their smelting.
9 Apart from one doubtful report that meteoric iron was used in Gusii. There also seems to be no connection between blacksmiths and meteorites in Kenya apart from the fact that Marakwet smiths always spit if they come across meteorites, but they do the same if they see a falling star.
10 This source of iron was mentioned by Johnston (1904: II: 745) who said that it was of excellent quality, and by Thomson (1887: 290) and Wagner (1949: 11: 9).
11 Routledge (1910: 81–83) describes and illustrates the collection of ironsand by the Kikuyu.
12 Chanler (1892: 253–4) describes it in the plains to the south of the Nyambeni range.
13 Hobley (1910: 29), Lindblom (1920: 527), and Gregory (1896: 34) refer to ironsand in Kamba country.
14 A.O. Thompson: Geology of the Malindi area. Geological Survey of Kenya. Report No. 36, 1956. Metal Resources map compiled by Saggerson, Geological Survey, in E.W. Russell (ed.): Natural Resources of East Africa 1962. Prins (1967: 74) mentions ore at Kipini and Mukunumbi in the hinterland of Lamu and it occurs at Mtangawanda (which is said to mean black sand in Kiama) on Manda island.
15 According to Sassoon (1963: 176–80).
16 e.g. the Bukusu and Marakwet.
17 e.g. the Luo.
18 e.g. the Somali.
19 Lanning (1954: 188–9) mentions that the Bunyoro in Uganda were also guided to the best places for ore by this beetle.
20 Lanning (1954: 188–9) says that the finder of the ore would automatically be in charge of all subsequent digging in the area and every new excavator had to present one basket of ore to him, but I did not come across this in Kenya although it is probable that it happened.
21 The Marakwet and Bukusu, for example, gave the owner a spear or a hoe respectively, while the Kikuyu usually gave a piece of pigiron, and the Kamba a protective axe.
22 This is mentioned in the Kenya Land Commission Evidence 12. Appendix A, 33 and 66.
23 Routledge (1910: 81–83).
24 The Embu, who had little iron ore, were particularly secretive about their sources.
25 Wayland (1931: 197) mentions that in Uganda whole families of Labwor smiths travelled 30 miles to Jie territory for their ore. Embu and some Luyia smiths travelled almost as far.
26 Smiths of most tribes of the Highland Bantu allowed their customers to collect their own ore in certain areas, but the Kamba did not because they thought that if anyone else collected it the work might be attended by misfortune.
27 The Marakwet did this. They seem to be the only tribe outside the Highland Bantu, who allowed their customers to collect ore, but this only applied to customers from nearby pastoralist tribes not to Marakwet customers.
28 Information from the Igembe (Meru).
29 Most of the western Abaluyia tribes (e.g. Samia, Marachi, Wanga, Hayo, Yala, Marama) obtained their ore from Samia and so did neighbouring tribes across the Uganda border, and smiths in northern Luo territory closest to the Luyia.
30 Results of the determinations on the ore samples by kind

permission of Dr. Ssekaalo, East African Industrial Research Organisation.

Constituent	Sample 1, best quality	Sample 2, poor quality
Silicon as S_iO_2	8.11	2.26
Iron as Fe_2O_3	82.91	85.36
Aluminium as Al_2O_3	Trace	Trace
Titanium as T_iO_2	"	"
Calcium as CaO	"	"
Magnesium as MgO	"	"
Manganese as MnO	0.07	0.21
Potassium as K_2O	Trace	Trace
Sodium as Na_2O	"	"
Phosphorous as P_2O_5	"	"
Moisture at 110 C	0.28	0.45
Loss on ignition at 1100 C	.00	11.00
	100.37	99.65

The iron content of these samples as a metal is 58.75% and 59.75%.

31 Leakey (1977: 304) describes this process in detail.

32 An iron pounder of type B1(a).

33 Baya-Kala smiths (Tessmann 1934: 166, quoted in Cline 1937: 38) are also reported to have powdered their ore.

34 The leaves are called *Shinamatsi*. The ore is treated in this way by the Bukusu, Tiriki, Isukha and Idakho tribes all of the Luyia group who all use marram as ore although the Bukusu also used ironsand and ore from Samia. It is often put in a strainer made of star-grass, while water is poured over it.

35 The Samburu say that they never panned it (although they winnowed it on a skin) and the Embu also say that it was frequently unnecessary. On Manda island in the Lamu archipeligo there is a beach of almost pure ironsand.

36 Mr. J. Walsh, Chief Geologist of the Kenya Mines and Geological Survey kindly gave me the following figures of a partial analysis of ironsand from the Geciono river a few miles beyond Ishiara on the lower Embu to Meru road:

Total iron as Ferrous oxide Fe_2O_3	89.28%
Titanium dioxide $Ti O_2$	7.32%
Phosphorous pentoxide P_2O_5	Nil

He comments that the balance to 100% is probably silica contained within the grains, and says that the absence of phosphorous is excellent in iron ore but the Titanium content of 7.32% would be too high to be acceptable to a modern steel plant.

37 Described by Routledge (1910: 81–83) and Kenyatta (1938: 72).

38 Kikuyu ironworking is said to have originated at Gaturi, a name which is derived from *Aturi*, the Kikuyu word for blacksmiths. The Ithanga Hills were a traditional ore collecting area both for the Kikuyu and Mbeere, and the Masai were also said to have obtained their ore from there, the Kikuyu name for it being *Muthanga* which merely means sand.

39 See illustrations in Routledge (1910: Plates LI, LII, LIII).

40 The Igembe transported their ore on donkeys and according to Daryl-Forde (1934: 298) so did the Masai.

41 The Embu describe a thing as black when it is neither red nor brown, i.e. when it is green. They also express degrees of blackness. If something is completely black in the normal sense it is referred to as being as black as a sorcerer, because a sorcerer is regarded as being not only dirty (black) in person, but black in his soul as well, as his intentions are always evil.

42 The Kamba, for instance, collected ore in May after the long rains. They then stopped collecting and smelted from May to September while the crops were growing. They could collect

again during and after the short rains in October-December but from January-March, the season of the "hot Moon" (so-called because that is the time of grass fires), they could not smelt but were busy forging tools to prepare the fields for planting.

43 A typical prayer is that of the Nandi, quoted by Hollis (1909: 37), "God (*Asis*=the sun) give us health, give us iron/wealth".

44 The Tharaka (Meru), who lived down on the hot plains, were always very careful to pray for wind.

45 The Somali also held a ceremony and sacrificed an animal but the Highland Bantu do not seem to have done so.

46 Only the Luyia sacrifice a hen. There is a fowl taboo over much of Kenya.

47 Typical of these prayers is that of the Bukusu:

"Bakuka befwe Khekhusute burare buno mu mani kenywe mala bibia bumramo bikhuwe efuma endaga".
"Ancestors, let us carry this ore home and through your power let us obtain the best iron and products from it".

48 A medicine man always conducted the ceremony amongst the Tugen (Kalenjin).

49 Although sometimes men were not allowed to see them doing so, e.g. if a man passed by when Tharaka women were collecting ironsand it was believed that the iron particles would never separate from the silica sand and the smelt would fail.

50 Where women of the Luyia and Kalenjin tribes, and the Luo, could not do so.

51 Samia (Luyia).

52 e.g. Kipsigis (Kalenjin).

53 In Nandi according to Hollis (1909: 37).

54 e.g. by the Pokot.

55 The Marakwet called it this.

56 According to Leakey (1977: 304) the Kikuyu called it *Mathaga* which is a personal ornament with a name sounding rather similar to *Muthanga* = ironsand.

57 The Marakwet.

58 The Samia.

59 The Bukusu.

60 It was referred to in this way by the Marakwet and Tharaka.

61 The Somali.

62 They stole pieces of the line itself, wedges, nuts, bolts, and any other pieces that they could remove, including the telephone wires. Theft from the railway was particularly bad on the Uasin Gishu plateau, the main culprits being the Nandi, Kipsikis, and Keiyo (Galloway 1934: 501).

63 Routledge (1910: 84) and Leakey (1977: 304) both describe this type of furnace and Routledge illustrates it (1910: 84a Plate LIV).

64 I have not heard of the roofed-over type anywhere else but amongst the Pokot and Marakwet.

65 This was the type described by Galloway (1934: 501) as being used by Keiyo smiths.

66 Hinde (1901: 86–90) describes this for the Masai. Merker's (1910: 114) description is not clear but Forde (1934: 298-9) assumes that he is referring to an open bowl hearth when he says that they throw on handfuls of ore and charcoal every few minutes. Hinde describes them as doing just that in the large dome furnace. Dome furnaces are usually associated with single wooden bowl bellows and I have never seen Masai smiths in Kenya using anything but those.

67 I have been given similar complicated descriptions when smiths are trying to describe the use of many tuyeres for one furnace.

68 The Masai, who according to Hinde (1901: 86–90) were using ironsand in a large dome furnace.

69 See Iron Ore Note 15.

70 The sizes of Fipa furnaces in Tanzania, which are 10–12 feet high, were said by Sutton (1969, 18) to be determined by the crude unrefined ore; they use vast quantities of limonite with a low iron content.

71 See details in "Iron Ore".
72 According to Hinde (1901: 86–90) the Masai used nothing but logs of Juniperus procera, and Galloway (1934: 501) says that the Keiyo did likewise.
73 Wood was also used in furnaces by the Fipa of Tanzania (Wyckaert 1914: 37–138) and by the Ba-Ushi of Rhodesia (Barnes 1926: 18994).
74 The Mbeere use chips of wood on top of the ore. See description of Mbeere smelting later in this chapter.
75 Both the Embu and Mbeere use a different species of wood. See description of Embu and Mbeere smelting later in this chapter.
76 See description of Embu and Mbeere smelting; Champion (1912: 79) describes the Tharaka as doing likewise.
77 The Luo used grass and the Idakho banana leaves. According to Leakey (1977: 304) the Kikuyu also use banana leaves.
78 e.g. the Bukusu.
79 From the smiths themselves. Kikuyu smiths say that they did this to keep the iron together in one lump. The Kamba say that they also did it, one smith adding that he put water with it. Bajun, Digo, and Giriama smiths also say that they covered the pot with a lid before piling more charcoal on top.
80 See description of Embu smelting.
81 Giriama, Kamba, Kikuyu, Marachi, Wanga, Samia and Bukusu smiths, and probably many others refer to it as a pot.
82 Two pieces of slag "smooth on the underside, with domical profile and concave on the upper side with knobbly and pitted surface" dug up on the ninth century site of Manda by Chittick (1967: 55) may result from an early use of a pot in this way, rather than being residues from the bottom of a furnace with cup-shaped base as Sassoon (Chittick op.cit.) suggests.
83 As Cline (1937: 55) suggests.
84 The Mbeere. See smelting description later in this chapter.
85 Which Hinde (1901: 86–90) says the Masai used.
86 Used by the Pokot.
87 Used by the Giriama.
88 Giriama, Marama, and Logoli all use concoctions of pounded-down leaves. The Ba-Ushi (Barnes 1926L 189–94) and the Chisinga of Rhodesia (Brelsford, 1949: 27) were said to do likewise. The Mbeere use sticky plants. See description of Mbeere smelting later in this chapter.
89 It is interesting to note that amongst the Luyia these smiths were usually trained by smiths of adjoining tribes who taught them to smelt as well. Some of the eastern Luyia found murram to smelt.
90 This was generally in August, and harvesting among many peoples, especially the Highland Bantu, was taken to be after the harvesting of bulrush millet, the grain used traditionally for ceremonial occasions.
91 April to August.
92 The Bukusu believed that they would be ruined by hail because the noise of striking two bits of metal together was thought to bring thunder and lightning.
93 The Tugen and Luo believed this.
94 The Mbeere had to do this.
95 This might be a father and his sons and their apprentices, or two brothers and their sons and apprentices.
96 e.g. in the Muranga area of Kikuyu.
97 Cline (1937: 53) also says that ant-hill clay is commonly used for furnaces and cites Barnes as saying that the Ba-Ushi and Balla also used it.
98 Hinde (1901: 86–90) said that the Masai repaired theirs.
99 Marakwet, Pokot, Tharaka, Embu, Mbeere, and Kikuyu smiths, and probably others preferred to work naked.
100 The Kikuyu wore *Maigoyo* (*plectranthus barbatus* Andr.) leaves over the penis. Leakey (1977: 306) also mentions this.
101 The Kikuyu were said to do this "to keep evil things at bay".
102 Bukusu and Luo smiths wore thick-skins.
103 Marakwet smiths cease all work if they hear either call nearby.

104 Ciriama smiths will not smelt if a hyaena or a guinea fowl is seen or heard nearby.
105 The Samburu cannot sneeze, neither can the Marakwet who have to sacrifice a goat to ward off ill-fortune if they do so. The Luo believe that it indicates the presence of a person with evil intent. Roscoe (1923a: 218) reports that sneezing was also regarded as bad in Unyoro in Uganda.
106 Marakwet and Bukusu.
107 The Kamba.
108 This is a very bad omen to the Giriama.
109 The Marakwet.
110 The *Kololo* bird, which seems to be a species of quail or partridge, is favourable for the Giriama.
 Tharaka smiths have a curious belief that a fly entering the nostrils during smelting indicates that the smith will soon be eating a lot of wild animal meat, i.e. that he will have a successful hunt.
111 The Giriama, whose week consists of four days, could only smelt on the first two days, *Jumwa* and *Kurumuka*. The other two days were most inauspicious.
112 The Kamba, according to Lindbom (1920: 530).
113 The Marakwet and Bukusu called it this, (*Musioso* in Bukusu).
114 The Tharaka call him *Mugao* or *Mukuru*, a medicine man.
115 The Pokot say that if it were all forged the next lot of ore would not smelt into iron.
116 Always made by the Kamba and Marakwet. See also Embu and Mbeere smelting.
117 The Tharaka sacrifice a goat. The Kikuyu only do so when the furnace is a brand new one. The goat is roasted in the furnace hearth. Leakey (1977: 306), says that a new Kikuyu furnace could only be lit ritually using fire sticks.
 A Bukusu master smith prayed to his smith ancestors as he hit his hammer (*enyuli*) on a stone of the furnace, and then killed a chicken and threw its feathers onto the roof covering the furnace.
118 Harm from burning, from the evil intentions of jealous fellow smiths, and from the wrath of the ancestors if the smiths inadvertently or otherwise broke any of the smelting taboos.
119 Tharaka.
120 Bukusu they call it *Kumutuba*.
121 A Samburu smith protects himself from sorcery by rubbing the iron flakes (*laing'oni nkune*) onto his forehead, in front of both his ears, at the base of his neck, and on each of his big toes. The procedure of Mbeere smiths is similar, but they use a different substance. See descriptions of Mbeere smelting. To protect his work a Tugen smith buries a spearhead a few yards from his smithy, while Tharaka smiths use undisclosed counter-magic to stop the sorcerer's tools from working properly.
122 The Embu smith, whose smelting is described, is the only smith left in Embu so he now rarely wears his smith's bracelet and does not bother with anti-sorcery ritual.
123 See descriptions of smelting.
124 See description of Embu smelting later in this chapter.
125 The smiths of the Basefu clan of Bukusu sing:

Bakiranyi, Basobobia be enyuli
Kharoro, Kharoro, mbe omwana anume,
Bikokwa mbe omwana anune,
Wekonjo, mbe omwana anune,
Mulwale, mbe omwana anume,
Lusweti, omwana anume.

We are the smelters of Basefu with a hammer.
Iron ore, iron ore, give me a child who can suckle,
Iron ore, give me a child who can suckle,
Bikokwa give me a child who can suckle,
Wekonjo give me a child who can suckle,
Mulwale give me a child who can suckle,

Lusweti give me a child who can suckle,
Bikokwa, Wekonjo, Mulwale and Lusweti are famous
past smiths of the clan. "a child who can suckle"
is a successful piece of iron.

Marakwet smiths repeat over and over again:

"May all smiths smelt iron and make iron artefacts
 wherever they are"

Somali smiths sing over and over again:

 "Ega Aboso, Ega Aboso, Li dallo"

 "Fear me, fear me, Give birth for me"

See notes Nos.150, 161 and 165 for Embu and Marachi smith's
songs.

126 e.g. Keiyo, Igembe, Imenti, Kamba.
127 The Kikuyu say that they always cooled it in water. Leakey (1977: 306) verifies this.
128 Samia, Marachi, Wanga, Samburu.
129 According to Routledge (1910: 86) the northern Kikuyu left it overnight.
130 Marakwet.
131 The Pokot and, according to Hinde (1901: 86-90). the Masai take it out on the third day.
132 The Bukusu ascribe this misfortune to the anger of their ancestors who are believed to come to warm themselves at the fire when the smelters have left. The Tugen fear some sudden catastrophe, while the Marakwet believe that the smith will die. The Somali and Kamba do not specify the misfortune.
133 Leakey (1977:304) says that each Kikuyu apprentice smelted his own ore on a different day. The same was true of the Meru tribes.
134 Hinde (1901: 86-90) says that the Masai smelted for four days, but it is likely that they removed the iron each day.
135 According to information by Leakey a Kikuyu apprentice was given approximately one third of the day's smelt.
136 Merker (1910: 115) says that the Masai crushed up small shells, *ol bikit*, and sprinkled them on so that the pieces would weld together.
137 See description of Embu smelting. Wyckaert (1914: 377) says that the Fipa of Tanzania also used a clay pot "with an aperture at the bottom for draining off the slag, and three holes in the sides".
138 See description of Marachi smelting later in this chapter.
139 The Dime in S.W. Ethiopia also produced axe-shaped wedges which were said (text to the Dime ironworking film of the Frobenius Institute) to be the official measure of worth among many tribes in that area.
140 The Embu say that to do so is tantamount to throwing away the smith's energy and ability to work.
141 Hunting dogs with bells were only used amongst the Interlacustrine Bantu in western Kenya.
142 Slag was never used for protective ornaments. Only the eastern Luyia tribes hung it on a smith's bag.
143 Specialist ornament makers were known as *Mucucio* in Kikuyu.
144 According to Leakey (1977: 306) the Kikuyu regarded the furnace as sterile if this happened and the apprentice whose smelt had failed had to make a sacrifice.
145 Galloway (1934: 501) gives the following report on the slag from a furnace site in Elgeyo. The ore is not specified.
"The East African slag shows it mainly to be composed essentially of iron-oxide, silica and alumina, the figures being as follows:

Silica SiO_2	27.8
Ferrous oxide FeO	51.0
Alumina Al_2O_3	13.2

There are also present very small quantities of manganese, lime and magnesia together with doubtless, potash from the ash of the charcoal used, and a little unconsumed carbon.
All the silica appears to be in the combined state as the slag gelatinises on treatment by acid and we have not been able to detect any free or uncombined silica.
146 The Tugen did this by studying the bubbles, pits, and knobs in it. See also Status Note 157.
147 For analysis see Ore, note 36.
148 Before adding the sand (*muthanga*) it is called *umbalia gedwa*. Once the sand is added the mixture is called *yumba*.
149 It was usually said to take half to three quarters of an hour.
150 These are some examples of the songs that he sang:

The Smith tells people to be happy when collecting iron sand, and not to have a "black heart", i.e. not to have evil intent. He warns those who bring ironsand to him for making into artefacts not to try to cross him in any way. When collecting it and bringing it for smelting they should also avoid people lest they have the evil eye or are intent on using sorcery, for both can affect the sand so that it will not produce good iron.
He sings of the noise that his bellows make, saying that they are crying and crying like a he-goat or ram which has been sheltered and given special food to fatten it, and is being slaughtered on a ceremonial occasion.
He warns any man with evil intent towards the smelting, and any woman with ideas of stealing his charcoal, to beware for the smiths have a powerful curse which can harm those with evil intent far more than they can ever harm a blacksmith or his work. A smith's property is safe against any harm for a blacksmith owns the hammer, and once he has that he has the means to curse and to get whatever he wants. No-one can stop him.
He sings to the Mother of the apprentice, saying she should be told that her son is not a bad boy just because he is not at home herding but is away "herding" (i.e. helping) for the smith instead. He, the smith, is now old and his work is too hard for him so the apprentice is helping him and learning the craft at the same time.
He sings of an attractive woman whose body undulates seductively as she shakes the basket with a circular movement to winnow the iron sand, and how her earrings move rhythmically in time with the undulations of her body.
He sings that he has two Mothers, one with her head completely shaved and another whose hair is shaved with the exception of a small top-knot. (This refers to winnowing the ironsand, for traditionally two women did this for Embu smiths, a newly married one whose status was shown by the tuft of hair left on her head, and an older women with circumcised children whose head was always clean shaven).
Another song says that if a man wants a sword he must go to a smith to obtain it. All who require weapons for protection, or tools to till their fields, rely on the smith. They must come to him bringing ironsand. As he sings he looks at the furnace, saying "this circle (i.e. the furnace), makes a lot of fools abandon their fields." He teases those who are too lazy or not clever enough to find and collect their own ironsand for making swords, intimating that some do not do so because they are cowards afraid to fight. He says "You fools just keep on sleeping if you think that someone will make a sword for you out of nothing." (In effect he is telling people to go out and search for ironsand and bring it to him so that he can make swords, for in days gone by the fields, crops, and lives of the Embu often depended on their swords).
He sings of the fur hat that he is wearing, praising it and saying that the skins (i.e. the Bellows) are also praising it, so that wearing it makes him feel happy for smelting is a joyous occasion.
This is another song: quoted from Mwaniki (1974, 75)

Kaari tukagura, uguo mwaari tukagura,
Tukagura na miringa tugetage
Ciaturi, kaari tukagura

The small girl we shall marry,
The girl we shall marry,
We shall marry with bangles and be calling her *ciaturi*
(of blacksmiths)
The girl we shall marry.

Two further songs sung by him, see Bellows notes 6 and 24.

151 It was explained that this is similar to when a child is born for no-one is allowed into the house with it for a month, and the event is also connected with the loss of blood.

152 See Iron Ore, note 41.

153 Forked sticks are used to hold the bellows nozzles in place, and underneath the bellows an armful of grass is always placed to prevent the skin of the bellows, where it enters the nozzles, from wearing out through constant friction with the hard ground.

154 This name refers to several different plants which all have burrs and are used for purification. The liquid is made from the leaves.

155 *Ira* is a white diatomaceous powder which is used mostly by medicine men. It is commonly supposed to come from "high up on Mount Kenya", possibly because Mount Kenya is snow covered.

156 The only other smiths in Kenya who use shell as a flux are those of the Masai which suggests that there may be some truth in the Mbeere claim that they taught the Masai ironworking.

157 Their ore digging is already described in the chapter on Iron Ore.

158 Analysis given in Ore Note No. 30.

159 At one point the clay became too wet so they removed some banana leaves from the roof to allow it to dry off in the sun. It then rained suddenly so they constructed a shelter of sticks and banana leaves immediately over the growing wall as the roof was not water-proof.

160 The charcoal was made from *Olulando* (*Hymenocardia acida* Tul. *Euphorbiaceae*), *Olichuta* (*Combretum molle* G. Don *Combretaceae*), *Olokhongwe* (*Terminalia mollis* Laws. *Combretaceae*, and *Olurianyi* (*Acacia* species) whichever wood is most easily available.

161 Each song was sung over and over again, and the words are repetitive. One song says that if you are tired, hungry and thirsty you still go on working because ironworking is your craft and has long been carried out under the hill of Odiado. Another song praises a famous ancestral smith called Ochaka. They were singing about him doing this work, and he was supposed to be replying, and they were praising him.

162 It must be male and *all-black*. No other colour is permitted.

163 One lot is usually sufficient to protect the work from any impurity that may be around, but this smith has to do it three times because his wife had born twins.

164 Analysis showed this bar to be composed of the following:

Constituent	% Content
Iron as Fe	99.67
Silicon as SiO$_2$	0.07
Manganese as Mn	0.04
Sulphur as S	0.01
Total	99.79

Most of the drillings of the bar were silvery in colour and these are the ones that were taken as the representative sample. Some of the drillings at the pointed end of the bar were, however, coloured a bit blackish/blue which was suggestive of the presence of some oxides of iron.
Analysis was by kind favour of Dr. H. Ssekaalo, East African Industrial Research Organisation.

165 One song tells of a banana plantation. It says that the banana is a very wonderful plant, if cut down even by children it will still grow up again. This is an allusion to the smiths' craft which was practised by their grandfathers and, like the banana tree, cannot be stopped, for it will be continued by their sons. Another song likens the red-hot iron bar to a young woman and says "Why are you calling me when you are yet still too young", i.e. not yet being made into an artefact.

166 A widow, who is still considered partially impure after the first period of mourning, would have to throw on only one lot of charcoal if she entered the smithy, in case her presence should harm the work.

167 The Somali and Tharaka are the only people who say that women can approach even when they are in a state of impurity. The Bari of the Sudan (Seligman 1928: 432–3) did not object to women being present. There is a somewhat suspect report by Baumann (1894: 233) that Pare women, just across the Tanzania border, actually smelted iron. The only reference to them doing so in Kenya is the Idakho myth which tells of an old woman who knew how to smelt iron but died before she could impart her knowledge to anyone else.

168 The Idakho say that a smith must be clean both physically and mentally. It is important that he is "pure" and "holy", free from all sin, helpful to people in every possible way, and must not even have had any minor quarrels before smelting iron.

169 Banyankole in Uganda (Roscoe 1923b: 136); BaKaonde (Melland 1923: 36); Unyoro in Uganda (Roscoe 1923a: 219); Baganda in Uganda (Roscoe 1911: 381); Nyamwezi (Stern 1910: 155); Fipa, Tanzania (Wyckaert, 1914: 371, 373–80).

170 e.g. Embu.

171 According to Leakey (1977: 306) the Kikuyu liken the production of iron to a birth; so do the Marakwet, and Somali who believe that just as a woman gives birth by the heat from a man so the heat of the fire in a furnace gives birth to iron.

172 Leakey (1977: 305, 306) says that the Kikuyu thought of the furnace as female and the bellows nozzle as male although they did not speak of them as such. He further notes that the shape of a Kikuyu furnace is suggestive of the female genitalia, while that of the tuyere is suggestive of a penis.

173 Brelsford (1949: 28) reports that the Chisinga and Bemba of Rhodesia look on the smelting furnace as the smelter's wife for the duration of the smelt.

174 The Marakwet refer to it as both.

175 The Marakwet also refer to it as a wedding, but a wedding in most Kenya tribes is generally only concluded with the birth of a child.

176 Breslford (1949: 28) reports that the Chisinga and Bemba consider that a smith who has sexual intercourse during smelting is committing adultery since the furnace is regarded as his wife, but there is generally no objection in E. African societies to a man having intercourse with another of his wives when one is pregnant. Adultery is a more complicated affair. The reason for avoiding intercourse is to avoid impurity.

177 A very rare occurrence. See end of the chapter on the Status of smiths and the Attitude towards them.

178 The Somali and the Tharaka are exceptions to this. The Luo believe that not only would the smelt be ruined but the new-born child would die.

179 e.g. Logoli, Tugen, Marakwet, Embu. The smelt would fail. The Marakwet believe that the bellows would not function properly. The Tugen believe that as well as the smelt failing the woman would become infertile, while the Logoli believe that she would die. The taboo on menstruating women has been recorded by Brelsford (1949: 28) for the Chisinga and by Roscoe (1923: 105, 1923: 190) for the Ankole and Bakitara in Uganda.

180 Samburu and Pokot smiths are said not to be able to work for 'a month' but by that they mean until the next new moon appears so it may be for a much shorter time.

181 This only seems to apply to the Interlacustrine Bantu. For details of the ritual see description of Marachi smelting.

182 Bunyoro smiths in Uganda could not return home during smelting (Roscoe 1923b: 219).

183 The Marakwet and Tugen could not return home until they had produced "pure" iron.

184 The Chisinga of Rhodesia (Brelsford 1949: 28). The Bambara of Zaire (Sayce: 1933) and The Unyoro of Uganda (Roscoe, 1923a: 219).

185 The Bukusu.

186 In Uganda Bunyoro smelters (Roscoe 1923a: 221) ate only maize and bananas like the Logoli. Chisinga smelters (Brelsford 1949: 28) must eat their relish cooked and hot and it must not be slimy or liquid. Bambara smelters (Sayce, 1933) are not allowed to drink water. In Konongo (Stern 1910: 152–4) they were not allowed to eat honey or fish. They generally ate porridge without salt and could only spice their food when the smelt was seen to be successful.

187 The Tugen.

188 The Mbeere.

189 The Giriama are very strict about this.

190 Bukusu smiths and their apprentices may cook only finger millet as it is the traditional food of the ancestors of which they were very fond. If any other food is cooked there it is believed that the ancestors will cause the smelt to fail. Logoli may cook only maize and bananas.

191 Livingstone (1899: 412) reported the same practice at Tete on the Zambesi and said that they preferred their own iron because they could not do this to commercially manufactured imported iron.

192 Merker (Merker 1910: 115) says that the Masai twisted 15–20 foot lengths together; Beech (Beech 1911: 18) says that the Pokot required seven coils of wire to make one spear; There are also reports of the Kamba (Dundas 1913: 503); (Hobley 1922: 168); Kikuyu (Routledge 1910: 91–92) and Somali (Dracopili 1914: 150) using wire for forging.

193 e.g. when making a haft hole in a hammer head.

194 By Somali smiths and by Konso smiths working for the Borana who use it mainly for rivetting loops onto pendants.

195 Where it is used mainly by Bajun smiths for rivetting the ends of bracelets together.

196 Occasionally spears may have a little decoration just below the blade or on a protrusion on the butt. Iron bracelets (*Katar*), worn by Masai whose fathers have died, are always decorated in this way.

197 e.g. Samburu, Isukha.

198 e.g. Mbeere.

199 e.g. Marakwet.

200 By Konso (Ethiopian) smiths working for the Borana.

201 Amongst the Borana.

202 They were probably introduced by Arab boatbuilders. Even some of the Dhow-type boats (e.g. *Mtepe*) were sewn until the end of the last century.

203 For times taken to manufacture artefacts see Appendix VIII.

204 The following is a report of an analysis, and of tensile and hardness tests, kindly carried out by Mr. N.B. Onduto, Chief Materials Engineer of the Ministry of Works, Nairobi, on a knife from Embu forged from this material:

"As received the knife had the following dimensions:

Weight	450 gms.
Length	325 mm.
Width (max)	48 mm.
Thickness (max)	9.5 mm.

To establish the composition of the steel a chemical analysis was performed which yielded the following results:

Combined Carbon (as Fe_3C)	0.06%
Graphitic Carbon	TRACE
Sulphur	0.03%
Phosphorous	0.05%
Silicon	0.01%
Manganese	0.43%
Titanium	NIL
Chromium	TRACE

This analysis shows the material to be a low carbon mild steel. This type of steel is very common and used for light engineering and structural purposes.

Further to this chemical analysis the material was examined metallographically and the following observations were made: In the unetched condition the steel appeared to be very pure with few inclusions. The unetched structure indicated that the material was a mild steel and not a cast iron. The specimens were then etched in a 4% Nital solution and re-examined. The microstructure consisted of very uniform ferritic iron grains with a very little pearlite. This showed the material to be a low carbon steel. There was no apparent grain deformation or elongation as one would expect after a forging operation and this would indicate that the knife was allowed to anneal either during or after the actual forging process.

Tensile and hardness tests were also carried out on the samples which gave the following results:

Yield Point	32.5 kg mm^{-2} (20 t.s.i.)
Ultimate Tensile Strength	43 kg mm^{-2} (27 t.s.i.)
% Elongation	35%
% Reduction in C.S.A.	65%
Hardness (Brinell)	102

These results are to be expected from a low carbon mild steel having the aforementioned analysis and microstructure. It will be noticed that the steel is ductile and fairly soft.

From these tests it is established that the material from which the knife was made is a mild steel of the type used for general engineering and structural purposes. This type of steel is common in this country in the form of reinforcement bars for concrete and mild steel plate and strip etc. The steel was found to have a very uniform grain structure with very little observable impurity."

205 The tip of this thrusting spear is designed to make a wide cut. The blade then narrows so that it can be thrust home easily.

206 e.g. the Kikuyu.

207 Pokot smiths do this.

208 The Pokot, Turkana, Marakwet, Samburu.

209 Marakwet smiths always do this.

210 Samburu, Pokot and some Masai.

211 Amongst the Luo and Luyia, in western Kenya, and the Orma, Borana, and Somali in the north-east.

212 The Somali, Orma, Borana and other tribes are very fond of doing this. Woodash and skins are also used for polishing.

213 Merker (1910: 115) mentions that Masai smiths used this.

214 Leakey (1977: 308) says that Kikuyu burnishers were rewarded for their work with a goatskin, piece of pig-iron, or a broken sword.

215 Analysis of the Embu razor made from smelted ore (analysis Ore note 36) says that the iron has a coarse structure with high graphite and silicon content with inclusions of ferrosilicates and other silicates, and that titanium dioxide is readily apparent. The iron is fairly brittle with low ductility and only moderate tensile strength.

216 Details kindly provided by Prof. Stanley Sheldon.

217 Not washing tools after work is frowned upon.

218 The Marachi and Samia use the wood of *Mulianyoni* and *Musiola* trees almost exclusively for this.

219 The Marachi, Samia and Wanga use a gum called *Obudua* (from

the *Obudua* tree). It is normally kept stuck on a stick which is stored in the thatch of the smithy. When required a piece is cut off the end.

220 e.g. The Marachi, Samia and Wanga.

221 Coastal smiths, particularly the Giriama, do this.

222 Marakwet smiths sell arrows ready for use with shafts fitted and fully fletched. Digo smiths do likewise.

223 Especially in western Kenya. Isukha and Kisa smiths seem to be particularly good woodworkers. Among other things one Isukha smith specialises in making one-stringed fiddles.
A famous Gusii smith was said to be an expert in wood and stone working. (Information Tony Manners).

224 Many of the more recent digging sticks have tanged iron blades. This is one of the rare instances when smiths provide a haft for a tanged object. Kikuyu and Meru old mens' walking sticks have a small socketed butt (not unlike a spear butt) on the end of them.

225 i.e. amongst the tribes of the north-east the Somali, Borana, Gabbra and Orma.
Bajun smiths make sheaths for themselves, and for the Pokomo, Somali, Orma, and Boni, who will not work leather.

226 Kikuyu smiths, who will not normally make sheaths for the Kikuyu (Hobley 1922: 169) do so when they make swords for the Masai.

227 This is very common amongst Masai and Kikuyu. The metal tip is often a half cent piece.

228 Kikuyu smiths produce the red dye by boiling the roots of *Anthericum subpapillosum* von Paellu, and *Rubia cordifolia* Paellu. The Borana make it from a tree called *Halu*. The Keiyo use *chesalei* (Massam 1927: 48).

229 Amongst the Galla and Somali tribes, the Boni and the Orma.

230 The Bukusu hit the hammer on the anvil to show that they have arrived at work. While doing this they pray and end by saying "Ancestors let us do the work successfully". Pokot smiths pour a libation of beer to keep any evilly disposed ancestral spirits from harming the work. Luo smiths point one of their tools at the sun as they pray. Somali smiths recite some verses from the Koran, and other smiths pray silently.

231 Luo smiths point one of their tools at the setting sun as they finish work.

232 A Marakwet smith, who comes to work after having sexual intercourse, can only make bells for the rest of the day even though he has provided a goat for sacrifice and he and the smith have been purified. Luo smiths who do so can work but have to be very careful because they are thought to be prone to a sudden accident. Their work that day is always believed to be of poor quality and no customer will buy it if he knows.
A Giriama apprentice who borrows his master's tools and leaves them in his home instead of returning them immediately is thought to be in great danger if he does not refrain from sexual intercourse. It is thought that he will be deafened, even in his sleep, by the sound of bellows which will grow louder and louder until he dies.

233 e.g. Luo, Pokot, Marakwet, Embu.

234 An Embu smith cannot forge if his wife is menstruating.

235 The Kikuyu.

236 See Note 42 Heredity and Training.

237 See smelting notes 186 and 190.
The maize and bananas which Logoli smiths are permitted to cook in a smithy must never be eaten by unmarried boys for fear that they will never marry, or will lose their fertility and be unable to have children.

238 Tugen smiths may not eat at all whilst forging, and Samburu, Somali and Marakwet smiths may only eat in the smithy if the food has been cooked on the domestic hearth.

239 But not always see Heredity and Training note 33.

240 A woman entering the smithy of a Marachi or Wanga smith during forging not only causes the artefact in process of manu-

facture to be ruined but the smith himself to lose his immunity to burning (temporarily).

241 The Kikuyu believe that if women go near forging, sometimes only within earshot of the hammering, they will die. The Isukha believe that such women will develop continuous bleeding which is only curable by swallowing a concoction of herbs and iron flakes from the anvil, served from one of the smith's tools.

242 See following notes especially No. 250. A Kamba smith will not even shake hands with any woman in case she might be menstruating.

243 During wars the Bukusu herded their smiths together, for protection, in their defensive forts, and only women past the menopause and those who had been proved infertile were allowed to take them wood.

244 Luo, Kisa, Tugen, Pokot and Marakwet allow them in because they say that "they are innocent" and therefore protected from harm, but they must stay away once they start menstruating.

245 The Logoli only allow little girls to enter the smithy when the smith is not forging, but the Bukusu keep them away entirely for they are reckoned to be too young to be aware of the prohibitions and the possible dangers which might befall them.

246 Samburu. Also sometimes Rendille.

247 Tharaka.

248 Samburu smith's wives all have to wear them.

249 Tharaka and Somali women can go to a smithy whether they are menstruating or pregnant, but this is most unusual.

250 Pregnant women keep away because most tribes, like the Isukha, believe that to enter is tantamount to killing the unborn child. The Luo believe that if a pregnant women enters, the tool that the smith is using will slip from his hand to hit the woman's belly and thus kill the unborn child. The Marakwet and Pokot hold that a pregnant woman is so heavy that her presence will cause any work in progress to be ruined.

251 A Luo adulteress, for instance, is believed to die of a wasting disease if she approaches forging operations.

252 Samia, Marachi, and Wanga widows remain in a state of semi-impurity for some time after emerging from the initial period of mourning. They are allowed to enter at that time, if they have to, but must first throw some charcoal on the fire to counteract any pollution they may bring.

253 Initiates who come near will find that their wounds begin to putrefy and they become ill, and their presence will also harm the work.

254 Somali and Tharaka, who know that they have the evil eye, will rarely enter a smithy because they are too afraid of the consequences.

255 In case anyone with the evil eye enters a Bukusu smithy the smith adds a request, in his morning prayer to the ancestors, for anyone who knowingly has the evil eye to be burned or hit by the hammer (which will inadvertently slip out of the smith's hand), and for anyone who unknowingly has it to be guided out of the smithy automatically without being harmed.
The Marakwet believe that no harm can come to their work from the evil eye as the bellows blow away any evil influence, but for additional protection they place charcoal and water in the smithy. The Kamba always bury a protective axe-head in the smithy.

256 The Luyia tribes, in particular, do this. Failure to do so is thought to result in a bad skin infection.

257 See description of Marachi smelting, and smelting Note 166.

258 The Bukusu greatly fear these people. (They are called *Omuboelela* and do not have their heads shaved) as they are believed to have malevolent ancestors everywhere. The smith's fire is also believed to burn them.

259 Particularly amongst the Luyia who regard them as a blessing, but at the same time believe that they have some mystical power which is a danger to themselves and to anyone (and anything) with whom they come into contact. This power is at its height for several years after birth so, for that period, Bukusu twins are

secluded in their mother's hut and anyone inadvertently entering and seeing them has to pay an iron necklet or armlet (Wagner 1949: 3Z9). The power diminishes after this period, but does not abate, so that if they go near ironworking nothing can prevent the tools from cracking up.

260 The Samia, Marachi and Wanga do not consider twins as dangerous as do some other Luyia tribes. See description of Marachi smelting for their precautions.

261 e.g. Marakwet and Somali. The Isukha believe that if old water is used the woman who fetched it will haemorrhage and die.

262 This applies particularly to the Luyia group. The Bukusu believe that the woman would be harmed by a flying fragment of red-hot iron.

263 Logoli or Kikuyu who questioned a smith would be cursed. It is not taboo for a Somali but he would disdain to do so as Somali regard smiths as inferiors.

264 Pokot and Kikuyu could never make remarks such as "This iron is very heavy" or "very hot" or "very red". The culprit who did so would have to provide a goat or sheep for the purification before work could begin again.

265 Orde-Browne (1925: 130) mentions this for the Chuka. It also applies to the Kikuyu and Embu who are thought to die if they do not pay a goat quickly. It applies particularly to the smith's apprentices who have to become used to sparks.

266 It is taboo for a Kikuyu smith to do so but he could rub his burn with sacred *Mathakwa* leaves if he had any near.

267 The Logoli believe that the lips of anyone whistling will turn blood red; blood-red lips are very much disliked. A Giriama doing so is believed to die as well as harming the iron if he does not immediately chew a piece of a certain rhyzome and provide an animal for the purification.

268 Pointing smiths' tools at a Pokot is liable to bring him life-long ill-luck and misfortune. Pointed at a Tharaka they will cause him to spit blood until he dies. The Bukusu believe that death is certain because the smith's tools are used to make sharp things, like spears and arrows, which bring death; they likewise must never be pointed at anyone. Guttmann (1912: 81-83) says that pointing the tongs at a Chagga (a tribe just over the border in Tanzania) smith made him liable to be bitten by a snake.

269 In Kikuyu smithies.

270 The Tharaka, Embu and Marakwet believe that misfortune will befall a smith whose hammer does this. They hold a purification ceremony. For the Marakwet ceremony all the smiths foregather, slaughter a cow, drink honey beer and forge a new hammer.

271 The above tribes also believe that this is a bad omen. The Luo say that it indicates that the smith has broken the taboo on sexual intercourse.

272 The Luo believe that this is also a sign that the smith has broken the taboo on sexual intercourse. The Tharaka and Tugen look on it as boding ill for the work. Bukusu smiths chase away any onlookers in the belief that one of them has brought the ill-luck.

273 The Tharaka and Tugen regard this as an evil omen.

274 The Isukha believe that the transgressor will first burst out in a horrible skin rash.

275 The bellows are believed not to function properly if they are stepped over. There may be some connection with the taboo on stepping over the outstretched legs (the usual sitting position of women) of women which is liable to render them infertile.

276 See Heredity and Training Note 24.

277 Samburu smiths are very emphatic about this.

278 Only the wives of Tharaka and Somali smiths seem to be allowed to touch the tools. Smiths' wives cannot do so elsewhere. Samburu women have to be very careful not to touch the tuyere when blowing the bellows. Marakwet women can carry home their husband's bellows but must never touch any of the other tools.

Customers were sometimes given permission to pump a southern Kikuyu smith's bellows but were never allowed to touch other tools or unfinished products (Leakey 1977: 307). Potential apprentices were also allowed to try blowing the bellows.

279 The Kikuyu of the Muranga area, most famous for its smiths. The smiths there were very exclusive.

280 The Ogiek Dorobo of the Mau Forest who usually obtain their iron artefacts from Masai smiths.

281 The Turkana and Pokot.

282 Discarded axe heads are usually obtained from agriculturists and are used mainly as skin scrapers.

283 The one I watched was Kikuyu. The Kamba often use the same material for tweezers.

284 Baker (1877: 165) says that wire drawing was only done after the advent of coastal trade in Unyoro (Uganda) where smiths "drew fine wire from thick brass and copper wire." Burton (1860: 395) also says that "East Africans have learned to draw" fine brass wire "which they call *usi wa shaba*."

285 Thompson (1887: 290) mentions Samia smiths making this square cross-sectioned wire in imitation of coastal *Senenge* and says that, as the coils were not continuous, they were joined ring on ring. I only came across one Luyia tribe, the Hayo, using a drawplate.

286 See Routledge's (1910: 92–93) description of Kikuyu wire making. The Kamba made it in the same way. So did the Giriama. Some of the Kalenjin, e.g. the Keiyo (Galloway 1934: 502) and the Marakwet, also made chain, but the Kipsikis, like the Masai, apparently did not do so.

287 Routledge (1910: 93) also mentions this.

288 See Routledge (1910: 94–95) who also gives an illustration (p. 94b).

289 This method was used mainly by the Kamba, and to a lesser extent by the Giriama. The Kamba were fond of belts, bandoliers and necklaces of multiple strings of spirally coiled fine wire. They also used them to decorate the tops of stools. The design was first scratched on the top of the stool. The spiralled wire was stretched, so that the coils were not quite contiguous, and then hammered into the stool top.

290 This seems to be confirmed by Hobley (1910: 34) who says that brass and copper wire was "annealed" before being drawn out.

291 e.g. the Masai (Merker 1910: 115–116, and personal information). the Kipsikis, and most Luyia tribes.

292 According to Lindblom (1920: 530) the Kamba had stopped making wire, but the Kikuyu continued to do so.

293 The Masai, who did not make wire, did a lot of wire drawing (Merker 1910: 115). Dundas (1913: 503) says that the Kamba did not obtain the finer wire from traders "probably because it was too expensive for the native to buy."

294 Routledge (1910: 95–97) also describes this process in detail. It has not changed.

295 Particularly the Giriama.

296 The Kamba.

297 e.g. The Masai (Merker 1910: 114). My findings agree with this.

298 I have seen Giriama chainmakers do this.

299 The Giriama do this.

300 Bajun smiths working for the Oromo Galla and Pokomo on the Tana river do as much jewellery making as iron-working. Some Giriama smiths also do a lot.

301 Women are no danger to this work, nor does it endanger them.

302 Amongst the Luo and Luyia.

303 The Kamba say that they did, and the Giriama say that they used to cast into square or rectangular holes cut into a log of *Moria* tree. The Chagga were said (Sheldon 1892: 290) to melt the metal in a hollowed stone and to cast it in a wooden mould previously soaked in grease and then water.

304 I was told this by an Mbeere smith but I have found smiths' descriptions most inaccurate.

305 By the Samburu, but the last few age-sets have taken to wearing aluminium earrings.
306 These are handle-less *sufurias* of Indian design.
307 These are very typical of the Masai group but were also worn by the Kikuyu, the Nandi and others.
308 I have seen Bajun and Konso smiths do this.
309 Giriama smiths.
310 Of the Kamba tribe.

311 Mrs. E. Moore, Catalogue of the Processional Crosses of Ethiopia. Haile Selassie I. University Museum, Addis Ababa.
312 Adamson (1967: 355) illustrates this.
313 The Turkana and Pokot.
314 The Kamba (Lindblom 1920: 375) also mentions that in his day copper or brass was inlaid into tin.
315 By Konso smiths working for the Borana and Gabbra.

The Products

SMITHS PRODUCTS AND ATTITUDES TOWARDS THEM

Introduction

A complete account of smiths' products in Kenya is beyond the scope of this paper, therefore only a brief outline can be given here. The range of tools is limited because smiths are skilled only in making tools for which there is a steady, often seasonal, demand from the people whom they serve; the wants of those people are simple and the tools are generally made to order. All smiths make a range of artefacts as they do not have the raw material or the markets to specialise. Even when the demand for one article predominates over others, smiths do not concentrate on that article to the exclusion of other products. Iron ore is plentiful but the ironworking process remains highly uneconomic and the products expensive and comparatively scarce,[1] even nowadays when scrap from commercially produced iron is readily available. This is because of the tremendous amount of work necessary for a small result: the slow and laborious methods of production which have advanced very little since ironworking was introduced; the fact that production is not continuous because the demand is seasonal and taboos restrict the smiths from working at certain times of the year and when they are in a state of ritual impurity. Smiths' products are, therefore, highly valued and well cared for so that they last indefinitely.

Although some iron products notably spears and personal ornaments which are not worn for protective purposes are liable to changes in fashion, and the spear type of a successful and much admired warrior tribe is sometimes copied[2] whether or not it is a superior weapon, iron products are generally restricted to the industry which makes them and change little in form and technique over the years.

African societies are deeply conservative. Radical change in their socioeconomic life has to take place before they are ready and willing to accept new and different tools and techniques; even when introduced, traditional beliefs ensure that their acceptance is slow and that nowhere do they cause a complete break with the past. The beliefs associated with ironworking itself make it a particularly conservative craft which is not organised to cope with a sudden rise in demand or the introduction of a new tool.

Apart from the smiths' own ironworking tools, which are not used by other people, the usual products are swords, knives, hoes, billhooks and sickles, axes, adzes and other woodworking tools; awls, branding irons, bells for both people and animals, and protective iron ornaments. In a few restricted areas iron wedges for splitting wood[3] and coconut scrapers are made. Occasionally nails, fishhooks and harpoons are also made although the last two are more likely to be cold forged by the users as are many awls, arrowheads, tweezers and small knives.

Spears, arrows, knives, axes, awls, bells and protective iron ornaments are the basic artefacts made by most smiths although a few tribes[4] never made or used spears and the smiths of some others[5] were not skilled enough to do so. Axes are more frequently met with to the east of the Rift Valley. In the extreme west of Kenya, billhooks/slashers take their place. In the central highlands digging knives are found instead of hoes which are used at the coast and in western Kenya.

As is to be expected, smiths of the agricultural groups make a greater variety of tools than those of the pastoralists. Pastoralism, hunting and gathering[6] has long been the predominant mode of livelihood in Kenya where three quarters of the country is hot arid desert, semi-desert, or semi-arid open savannah unsuited to agriculture. Iron is not essential to these peoples. It offers them little technological advantage, for their basic artefact requirements (knives, spears and arrows) are adequately met by stone flakes and wooden shafts

91

with horn caps[7] or firehardened barbed and often detachable or poisoned tips, as long as they have adequate land for expansion and its natural resources are sufficient to maintain them.

As soon as that land and its resources are threatened by increased population, disease, drought or by competition from neighbouring peoples similarly afflicted, it becomes advantageous for pastoralists to adopt iron spears[8] for protecting their livestock from raids, for counterraiding and for expansion into new territory. Little is needed from a smith other than a weapon. Kenya pastoralists, without smiths, use their spears less as weapons than as general purpose tools for cutting meat, skin, string and bark, and for carving wooden artefacts. Small coldforged knives double as razors, and since huts are built of withies which can be torn from the trees, axes are a rarity. The few old axeheads acquired are usually used as skin scrapers not as axes.

Diminution of livestock and natural resources often results in expansion to areas suitable both for cultivation and herding. Well-watered more open bush areas, such as are found in the Interlacustrine region, are populated before the thickly forested highland zone to which people have to expand later.

Agriculture requires tools for cultivation rather than weapons for protection. Since wooden digging sticks are at first adequate the primary need is for iron tools for clearing rather than for digging, thus axes and billhooks seem to precede hoes everywhere until an increase in population in a restricted area and the consequent need for more efficient and intensive agricultural production necessitates the introduction of better tools in the form of iron hoes or digging knives. In a male orientated society where men clear the land while women dig and weed, it is also probably a foregone conclusion that the use of expensive new iron artefacts should, at first, be restricted to men.

Many of the basic products of ironworking appear to have wood or stone prototypes and to differ sufficiently in form for them to be placed in typological sequence.

The Products

Arrows

Weapons typical of Kenya's hunting peoples. Stone tipped arrows and arrows with firehardened points or with tanged and barbed, sometimes detachable wooden heads, are still made in Kenya. They are the prototype of metal ones. All smiths make arrows and only they make tanged arrows with barbs and socketed arrows. Others are cold-forged by the hunters themselves but those made by smiths are preferred. There are a number of different types of arrows (Fig. 62–63) almost all have tangs. Some have detachable headshafts (Fig. 62, Nos. 9

and 10). Unbarbed leaf-shaped arrows (Fig. 63, Nos. 5, 7–9, II) are usually larger and are rarely poisoned while barbed arrows are almost always poisoned.

Special blocked arrows for bleeding livestock (Fig. 62, No. 1) are also made by smiths. Some men cold-forge their own but those made and blessed by smiths are much preferred. Bleeding arrows are often regarded as semisacred objects. Some peoples use nothing else to cut an umbilical cord or to enlarge a woman's birth passage when necessary at parturition.[9] They are often used in oathing and are usually kept in a separate container apart from other arrows, even by agricultural peoples.[10]

A stone arrow lashed into a detachable wooden foreshaft must have given rise to the earliest form of iron spear at present to be found in Kenya. This has a carefully balanced shaft weighted at top and middle (Fig. 59, Nos. 9 and 10) and is peculiar to the Kalenjin speaking Ogiek Dorobo forest hunter/gatherers[11] who use it sometimes as a drop spear mainly for hunting elephants.

Spears

Tanged iron spearheads are usually presumed to derive from wood or stone prototypes and to have preceded socketed spears which are generally thought to be explainable only in terms of a metal industry. It seems possible, however, in view of the fact that Galla pastoralists of the northeast and the few smithless pastoralists of the northwest used only wooden spears with firehardened points or with stone or oryxhorn tips until comparatively recently,[12] that instead of going through an intermediate tanged stage socketed spears could have derived directly from horncapped wooden ones. Tanged spears are extremely rare in Kenya. Except for the northernmost riverine Pokomo whose crude tanged fish spears are made for them by smiths of the Cushitic speaking Orma Galla, the Coastal Bantu normally do not make or use them. This may indicate that tanged spears preceded socketed ones in the northeast. A more definite indication of a tanged form being earlier comes from the Kalenjin group west of the Rift Valley where the Marakwet ritual spear (*Swoger*)[13] is always tanged, not socketed like the rest of their many types of spears. Further evidence for it being an early form comes from northern Tanzania where the Dadog, who are descendants of the same linguistic group, also use tanged spears.[14]

In Kenya, tools are rarely socketed but practically all spears are. Flat bladed spears, which are found in the northeast[15] (Fig. 58, Nos. 2 and 4; Fig. 60, Nos. 2 and 3), are probably the earliest blade form. On simple stone anvils it is difficult to make any other type. Introduction of iron anvils resulted in stronger and better designed spears. They were strengthened by hammer-

ing them over the sharp unbreakable edge of an iron anvil to produce ogee cross-sectioned blades (Fig. 58, No. 5; Fig. 59, Nos. 1–2 Fig. 61, No. 5) such as are found in northeast and western Kenya.[16] An apparently more recent method of strengthening by means of a midrib was perfected by introducing grooves into anvils. Midribs can be made on an iron anvil without a groove but midribs can be made much better and more easily when a groove is present whether it be in a stone or iron anvil. It is probable that grooves were first cut in stone anvils as they are found in predominantly spear-producing industries in which iron anvils are nonexistent or are used together with stone ones.

The majority of Kenya spears have midribs. Small-bladed throwing spears, which are carried in matched pairs (Fig. 58, No. 1), are confined to the pastoralists of the arid north. Elsewhere longer and long-bladed stabbing spears (Fig. 58, Nos. 3, 6, 8) are in general use although some wide-bladed slashing spears are found. Most peoples have at least two types of spear, one for young warriors and another for elders, but the Southern Nilotic Kalenjin have developed a number of differ-

ent forms each with its own specific name.[17] This indicates that spears, which are their most important products, must have been made by them for a long time. Linguistic sources provide corroboration for this early use of spears; according to Ehret (1971: 53) the ancestral Masai probably adopted the long narrow-bladed spear from the Southern Nilotes in the first millennium A.D. They must therefore have had it for some considerable time before that.

In western Kenya[18] pronged fishspears (Fig. 58, No. 9) are found. Crude cold-forged harpoons, based on bone prototypes, are produced at Lake Turkana (Rudolf).[19] Spear butts may be long and delicate (Fig. 58, Nos. 1, 3, 6) or short (Fig. 58, No. 12; Fig. 60, Nos. 1–5).

Swords

Not found throughout Kenya. Some are flat-bladed[20] but most have midribs. They are a typical product of the Highland Bantu but are also found amongst pastoralists[21] and semipastoral agriculturists[22] to the north and west, especially where grooved anvils are used. They appear to have developed from spears. The

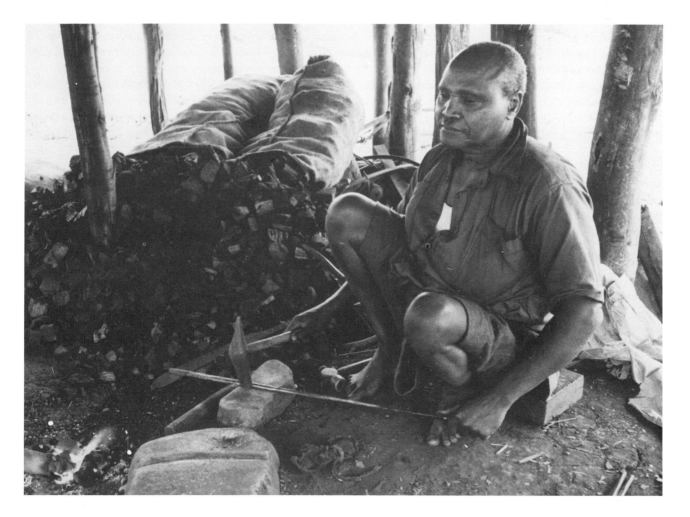

Plate 10. A Kikuyu smith with grooved stone anvil.

shape does not vary much but the swords of young warriors are usually long and narrow (Fig. 61, No. 1) while those of elders are shorter and wider (Fig. 61, No. 2). These are all sheathed in thin wood covered with skin, which is coloured red, and hung on a wide hide belt.

Flatbladed *daggers* resembling those of the coastal Arabs, took the place of swords in the northeast.

Knives
Of different sizes and shapes, predominantly sharpened on both sides but sometimes backed, are made by all Kenya smiths. Generally they reflect the shape of other tools typical of the culture, thus many Highland Bantu knives have midribs and resemble small swords (Fig. 64, No. 5); many Interlacustrine Bantu knives are curved like their slashers (Fig. 64, Nos. 1–3), and many of those of the northeastern Cushitic groups are flat bladed like their daggers. Most knives are general purpose instruments, but some are made for special purposes like harvesting heads of grain or bananas (Fig. 65, Nos. 1–2). Small knives may also be used as razors. The northwestern pastoralists[23] use small cold-forged finger-ring and wrist-knives (Fig. 67, Nos. 1 and 5) and their spears in place of other types of knife.

Digging knives (Fig. 65, No. 6) are confined to the Highland Bantu group. They are a shorter and stouter version of their swords, with a thicker handle, and are often made from cutdown old swordblades. They can be used as a slasher for bush clearing and grass cutting, as well as for digging and weeding. Longer knives are used by men and shorter ones by women. In the past they could also be used as weapons. These tools took the place of the earlier digging sticks (which one of the group[24] still uses) but nowadays, instead of pointing the end of the stick they insert a leafshaped blade (Fig. 65, No. 7).

Axes
Found all over Kenya but are more frequently used to the east of the Rift Valley than to the west of it. The usual method of hafting an axe is to burn in the blade but blades may also be wedged in (Fig. 72, No. 2). A typical haft has a heavily indented head (Fig. 72, No. 7).

Iron axes appear to be of ancient origin. Kenya has no traditions of them having come from stone prototypes although axes appear to have given rise to smiths' heavy hafted chisels (Fig. 9, Nos. 4–5) which, as already noted, were probably originally of stone. Many are, indeed, made from old axeblades and have no name other than "axe". They are a very old feature of Coastal and Highland Bantu ironworking and of Nilotic Kalenjin ironworking west of the Rift. They are used by the blacksmiths of the first two groups to administer the most serious oath of all, and some Highland Bantu

smiths[25] hammer an axe into the earth in their smithies to protect themselves and their work from any evil influence. This axe is known as "the post of the smithy" and must be moved with the anvil if the smithy moves. At the coast axes date from as early as the beginning of the Christian era for it is known from the Periplus of the Erythraen Sea (Schoff 1912: 6) that they were imported and may have been copied soon afterwards. They may also date from at least the end of the first millennium A.D. amongst the Kalenjin, for the Interlacustrine Bantu in Kenya borrowed the word for axe from the proto-Kalenjin (Ehret 1971: 18). Axes also appear to have given rise to adzes (Widstrand 1958: 87) and hoes. The semi-socketed axes and adzes of the north-eastern region appear to be of more recent introduction.

Adzes
Common amongst the Coastal and Highland Bantu. The best-made are those of the Kamba who belong to the latter group. Theirs, which are produced in a wide range of sizes, are beautifully hafted into a thick piece of rhinoceros hide fixed to the top of the handle (Fig. 73, Nos. 2–3). In the northeast, adzeheads are made with deep flanges which have almost become sockets (Fig. 74, Nos. 2, 4). These fit onto sharply elbowed shafts. Elsewhere adzes are generally made only in one size.

Instead of using adzes for hollowing out wooden utensils some peoples hollow the wood by burning and then dig, scratch, or scoop out the rest using a variety of tools (Fig. 73, Nos. 5–7; fig. 74, Nos. 1 and 5). A woodworking tool peculiar to the Highland Bantu[26] is a heavy long-handled mortar-like pounder terminating in a chisel (Fig. 74, No. 6). This is used exclusively for hollowing out tree trunks to make beehives.

Billhooks or Slashers
Appear to have come from the west.[27] are the typical tool of the Interlacustrine Bantu. They were adopted by the neighbouring Luo but penetrated only slightly to the Kalenjin. Larger billhooks are used for clearing land of bush for cultivation; smaller ones for cutting grass for thatching. They, not the axe, appear to be the oldest, most venerated and most important agricultural tool in the extreme west of Kenya. Until recently axes were so scarce in the area that there was only one to a subclan (Barnett 1965: 67). Like the modern bushknife (panga or Machete) a billhook is a good substitute for an axe.

Billhooks vary in shape, some being more curved (Fig. 71, Nos. 1, 2, 4) than others (Fig. 71, No. 7). The typical billhook haft projects upwards at the back of the blade (Fig. 71, Nos. 1, 3, 4). Nowadays, some billhooks are socketed (Fig. 71, Nos. 2, 8, 9) instead of tanged. Sickles (Fig. 65, Nos. 3–4), which almost cer-

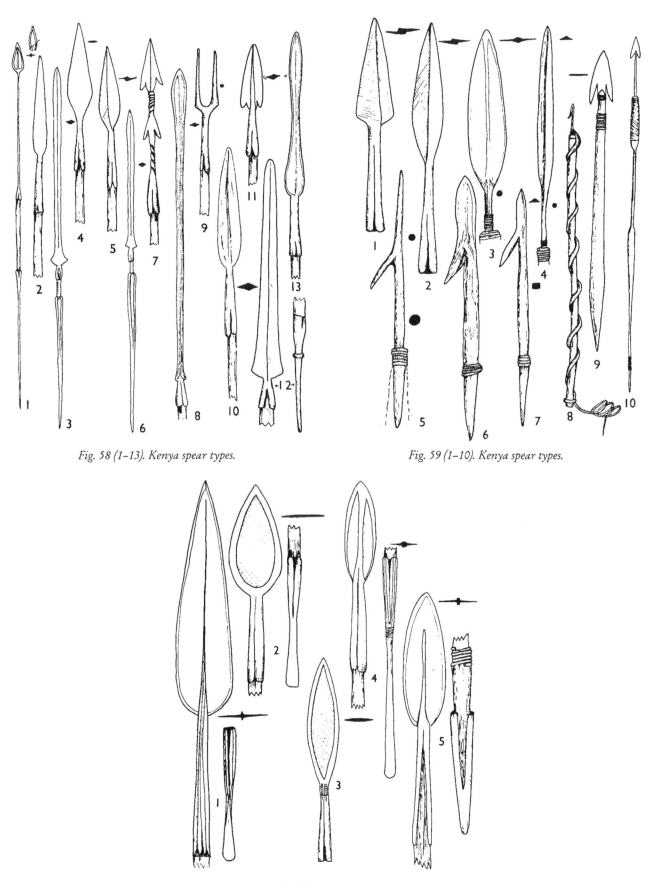

Fig. 58 (1–13). Kenya spear types.

Fig. 59 (1–10). Kenya spear types.

Fig. 60 (1–5). Kenya spear types.

tainly developed from billhooks, are likewise restricted to the extreme west of Kenya and nowadays may also sometimes be socketed.

Hoes

Found only in the coastal and Interlacustrine areas. They are of recent introduction in the latter area where their heads are lashed onto elbowed shafts (Fig. 70, Nos. 1, 2, 6) a pre-metallic form of hafting but they appear to have been produced at the coast for a long time. There the blades are hafted by pushing the tang through a hole in the straight handle and hammering it over (Figure 68, Nos. 2, 4). Coastal hoes are basically the same shape (Fig. 68) but are made in a variety of sizes and weights for doing different types of work.[28] Interlacustrine hoes are made in a variety of shapes, but heart-shaped and oval-ended hoes predominate (Fig. 69, Nos. 2–3, 4, 6). There are usually large and small sizes used for digging and weeding respectively. When worn down, the blades of some hoes (Fig. 70, No. 3) are used for digging potatoes and for cooking pancakes. Axe-hoes, used for clearing and planting, are occasionally found[29] but seem to be a recent introduction.

Wooden digging sticks, occasionally tipped with oryx horn and with or without stone weights, are probably the earliest agricultural tool. Until comparatively recently they were the only digging tool found amongst the Highland Bantu. They are still used by them[30] as well as by the Taita and by the Kalenjin[31] who also still use wooden hoes lashed onto elbowed hafts, a tool typical of the Interlacustrine Bantu and Luo who use them together with iron hoes.

In Kenya, the wooden bladed hoe appears to be a copy of the more expensive iron hoe rather than its prototype derived from an elbowed stick with or without a lashed on stone or bone blade.[32] This does not mean that wooden hoes elsewhere were copies rather than prototypes of iron hoes, although this does seem to have been the case in parts of Uganda[33] as well. It merely shows that hoes were considered an improvement on digging sticks and so desirable that they were copied in wood when iron ones were unobtainable, because local smiths were not yet skilled in making them or because imported ones were too expensive.

The Coastal Bantu appear to have no traditions of having used wood for agricultural tools in the past nor are there any clues as to when they first began to use iron hoes. They have obviously had them for some time. An earlier and rather insecure type of hafting, by fixing the blade onto an elbowed shaft by means of rings cut from the shell of a palm nut (Fig. 70, No. 7), is still used by the riverine Pokomo, and coastal hoe blades are closer in shape to axeblades than elsewhere (Fig. 68). Since axes are obviously a very old feature of the coastal industry[34] and are of great ritual importance

there[35] it is possible that hoes developed from axes on the East African coast.[36] The related Taita still occasionally use wooden hoes for cultivation after breaking up the ground with large digging sticks. They also have a tradition of having previously used stone hoes.

The Highland Bantu did not acquire hoes until they were introduced by Colonial administrators. The semi-pastoral agricultural Kalenjin acquired hoes from their Bantu neighbours (Ehret 1971: 45) with whom some of them had intermingled but the Highland Bantu, surrounded by pastoralists and hunter-gatherers, had no agricultural neighbours from whom they could adopt hoes, hence the development of digging knives probably based on sword prototypes.

Apart from the ironworking centre of Bunyoro in western Uganda, for which there are no references to the earlier use of wooden agricultural tools, digging sticks or wooden hoes seem to have been in general use in parts of Ethiopia,[37] much of Uganda,[38] Tanzania[39] and Kenya, until comparatively recently. Once iron hoes were introduced, the demand for them became so great that during the latter half of the nineteenth century a flourishing hoe trade developed in East Africa (Low 1963: 327, Alpers 1969: 35) which reached its zenith around the turn of the century.[40] It appears to have originated in Bunyoro where the increased demand for these products caused more intensive ironworking and led to one of the few instances of specialisation of smiths into smelters and forgers (Roscoe 1923a: 217).

Awls

Of various sizes are made by smiths throughout Kenya. Small ones (Fig. 40, No. 3; Fig. 42, No. 7) are used primarily for leather working[41] and for gourd repairs, while large ones are used to burn holes in wood or as castrating tools (Fig. 66, No. 1), and in some parts of the country, as branding irons, although most branding irons are not just simple awls (Fig. 66, No. 2).

Bells

Worn by both people and animals, are found almost everywhere. They are not common, however, at the coast and are seldom found in the northeast where people do not wear them and camels wear wooden bells. Bells are hung on favourite animals for ornament;[42] on straying animals and the herdleaders so that the herdsmen know where they are; and in western Kenya, on any animal as a protection against theft.[43] In western Kenya, hunting dogs also wear bells around their middles so that the hunters know where they are.

Large heavy bells with closed sides (Fig. 75, Nos. 1 and 4) are hung on cattle only, while smaller open-sided bells (Fig. 75, Nos. 2 and 3) are usually reserved for goats although the heavier ones are also hung on cattle.

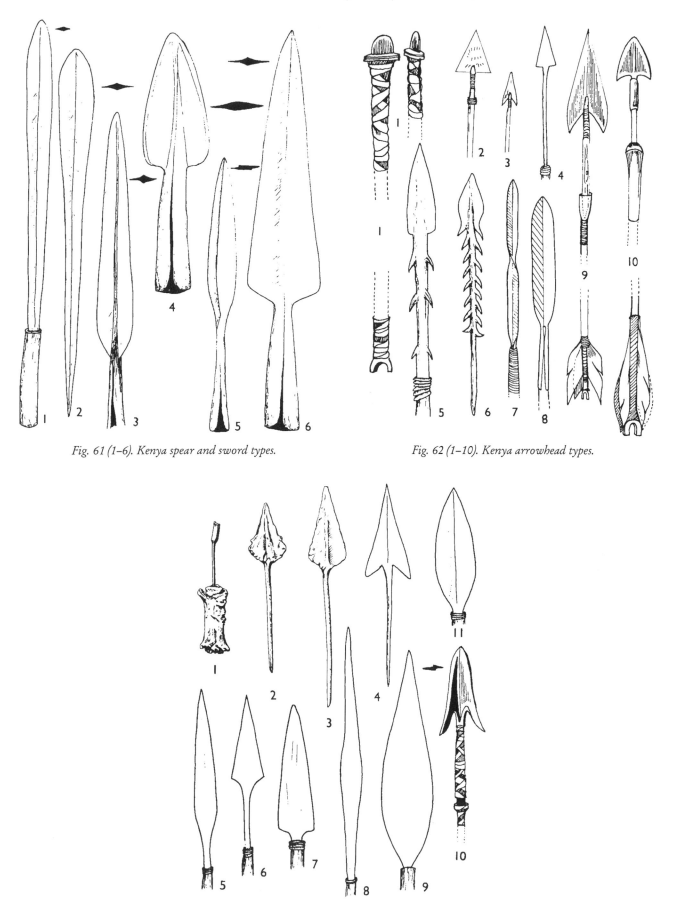

Fig. 61 (1–6). Kenya spear and sword types.

Fig. 62 (1–10). Kenya arrowhead types.

Fig. 63 (1–11). Kenya arrowhead types.

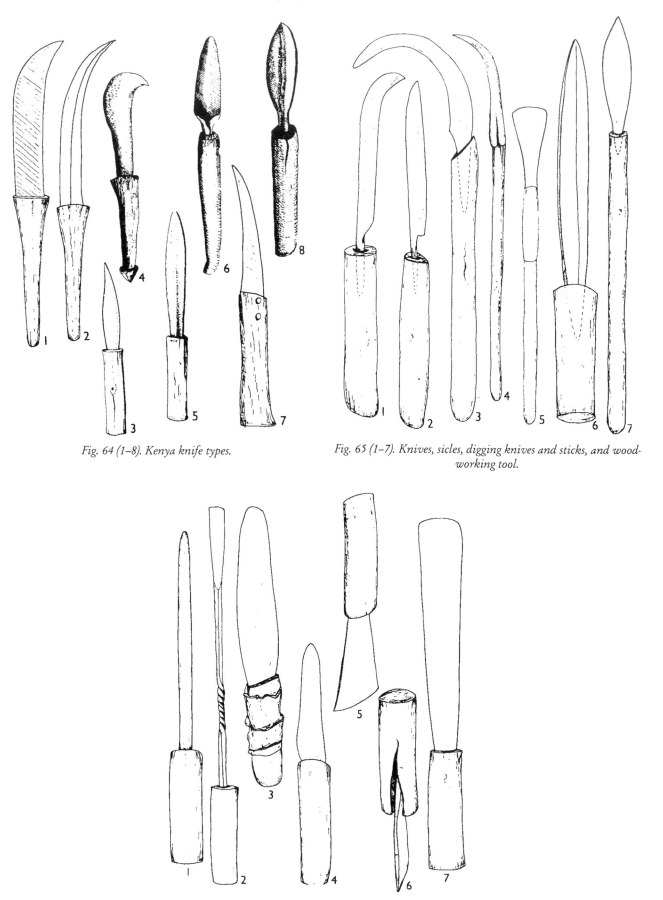

Fig. 64 (1–8). Kenya knife types.

Fig. 65 (1–7). Knives, sicles, digging knives and sticks, and wood-working tool.

Fig. 66 (1–7). Castrating and branding irons, knives and skin scrapers.

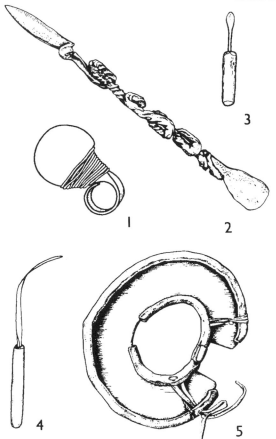

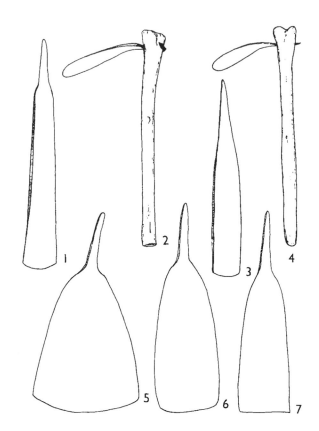

Fig. 67 (1–5). Circumcision knives, finger-ring and wrist knives and a tooth remover.

Fig. 68 (1–7). Different hoe types produced by a Taita smith for different purposes.

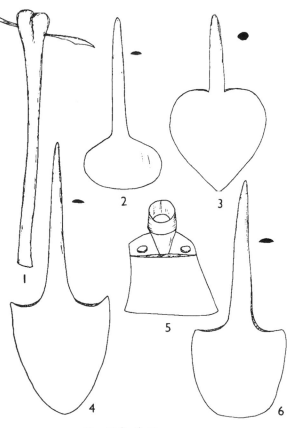

Fig. 69 (1–6). Hoe types.

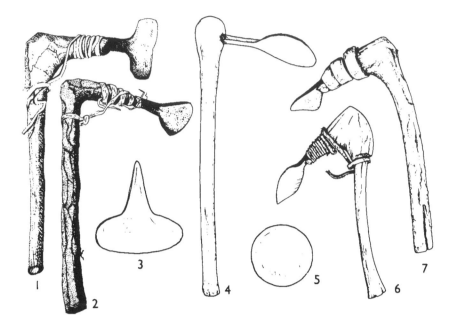

Fig. 70 (1–7). Hoe types and methods of hafting.

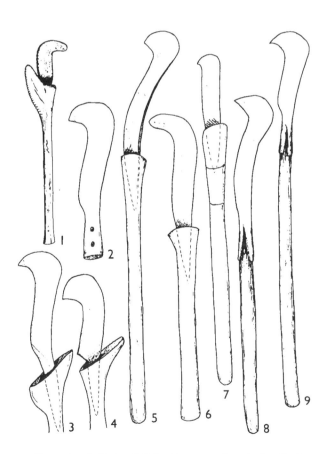

Fig. 71 (1–9). Slasher (bill-hook) types and methods of hafting.

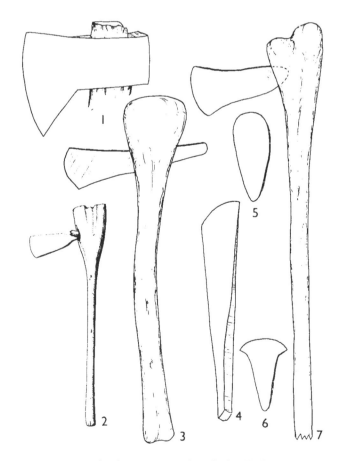

Fig. 72 (1–7). Axe types and methods of hafting.

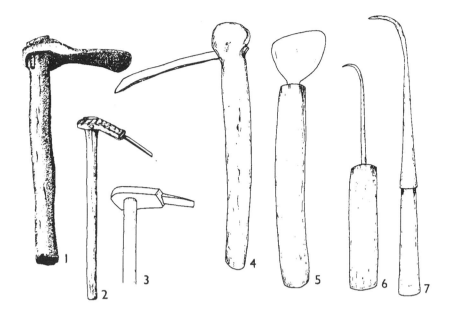

Fig. 73 (1–7). Adzes and woodworking tools.

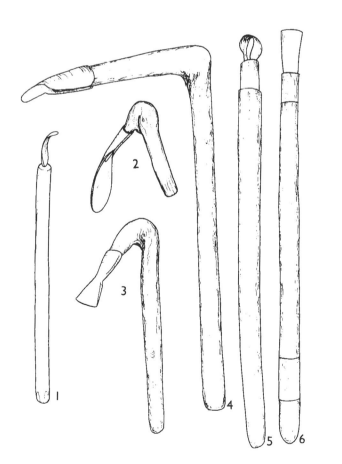

Fig. 74 (1–6). Adzes and woodworking tools.

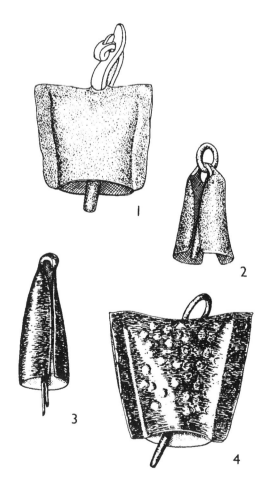

Fig. 75 (1–4). Bells worn by livestock.

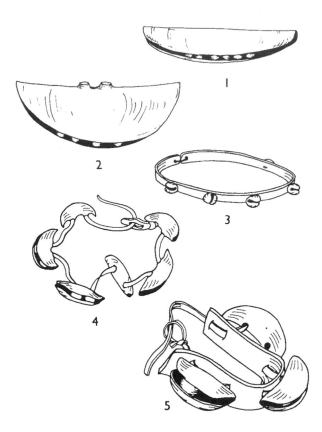

Fig. 76 (1–5). Bells worn by people.

Bells are worn by people on ceremonial occasions, especially when dancing. Large single bells, long horizontally (Fig. 76, Nos. 1 and 2) are worn tied on the thigh, while single or multiple small bells (Fig. 76, Nos. 3–5) are attached to armlets, bracelets, anklets and sometimes belts. Bells are also worn by musicians to provide accompaniment to their other instruments[44] and by women to warn men (who in certain conditions are not allowed to see them)[45] of their approach.

Bells are also worn as a protective ornament. They are a favourite form of amulet for tiny children because the jingle attracts them and encourages them to walk and because mothers can locate them easily if they wander off. In western Kenya[46] bandoliers of tiny bells are worn as protection against the recurrence of a certain form of madness. Sometimes[47] a bell is included amongst sacred clan objects which are believed to protect the whole clan from sterility, poverty, disease and other calamities.

The attitude towards Smith's iron products

Protective iron ornaments, made by smiths for themselves and their families as well as for the rest of the community, are considered to be one of the most important products of smiths. The attitude to all artefacts produced by smiths is ambivalent for they are not only capable of providing protection, but are also highly dangerous and can cause harm. For this reason smiths always bless their products before handing them over. This is usually done by spitting on them and making a silent blessing,[48] some smiths just murmur an audible blessing over them.[49] A smith who does not bless his products is liable to lose his customers, for blessing a tool not only ensures its success but also reassures the purchaser that no harm will come to the users from indirect contact with the smiths' supernatural powers especially his curse, for if a smith withholds his blessing it has the effect of a curse. Those people with the greatest fear of direct or indirect contact with smiths also safeguard themselves from possible pollution, before accepting an artefact, by spitting onto their hands or onto the artefact, rubbing their hands with fat, or murmuring a prayer.[50]

Some explanation of this ambivalent attitude towards the smiths' products is called for here before describing the protective iron ornaments which smiths provide. Iron is always thought of as being black in colour. Throughout Kenya it is looked on with awe and respect[51] and is regarded as semi-sacred by many peoples because it is believed to have a strong mystical power. This attitude does not apply to other metals[52] probably because they were never mined or smelted in Kenya and, when obtained in trade, were never used for anything other than ornaments.[53] It does not apply, either, to iron ore,[54] which many peoples[55] regard as an unclean substance which is only purified by smelting. Even the taboos and rituals connected with ore collecting are observed only to ensure the successful outcome of the smelt.

Iron only acquires its mystical power during the long and arduous process of transforming ore into metal. The purification and transformation of this often hard rock-like substance into shiny metal artefacts can only be brought about by the use of fire which is controlled, in a shamanistic-like way, by an initiated smith whose professional secrets have been handed down to him from his smith ancestors whose spirits are believed to guide his work. This process, which must have seemed miraculous to the uninitiated, understandably gave rise to a belief in the magical power of the product and the belief that the smiths themselves were powerful magicians.

On one hand iron is regarded as beneficial because it is capable of giving the most powerful protection to men and animals in a variety of circumstances, whilst, on the other hand it is regarded as highly dangerous and capable of causing them great harm. Whatever the attitude it is invariably treated with awe and respect because it is a powerful substance.

The iron, itself, does not have this power until it has been activated by a smith. It can only be activated by undergoing both the smelting and forging processes. It must have been *heat-forged into an artefact* and then *blessed by a smith* in order to provide protection. Iron blooms cannot be used to protect people because they have not yet been forged into artefacts. They cannot harm people either unless they are stolen from a smithy, or have otherwise had a smiths' curse placed upon them. Iron not heat-forged by a smith can neither provide protection nor cause harm.

The smith is the vital link. The mystical power of iron and its successful production, depend on the mystical power of the smith which is inherited from his ancestors and, ultimately, from God. Only smiths have this power for it is passed on to them at the initiation ceremony. If they do not remember their ancestors in their prayers, or fail to observe the taboos laid down by them, their power will be lessened and their ironworking will be unsuccessful. The smiths' power is not connected, as has been suggested (Cline 1937: 115–17 quoting Guttmann), with the fact that they make dangerous weapons which spill blood. Nor have the smiths' tools any power of their own.

Fire plays the vital role in ironworking, particularly in smelting, because it "melts" the ore and separates iron from the residue. Smiths, however, are not thought of as having any special powers over fire. Like other people they incur impurity if they break the taboos connected with fire, but unlike other people, they are regarded as being immune from burning because they are protected by their ancestors.

All iron artefacts thus have the power to cause harm. They automatically transmit pollution and can therefore harm anyone and anything with whom or with which they come into contact unless the smith blesses them in order to render them harmless. This blessing can, however, be reversed if the smith's taboos are broken and his curse incurred, for the curse can be transmitted through contact with his products so that even innocent peoples are sometimes indirectly affected.

Thus, if a smith has protected crops or animals by placing a curse on anyone who may steal them, the curse is believed to be effective because the iron tools with which the crops are planted and harvested and the bells which are hung on the necks of the livestock, are provided by the smith and it is through them that the curse is thought to be transmitted.[56]

The thief is not the only victim, for anyone who eats food made from the stolen crops, or eats meat from the stolen animal, or even uses its skin for any purpose will also be affected. Any artefact stolen from a smithy has not been blessed, the smithy is automatically protected by the ancestral curse, so the stolen object itself is harmful.

There is a widespread belief that iron can damage crops by contact with them and with the earth in which they are growing. It is damaging to them because they are produced by the earth which also produces the ore from which the iron tools are made.[57] It also damages crops indirectly because it is antagonistic to rain.[58] If iron tools are used, drought will result and the crops will dry up and fail completely. This idea is prevalent amongst the Highland Bantu who did not traditionally cultivate with a hoe. Even nowadays many of them still use a wooden digging stick when preparing the land for the first crop[59] and when planting the crops,[60] but, at the same time, some women[61] wear an iron bell, when planting, in the firm belief that it will prevent any insect attack on the germinating crop!

In western Kenya where wooden hoes were used, and are still used in some places, only a wooden one can be used to bless the crops.[62] The neighbouring Kalenjin believe[63] the exact opposite: to ensure good crops their planting must be done with an iron hoe made from ore smelted and forged in the traditional manner and blessed by a smith!

Most harvesting can be done with iron tools but there is a general belief[64] that harvesting root crops (such as yams) with iron is not advisable because if a tool strikes the root it will cause it to decay. Pointed wooden sticks are therefore used.

The products of a smith are equally powerful in combating harm and misfortune when blessed by him,[65] but first, he himself, must be protected from suffering ill-effects from inadvertently breaking any of the ancestral taboos,[66] for if his smith ancestors are displeased for any reason[67] they can cause his powers to weaken and his ironworking to fail. A smith must also be protected from the possible sorcery of a jealous fellow smith of another family,[68] or from the malevolent action of that smith's ancestors, and from the minor dangers of being burned by sparks jumping from the fire or of being struck by exploding pieces of red-hot iron.

Kenya smiths, like the Kenites of the Bible (Forbes 1950: 78), therefore wear special insignia to protect them and to denote their calling. This takes the form of an iron bracelet or, more rarely, another iron ornament.[69] Smiths of a few tribes[70] do not wear these insignia but are scarified instead.

These ornaments, with rare exceptions,[71] are all of twisted iron. The typical smiths' bracelet preferably has a central loop opposite its opening[72] (Fig. 77, No. 3; Fig. 78, Nos. 8 and 9). The twist in the iron is significant because only initiated smiths are capable of twisting a fairly thick iron bar, for only they can heat-forge iron.

By protecting the wearers from the dangers to which they are exposed when working iron, these ornaments protect the ironwork itself. They also identify the wearers as smiths ensuring either respect from fellow

tribesmen or avoidance if that is their custom, while amongst groups where smiths are inviolate enemy tribes can avoid killing them or harming their families or property. In addition the insignia acts as an advertisement of the smith profession to would-be customers. For these last two reasons some smiths,[73] who may be lax about wearing their bracelets whilst working, always wear them when walking abroad especially when going to market or attending ceremonies.

The bracelet is usually worn by all initiated smiths even when they work together. It is never worn by apprentices, although occasionally apprentices do wear a special ornament.[74] The bracelet is always worn on the smith's right arm because he is a male. It is sometimes inherited.[75]

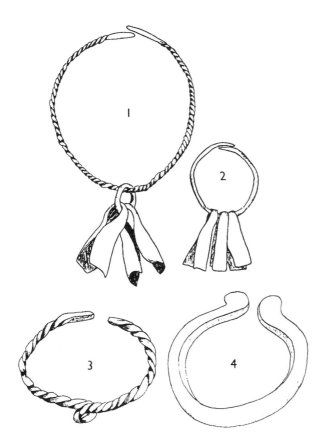

Fig. 77 (1–4). A smith's twisted iron bracelet and other protective iron ornaments.

The wives and children of many smiths also wear protective ornaments for they too are exposed to the dangerous ancestral forces by reason of their contact with the smith and with his work. Because they may have to visit the smithy on errands and, in rare instances, actually work there,[76] they are particularly vulnerable to danger from breaking the taboos. These protective ornaments take different forms.[77] If a bracelet is worn it usually has no central loop and must always be worn on the left

wrist, but the most common ornament is a twisted iron neckring often with an attached pendant or pendants[78] (Fig. 77, No. 1; Fig. 80, Nos. 3 and 4). Although the children of most smiths[79] wear protective ornaments, some smiths do not consider them necessary for they believe that their children who fall ill have only to touch the hammer in order to be cured.[80]

In many countries iron has, from its earliest days, been regarded as having powerful protective properties. Worn on the body it is a good luck symbol. It is believed to provide protection from and invulnerability towards illness and loss of life, sorcery and witchcraft especially the evil eye, infertility and abortion and many other things. It can also be used as a gesture to ward off thunder, lightning and rain.

Its use for these purposes is widespread in Africa[81] and we know that it has been used thus in East Africa for several centuries.[82] In special circumstances[83] smiths provide non-smiths with their own particular ornaments and also make for them a great variety of other forms of protective device. It must be emphasised that these iron amulets can never cure diseases, as stated by some writers (Seligman 1932: 257), but do render the wearer invulnerable to attack or prevent the recurrence of an illness which has already occurred. They may be directed against a specific illness or misfortune (or against illness or misfortune in general) but they are always directed against the ultimate cause i.e. the underlying mystical agent of the disease. This is almost invariably a malevolent ancestral spirit.

The power of such objects, like that of any amulet, has nothing to do with the wearer. The potency resides in the object itself. It has no inherent power but depends, for its efficacy, on its activation by a smith who derives his power from his ancestors and ultimately from God. While other amulets need not necessarily be made by the medicine man or holy man who activates them, iron amulets must be heat-forged in a smithy by the smith himself, and only he has the power to activate them because only he has been initiated into the jealously guarded secrets of his ancestors who are believed to help him in his work. He must also call on them as he blesses the recipient on whom he is placing the amulet. All these conditions must be fulfilled for an amulet to become potent. In addition a smith may treat the object with a secret concoction. People believe in the effectiveness of the smith's amulets because they are blessed by him and because, in agricultural tribes in particular, he himself is looked on as a blessed man because he has inherited the mystical powers of his ancestors.

The smith's own twisted iron ornaments are considered the most effective of his protective devices, but they are usually only given to serious cases referred by a medicine man. They are generally slightly different from those worn by smiths.[84]

A sick person invariably tries home remedies first. When these fail a herbalist is approached and only when there is no improvement is a diviner consulted. If the diviner believes the illness to be caused by malevolent spirits[85] or a sorcerer, he may prescribe the wearing of a protective iron device or, in the more serious cases, the wearing of a smith's twisted iron ornament.[86]

Obtaining these ornaments can be an expensive business for they can only be put on by the smith himself, usually at a small ceremony which includes the purification of the patient with chyme from a sacrificed animal which he, himself, has had to provide.[87] The smith spits on the ornament in blessing[88] and blesses the recipient as well. In some cases the ornament must be regarded as the receptacle for the illness because if other people touch it they too are believed to contract the sickness from which the wearer has suffered, and will have to be purified.[89] Most people consider the expense worth while for wearing a smith's ornament ensures a healthy and good life. It serves as a protection against all unknown forces including sorcery, witch-craft and wild animal attack.

A man who has fallen under a smith's curse is occasionally presented with a bracelet by the smith when he revokes the curse.[90] This establishes a reciprocal relationship between the two which is extended to their families. The family of the victim are often presented with ornaments as well.

People may go directly to the smith to order lesser amulets and charms but they are also sold in the markets for a very small sum, usually by the smiths themselves, but sometimes by medicine men who have obtained them from smiths. They are bought on the advice of a medicine man or merely because the purchaser feels the need for one. They can give general protection against any harm caused by malevolent ancestors, sorcerers, witches, or ill-omens, or only ward off specific things like snake-bite, stomach-ache, poisoning, or broken bones.[91] Some of them are charms to ensure riches and promotion in public life or, nowadays, in government service. At the same time they protect from demotion and from harm by rivals.

The protective power of these objects is less for, although they have been given a general blessing by the smith, they have not been blessed for a named individual who has undergone an expensive purification ceremony and had the ornament put on by the smith. Wearing them seems to give the same sense of security that a westerner gets from carrying tranquillisers in case of need.[92]

Iron amulets take many forms: bracelets, armlets, anklets, necklets and rings are the most usual. The greatest variety are found amongst the Interlacustrine Bantu but their amulets are not often in evidence for they are hidden under their clothes because, nowadays,

most Interlacustrine Bantu are nominally Christians. One of their commonest amulets is a tiny replica of their typical tool i.e. an iron slasher, but these miniatures, which range in length from only 2.5 to 23cm usually have twisted iron tangs, are never meant to be hafted (Fig. 78, Nos. 5–7; Fig. 79, Nos. 2–4)[93] and are not sharpened.

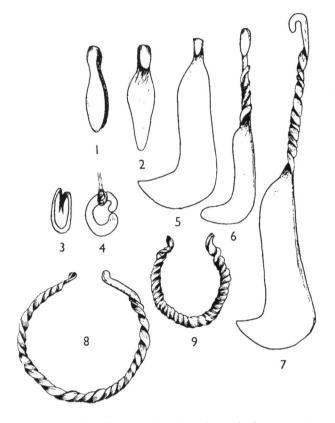

Fig. 78 (1–9). Smith's twisted iron bracelets and other protective iron ornaments.

Chain, made from iron smelted by a smith, is the most common form of iron amongst the coastal and Highland Bantu[94] and some other peoples.[95] It may be prescribed by a medicine man, or the wearer may have dreamed that an ancestor ordered him to wear it.

Smiths are frequently called upon to provide protection in connection with the crises of life, especially birth and initiation but occasionally also marriage and death. The effect of iron on people in these states is ambivalent for it can both harm and protect them. Unless an iron object is known to have been blessed by a smith it could equally well be carrying his curse since that is often transmitted through contact with his products. For this reason some peoples[96] remove all iron objects from a hut in which a woman is giving birth, while others first pretend to cut the umbilical cord with a piece of wood before actually cutting it with iron.[97]

Smiths provide ornaments to protect both new-born children and animals[98] from the evil eye, but since a smith himself usually cannot place them on a new-born child, as both Mother and child are in seclusion after birth, his wife may have to deputise for him.[99] The most common reasons for providing babies with protective ornaments are because they are sole surviving children or the sole surviving son or daughter; have been born in an unusual way i.e. are twins, have had a breach birth, or been conceived by a woman who has never menstruated or missed menstruating at the time of conception; or are crying continuously because an ancestral spirit[100] is worrying them and wants to reclaim them. Often it wants its name perpetuated.[101]

In all these cases it is usually, but not necessarily,[102] the smith himself who puts the iron object on the child at a small ceremony.[103] A simple ring of iron put in the helix of the ear (the right ear for a boy and left ear for a girl) is common. Bells too are a favourite form of amulet for tiny children.

Waist, arm, leg, finger[104] and neckrings with or without pendants are also used. Special amulets, of different shape for each sex (Fig. 78, Nos. 1–4), are worn by twins in western Kenya to protect them from the mystical force behind their birth which is a source of danger to them.

At the age of puberty (usually about 12 years), when all these children are considered to be past the vulnerable and dangerous period, another ceremony is held to remove the amulet and to bless them so that they will have long and fruitful lives.[105] The amulets of sole-surviving children are then sometimes transferred to their mothers who return them when the children marry.[106]

Barren women, and women who have lost all their children or have only one surviving child, always wear a smith's bracelet or other protective ornament to ensure their fertility, prevent them from miscarriage, and to safeguard the survival of any future children.[107] Their husbands may be asked to wear similar ornaments.[108] Livestock have small iron rings put in their ears for the same reason.[109] In some groups[110] when such women do conceive they are often advised to give birth to the child in a smithy, for it is there that the mystical powers of the smith ancestors are concentrated, and since the smith's blessing is as strong as his curse, no evil influence can affect them and the child is more likely to survive. To ensure a safe delivery some smiths use their bellows, during parturition, to blow all evil away.[111] The mother of dead children who have smith ancestry (however remote) on either side, can even secretly take a smith lover to ensure the survival of her

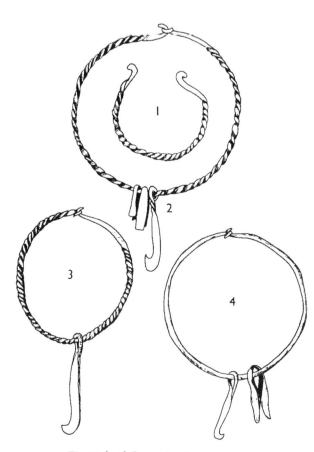

Fig. 79 (1–4). Protective iron ornaments.

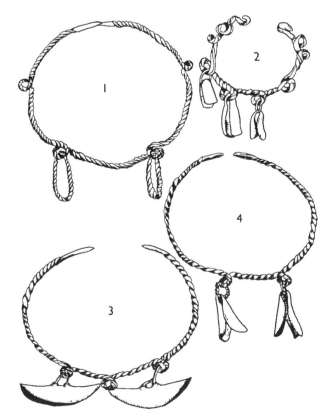

Fig. 80 (1–4). Twisted protective iron ornaments.

next child, for it is believed that such children die as the result of the malevolence of their smith ancestors. If the child resulting from that union survives the smith will remain the genitor of her subsequent children.[112]

As well as providing protection in the days of birth and early childhood, smiths also do so during that other vulnerable period of life — initiation, especially when this is by circumcision, for then candidates are in a state of ritual impurity for the whole period of seclusion and can be harmed by iron as well as protected by it. Many peoples regard the circumcision knife (Fig. 67, Nos. 2 and 4) as potentially the most dangerous iron object of all because an evilly intentioned smith could cause the sickness or death of the initiates by using it as the medium to transmit his curse.[113] It should never be a shop-bought knife but must be made and blessed by a traditional smith and must never be used for anything else.

In order to demonstrate that they mean no harm some smiths deliver the circumcision instruments, in person, to the homestead head who orders them, and then bless them in front of witnesses.[114] It is probable that this is also partly the reason why smiths' sons are operated on first in some societies,[115] while in others smiths' sons do not pay the customary goat or sheep.[116]

Smiths' twisted iron bracelets,[117] or other ornaments in a variety of forms,[118] are given as protection to initiates of both sexes of most tribes which practice circumcision and clitoridectomy. Sometimes a girl's ornament has a detachable part which she keeps to put on her first-born child. Sometimes loops are added to a girl's ornament after the birth of her first girl child (Fig. 80, No. 1).[119]

EXCHANGE AND DISTRIBUTION OF PRODUCTS

Smiths' products, except in a few rare instances where middlemen developed a trade in specific artefacts, were and are exchanged directly between smith and customer either at the smith's home or smithy or, more rarely, in local markets, but even today when there are regular established markets most craft specialists, including smiths, do not operate there. Instead customers go direct to the source of manufacture. In some agricultural areas smiths who have surplus products take them to sell at local markets; but they go there primarily to meet potential customers who arrange to go to the smithy unless the smith agrees to take an order and return to market the following week with the finished article. No smith anywhere wandered around like a door-to-door salesman trying to sell his products, nor did he travel far from his smithy to sell them.

Smiths usually lived and worked where they could most easily sell their products so they were — and are

usually to be found within easy reach of local markets or close to the main routes leading to them. A smith may live within a mile of the nearest market where he sells his wares and he may travel to the neighbouring market to sell them, but I have never known a smith travel more than ten miles to do so, or to travel to a market outside his own tribal territory. Except in border areas there is therefore generally a direct exchange of iron products between smith and customers in the smith's own immediate neighbourhood; it is the smith's customers who travel to buy those products, not the smiths who travel to sell them. In most agricultural communities customers rarely have to travel more than fifteen miles but they will sometimes walk as far as seventy miles in order to obtain the products of a smith famed for making first-class tools which are long-lasting and do not crack.[120]

Occasionally a number of people from the same district who walk that far to a famous smith are able to persuade him to travel to a pre-arranged meeting place in their area if they are able to guarantee an immediate sale of his products and if he is able to make enough artefacts in advance to make his journey worth-while.[121] A smith travelling in this way is, however, a rare occurrence; he will never work there even for a short period unless he is thinking of settling there because of insufficient demand for his products in his home area. Then he can only do so for a trial period if he has an age-mate there who can intercede with the elders on his behalf for he will, almost certainly, be encroaching on the territory of some other smith.

Apart from such instances it is pastoralists who have to travel furthest to obtain iron products.[122] Where smiths live and move with the largest pastoralist encampments[123] most of their customers live with them; those who don't and customers of other pastoralist groups have to travel long distances either to their own smiths (who live in semi-permanent smith settlements)[124] or if they have no smiths[125] to neighbouring agricultural smiths who live close to the inter-tribal boundary.

The majority of smiths sell their products within their own tribes but when a neighbouring tribe has no smiths (or its smiths make inferior products, or cannot make the whole range of products that are needed) it is on the borders that a brisk trade in iron arises. In some cases, however, when a tribe does not have many smiths, they are actually restricted from selling their wares outside as the tribe wishes to benefit from their work exclusively.[126] In at least one instance smiths from outside were welcomed by a smithless people on condition that they did not make weapons for the enemies of those people.[127]

The smiths themselves carry on this border trade directly from their smithies but occasionally from border markets which serve both groups of peoples. Mar-

kets are restricted to the agricultural areas. Before colonial times there were no *regular* markets. The elders of two adjoining peoples met to appoint a day and place where their people could gather to exchange goods (Mwaniki 1974: 38) but such gatherings were continually shifted from place to place (Mwaniki 1974: 303). Trade, mostly in food, was for subsistence not for the accumulation of wealth; it was carried on largely by women who were given safe conduct between the two groups sometimes even in time of war.[128]

Rich ore-bearing areas such as Samia, Kikuyu and Mbeere, attracted a sufficient concentration of smiths for small-scale iron industries to develop; it was in those areas that smiths began to make use of markets to sell their surplus ingots[129] in exchange for scrap iron and food. They sold them to customers and to fellow smiths who did not bother to smelt for themselves, or who did not have access to ore. Although many such smiths travelled into neighbouring territory to collect their ore, and sometimes smelted it there, others found it easier to buy ingots direct from smiths at the small border markets.

The increase in smelting led to an increase in forging and an increase in the amount of iron available as scrap that could be recycled, so that some smiths were also able to sell finished products in the markets. Only smiths who could produce surplus artefacts were able to do this as it entailed having plenty of time or labour and plenty of raw materials, and the latter were only available in areas of concentrated ironworking. The exchange of ingots was primarily seasonal. Some smiths realised that by concentrating on forging, and buying and selling at the most profitable time, they could become wealthy. They bought ingots from poorer smiths, in exchange for food, during periods of famine,[130] and stock-piled the raw material to make implements in readiness for the planting and weeding seasons when there was the greatest demand for their products.

As conditions became more settled the markets began to meet regularly at the same place. Many of those famous for selling iron developed into thriving trading centres. Markets did not develop amongst the pastoral and semi-pastoral agricultural communities except where the smith caste occupied separate homesteads where those in strategic positions[131] developed into the largest trading centres in the area. Of recent years, small trading centres have sprung up all over the pastoral areas and smiths are increasingly moving to them to set up their smithies there, or on the outskirts.[132] Smiths in agricultural communities have not been attracted into the trading centres for, if they wish, they can take their ware to their local markets; not many of them do so because they either do not have the inclination or are unable to produce a surplus for sale

because they have neither the time nor the necessary amount of raw materials. Some energetic and enterprising smiths, who work together and are able to obtain sufficient raw material, do, however, anticipate the increased demand for their tools during the planting and weeding seasons by producing a stock of hoes and digging knives during the period when there is little demand for their goods. Some coastal smiths,[133] who make hoes in quantity, nowadays also make use of the trading centres. They sell the hoes to small shops or else place one on show in the shop and when a customer enquires about buying it he is directed to the smith.

The main reason why smiths do not gravitate towards these centres is because they still try to maintain the mystery and secrecy of their craft; they prefer to make articles only on request, while their customers also prefer to go directly to a smithy to obtain a custom-made artefact which they know has been blessed by a smith. Customers wanting special protective ornaments have to go there for the smith has to put them on personally, and other very heavy ornaments can only be fitted by a smith.[134] Another reason is because money is used almost exclusively in markets nowadays but most smiths in country districts still prefer to be paid in kind and most of their customers are only able to pay them in that way.

Customers ordering artefacts frequently go to the smith's house, rather than his smithy, taking with them a present of honey beer which smith and customer drink together whilst deciding on a mutually convenient day for production.[135]

Often customers cannot deal directly with smiths, especially with important ones who let it be known that it is bad luck to do so, their apprentices, therefore, (and occasionally their wives) take orders for them. The story told of the famous Kikuyu smith, Njabia, is that he would not allow customers to approach and speak to him face-to-face. Instead he employed a host of special messengers through whom customers had to convey their requirements.

It often happens that a customer in need of an artefact does not order it in person but sends, as mediator, an old man who is better qualified to bargain with the smith.[136] If a tool can only be obtained from the smith of a neighbouring tribe, a member of that tribe, married into the tribe of the person requiring it, is sent to buy it (Wagner 1949: 161) as a safeguard against it causing harm.[137]

An artefact might be paid for when it is ordered, but is generally paid for when the customer collects it. In rare instances a smith, who repeatedly does not finish tools for which he has been paid, can be given a public beating, as this defaulting is regarded as theft.[138] Customers who fail to pay smiths for their work, or fail to give the asking

prices normally considered fair, are liable to find themselves cursed by the smith. If the buyer already has the artefact it will then break as he uses it. If the smith still has it and anyone comes and takes it without permission, then disaster will befall them.[139]

Friends and age-mates of a smith, and his best customers, are often given small objects, such as arrowheads and tiny bells, free of charge. Other people have to pay for them, usually with small amounts of beer, grain or gruel (which the smith eats while he works),[140] for smiths have to protect themselves and their families from people who try to obtain articles from them cheaply or even try to persuade them to make them for nothing. Smiths are often given presents[141] in the hope that the donor will be given the best tool at the lowest price when he next needs one. In western Kenya girls are said to be keen to marry smiths so that their families will get free tools and protective ornaments; it is not unknown for married women to ingratiate themselves with smiths[142] in the hope of obtaining a free hoe.

Customers wanting larger objects are frequently asked to provide their own raw material[143] plus sufficient extra to pay the smith for his work. In those areas where iron ingots were produced it used to be possible for the customers to obtain them from local markets,[144] or from the apprentices[145] of some smiths in exchange for food, but scrap iron was, and still is, the most usual form of raw material. Broken tools and weapons are carefully hoarded by everyone for future use. In the back of many huts there is an old cracked pot, a basket, or leather bag, into which a variety of bits of scrap iron are put in readiness for the day when the family needs a hand-forged tool. The same applies to aluminium scrap which is carefully saved for making ornaments. Scrap iron was traded between non-smiths, and between smiths and non-smiths, long before scrap from commercially-produced iron became available. It was bought for a small amount of food, a skin, or a wooden container, by people who required tools but lacked raw material, or by those who wanted to make a gain by selling it to the smith.

The importation of iron into Kenya gradually made smelting redundant. Iron wire, traded inland from the coast, was first used as a substitute for ingots. The next great source of iron was the railway from which sections of the actual track, as well as easily extracted nuts and bolts, were stolen. Once commercially-produced iron goods were imported in quantity there was plenty of scrap iron; smiths came to rely on this more and more until today it supplies all their needs. Smiths' customers now save up not only their own scrap but any that can be salvaged from garages, farms and building sites. Smiths obtain most of the scrap, seen lying about their smithies and occasionally in their homes as well, in this way. Most smiths in country districts find

it difficult to obtain scrap from other sources nowadays as it has become a valuable commodity for which dealers scour the country. Dealers obtain high prices for it in the larger towns where it is recycled, prices which smiths cannot afford so they are sometimes short of raw materials and one smith, at least, has had to start smelting again.[146]

Scrap iron is even more difficult to obtain in pastoral communities which use few iron artefacts themselves and are a greater distance from any source of scrap from commercially produced goods. When pastoralists have to move quickly because of enemy raiding their scrap goes with them if possible, even though other things like stools have to be left behind.[147]

In at least one instance[148] pastoralists who could not obtain scrap brought a quantity of ore to the smith in exchange for a spear, arrows or protective iron ornaments; if they had come a long distance without food, they were given a goat leg as well as the products.

On the appointed day the customer presents himself at the smithy with his raw material, if he has been able to obtain any, and some food, and waits while the smith makes his tool. In many areas[149] customers were not allowed into the smithy so had to sit and wait some distance away.

When the smith has to provide the raw material himself the cost is higher. All transactions were carried on by barter and, in the majority of cases in country districts at this level of primary exchange, they still are (see Appendix VII). Amongst both agriculturists and pastoralists livestock are the chief means of exchange for larger items but equivalent values of other things can be accepted without premium. Foodstuffs are generally exchanged for smaller products and smiths who accumulate a surplus of food are able to re-exchange it for small livestock. Pastoralists pay for their iron goods mainly in milk,[150] meat and honey,[151] whilst agriculturists give whatever the smith is short of, or whatever he might need. He might be paid in yams, sweet potatoes, bananas, beans, peas, grain or honey.

Amongst the Highland Bantu millet was an important item of exchange so smiths found it most profitable to work after the harvest when millet was plentiful. In western Kenya hens and quails are exchanged for smiths' products; in one place[152] a mole is the most highly prized form of payment as it is considered a great delicacy and is very difficult to obtain. Smiths are also sometimes paid in things like wooden containers, baskets, feathers, beads and even labour, the customer digging the smith's field in exchange for a hoe.[153]

In general there was no stated fixed price and smiths were reluctant to name one. It was a matter of agreement over the items to be exchanged. If the tool was a sound one without cracks and the goat not too skinny a deal was concluded.

People gave what they could afford and, if possible, what was generally considered to be a reasonable price for the article. Thus a poor man might give a hen for an axe while a rich one gave a goat.[154] The smith would not ask the poor man for more because by doing so he could harm his own work; the idea being that as his craft was sent to him by God, divine retribution would follow such an act. Today this only applies in some underdeveloped areas. In their own minds, however, smiths usually fix a general price for each article according to its size and the amount of iron necessary to make it. This does not apply to protective ornaments which are considered to be of immeasurable mystic value and are hence very expensive.[155] In some cases smiths met together at markets[156] to discuss and fix the prices that they expected the average man to be able to pay for their products.

The prices of iron products are dictated by the law of supply and demand. They vary from place to place and time to time according to availability and the amount people are able to pay for them. In an area where there are many smiths and the tools are plentiful, and where there is a surplus of agricultural produce, they are cheaper than in one where smiths are scarce and there is little food. A pastoralist who walks many miles to an agricultural smith for a spear, is usually prepared to buy it irrespective of cost so will pay more for it than an agriculturist living a few miles away.

Prices also vary according to season for the demand for artefacts is seasonal. There is a great demand for agricultural tools during the planting and weeding seasons. Some smiths work hard in advance to prepare a stock of hoes and digging knives with which to meet this seasonal demand. There is also a seasonal demand for weapons. After the long rains and before the dry season sets in, when there is plenty in the land, all the ceremonies take place, especially initiation. Newly initiated warriors need to be equipped with weapons and newly initiated girls with metal ornaments. This applied to both agriculturists (Kenyatta 1938: 73) and pastoralists, but nowadays applies only to the latter who have not yet taken to wearing western dress.

In western Kenya, instead of direct exchange between smiths or between smith and customer, middlemen stepped in to extend the trading further afield. This secondary exchange, or trading on a wider scale in the hands of middle-men, was carried on mainly in finished products although some ingots were also traded. Hoes were the main item of trade and became the normal medium of exchange all along the eastern shores of Lake Victoria.[157] Hoes assumed this importance because the rapid growth of population, in an area which allowed no expansion, forced people to exploit the land more intensively. Bush country, previously used only for hunting, had to be turned over to agriculture, so there was an increased demand for agricultural implements, particularly iron hoes which were needed to replace the unsatisfactory wooden ones used by the majority of people.

Of the Luyia group only the Samia and neighbouring tribes had smiths who had established themselves within reach of the rich ore-bearing area of the Samia Hills on the Kenya/Uganda border. Until the Walowa, another Bantu group from Uganda, settled amongst them in the eighteenth century the Luo had no smiths. Further south there were smiths amongst the Gusii. Hoes became the most sought after products of Samia and made them famous. They were traded throughout Luyia country[158] and also to the Luo whose smiths made spears and other iron tools but not hoes.[159] Hoes became the currency of the area but even so the hoe trade rarely extended more than fifty miles from the source of production, and this was the biggest trade in iron that developed in Kenya.

Amongst the eastern Luyia and the Luo who were farthest from the manufacturing centre, hoes were, at one time, so scarce that one hoe had to be shared by an entire family (Barnett 1965: 55) and the man who owned one was considered wealthy. Hoes were used to buy land[160] and other commodities. They were given as bridewealth;[161] by sons-in-law to their fathers-in-law to strengthen their relationship;[162] as presents to friends; and as bribes to important people.

Those acting as middle-men were the central Luyia groups such as the Bunyore and Wanga who bought iron goods from the west and sold them to the eastern Luyia and to the Luo.[163] They obtained a hoe from smiths of the Samia and adjoining tribes in exchange for a bag of millet, simsim, monkey nuts or maize, and then exchanged the hoes for a goat, a sheep or a young heifer. These were then traded for ivory which was sold to Arab traders.

The further a hoe travelled the more the buyer had to pay for it. At one period a buyer who obtained three hoes for a goat or sheep direct from a smith in Samia, sold only two of them for the same amount in Kabras (Hobley 1929: 248).[164]

The great demand for iron goods for agriculture and for weapons with which to fight the wars of the nineteenth century led to an expansion of the hoe trade on a scale not seen elsewhere in Kenya. The smiths became very wealthy. Those of the Gusii (to the south of the Luo) were said to be the wealthiest men in the tribe.[165] They too, like the Highland Bantu smiths already mentioned, took advantage of famines to accumulate wealth. During a famine remembered as being one of the worst ever suffered, only the smiths were not forced to move because their ability to produce weapons gave them the power to be able to seize food from everyone else.

In spite of the growth in trade there was still a scarcity of iron goods away from the centre of manufacture and their cost was so high that it was prohibitive to most people. This led to an expansion in the knowledge of ironworking. Smiths wishing to move were readily accepted by other Luyia groups without smiths who were anxious to obtain cheaper iron products.[166] A considerable amount of intermarriage often takes place between the various Luyia groups and women from smith families were quick to see the advantage of sending their husbands or sons back to their fathers for training. The most famous case is that of a Luo who married the daughter of a Tanzania smith. She persuaded him to return with her to Tanzania to learn the craft which he then introduced into his area of Luo country which had no smiths.

The new smiths of tribes near the Samia Hills could travel there to obtain their ore, but unless those further afield could find a source of ore in their own districts[167] they were still dependent on buying ingots from the ore-producing area. The ingots too became more expensive the further they travelled. As tools became more plentiful the price was lowered[168] but there was little reduction in the trade in finished products as a result of this trade in ingots for even when the eastern Luyia had learned the art of ironworking many of their smiths could only produce simple tools like knives, and still had to buy their hoes from others.[169]

With the introduction of money and of commercially-produced hoes, and with scrap from commercially produced iron being easily available, smelting and the trade in ingots and hoes gradually died out, but hoes are still produced for local use by the majority of smiths in western Kenya, although they now usually sell them direct to their customers at a cheaper rate.[170]

Elsewhere in Kenya middle-men did not generally engage in trading in smiths' products as smiths preferred to deal directly with their customers. Nowadays this is beginning to change in some areas[171] as traders who buy from a famous smith can easily sell his wares in a far market merely by mentioning the name of the maker. One smith,[172] who felt very bitter about it, told me that he suspected traders of posing as owners of large fields in order to buy several hoes from him to re-sell elsewhere at a profit.

Although it was only in western Kenya that middle-men took part in the distribution of smiths' products, elsewhere they played an important role in the trade in metal ornaments, especially chain. In the forefront of this trade were the Kamba who in 1845 were encountered by Krapf (1860: 302, 357) in a village outside Mombasa where they "had been settled since the famine of 1836". His diaries indicate that there were Kamba settlements at the coast by at least the 1820s. He mentions that they were very fond of ornaments, particularly copper wire,

and that they traded inland in caravans of two to three hundred men to fetch ivory, cattle, sheep, goats and grease, to exchange with the Swahili and other coastal peoples for cloth, beads, copper wire and blue vitriol. The iron, ivory and cattle recorded by Reitz (Gray 1957: 61) as being traded to Arabs at Kwa Jumvu on the mainland of Mombasa was presumably brought there from up-country by these Kamba traders, for on his second journey into Kamba country in 1851 Krapf noted that there was "An abundance of iron of an excellent quality which is preferred by the people of Mombasa to that which comes from India, as they deem it equal to iron from Suez". The Taita are also mentioned as obtaining much of their iron from the Kamba.

These Kamba traders were probably trading to the coast for many years before that because trade in ivory at the coast was of long standing and Kamba were actively engaged in that trade. Oral traditions from mid-nineteenth century Meru age-groups (Fadiman 1970) tell of Kamba traders obtaining ivory from present Mwimbe, Imenti and Tigania areas (then occupied by Dorobo hunters) in exchange for "small amounts of metal from the coast."

This metal took the form of ornaments and chain as well as wire. The Kamba obtained them from the Bantu Giriama[173] who had become skilled chain and ornament makers after learning the techniques from the Bajun and ultimately from Arab silversmiths. It was not long before the Kamba also learned how to make them. They imported brass and copper wire,[174] and later bars of tin[175] and small copper coins,[176] and became equally skilled chain and ornament makers back in their own homeland. They traded the ornaments mostly to the rest of the Highland Bantu.[177]

Kamba chain making became famous and the chain much sought after throughout Kenya. It was sold to most of the neighbouring tribes, particularly to the Masai[178] who even today, continue to be good customers of Kamba chainmakers although they do not deal directly with them. Chain is sold in the local markets by length, the length being measured by stretching it from the thumb to the elbow.[179] Occasionally a stick is used to measure it. Such was the demand for this chain that Kamba chainsmiths, like blacksmiths, could also take advantage of famines to get a better price for it. During famines in their own country they were able to obtain a load of food from the Kikuyu in exchange for their chain (Wainwright 1942: 107).

Kamba chain was so much in demand that Lindblom (1920: 533) could write "In many remote places there are small Kamba colonies which have settled down principally to manufacture and sell chains. Up at Lake Victoria there are at Kisumu a number of Kamba who sell chains to the Kavirondo" (Luo).

In western Kenya the trade in metal ornaments was

concentrated round the shores of Lake Victoria. There the fishermen of the islands doubled as traders. According to Ochieng (1974b: 59–60) the fishermen of Mfwangano[180] and Rusinga islands in South Nyanza, who originally hailed from Uganda, traded their fish to the mainland Luo for grain which they exchanged for goats. With those animals they sailed to the south-east corner of Uganda to exchange them in S. Busoga for metal ornaments and bananas which they took back to the Luyia and Luo to barter for more small stock. This trade was taken over in the mid nineteenth century by the people of Mageta Island in the Luo district of Yimbo adjoining Bunyala territory in North Nyanza. They sailed to nearby Busoga for metal ornaments, bananas and salt, returned home to take on grain and pulses, and sailed on to Rusinga Island. They exchanged the bananas, grains and pulses there, and the metal ornaments and salt with the Luo of the South Nyanza mainland in exchange for small stock with which they returned to Busoga.

Metal ornaments were also traded to the southern Luo from the famous iron-working area of Nyangoko in the Sironga valley of North Mugirango in Gusii country[181] to the south (Ochieng 1974b: 62).

Apart from this trade in the hands of indigenous peoples there was an influx of Arab and Swahili, and later European, trading caravans (generally in search of ivory) from the coast, bringing with them cloth, beads, iron, brass and copper wire,[182] and chain which was manufactured for them at the coast by the Giriama[183] (Hobley 1929: 247).

All these transactions were carried out by means of barter for as late as 1897 the use of coinage was still restricted to the coast and to the few European outposts up-country.[184] Indigenous traders could only venture alone into alien territory if they spoke a closely related language, and not always then. Otherwise they dare not venture in alone. They always went in groups, the larger the better, especially if they were travelling from their own territory as the Kamba did.[185] Such groups were never free to roam about amongst another tribe for purposes of trade but had to obtain a guide at the border who expected to be paid for his services. They might also have to pay for the privilege of traversing the territory.

It might be supposed that with the ready availability of iron goods in the shops forging would die out as smelting has done but, in most areas, the smiths are able to compete very effectively. Unlike the shops, smiths can produce on request the exact type of article that a customer requires. Mass-produced hoes, for instance, come in one size and shape only, but agricultural peoples often require several different shapes and sizes for working different types of terrain and soil. Smiths can also supply tools when the shops run out of stock as frequently happens, and, usually, more cheaply as shops will not accept scrap in part-exchange for a

tool. Cheapness is not, however, always the main consideration for sometimes hand-forged tools are initially more expensive but are preferred because their durability makes them cheaper in the long run. Hand forging is also essential for tools which are used for ritual purposes.[186]

Smiths' artefacts thus have a reputation for lasting much longer and remaining sharp longer[187] than those bought in shops, and they rarely break from faulty workmanship. If they do they are repaired or replaced free of charge, a service which no shop is prepared to offer.

Notes

1 One smith in the Taita hills, who concentrates mainly on producing hoes, sells about ten a month except in the dry season when there is no demand for them.
2 e.g. the Kikuyu who appear to have copied the Masai-type sword.
3 Wooden wedges are normally used. Iron wedges are only used occasionally by the Luyia and Luo.
4 The coastal Miji Kenda group and the Kamba whose main weapon is the bow and arrow. The Kamba are good hunters and hunting must once have been their main means of livelihood.
5 Sebei smiths were not capable of making their own spears. (Roscoe 1924: 66). The Rendille were said (Chanler 1896: 253–4) to obtain most of their ironwork from their neighbours as their own smiths were not very good. The Kikuyu were said to make the best swords and spears so the Kipsigis generally acquired theirs from them rather than from their own smiths (Peristiany 1939: 149). (N.B. There were hundreds of Kikuyu squatters living nearby).
6 Hunting and gathering is an important aspect of the economy of pastoralists in the drier areas especially in the dry season.
7 The El Molo of Lake Turkana (Rudolf) still use them as fish spears.
8 Melland (1923: 159) makes the point that the Lunda and Kaonde myth tells that when God told these Zambian people how to make iron one of the first things that they made were spears to protect themselves.
9 The Pokot use them for this.
10 e.g. by the Kamba.
11 This was usually made for them by the Masai, although nowadays they will cold-forge one from an old commercially-produced panga blade.
12 The Pokot and Turkana of the north-west used all three types. Pokot elders can still make the stone tips, and their name for a spear with a fire-hardened tip is the same as that for a wooden arrow point. Haberlund (1963: 776) says that the Galla are said to have possessed iron at the time of their penetration into central Ethiopia. In the Nile Valley about 450 B.C. Herodotus found the middle Nile people likewise using stone and not iron arrowheads, although they knew of iron.
13 This is used by the Marakwet and Endo. The blade varies in shape but both blade and butt are tanged and the blade is never polished or sharpened. Each neighbourhood has its own *Swoger* which is used for oathing, as a witness in marriage transactions, and for stopping the advance of an enemy. Smiths always have a separate *Swoger* for themselves and it cannot be used by non-smiths (Nauta 1972: 45–52).
14 Also from the Didinga, now living in the probable homeland of these Southern Nilotes in the extreme south-east of the Sudan, come the only tanged spears used by the Karimojong just across the Uganda border.

15 Amongst the Somali, Borana, and Boni.

16 In western Kenya they are typical of the Luyia, Luo and Kuria but in the south-west they are also found amongst the Kipsikis and Masai.

17 e.g. the Nandi who have:

Tenget	a throwing spear.
Merokit	the generic term for a long-bladed spear.
Kagiganet	short handled spear.
Kapseruiyot	blackened bladed spear with burnished ridge and cutting edge.
Kaplelgoyot	burnished white blade.
Ereng'gatiat	Long-shanked blade.
Ngotit	the generic name for a spear.
Erembet	blade widening towards wings.
Mereet	broad-bladed.

(Information Dick Nauta)
The Pokot have almost as many names.

18 Used mainly by the Luo.

19 By the El Molo.

20 Many Masai swords are flat-bladed nowadays but on examination they turn out to have been made in Europe.

21 The Masai, Samburu and Rendille use them.

22 The Nandi, Tugen, Keiyo and Marakwet use them but neither section of the Pokot do.

23 The Pokot and Turkana.

24 The Kamba who do not use digging knives.

25 The Kamba in particular do this. In the Interlacustrine kingdoms to the west of Kenya an axe is part of the royal insignia in Karagwe, Toro, Ankole and Ruanda. In Ruanda its name means "the one who decides law suits" and it was hung above the entrance to the place where the Mwami was in session (Sassoon 1971: 208. Figs. 140, 142–144).

26 I have not seen it used by the Kamba, but the Kikuyu, Embu and Meru groups all use it.

27 The Rundi have a bill-hook (Widstrand 1958: 98) so have the Nyatura in Tanzania, and it is a common tool in Madagascar. It is also a common bush-clearing tool in Karagwe, Toro and Ruanda and formed part of the royal insignia of the kingdoms of Karagwe, Ankole, Ruanda and Toro (Sassoon 1971: 184–185, 234).

28 The Taita make the following:
Wide hoes are used for wider and shallower digging especially in the lowlands; narrower ones for weeding between close rows of crops and in the steep highlands where cultivation is often on very narrow terraces. The very long narrow blade is used where there is bad couch grass whose roots are difficult to extract. It is also used in soft swampy places where there are sedges and reeds, and for planting and weeding rice in the lowlands.
A wide blade is used in the lowlands where crops are wide apart and soil is only dug shallowly.
A long thin blade is used by men for digging up vegetables, mixing manure, digging lines for planting and neatening corners.
A medium-wide blade is used for weeding amongst maize and beans and for planting them. This is the blade commonly used by old women as it is not too heavy and cumbersome for them. It is easy to handle.
A long thin blade is used mainly for cowpea and bushpea cultivation on terraces.
Another one is used for planting and weeding vegetables by both sexes.
A wide blade is used by older women for everything but especially weeding.

29 e.g. the Marama use them.

30 The Kamba still use them. See notes 59–61.

31 The agricultural section of the Pokot use them but they are used only by men and then only in very stony ground. Women of the neighbouring pastoral Turkana also use them where conditions permit cultivation.

32 The Baganda of Uganda were said (Roscoe 1911: 378–9) to have used cow-ribs for hoes prior to Kimera, their king, bringing them from Bunyoro.

33 In Itesyo in Uganda there was a thriving trade in wooden hoes during the 19th century as Itesyo smiths made spears but no hoes. At that time one wooden hoe was exchanged for one chicken (Webster 1973: 100).

34 The Periplus of the Erythraen Sea (Schoff 1912: 6) mentions axes as being amongst the goods imported to east Africa. Widstrand (1958: 162) points out that the Ethiopian word for iron *Hasin* almost certainly derives from the Aramaic or Babylonian word meaning axe.

35 See note 135 the Smiths Status. The Swahili also oath by licking a hot axe, so do the Nyamwezi and Zaramo in Tanzania, while the Shambaa (Tanzania) put the foot on a hot axe when taking an oath, and the Kikuyu of Kenya have to remove an axe from red hot liquid (Widstrand 1958: 132).

36 The Jopadhola Luo of Uganda use an axe blade as a small hoe (Widstrand 1958: 77). The Pokot use an axe as an axe, as an adze, as a chisel and as a scraper for skins. The head is used unhafted as much as hafted, while the haft is used on its own to bludgeon oxen to death when no blood may be spilled.

37 Stuhlmann 1910: 56.

38 Roscoe says that the Bagisu were still using wooden hoes (1924: 13) and the Baganda were using a wooden digging stick to dig up potatoes when he visited there (1911: 379). In the mid 19th century Burat saw the Burundi using wooden digging sticks.

39 In Tanzania the Nyamwezi formerly used wooden hoes (Stern 1910: 152-58) but Stanley (1872: 545) gathered that later they were making iron hoes for a wide area. Others using wooden hoes were the Iramba (Obst 1912: 108–32) the Chagga (Johnston 1886: 439), the Iraqwe (Fukui 1969: 64) the Liguru (Young and Fosbrooke 1960: 31) Nyaturu (Baumann 1894: 190, 200–20) and Kara used them well into the nineteenth century.

40 In Kigezi one hundred smiths, apparently all of the same family, were said to be working in one village at the turn of the century (White 1969: 65). In Samia there were reckoned to be 82 smiths in 1900 but by 1914 they had dropped to 30 and in 1972 there were only two (Were, 1973).

41 For making skin clothes, bags of various sorts, and sandals.

42 e.g. On favourite or name-oxen by the Pokot and Turkana.

43 Not only is the owner more likely to hear it being stolen but if the thief touches the bell, or the animal wearing the bell, he will be subject to the smith's curse.

44 Particularly by lyre players in western Kenya Luo and Interlacustrine Bantu.

45 Pokot women wear them when their sons are in circumcision as they may not see their mothers at that time and are fore-warned of their approach. Masai women wear jangling attachments to their legrings so that warriors can hear them coming if they are eating meat, for women may not see them eating meat.

46 Worn by Marachi and Wanga who have suffered from a madness which makes them wander around uttering strange cries.

47 The Taita do this. A knife is another sacred clan object which ensures fertility.

48 Mbeere smiths vary this by spitting honey beer on them.

49 Marakwet smiths murmur, "May the recipient get something good from you". Hobley (1922: 174) says that when handing a branding iron to a customer a Kamba smith said "May the cattle branded by this iron be lucky. May they escape disease and be fruitful". A Bukusu smith touches his hammer as he murmurs a blessing.
A Kikuyu smith rubs a piece of toothbrush twig (*Salvadora persica*) onto a sword or spear and says to it "If the owner of this meets with an enemy, may you go straight and kill your adversary, but if you are launched at one who has no evil in his heart may you miss him and pass on the other side without entering his body" (Hobley 1922: 169).

50 Cline (1937: 116) quoting Guttmann, says that Chagga (Tanzania) smiths also bless their products. The Masai rub their hands with fat (Merker 1910: 110, Hollis 1905: 330, Huntingford 1969: 109, Eliot 1905: 148) and then rub the weapon with grease. The Somali murmur verses from the Koran in the belief that all pollution will then be left behind in the smithy.

The Tugen believe that if they do not spit the tool will cut or otherwise harm the user. The Nandi (Hollis 1909: 127), Tugen, Tharaka and Marakwet spit on their own hands.

In Tanzania the Tatoga and Iraqwe wash the new tool and their hands in a stream (Cline 1937: 114). (Haberlund 1961: 202) says that tools purchased from smiths in Ethiopia must be purified before they are used.

51 The Igembe, for instance, say that an iron tool or weapon must never be carried in the same offhand manner as a wooden digging stick, walking stick or club.

52 Cline (1937: 140) suggests that it does.

53 Copper and Bronze spears were made in neighbouring Uganda but they appear to have been purely ritual objects associated with kingship.

54 Cline (1937: 140) suggests, wrongly I think, that Africans believe that metal possesses an inherent mystical quality because of its "hardness and brightness when found in the natural state."

55 e.g. Luo, Marakwet, Tharaka.

56 This is particularly true of the Interlacustrine Bantu.

57 There is no idea of agricultural tools wounding the earth as weapons wound people, as has been suggested by Zahan (Alexandre 1973: 106).

58 Dundas (1913: 525) says that iron tools were not used in the Kitui area of Kamba country in the early part of the century because the Kamba believed that iron was antagonistic to rain. Even when the colonial government provided them with free hoes it took a long time before they would use them (Lindblom 1920: 327).

The Kamba and other nearby peoples believed that the great famine of 1888–89 was due to the building of the Uganda railway (Dundas 1913: Z77–8) which laid "a rope of iron over the land" (Hildebrandt 1878: 372). The Kikuyu "Have periods when rain sacrifices are offered and during these no man may touch the earth with iron." (Dundas 1955: 48).

A Kamba *Kithitu* (an object used for oathing and to curse with) which contains iron is kept well away from agricultural land and is tucked away from rain because it is believed that if rain fell on it the crops would fail. The idea that the crops will fail is not peculiar to Kenya. It is found in Java (von Ende 1889: 10), and in Poland (Alexand 1627: 276).

The Bukusu believe that if two pieces of iron are beaten together to make a loud noise hailstones are formed which will damage the crops, and thunder occurs if it rains. They, therefore, do not smelt or forge during the growing season.

Members of the Pokot fire clan cut the rain with a spear to stop it.

Members of the Nandi thunder clan will seize an axe during a thunderstorm, rub it in the ashes of the fire and hurl it outside saying "Thunder be silent in our place" (Hollis 1909: 9).

A medicine man of the Gogo of Tanzania goes to the door of his hut and clashes together an axe-head and hoe-blade to ward off rain.

59 The northern Meru tribes still do.

60 The Kamba, Mbeere and Tharaka still do.

61 Kamba women in the Kilungu hills.

62 The Luo (and probably some of the neighbouring Luyia) must use a wooden hoe.

In neighbouring Tanzania, in the 19th century the Nyatura also only used wooden hoes in their planting rituals (Baumann 1891: 190, 200–20l).

63 The Tugen and Marakwet.

64 e.g. from the Igembe in the east, and the Bukusu in the west.

65 e.g. Pokot protect their cattle and ensure their safe return in the evening by pointing a spear in the direction in which they went to graze. They will also point a spear in the direction of an outbreak of infectious disease and curse in the hope that it will not come to attack them. An old man's spear is considered doubly effective, but it must be a "pure" spear which has never shed blood except in sacrifice.

A Bukusu who hears an owl hoot in a tree near his homestead, protects himself, his family, and his property from the misfortune signalled by this harbinger of death, by striking the tree on which it perched with an iron hoe.

66 A Samburu smith must always wear his bracelet whilst working for he might inadvertently step over the hearth, bellows, or tuyere, thus breaking one of the strictest ironworking taboos. To step over the first two without it would cause his legs to get broken (Spencer 1973: 119 also mentions this) while to step over the last would bring him paralysis.

67 Malevolent smith ancestors are troublesome amongst the Kamba but much more so amongst the Luyia where they afflict a man with an illness curable only by taking up ironworking. At his initiation this man is given a bracelet, forged for him by his master, which he must wear always. If he does not the illness will recur.

68 Embu and Mbeere smiths wear their bracelets mainly to ward off the unwelcome attentions of malevolent ancestors, and jealous fellow smiths of other families who can bring illness to themselves and their families and harm their work. To be on the safe side they take other precautions as well.

69 Tharaka smiths wear small wrist bells which jingle as they work.

Embu smiths wear a special iron earring.

Bukusu and lsukha smiths wear finger rings, the latter on the middle finger of the left hand, and also anklets.

Bukusu smiths also wear neckrings. So do Idakho smiths.

70 Tugen, Luo and Kamba. Kamba smiths are also protected by the axe buried in the smithy.

71 See Note 69.

72 Highland Bantu smiths' bracelets almost invariably have this loop as do those of the Rendille.

73 e.g. Marakwet who do a tremendous trade in spears to the neighbouring tribes.

74 Kikuyu apprentices wore an untwisted iron bracelet.

75 Kikuyu smiths, working for the Masai, told me that the eldest son who follows his father's craft inherits his dead father's bracelet, but all Masai eldest sons inherit the special iron bracelet worn by their fathers. The custom may be more widespread amongst smiths.

76 This applies particularly to the wives and daughters of Samburu smiths. A Samburu smith's wife must possess this ornament for her protection but it is not necessary for her to wear it in the smithy whilst blowing the bellows *if her* husband is wearing his bracelet, for his also protects her from getting her legs broken if she inadvertently steps over the hearth.

77 Womenfolk of lsukha and Marama smiths wear a special iron waistring, those of Logoli smiths wear special leg-bells, and those of Tharaka smiths a small wrist bell.

78 That of a Samburu smith's wife has a small pear-shaped twisted iron pendant which is said to symbolise the female nipple, while the round necklace itself symbolises the breast.

79 Idakho smiths do not like their children to wear obvious ornaments. Instead small iron amulets are sewn secretly into their clothes.

80 Bukusu. The hammer they touch is the *Enyoli*.

81 In Morocco (Leared 1876: 273) and in West Africa children wore bells and iron chains to protect them (Baudin 1884: 249, Ellis 1894: 113). The Bari of the Sudan (Seligman 1932: 37) wore shin guards and bracelets to ward off illness.

The Dime of Ethiopia (Haberlund 1961: 205) wore iron to ward off illness.

The Amhara and Galla of Ethiopia (Haberlund 1961: 205) bound their wounds with iron.

82 The earliest reference to the protective use of iron in East Africa comes from Ahmed Razi, a Persian of the seventeenth or eighteenth century whose "Haft Iqlim" mentions that the natives of East Africa prefer ornaments of iron to those of gold because they believe that "iron protects them from demons" (Huart 1895: 87–115).

83 e.g. amongst the Igembe certain unfortunate young men, whose mildest blows are always believed to result in certain death, have to wear a smith's bracelet forged especially for them so that their blows will be rendered harmless.

84 The bracelets worn by Igembe smiths, for example, are much thicker than those they forge for non-smiths.

85 Smiths' particular ornaments are always prescribed by Luyia medicine men for people seized by a special kind of madness (*Kamusambwa*) caused by ancestral spirits. If this condition, which is often indicative of a would-be diviner or medicine man, appears early in a man's life it is held to be showing itself too soon, so an ornament is worn to suppress it until he is considered old enough to follow the calling. It is also worn by people who have persistent bad dreams which are interpreted as portents of serious illness, such as leprosy or epilepsy, later in life.

86 The Bukusu say that such ornaments are only effective against illness caused by malevolent ancestors. They believe that the wearer will no longer be troubled because he is demonstrating his awareness of the fact that it was they who were causing the illness.

87 The Hayo, and the Purko Masai, have to provide the smith with a cow and some honey beer once the bracelet is on.

88 Chagga smiths (Guttmann 1912: 81–93) also did this. They spat on it four times.

89 The Isukha are very emphatic about this.

90 A Kikuyu smith gives one, under these circumstances, to the man whose homestead he has cursed because of a special grievance against him (Hobley 1922: 172). A Samburu smith presents one to a man who has broken the taboo of stepping over the hearth and bellows when he purifies him with the chyme of the ox which the man provides. Spencer (1973: 119) mentions the same thing but says that the culprit first has to re-cross the hearth four times and sacrifice a sheep. (Either animal can probably be sacrificed depending on the smith's demands). Because of their curse Rendille cannot withhold animals from smiths if they demand them. In return the smith usually gives a bracelet or sometimes another product like a knife, and the animal donor can get his iron products free from that smith in future. One informant, who said that a smith had given his whole family twisted iron bracelets and demanded a bull, added that the protection provided by the bracelets would probably be of far more value than that of the bull (Anders Grum personal communication.)

91 The Marakwet, who live on a particularly steep rocky escarpment, even wear toe-rings to protect them from the effects of banging their toes, for banging the toe of the left foot is a particularly bad omen there.

92 A Marakwet of my acquaintance who wears an amulet as a protection against further attacks of stomach ache from which he once suffered badly, licks it hastily, and chews up some cyperus sp. root provided by the smith, if he feels a twinge of his old trouble.

93 Marachi, Wanga, and Samia hang very tiny ones around the necks or waists of babies to ward off illness. This is usually done if the baby cries constantly for such crying is attributed to an ancestral spirit wishing to perpetuate its name in the child. The child must be named after the ancestor quickly before it becomes ill. The family of a smith who has recently died will be on the alert for the constant crying of a new male child. Once a slasher has been given, the ancestor is thought to become the boy's guardian spirit who will help him in his inherited craft, protect him from the malevolence of other spirits, and enlist their aid to combat any sorcery which might be used towards him by the living.

94 Amongst the Highland Bantu this applies particularly to the Kamba and, to a lesser extent, to the Embu and Meru.

95 One of the most influential elders amongst the Eastern Pokot wears iron chain around both ankles because a man in his position is a likely target for jealous and evil people.

96 Before a Kamba woman gives birth all weapons and other iron objects are carefully removed from the hut (Hobley 1922: 160); i.e. during the period after birth both mother and baby are very vulnerable to harm as they are in a state of ritual impurity.

At the building of a new Kamba hut, when its framework is completed but not yet thatched and before the ritual fire is lit in it, any iron tools left lying around inside the hut are removed in the belief that if they did not do so the house would always be cold and draughty (Lindblom 1920: 442).

97 The Kikuyu first pretend to cut the umbilical cord of a newborn baby with a splinter of wood from the sacred *Muthaka* tree (*Vernonia hostii* O Hoffin), and *Vernonia curriculfera* Hiern) (Leakey 1977: 5!5). Spencer (1973: 119) suggests that it is fear of infection, through cutting the umbilical cord of a newborn baby with an iron tool, that makes a Samburu woman who has lost many children go to a smithy to give birth to her next, because she knows that there it is protected by the smith's blessing and the cutting tool is similarly blessed.

98 A Kikuyu smith himself protects new-born goats and cows from the evil eye. The newly-born animal is carefully hidden so that no-one will see it before the arrival of the smith. As with a human baby it must be treated very early in the morning. The smith mixes a concoction of chewed-up heated charcoal, earth from a termite mound, bits of a sacred shrub (*Maigoya* = *Plectranthus barbatus* Andr.) and spit, and applies it to the mouth of the baby and around its neck as well as to the udder of its dam. An amulet was not mentioned but it is most likely that one is given.

Mbeere smiths provide protection from the evil eye by making a small incision under each eye and rubbing into it some ground-down flakes left on the anvil after forging.

99 In the Marangu area of Kikuyu the blacksmith's wife gives protection from the evil eye to a new-born child. This is done very early in the morning, if possible before anyone has seen the child and before it has taken anything to eat, for it is better done on an empty stomach. To cleanse the baby the smith's wife chews up a piece of charcoal, which she first makes red-hot, and spits it into her hand, adding to it a concoction consisting of earth from a termite mound, bits of a special herb (*Maigoya*), and more spit. With this she smears the baby's forehead and surrounds its eyes, smears its neck, knees, umbilicus, ankles, elbows and wrists in that order, and mutters "May the evil eye keep away". Finally she pulls out any one of its fingers with a sudden jerk so that the joint makes a cracking sound and the baby starts to howl. An iron ornament is then put on it and it is given its mother's breast to suck.

A Tharaka father usually sends a present of honey beer directly to the smith who, in return, makes the child a protective bracelet. See no. 101.

100 This idea is not confined to Africa, for the Annamites (Cadière 1902: 354) took a new-born child to a smith to have an iron ring put on its foot because a new-born was exposed to the attack of evil spirits. When the child outgrew it the smith broke the ring.

101 The Logoli believe that the ancestors make a baby cry because they want their names perpetuated. They name the child and give it a protective bracelet which when outgrown is carefully preserved in the house in a small pot (Wagner 1949a: 319). The

possession of an ancestral name is sometimes considered a necessary condition for being considered a human being; according to Lindblom (1920: 34–5) the Kamba only consider a baby so when its father has named it, hung a protective chain around its neck on the fourth day after birth, and had ritual sexual intercourse with its mother on the fifth day.

102 The Kalenjin group protect children troubled by spirits, and sole surviving children, but the ear of a Pokot child may be cut and a ring inserted by a member of the fire clan as well as a smith.

103 If a baby of the Isukha and other Luyia tribes cries continually it is taken as a sign that the ancestral spirits are troubling it and might cause its death, so a medicine man advises taking it to a blacksmith. The smith takes the baby into a roadway where, looking this way and that to make sure that there are no onlookers, he shaves its head leaving only a small tuft of hair on the back of the crown. He then drives an iron pin through the helix of its ear and bends it round to form a small ring onto which he hangs an ornamental bead or button. At the same time he invokes his smith ancestors saying "Fathers of our own people we thank you for giving us additional offspring, guide them and make them prosperous as they live amongst us; guard them from evil and the evil eye and render harmless those that might cause them harm".

104 It is unusual to use finger-rings for this, but the Kipsikis do.

105 The earring on an Isukha child remains in the ear until the child is about twelve years old. Then it is removed, by the smith, at a special ceremony at which an all-black hen is sacrificed for the child's purification. The smith invokes his ancestors again, makes many references to the circumstances of the child's birth, and asks that the spirit or spirits that were bothering it should now leave it in peace for the rest of its life. He then removes the earring and buries it behind the house.

106 As well as making a cut in the child's ear and fixing in an earring Pokot children are given a great bunch of iron to hang on their arms. This is later given to the Mother who eventually passes it on. If the child is a boy it is passed on to his wife.

107 In order to ensure conception and the survival of their children Samburu and Masai women wear a twisted iron necklet provided by a smith. A Purko Masai woman has hers put on for her by a smith at a small ceremony at which the smith rubs her, and all who participate, with iron flakes and dust left on the anvil after forging. In return he receives a cow which is sacrificed so that its chyme can be used to purify the woman. For the same reason a Luo woman visits a smith who pours the blood of a sacrificed goat into his bellows and blows it over her before giving her a protective bracelet. A Kambu woman goes to the smithy (never the smith's house) where he protects her by using the axe in some secret way.

108 When his wife does not give birth or his children are dying, a Bunyala man has an iron bracelet put on in the presence of all the elders of his family. It is not removed until the man dies, when his grandchildren remove it (Barnett 1965: 48).

109 The Luyia and Kalenjin groups both do this.

110 The Somali, Rendille, Samburu, Marakwet and Tugen all do this. Rendille give birth in the smith's hut not his smithy, and the smith makes a hole and puts an iron ring in each of the child's ears immediately after birth. The child is called *Tumal* (smith). (Information Anders Grum).

111 Marakwet smiths.

112 The Bukusu do this.

113 e.g. the Kikuyu. The circumcision instruments he makes are the razor for the actual operation, the awl used to pierce the ears of the boys which is ceremonially passed through the existing hole in the initiate's ear at his circumcision, the small iron ornament placed in the ear, and the specially forged knife used to kill the sacrificial ram. In return he is given beer, some of which he spits over them in blessing (Hobley 1922: 170).

114 Spencer (1973: 63) says that Rendille smiths "have the power to bless and curse especially in relation to dangerous iron objects such as circumcision razors".

115 No Rendille is ever circumcised before a smith. Smiths' sons are circumcised one month beforehand "to bless the knife". One son of a smith is also circumcised one month before the circumcision of *Sapade* women (whose circumcision is deliberately delayed until they are quite old) but not before that of other women (Anders Grum. Personal communication).

116 Igembe smiths never have to pay an animal for their circumcision as other youths do.

117 A replica of the smiths' twisted iron bracelet is worn at their clitoridectomy by Rendille girls, and by Embu and Mbeere smiths' children of both sexes. Boys wear the bracelet on the right wrist and girls on the left. Other circumcision candidates may also wear one if advised to do so by a medicine man.

118 At circumcision, Kamba girls have a small piece of circumcision stick with an iron bead on the end of it hung round their necks (Hobley 1910: 29).
Bukusu male candidates obtain, from a smith, fringes of iron beads which they tie around their waists so that they hang over their genitalia to ensure "that they are not afflicted with any ritual impurities which would increase the danger of the operation through ritual contamination" (Wagner 1949.II.341). After a month they attach sharp pieces of iron to the belt, put plain iron rings on each arm and, with a borrowed cowbell, bang the bracelets to announce to all within earshot they they have sinned against the tribal code. Anyone so inclined can beat them. All their sins must be confessed so that they are "pure" for the great day. At the actual circumcision smiths' sons, instead of carrying a stick like other initiates, carry a hammer which they have forged to show that they have accepted the fact that they must become smiths; then the smith ancestors will support and protect them in their ordeal. Without it they believe that they might run away in fear, bleed to death, or otherwise die.
On the fourth day after circumcision, when Sebei boys undergo a ceremonial washing, an elder brings an iron hoe, knife and bracelets to the initiates who spit chewed-up *Cyperus* sp. root over them and then sing a special song. This is a protection against a ring of white skin forming around the penis.

119 A twisted iron bracelet, with two twisted loops from which hang rings to which bells are sometimes attached, is also worn by newly initiated Mbeere girls just after the seclusion period. When the girl has her first female baby one of the rings is transferred to its left wrist. The second baby girl is given the second ring. For boys, and any other girls, other bracelets have to be made. A similar idea is to be found amongst the Marakwet and agricultural Pokot where an iron band, bound round the tip of the carved phallic circumcision and wedding stick, is taken off and put on the necklace of the first-born child.

120 I know of Kamba who travel this far, and Taita will walk the 30–40 miles from Kasigau to Wundany.

121 Kamba smiths who did this exchanged their tools for broken tools and small livestock which they had to walk home.

122 Some may have to travel about 100 miles.

123 As with the Rendille and Borana.

124 As with the Masai, and those of the semi-pastoral Kalenjin do.

125 Like the Turkana and Pokot.

126 According to Merker (1910: 318) the Masai imposed this restriction.

127 e.g. The Walowa, originally Bantu speakers from Uganda, were expert smiths who arrived in Yimbo in Luo territory in the early eighteenth century. They were given land in Ulowa on the condition that they never gave weapons to an enemy of the Kadimo clan who allowed them to settle there (Ochieng 1975: 22).

128 The Masai and Kikuyu ceased hostilities for a time to allow this trade.

129 Giitwi in Gaturi, and Ngindu, both in northern Kikuyu, were markets famous for selling ingots.

130 Njabia, the famous Kikuyu smith did this, and Mwaniki (1974: 145) says that the Embu smiths profited from the Mbeere ones in the same way.
131 See Smithy note 13.
132 This is happening in Rendille, Somali and Borana areas.
133 e.g. Giriama, Digo and Bajun.
134 e.g. very heavy aluminium armbands.
135 This is the custom of smiths of most of the Highland Bantu group who will not do anything without first being given honey beer.
136 e.g. Tharaka.
137 The Logoli do this.
138 This can happen to a Pokot smith. He is beaten at a council meeting of elders. Seligman (1928: 432–3) quotes Whitehead as reporting that the same can happen in the Sudan; a Bari smith who has been paid for a hoe but does not bring it when asked, can be beaten.
139 This is particularly true of the Isukha, Idakho and Bukusu, but generally no-one would dare to take anything from a smithy.
140 Leakey (1977: 309) also reports this, saying that women, in particular, exchanged cooked food for small things.
141 Bukusu and Isukha smiths say that this often happens.
142 e.g. the Hayo. Tharaka women are also said to try to have smith lovers in the hope that they will be given free artefacts.
143 The raw material sometimes included charcoal e.g. some Kikuyu and Imenti had to provide it.
144 See No. 129. Routledge (1910: 88), and Kenyatta (1938: 75), also mention this for the Kikuyu, and Mwaniki (1973: 138–9) for the Embu.
145 e.g. the Kikuyu (Leakey 1977: 309), Imenti, Tharaka.
146 The Mbeere smith whose smelting has been described.
147 I have known this happen with Pokot and Turkana.
148 e.g. Pokot brought it to Marakwet smiths.
149 e.g. Kikuyu.
150 For awls and tweezers the Masai gave milk (Merker 1910: 115). The Samburu gave milk for small things like knives.
The Rendille pay meat or two large wooden containers holding altogether 8–10 litres of milk, for 1 spear at present. (Information Anders Grum).
The Pokot gave 1 goat and a gourd of milk for a spear (Beech 1911: 18).
151 Marakwet smiths often get paid in meat or honey by their pastoral Pokot customers at present.
152 Logoli.
153 e.g. Samia, Marachi, Wanga and Kamba where hoes were a very late introduction.
154 This actually happened in Kamba country.
155 e.g. The Hayo had to give one cow when a smith fixed on a protective bracelet and also had to provide the smith with beer. The Samburu gave milk for knives but a cow for a twisted iron protective bracelet for a woman.
156 e.g. Kikuyu smiths did so at Giitwi market.
157 It does not seem to have extended eastward beyond the Luyia and Luo borders, although some hoes filtered into Kalenjin country.
158 The Tachoni Luyia took theirs to Msaba on the Uganda border (Barnett 1965: 55).
The Logoli went to Mumias in Wanga.
159 Johnston (1904:II:790) says that Luo smiths import hoes, but forge spears, knives, bill-hooks and axes.
160 e.g. by the Logoli. They were also used to pay hut tax when that was introduced. Two hoes were given for a tax of three rupees (Hobley 1929: 248).
161 An Idakho bride ceremonially carried one or two hoes, paid in bridewealth, plus some sorghum when she followed the groom to her new home. Hoes also formed part of Giriama bridewealth.
162 A hoe and knife were taken by the prospective groom's father to the prospective bride's father (Barrett 1911: 41).
163 The Luo of Gem used to buy goods from the Banyore who had

already bought from the Wanga or from the Bukusu (Barnett 1965: 55).
The Luo of Alego bought from the Samia and sold to the Luo of Gem, Ugenya and Asembo (Ochieng 1974: 67).
164 Ochieng (1974: 68) says that an Alego Luo would buy a hoe for one goat and sell it in Seme for two, or demand one heifer for two hoes when he had paid the same for six. He also says that the middlemen demanded baskets of grain, on top of the normal prices, as their profits.
165 So wealthy that one old man told (B.O.S.S. African History and Culture Quarterly of Bishop Otunga High School No. 2 April 1970 p. 9) how the cows and goats owned by his smith father were so numerous that the family lived almost entirely on milk and meat, a diet rare for agriculturists. Gusii smiths also trace themselves back to a smith said to be so rich that he had more wives than any other man then or since.
166 e.g. Barnett (1965: 55) says that the Banyala moved from Samia and went to live with the Kinusu people. The Banyala taught their skill to the Kinusu who later "passed on the secret to the Babihya and Bangachi clans of the Tachoni tribe". It is most likely that this was through intermarriage.
167 The Tachoni managed to find it near Lugulu (Barnett 1965: 55).
168 e.g. at one time in Marama people had to pay a heifer for a hoe but later on they paid only an ewe.
169 e.g. The Logoli had to buy theirs from the Tiriki (Wagner 1949:II:161). The northern Meru also bought spears from the Masai as they could not make their own (Radycliffe Dugmore 1900).
Chanler (1896: 318) said that Rendille smiths were not very good so the Rendille preferred to import ironwork from their neighbours.
170 Marachi and Samia smiths now sell a hoe or a spear for a hen. When they produce a surplus they take the artefacts to market about five miles away and sell direct to customers.
In the heyday of their ironworking Gusii smiths exchanged a hoe for a cow, but when commercially produced hoes appeared in the shops they could be bought for one rupee while a cow fetched ten rupees in the market so the smiths were gradually put out of business and took to agriculture instead (B.O.S.S. African History and Culture quarterly of Bishop Otunga High School. No. 2 April 1970: 9).
171 e.g. Kamba.
172 A Taita to whom customers came from miles around.
173 Often by way of the Rabai.
174 Hobley (1910: 2) says that the Kamba were very clever at working copper wires and that they said that "they learned the art from the Giriama". Most Kamba maintain this and the Giriama told me that it was they who taught the Kamba.
175 Lindblom (1920: 533) says that the Kamba got tin bars from Indian traders and also collected tin from biscuit boxes and the casing of old packing cases, with which they made massive arm-rings. Professor Robbins analysed a similar Zubaki bracelet for me. He reported that it was "almost pure tin analysing at more than 97% tin. The only other significant metal present is zinc which was detected quantitatively and which probably represents the remaining 3%". The Taveta also used tin (Willoughby 1889: 82), and it was imported into Tanzania (Burton 1860: 399).
176 Lindblom (1920: 530) reports that they also obtained the East Africa Company's small copper coins through Indian traders.
177 Particularly to the Mbeere, Embu and Meru. Orde-Browne (1925: 164) says that wirework was introduced irom the Kamba to the Chuka but that the Kamba still did most of it.
178 The Masai did not make chain. Merker (1910: 114) says that they obtained it from caravans or from neighbouring tribes. Some came from the Kikuyu who say that they learned chainmaking from the Kamba (Guttmann 1912: 81–93) but most came, and still comes, from the Kamba.

179 The Giriama sell a length measured from thumb to elbow for 1/-. The Kikuyu a length from thumb to shoulder for 40 cents. The Marakwet use a stick to measure it.

180 Barnett (1965: 56) says that there was plenty of ore on Mwfangano island, and iron used to be worked there, so they may also have traded their own wares.

181 Other Gusii areas famous for ironworking were Kitutu in N. Mugirango, and at Bassi, S. Mugirango, and Majoge (Ochieng 1974b: 62).

182 Arkell-Hardwick's (1903: 15) caravan carried with it *Uzi wa Madini* (thin wire), *Senenge* No. 6 (thick iron wire) and copper and brass wire. Gregory (1896: 34) wrote that when he passed through there was little demand for iron wire amongst the Kamba because they smelted iron. Lugard wrote (1893: 274) that in his time the Masai would only trade in iron wire, but by the time that Hobley was writing brass as well as iron "was in great demand in Masailand". Hobley (1929: 247–8) also says that trade wire in rolls about 15 inches in diameter, gauge about 8 BWG, was in great demand. Five pounds of No. 6 brass wire could be exchanged in western Kenya for seven hoes, and the Dorobo brought ivory to traders in return for wire, beads and cloth, which they then exchanged with the Masai for livestock (Chanler 1896: 353). Krapf (1860:*I*:268) mentions that copper and brass wire were being imported in the early 1820's. Burton (1860: 268) gives details of the trade wire available in Zanzibar for up-country trading. The traders had the brass wire converted into coil bracelets, by local ornament makers, for trading in slaves and ivory. At Ujiji in 1858 their value was double that of where they were made.

"White metal bracelets" made in Kismayo were said (Dracopoli 1914: 309) to be the trade goods most in demand by the Borana. They too may have been made by indigenous craftsmen as they would have been cheapest.

Brass was said (Johnston 1902: 846) to have existed as ornament amongst the Pokot and Turkana before the arrival of trading caravans. It is to be presumed that it had infiltrated from Ethiopia.

183 This chain was called *Mkufu* and was made of iron. It was said to be very popular amongst the Masai and others (Hobley 1929: 247).

184 Report of Sir A. Hardinge on the British East African Protectorate for the year 1897–8. This still applies to the trade between the Pokot and Turkana, and probably others.

185 Tate (1904: 225) met them at Laisamis on the road to Marsabit mountain. Von Hohnel reported (1894:*I*:331) meeting Kamba traders 50 miles north of Lake Rudolf (Turkana).

186 e.g. the first tree that a Giriama cuts for constructing a new house must be cut with a hand-forged axe.
The night before a Luo homestead owner moves his homestead he must spend the night at the new site with his hand-forged spear stuck in the ground beside him. If all is propitious he will then build there.

187 They have this reputation everywhere. The Digo maintain that a smith's hoe will last for six years but a shop-bought one will last for three if you are lucky. Samia and Marachi smith's hoes are said to last for six to eight years. Nails made by Digo and Bajun smiths, primarily for boats, also have the reputation of being far superior to those from a shop.

CHAPTER IV

The Smiths

HEREDITY, TRAINING AND DEATH OF SMITHS

Ironworking is a specialist craft; the only specialist craft in Kenya apart from potting which is generally in the hands of women. It is also a hereditary calling which is the jealously guarded preserve of certain families. Nowhere are those families restricted to one clan even in those tribes where smiths are of low status. The assumption that smiths belonged exclusively to one clan seems to have arisen partly because the vernacular name for the smith profession[1] has often been misunderstood to be that of their clan. Smith families are usually found in most clans within a tribe, especially if it has a long tradition of ironworking. There are, however, sometimes one or two clans who, for one reason or another,[2] are forbidden to work iron.

Sometimes there is one clan, which may be the leading clan[3] of the tribe, which is famous for its smiths because it is known traditionally as having been the first to introduce the knowledge of ironworking, and because for some time the majority of smiths were of that clan, but there are usually several other clans which are equally well-known as blacksmiths (see Appendix VI).

The fact that some clans are well-known for their blacksmithing does not mean that all members of those clans practise as smiths for the craft is handed down from father to son only in certain families. Fortunately not all a smith's sons desire to follow his trade for if they did there would soon be too many smiths. Generally most smiths teach only those sons who are most interested in the work and show most aptitude for it. In many cases only one son is taught the craft and that is usually the eldest son.[4] If he does not learn it is usually the youngest who is taught for youngest sons are considered to make the best smiths. The tendency everywhere is to teach the oldest and youngest sons rather than those in between. A smith begins to teach his eldest son in case he has no more sons or his younger sons refuse to learn. As there[5] is rarely work for more than three sons in a busy smithy some smiths will teach no more than three, and make it a condition that any others who insist on learning must move right out of the area to seek their fortunes elsewhere. This usually happens amongst pastoralists with few smiths. To be sure of having successors some smiths[6] place a curse on their sons so that they are forced to follow the trade.

A smith must have at least one helper to blow his bellows. If he has no sons, he takes a son of one of his brothers or sisters as his apprentice, or, if his earlier apprentices have left to set up their own smithies, he takes on a grandson. As a brother's son is not in the direct line of succession a ceremony may have to be performed by the neighbourhood elders "to divide the smithy into two". This allows the apprentice and his descendants to follow the craft, after the smith's death, and to continue to use the ancestral smithy.

If no apprentices are available within the family they have to be taken from outside but they must always come from a family which has smith forebears on either the father's or the mother's side. Usually they are grandsons or great-grandsons of smiths and are chosen from among the sons of the smith's best friends and age-mates. Even if a smith takes an apprentice from his son's wife's family that man can never have his own smithy and can only work as a smith during his master's lifetime.[7] It is very rare for a youth without smith ancestry to become an apprentice. When it does happen it is usually because a smith has moved into a new area belonging to another tribe which has no smiths,[8] or when a man from a tribe without smiths asks to be taught the craft in order to return to practise amongst his own people.[9]

It is usual for a smith whose master is still alive, however far away he may live, to obtain his permission and blessing before taking on apprentices from outside the family.[10]

Occasionally it is prophesied that a woman will bear a son who will become a smith[11] and sometimes there is a sign that a young man with distant smith ancestry has been chosen to become a smith. This usually takes the form of persistent illness of unknown origin,[12] bouts of madness,[13] bad nightmares,[14] or continued misfortune. The trouble is eventually diagnosed as being caused by the spirit of the ancestral smith agitating for his descendant to follow his calling because God wishes him to do so. The diviner advises that a cure can only be affected by training and initiating the sufferer as a blacksmith, and tells him to which smith he must go for training. This advice is always followed, for the sufferer is believed to die if he does not become a smith and to find the trouble recurring if he ever tries to give up the craft.

Before such a man can embark on his training, which is more costly than for normal apprentices, he may have to undergo a special purification ceremony for which he provides an animal or animals for sacrifice.[15] He is given protective iron ornaments to wear to prevent the trouble from recurring.[16] His relatives build a smithy especially for him to which objects from the ancestral smithy must be brought. There he is taught the craft alone in secret. A man chosen by a smith as his successor, but who is not willing to learn, is likely to be coerced into taking up the craft by being afflicted in the same way.

Smithies are usually located well away from homesteads so that children do not wander into them and harm themselves. Very small children are not encouraged to frequent smithies, but in rare instances where a pastoral smith's wife acts as his bellows-blower her tiny children accompany her to the smithy. It is not unusual for the two-to-three year old sons of such smiths to be given simple tasks to perform.[17]

Generally, however, a smith's sons do not begin to gravitate towards their father's smithy until the age of about seven to eight years, when most boys stop sleeping with their mothers. Really interested boys are continually loitering around the smithy watching their fathers. Often they are allowed to try pumping the bellows and sometimes, when the smith is exceptionally busy, they are asked to look after the part-made tools heating in the fire. They are never given any serious training until their voices begin to break at the age of about thirteen to fourteen years. Sometimes a simple test is applied to see if a boy is ready to start training. He may be asked to put his right hand over his head to see if his fingers reach below his left ear.[18] Apprentices from outside the family usually become interested in the same way.

A smith's son may work as an apprentice for about eight to ten years if he starts his apprenticeship when he is thirteen or fourteen, but apprentices from outside the family do not usually begin their apprenticeship until they are much older. The usual period of intense training for a young man who is intelligent, quick to learn and a favourite of the smith, is said to be three to six months if he can pay off the necessary fees in that time, but an apprentice who is not so good with his hands can take from one to three years to acquire the necessary skills, especially in western Kenya where wielding heavy stone hammers accurately is said to take a long time to learn.

Occasionally, in exchange for his tuition, an apprentice gives nothing but his services and a goat for sacrifice at his initiation,[19] but this is rare as blacksmiths usually demand fees even from their own sons, although the fees that they pay are always less than those for other apprentices. The fees are paid in instalments each of which is technically payable before the apprentice can proceed to the next stage of his training, but which, in fact, is not usually paid until he has completed that stage. If an apprentice in the last stages of training, when he has learned most of the secrets of ironworking, has fallen behind in his payments, or refuses to pay, he is threatened with the smith's curse. This forces the issue for he believes that if he is cursed he will lose his immunity to burns, which all smiths are reputed to have, and will be unable to smelt good iron or produce tools that do not crack. As a result he will lose his customers; furthermore he is likely to die of some dread disease.

Fees are usually negotiable between the prospective apprentice, or his father, and the master smith, but are sometimes fixed.[20] They are normally paid in goats, but can also be paid in sheep, cows, hens, baskets of grain and honey beer. Typical fees[21] for an apprentice from outside the family are firstly the present of a goat or sheep plus liquor to persuade the smith to take him on, then a black hen payable during the first stage of tuition, a goat or sheep payable during the second stage, and the same during the third stage, and finally one or two animals plus the food and liquor required for his ceremony of initiation into the craft.

Occasionally as many as forty goats or sheep were paid[22] but when such high fees were demanded it was usual for apprentices to be able to earn their own fees whilst working for the smith. As it was they who collected the ore they were entitled to a percentage of the pig-iron from every smelt. This they sold or asked the smith to convert into tools for them which they sold.

An apprentice from outside the family is generally welcomed into the craft ceremonially. The animal he brings is slaughtered. He is blessed, sometimes annointed, and introduced to the smithy and tools with such words as "Apprentice you are welcome to our smithy. We want you to learn something from which you can earn your living. God give you strength".[23]

His first tasks are to prepare and look after the fire. This entails learning how to blow the bellows properly. He is also taught all the taboos connected with the craft. He has to learn which woods are best for charcoal and, in some cases, how to prepare it; where and how to find the ore; and how to construct, load and tend a smelting furnace. Most of his apprenticeship is taken up by learning how to forge for that requires the most skill. In order to persuade his master that he is ready to embark on this second stage an apprentice will sometimes deliberately break a taboo.[24] After ascertaining the reason, his master fines him and allows him to proceed. He is usually then given a large stone as an anvil for, in most tribes, apprentices are not allowed to use their master's anvils, particularly at this stage. He gradually acquires skill in heating iron to the right temperature, beating it on the anvil to make simple tools like hoes or axes, and to rough-out more complicated ones for the smith who adds the finishing touches.[25] He also learns how to make handles and how to haft the tools. It is at this stage that he is taught the greetings used in a smithy[26] and the special songs[27] which help to while away the monotony of repetitive work and provide a rhythm to which to work.

In the third and final stage he learns most of the secrets of the smith's craft and is taught the more delicate work required in finishing tools.[28] He is then trusted to work on his own during the smith's absence. Sometimes[29] he is paid a monthly wage at this period, or the smith may even decide to share profits with him. At the beginning of this stage, in some tribes,[30] he is ceremonially enthroned on the smith's stool which he has hitherto not even been allowed to touch for fear of incurring the curse.

When the master considers that the apprentice is proficient in every way and when the apprentice can provide the animals and food necessary for his initiation, his master tests him to see if he can turn out well-made examples of all his products and then consults with his fellow smiths to fix the day for the ceremony. No man can ever be initiated as a smith until he has been formally initiated into adult-hood, for only then is he considered responsible enough to be entrusted with the secrets of the craft without divulging them to outsiders. In many cases[31] the initiate must also be a married man with children. If he is not, no matter how old he is, he cannot be initiated, for smiths are often classed as elders and, as such, are expected to be thoroughly honest men who understand the day to day problems of the people and are competent to act as counsellors. Only married men with children can command the necessary respect.

Before his initiation an apprentice has to decide whether he will stay on to work in partnership with his master, if the neighbourhood can provide enough work for both of them, or whether he will take the chance of setting up a new smithy in another area in the hope that there will be a demand for his products there, but he can only do this if there are no smiths already in that area. Sons, therefore, frequently stay with their fathers and are not formally blessed to inherit their smithies until they are elders and their fathers senior elders. In some cases[32] an apprentice without smith ancestry can never inherit a smithy, nor set up his own smithy, and must stop working iron as soon as his master dies.

The initiation ceremony varies in detail from tribe to tribe but conforms to the same general pattern everywhere. There is no difference between the initiation of a smith's son and any other apprentice. The ceremony may be celebrated for only one day or be spread over two days, and while some of it may take place in the smithy (the new smithy if the smith is building one), the main part may be either in the smithy or in the bush usually close to a river. Generally a smith's initiation is attended by all the other smiths of the neighbourhood who may travel from as far away as thirty miles. Occasionally,[33] however, the initiate's teacher and his assistants are the only smiths present for they fear that other smiths might be jealous of a newcomer and try to use sorcery against him so that he will not become a successful rival.

The master smiths may give the initiate a demonstration of how to smelt and forge, sometimes making the hammer with which he is presented at this time, but the hammer together with the other tools which are given to him are more likely to be made beforehand so that they are ready for the ceremony. The initiate's teacher usually has to give an account of his pupil's progress, itemising the products that he has successfully produced and praising his ability. The apprentice may then be called upon to demonstrate his ability, both in smelting and forging, to the assembled company so that they can see for themselves that he is worthy to join their fraternity.

The highlight of the ceremony is the presentation to the apprentice of the tools of his trade, particularly the hammer which is regarded as the symbol of his calling. He may be presented with one hammer only usually the largest one used for pounding, or with several hammers and his bellows, or with a complete set of tools[34] which must henceforth be used by him alone. These tools, the hearth and the initiate are smeared with chyme to purify them and more is scattered around to purify the smithy. The tools may also be anointed with blood or fat from the sacrifice, with honey beer, or with iron dust and flakes left on the anvil after forging.[35] They are then blessed and dedicated to the ancestral smiths.

The initiate is taught how to curse, and is taught the

remaining innermost secrets of the smith's craft which he has to swear not to disclose.[36] He is warned most solemnly that if he breaks the oath he will die, and that now that he is a smith he must remain one for the rest of his life.

During the ceremony there is feasting, drinking and dancing, while songs peculiar to blacksmiths are sung throughout. Most of these are in praise of smith ancestors, their tools and their work, and are often allegorical. At intervals the new smith himself is praised. He is finally blessed by the oldest smith[37] present who calls on the names of famous smith ancestors and pours libations to them as he conducts the blessing. When the sacrifice is made in the smithy it must be eaten there in its entirety. If any meat remains the participants have to return to the smithy to finish it on the following day. Woman are rarely allowed to eat it.

When a man is initiated as a smith the mystical power of his smith ancestors, derived ultimately from God, is passed on to him to enable him to smelt and forge iron successfully. Only an initiated smith has that power, and only he can impart it to his tools and products. In order to be successful he must, however, comply with all the rules and customs of his craft and observe the taboos laid down by the smith ancestors. During the ceremony the iron ornament[38] which smiths wear to distinguish them from other people, and which protects them from the dangers to which they might inadvertently expose themselves when working with iron, is either forged for the new smith or by him. A similar ornament is presented to his wife for she too must be protected from the mystical power of the ancestors.[39]

One tribe[40] speaks of the smith as "marrying" his tools at this ceremony while another[41] calls it the "wedding of the hammer" but this is not usual. It appears to be regarded more as the birth of a smith and, as with parturition, the ceremony may be followed by a few days rest when no work is done in the smithy.[42]

An apprentice does not forget his old master after this ceremony but usually sends him gifts, from time to time, until his death.

The death of a smith is rarely marked by any special ceremony. He is buried like any other member of his society. His grave, therefore, is unlikely to provide any evidence of his occupation. In a few instances,[43] however, ritual smelting takes place at the grave-side and the resultant iron, together with the hammer presented to the smith at his initiation, is buried with him in order to protect his living relatives from the dangers of the ancestral curse with which it is imbued. Such burials are not restricted to societies in which the fear of pollution from smiths is strongest nor are they indicative of the high or low status of the buried smith.

THE STATUS OF SMITHS AND THE ATTITUDE SHOWN TOWARDS THEM

The African "has preserved a knowledge that was lost to us by our first parents. Africa, amongst continents, will teach it to you; that God and the devil are one, the majesty co-eternal, not two uncreated but one uncreated, and the natives neither confounded the persons nor divided the substance."
Out of Africa.
Isak Dinesen (Karen Blixen) 1952.21

(Note: All Kenya peoples believe in an omnipresent God; the creator of the heavens and all that is on earth. As long as people are obedient to the mores decreed by the ancestors he is benevolent, but any deviation brings warning and punishment in the form of sickness, misfortune, or full-scale disasters.)

An understanding of the innate and automatic curse of smiths and of their ability to impose a deliberate and most potent curse, is vital to the understanding of the attitude shown towards them and of their position in society.

Throughout Kenya men who are initiated into the art of smelting and heat-forging iron are regarded as being different from everyone else in society by virtue of the mystical power which has been inherited from their smith ancestors and ultimately from God. Since this power is capable both of causing harm and providing protection from harm smiths are universally feared and respected whatever their status.[44] Close contact with them, their work, or their products, can be dangerous because it causes ritual pollution as a result of the innate and automatic curse.

In the more highly populated agricultural areas people are not so afraid of the automatic curse; fear of pollution from physical contact with a smith is consequently minimal so the smith's power is manifest more through iron and the tools used in ironworking than in bodily contact. The smiths have also generally managed to build up their wealth and prestige to a point where they find it necessary to maintain their position by making their craft exclusive. This is done by surrounding it with a veil of secrecy and mystery which is preserved by a host of strict taboos designed to keep people away, and by making use of deliberate and most potent curses which pastoralists rarely need to use.

Since these curses, which have seldom been mentioned,[45] form the basis of the beliefs surrounding smiths and their ironworking it is necessary to explain them in some detail.

In many African societies behaviour is controlled, relationships are checked and justice is administered in the form of a curse. Cursing is common throughout Kenya; it is believed that a person who is guilty of

misconduct sufficient to incur a curse will inevitably suffer illness or misfortune usually in accordance with the words used to curse him or the unknown offender, but the potency of the curse depends entirely on the person who imposes it. In principle the curser must be of higher status than the person cursed. Theoretically anyone can curse but in effect it is only those with some sort of mystical power whose curses are considered effective. Old people, who command respect and authority, have that power because they are closer to the ancestors who are closer to God, so the curses of those most advanced in age are considered the most powerful. Some people have additional mystical power, those with the strongest being medicine men,[46] so their curses are even more effective, but the curse of blacksmiths is, almost without exception, the most powerful curse of all.

The Smiths imposed curse

The smiths of every Kenya tribe have the ability to curse, but those in agricultural societies make more use of it to preserve their position. In one instance,[47] however, they no longer curse because they are now few in number and all Christians who have no fear of anything harming their work; in another[48] they do not do so because they are new to an area which has previously had no smiths and the people there have no fear of them.

In almost every Kenya tribe the smiths' curse is the most potent and therefore the most feared of all curses.[49] The smith who stated[50] that smiths are afraid of no-one, that nothing can protect anyone from their curses, and that there is nothing stronger than their own protection which is proof against any sorcery, is stating the general position of smiths throughout Kenya for generally only another smith can curse a smith. In only one case[51] is the curse of the tribal leader and prophet equal to or stronger than that of the smiths. Only men who have undergone initiation as smiths can curse for only they have the required mystical power. A smith too old to practise retains this power but some peoples[52] believe that his curse is less effective. Members of a smith's family can only curse if they are qualified smiths. Apprentices do not have the ability to do so.

A smith's curse is effective because of the mystical power inherited from his smith ancestors. He curses because something wrong has been done which he knows will gravely offend those ancestors. When cursing, therefore he calls on their help to ensure that the curse will be effective. Most smiths believe that a curse will not work unless they do this. The implication is that they are calling ultimately on God[53] although his name is rarely mentioned because "He is not as close as the ancestors". If the case is a particularly serious one

and the smith is very upset he might even sacrifice an animal in the hope of a rapid response to his call, but a curse need not be spoken; it can, on occasion, be willed silently, and even then the ancestors will make sure that it is effective.

In general no smith can curse merely because he dislikes or has a personal grievance against a victim, for that might bring down on him the wrath of his ancestors who would cause his work to deteriorate. Occasionally smiths will admit that they might curse for a personal grievance[54] or because malicious harm has been done to themselves or their families.[55] The fear that smiths will curse for these reasons is strongest amongst pastoral[56] peoples for in those societies the smiths' curse aims only at self-protection. It is never used to help the non-smith community as is customary amongst agricultural peoples where it may be used to protect the property of the community as well as that of the smith. In practice smiths rarely resort to cursing; when they do, it is almost always with good reason. A man has to be a repeated wrong doer, on whom normal punishment has had no effect, before a smith will deliberately curse him *to die*. Some smiths, however, who are known to be particularly ill-tempered are liable to curse if they are continually annoyed, interrupted or questioned about their work. So unauthorised visitors are even more careful than usual to avoid their smithies.

Fear of incurring the smiths' curse is so strong that people are generally afraid to joke with or insult a smith. This fear is strongest in pastoral and semi-pastoral societies[57] but even in agricultural societies[58] only the particular friends and age-mates of a smith dare joke with him and they take particular care that their joking will not annoy him. In popular imagination smiths are always thoughtful, serious and quiet people who never joke with anyone.

People are even more afraid of insulting a smith for it is believed, throughout Kenya, that to do so will result in death or dire misfortune. An imagined insult is enough to make many smiths[59] demand a goat for a purification ceremony. Even those few peoples who talk of smiths with disparagement behind their backs,[60] and sometimes even question their honesty,[61] never dare insult a smith to his face. In some pastoral societies even mentioning the word for smith, especially after dark, is likely to bring calamity to a homestead,[62] while to refer to a smith as such in his presence results in having to give him an animal to ward off the curse.[63]

Smiths can curse secretly, in front of a few witnesses, or in public as they almost always do when protecting the property of others. When death is intended the curse is usually made in secret. As a safeguard against indiscriminate cursing the smiths of some semi-pastoral groups[64] are not allowed to curse, or to

revoke a curse, without first obtaining approval from the neighbourhood council of elders. Some of them can then go to curse in secret,[65] but others[66] must curse in front of witnesses in case they take advantage of their powers. The smiths of pastoral tribes generally curse in secret.

Unless a smith goes to the scene of the crime to curse on behalf of someone else whose property has been stolen, he will always curse in his smithy because it is there that the mystical power of the ancestors is concentrated. In some cases[67] smiths meet together in order to curse. When this happens it is always the oldest smith present who will do the actual cursing. Some smiths[68] can only curse during the hours of darkness. Others use charcoal or soot to blacken themselves all over,[69] or to put just around the eyes.[70] The use of black, which symbolises evil and impurity, ensures that the smith ancestors, who are the real power behind the curse, will make it effective. It also makes the smiths themselves look fierce and terrifying. Smiths are often credited with having black spots on the tips of their tongues which are said to be an indication of their ability to curse.[71]

Smiths will curse if any of their household property, crops, or animals, are stolen, but they use the curse primarily to keep unauthorised visitors out of their smithies, to protect the contents from theft, or to recover them if they are stolen.[72] Fear of a smith's curse is, however, so great that theft rarely occurs; property can be left more safely in a smithy than anywhere else in Kenya.

Because all smithies have been blessed by smith ancestors whose supernatural powers are concentrated there, both smithy and contents are automatically protected by the ancestral curse. A trespasser entering when the smith is absent is therefore subject to that curse, so (except in the coastal area) is a person entering uninvited when the smith is there.[73] The effects of the curse are more severe if the trespasser touches any of the contents. If he steals anything he can be sure of certain death because many smiths rely not only on the automatic curse but also curse each time that they leave their smithies,[74] while a smith who discovers a theft always manipulates his tools as he pronounces the most powerful curse on whoever may have stolen his property.

Smiths who curse as they leave their[75] smithies often hang up something to indicate that they have done so. Anyone who enters an empty smithy and sees such a sign is usually so terrified by his action that he waits until the smith returns; the curse is believed to take effect as soon as he enters; he knows, therefore, that he is doomed to die unless he confesses and has the curse revoked at the earliest opportunity.

Fear of the curse in a smithy is so strong that the site of an abandoned smithy will be avoided, and never built on, as long as memory of it persists. When something has already been stolen the curse is usually spoken, for, under the circumstances, the spoken word acquires a mystical potency. Misfortune is believed to overcome the person who is mentioned, either directly by name or indirectly, in the spell. Sometimes a specific misfortune is mentioned as when a smith says "May he blow up as I blow up these bellows" or "May he be struck by lightning". A common curse, applied most frequently to women, renders the victim sterile. Often the smith does not mention a specific illness or misfortune but merely says "You will see" or "Get cold as when dead". In that case the victim may be attacked by any illness but most peoples recognise particular ailments which stem primarily from a smith's curse.

In western Kenya, these are said to be skin diseases like scabies or leprosy; swelling of the feet, arms, or stomach; or bloody diarrhoea and severe headache.[76] The thief may have a sudden accident, or even hang himself, or he may walk about singing and shouting in a demented manner. Sometimes he is compelled to mention repeatedly the things that he has stolen. Occasionally he may go berserk and use the stolen object to harm animals or people, but this is rare since the smith himself might be harmed.

The method of cursing and the words spoken vary with the circumstances. Most smith families have several set curses which are passed on from one generation to another. These curses vary slightly between families, between tribes and, sometimes, between different geographical areas of the same tribe if it is a large one.

The curse is considered to be far more effective if, when pronouncing it, the smith manipulates one or more of his tools. When used by the smith the tools themselves are imbued with the power of his ancestors who invented and blessed them and those tools play an important part in the magical production of iron and iron artefacts. The best tools to use are those which have most power because they are most vital to production, namely the hammer, bellows and tuyere.

Occasionally another artefact such as an axe, spear, or hoe, is used when cursing especially if the same type of artefact has been stolen. It is common practice for a tool utilised in this way by a smith not to be used again until the stolen object is recovered. If it is never returned, which is extremely rare, the tool will never be used again. If tongs are used for cursing[77] (Fig. 36, No. 3) some smiths leave the jaws open until the stolen goods are recovered.

The hammer is the tool most frequently used to curse as it is the symbol of the smiths' craft which is especially forged, blessed and given to him at his initiation. A smith may have several hammers but only the one presented to him at his initiation will be used.[78] He

utters the curse as he strikes the hammer on the anvil. He may use it to strike the iron flakes left on the anvil after forging,[79] to strike a piece of red-hot iron or iron tool,[80] or in conjunction with a chisel to cut a red-hot piece of iron in two.[81] This last method is most frequently used by the Highland Bantu. The alternative to beating the hammer on the anvil is to bang it on the place from where the objects were taken.[82] For this to be really effective the smith must leave that place without giving a backward glance.

In western Kenya a spear may sometimes be used instead of a hammer. This is not only because it is an important ritual object there[83] but because it is very sharp and is therefore thought to reveal the thief more quickly. During the cursing the spear is hurled into the ground.[84] A spear is always used if a spear has been stolen.

Bellows are used for cursing by a number of tribes particularly in western Kenya.[85] The bellows sticks are said to be the vital part as they pump the air. The bellows must be used together with the tuyere which, if the smith is not cursing by blowing into his fire,[86] is positioned so that the draught of air is blown onto the place from where the things were stolen.[87]

Air is generally blown out of the bellows when cursing, but as some smiths believe that their bellows always blow evil away, they blow into them instead. This is done by holding shut the intake valve in the diaphragm while blowing through the nozzle by mouth until the diaphragm fills up with air. The nozzle is then stopped up while the smith curses.[88] The victim's belly is supposed to blow up like the bellows until eventually his umbilicus bursts and he dies.

Other smiths who use bellows, slaughter a goat, pour its blood into the bellows bowls and then pump the bellows so that the blood is blown out through the nozzles. In this way they can curse so that the victim gets thinner and thinner and then dies, or becomes infertile if she is a woman.[89] They can also curse so that the victim will never again obtain a good harvest from his fields or many progeny from his livestock.

In one case[90] an assembly of smiths blew into a horn to curse a man who had persistently broken tribal custom.

Discarded tuyeres are particularly powerful. They can cause harm unintentionally if left lying around; people merely have to pass close to one to be affected. Smiths are, therefore, usually very careful not to throw tuyeres where they can harm innocent people. They are, however, frequently used to curse the guilty. They may be buried secretly, or hung up as a sign that anyone approaching will be subject to the smith's curse.[91] Some smiths spit on them to curse,[92] others hold up the tuyere and then smash it on the anvil cursing as they do so,[93] while others rub their fingers inside a tuyere then rub the resultant dust on various parts of their anatomy

and onto their tools before uttering the curse whilst sitting on the anvil.[94] In one area the smiths sometimes curse by blowing air into the tuyere from a bamboo tube.[95] Another method of cursing, used mainly by the Highland Bantu, is to heat a piece of iron or an iron tool[96] until it is red-hot and then plunge it directly into cold quenching water.[97] It is very important not to beat it because not beating hot iron with a hammer is tantamount to throwing it away, as the smith intends the victim's life to be thrown away.

These are the common methods of cursing but individual smiths may have different methods. Probably because they are of recent introduction, tongs are rarely used for cursing, and then generally only in conjunction with other tools (Fig. 36, No. 3).[98] Some smiths pour sacred honey beer through the loop of a twisted iron object[99] (Fig. 67, No. 2).

Smiths may invoke lightning to strike their victims[100] when cursing, or may use an animal as a vehicle for the curse. Calling on his ancestors for help in causing the thief to be wounded or killed by a wild animal the smith utters such words as "If he meets an elephant may it trample him", "If he meets a snake may it bite him".[101]

Smiths of the agricultural groups, particularly the Highland and Interlacustrine Bantu and to a lesser extent the semi-pastoral agricultural Kalenjin group[102] (but not those of the pastoralists), can also curse on behalf of others, but only in cases of theft of crops or livestock, almost never of personal belongings.[103]

A smith may be asked to curse after the theft has taken place in the hope that the stolen property will be recovered. In return he will be given anything that he wants. This is usually a cow, goat, or sheep. If the thief has stolen a cow the smith will go to where the cow was stolen, remove the stake to which it was tethered and hang his hammer into the hole.[104] If more than one cow is stolen the smith will pull out all the stakes but will only bang his hammer once as he utters the curse. He then takes the stakes back to his smithy.

Another method is to find the thief's footprints and to bang the hammer into them.[105] The victim's legs are expected to swell up or he may become a hunchback.[106] In some areas it is thought that he carries a particularly bad smell with him which lingers in the air after he has passed.

Most people do not wait for their crops or livestock to be stolen. Instead they go to a smith with a present of honey beer and ask him to protect the property, from possible theft, by placing a curse on anyone who might trespass on it or steal. In the case of crops this is most frequently done for fields which are out of sight and hearing of the homestead, particularly those which are planted with slow-growing crops like yams, bananas, or sugar-cane. The curse protects the crops at every

stage of their growth.[107] Granaries are sometimes protected as well. In some cases a whole community might approach a smith to ask him to protect a large area of bush or forest to save it from being cut down, to keep it free from grazing, or to allow it to lie fallow for a period.[108]

Smiths use a variety of methods to place a curse on property but most of them involve the use of hammers and/or tuyeres, or, more rarely, one of their iron products.[109] The curse is always made in the field or livestock pen where the crops or animals are to be protected. It may be done secretly[110] after which no visible sign is left to show that the property has been protected, but usually, when a field is to be protected, the smith makes a public announcement beforehand and word quickly spreads around that he is protecting it. In such cases a sign, frequently a tuyere, is left to show that the fields or animals have been protected.[111] Sometimes the smith announces his action immediately after cursing and specifies the period during which the curse will operate. During the growing season when these curses are in force it behoves everyone to take heed of the smith's announcements for, in some areas,[112] anyone unknowingly thieving from such a field is left to die. The knowledge that crops are thus protected is a powerful deterrent to would-be thieves. Usually no-one dares to enter; if they do the smith generally knows as he watches his neighbours to see if any are stricken with an inexplicable disease.

In most areas the curse on a field also affects the owner and his family who have to be warned to keep away until it is lifted, but, in some instances, they can pay the smith for a special "medicine" to protect them from the effects if they have to go there.[113]

The results of a smith's curse are mystical, but mystical ones are by far the most effective. They are believed to work on a victim wherever he may be and, in many cases, will affect not only him but also his immediate family who will suffer the same illness or general misfortune. Often the curse is transmitted through iron. This is generally given as the reason why a smith spits in blessing on a newly made tool before handing it over. A curse is believed to become operative through the thief touching the object[114] that he has stolen. This is usually an iron tool. The effect is accelerated if the stolen tool is used for cultivation, for if the thief eats any of the harvest produced by using that tool, he will die very quickly.[115]

When a smith curses to protect crops or animals on behalf of others, the person who actually takes them, his accomplices and anyone else who touches them or will touch them in the future are affected. Those who eat food made from the stolen crops, or meat from the stolen animal, or even use its skin, will also be affected. If the thief eats any of the stolen crop his stomach will swell and he will die before the next harvest. It is said

that nobody worries if such a man dies as the owner is thought fully justified in calling in the smith. In some instances,[116] during war smiths can curse the enemy on behalf of the people of the whole area. This is the only instance in which they can impose a collective curse.

Smiths also curse in order to prevent those who already know the secrets of ironworking from divulging them. Into this category come their wives, families and apprentices. Those who have divorced their wives,[117] or been deserted by them, always curse them, usually so that they will become sterile. The fear of this is so terrible that smiths' wives will suffer anything rather than leave, and they will return very quickly if they run away.

Some smiths place a curse on their immediate families. In practice this means that those sons who have been taught ironworking have to follow their father in the craft or suffer the consequences. Some[118] readily admit that they use the curse in this way because ironworking is an exclusive and profitable craft, of which only a few families in each district have knowledge, and they wish to maintain the monopoly.

The ultimate aim of the smiths' curse, like the maintenance of the taboos surrounding the craft, is to instil awe and fear into the non-smith community, and to make them believe in the supernatural powers of smiths. In this way the smiths are able to keep the jealously guarded secrets of their craft intact, and protect their closed society from outsiders. In agricultural and semi-agricultural societies the smiths' curse has wider implications for it controls thieving and other misuse of property within a tribe and minimises quarrelling thus helping to maintain the traditional social order. People incurring the smiths' curse are thought of not only as having transgressed the rules of the smith community, but also those of the whole tribe, and are thus considered to be undermining the structure of society. They are regarded as outsiders who cannot be re-instated as insiders until they have confessed, made retribution, been purified, blessed and forgiven. This re-instatement can only be done by the smiths.

If the person was present when he was cursed and the curse was of a specific nature, he will know that it has taken effect by his symptoms. If he was not present but has entered a smithy and touched things, he usually has such a guilty conscience that if he falls ill he will immediately suspect that he has been cursed. A sensible man will then hasten to the smith to confess and ask for forgiveness. Some men, however, may either worry themselves sick with fear, especially if they hear that something has subsequently been stolen from the smithy and the smith has cursed, or behave in such a strange manner that suspicion will inevitably fall on them. In such a case a man begins to attribute any misfortune suffered by himself, or his family and property, to the curse. In some instances he may even run away in the vain

hope of avoiding the consequences. Others who have inadvertently and unknowingly incurred the curse, usually as the result of eating crops from a field protected by a curse, may have no idea of the cause of their symptoms, but will find out as soon as they visit a diviner.

Thieves who escape the anticipated disaster sometimes become so cocksure that they are tempted to steal again, but the successful removal of a curse from another thief who is close to death acts as a powerful deterrent; it demonstrates that the illness was actually caused by the curse and was removed only by confessing and having it revoked.

The victim of a smiths' curse does not usually resort to counter measures until he is actually suffering from its effects.[119] Once the cause of the illness or misfortune is ascertained every effort is made to have the curse removed for death might be imminent. Generally the accursed himself does not go directly to the originator of the curse, but sends an elder as his mediator. This man tries to arrange a ceremony at which the curse will be lifted.[120] A smith is under no obligation to remove the curse he has imposed, nor can he guarantee a cure for that is brought about by God via the goodwill of his ancestors.

In some cases, usually if the victim leaves it too late,[121] the curse cannot be removed and the victim dies. After consultation with the elders a smith may also refuse to revoke the curse of a confirmed criminal who will deliberately be left to die. If the thief dies it is usual for the stolen things, together with an animal for reparation, to be returned to the smith by the dead man's family,[122] while a smith whose curse has killed a man often has to make a sacrifice to purify both himself and his smithy, for it is believed that the spirit of the dead man might seek revenge. It can cause the smith to have continuous nightmares and make his work deteriorate, or ultimately cause his death.[123]

Since curses can generally only be revoked by those who administer them, medicine men generally have no power over a smiths' curse,[124] and smiths cannot revoke the curses of non-smiths or cure anyone affected by a witch or sorcerer. Usually only the smith who imposed the curse can remove it,[125] sometimes another smith can do so,[126] and occasionally a council of smiths[127] or the leading elders of the community meet to do so in the presence of the man who imposed it.[128] In those cases where only the smith who imposed a curse can revoke it, if he dies before doing so his victim will die, but where it can be revoked by a council of smiths the victim of a dead smith has more chance of survival.

The removal of the curse is surrounded by as much ritual as its imposition. The ceremonies differ according to the nature and potency of the curse, and according to the tribe, district and family of smiths who impose it, but, in all cases, it is essential for the victims

to confess the offence, repent, make retribution, and be reconciled both to the person who imposed the curse and to the person who was wronged if they are different people.

The ceremony takes place at the smithy or home of the smith[129] who imposed the curse or at the home of the thief. In either case it is rare for a woman to be present unless she is the thief.[130] If possible the thief returns the stolen property[131] and his first action is to admit his guilt. He is usually questioned to make sure that he is the guilty party.[132] For reparation he invariably has to provide a "pure" animal of one colour,[133] as specified by the smith, for lifting a smith's curse always entails the shedding of blood by sacrifice, and the sharing of the sacrificial meat by the imposer of the curse and his victim.[134] Most important is the purification of the thief, and of anyone else who may inadvertently have been affected by the curse, by annointing him with the chyme of the sacrifice.[135] In addition he may have to drink a specially concocted "medicine" made from purificatory herbs sacred to his people.[136] Frequently an important ingredient of this "medicine", or otherwise of the purificatory ceremony, is the iron dust or flakes left on the anvil after forging.[137] The tools used for cursing may also have to be purified.[138] This purification ceremony sometimes gives rise to a special relationship between the smith and his victim. In one case anyone undergoing it may, if he so wishes, become the smith's apprentice,[139] while in another, the victim is presented with a smiths' protective iron bracelet which initiates a relationship involving reciprocal gifts.[140]

The smith then performs an act by which the original action accompanying the curse is either reversed or undone. In most cases he uses the same tools with which he imposed the curse, and goes through the same actions with those tools, but does so in reverse order.[141] In doing so he invokes the help of his ancestors for it is only with their power, derived ultimately from God, that he can remove the curse.[142] Finally the victim is blessed,[143] for a blessing is the positive counterpart of a curse. He is then accepted back into the community. His recuperation is believed to commence from that moment and, providing that he does not again lapse into thieving, he will remain healthy.[144] Such ceremonies take place at any time, the sooner the better if the victim is seriously ill, but some people insist that they take place very early in the morning before those concerned have done anything wrong which might adversely affect the outcome of the ceremony.[145]

In order to be able to harvest his crops from a protected field, the owner has to invite the smith to drink beer with him and persuade him to remove the curse. As with the removal of any curse this entails ritual purification. The owner therefore has to provide an animal for slaughter so that its chyme can be used as

the purifying agent. In great secrecy the smith then reverses the process by which he imposed the curse.[146] By way of payment for protecting a field a smith is usually given a small portion of the crop.[147] If the owner wishes to use part of his crop while the curse is still operative but does not yet want to have it removed entirely, he may have to pay an animal for "medicine" with which to remove the curse from the specific plants he wishes to harvest (Leakey 1977: 1228).

The Smiths as oath administrators

The smiths' curse helps to maintain order in society in several other ways. Smiths may be called on to curse those who break tribal customs,[148] or people who perpetually quarrel or fight,[149] but most important is their function as oath administrators.[150] Swearing an oath in a smithy before the smith's bellows,[151] on his anvil,[152] or by touching a red-hot axe,[153] is regarded as the strongest form of oath by several peoples.

The oath-taker (or takers for often they are protagonists), is warned clearly beforehand, by the smith, of the dreadful danger to which he will expose himself (from the curse) if he lies or falsely accuses anyone. This warning is usually sufficient to make a guilty party confess for he knows that the penalty for swearing falsely is death and that no-one will save him.[154] It is also believed that were a smith to accept a bribe from either party he would lose his mystical power for ever, for the ancestors would be so angered by the misuse of their power that they would take it away from him.

Because of the power of their curse smiths are also otherwise involved settling in legal cases (Routledge 1910: 91) such as boundary disputes[155] or the recovery of debts. Such is the power of their curse that merely by accompanying a man who is owed a debt, a smith can make the debtor pay up (Hobley 1922: 173).

Smiths themselves sometimes hold courts where smith thieves are tried by oath,[156] for only the combined curses of smiths can affect a smith.

Smiths and witchcraft

Linked with this fear of the smiths' curse and pollution is the fear of witchcraft and sorcery, for amongst most peoples smiths, if not actually thought of as medicine men, are regarded as being very little different from them, for they have to be initiated not only into the secret magical techniques of ironworking but also into the secrets of the magic that goes along with it. As Eliade (1962: 470–77) has pointed out these secrets closely resemble those of shamans. Like theirs they are carefully guarded and only divulged at secret rituals. As with shamans they may be made aware of their hereditary calling through bad dreams or sickness brought on

by a visitation of an ancestral spirit, and with help from their ancestral spirits they are able to discover thieves, protect men and animals from sickness and other misfortunes, counteract the work of witches and sorcerers, and sometimes prophesy the future,[157] while the iron which they produce can be used to prevent or stop rain.

When cursing wrong-doers smiths manipulate objects for the general good, but, like medicine men, they are also suspected of manipulating them for evil, and many smiths do, in fact, secretly practice sorcery. In western Kenya[158] many smiths are known to be both smiths and medicine men. As the latter they have the power both to help and harm people. The most feared and powerful substance for sorcery at their disposal is the iron dust and the flakes left on the anvil after forging, and this is frequently used,[159] but they also use many other things.[160] Some peoples[161] believe that their smiths have only malicious intentions, others avoid them because they believe them to have the evil eye.[162]

When smiths resort to sorcery the effects cannot be removed by the smith who caused them. They have to be removed either by another smith,[163] or by a medicine man,[164] or more frequently by a medicine man and smith acting together.[165]

There is usually a symbiotic relationship between smiths and medicine men. The smiths provide the medicine men with the much sought-after iron dust and flakes left on the anvil after forging,[166] and with protective iron ornaments which the medicine men prescribe for their patients. In return the medicine men send many patients to the smith so that he can make protective iron ornaments for them personally.

The automatic curse and the fear of pollution

Avoidance of physical contact with smiths for fear of pollution is expressed by a dislike of marrying them, having sexual intercourse with them, shaking hands with them, or striking or being struck by them. This fear is expressed indirectly by not allowing them to touch the food or food containers of non-smiths, or enter their homes and sometimes fields; by keeping livestock well away from them and by only accepting their products after safeguarding against the consequences.

Fear of contamination expresses itself first and foremost in an aversion to or actual prohibition against marriage and even sexual intercourse with them. Reports to this effect come from many parts of Africa, as well as Kenya[167] and its adjoining territories.[168]

Amongst all Kenya peoples averse to marrying smiths, members of smith families in extreme cases whether they are practising smiths or not are restricted to marrying into other smith families, so that smiths usually form an endogamous caste within a tribe. They are, however, subject to the normal rules of clan ex-

ogamy since smiths are to be found in most clans, and there is usually no prohibition on intermarriage with the non-smith members of a clan of which smith families form a part.

Where the marriage prohibition is most strict smiths could never marry outside their caste even if they abandoned ironworking or became very wealthy,[169] but non-smiths who helped with ironworking would never be regarded as smiths. They were merely looked on with contempt.[170] Non-smith men could generally not marry into smith families either, although there are reports[171] of them sometimes doing so, but if they did they themselves were forced to join the smith group and become smiths.

These strict attitudes are only now beginning to break down. The attitudes of other groups who frown on inter-marriage[172] have never been as severe, and are now even less so. Aversion to inter-marriage with smiths applies always to initiated smiths and to their sons and daughters of the first generation, but does not generally apply to anyone more distantly related, although some peoples would never even consider marrying the grand-daughter of a smith.[173] Amongst those whose attitude is more relaxed[174] it is possible, and probably always has been possible, for a smith to marry outside his caste and for his descendents to break free of it entirely after two or three generations. This is possible because in most societies there are rare cases of women who, for one reason or another, are unable to find husbands prepared to pay the necessary bridewealth. These women are usually orphans of out-castes, have become out-castes because they are themselves illegitimate or because they have given birth before being circumcised, or have been abandoned by their husbands. Such women are only too pleased to find a male protector of any sort.

In those societies there is usually no objection to inter-marriage in the second generation,[175] and, nowadays, some peoples have no objection to marrying a smith's son who has not taken up his calling,[176] but the old attitudes remain strong. Girls still refuse to dance with smiths[177] and men and women who marry them are openly insulted[178] although it is said that no harm is thought to come to them. Men who marry a smith's daughter are looked down on for they will never be able to lead men on a raid.[179] They are also ridiculed about not being able to satisfy their wives' insatiable appetite for meat, because as a smith's daughter has been used to a plentiful supply. For this reason some girls[180] do not mind marrying smiths because, with a plentiful supply of meat and food, they do not have to work hard in their fields. When inter-marriage does take place, fear of transmission of the smith's bad blood is usually still so strong that a woman marrying a smith has to undergo a special purification ceremony in order

to avert misfortune[181] (Hobley 1922: 170). This is additional to the normal protection essential to the bride of a smith throughout Kenya. Whether she is from a smith family or not she has to be ceremonially introduced to the smith's tools, blessed, and protected from the mystical powers of his ancestors.

The prohibition on marriage is usually, though not always, coupled with one on sexual intercourse. Where this is strictly observed a woman becoming pregnant by a smith might be put to death with her lover,[182] or have to have her child aborted.[183] Where it is less strict she has to undergo a special purificatory ceremony which may have to be conducted by another smith. Elsewhere there seems to be no objection, other than that of adultery,[184] to having secret sexual relations with members of smith families, although a smith's wife would generally be subject to his curse if found out.

The main reason for this prohibition on marriage and sexual relations with smiths is fear of the smith's "bad blood". This fear is so strong that when a smith is ill often only members of his own family can bleed him.[185] Where there is no aversion to inter-marriage, a smith, when ill, can be bled by anyone.

Underlying this fear of the smith's blood is the idea that blood is the medium whereby the mystical power, which is capable of causing such grave misfortunes by reason of the curse, is transmitted to the smith from his ancestors. Everywhere smiths are regarded as impure and unclean. As is usual with people in a state of impurity they transfer their impurity automatically to all with whom they come into close contact, especially their own families; those marrying into such a family will likewise be tainted and suffer misfortune, as well as their children, for the power is still strong in the first generation. It may even be passed on to the second generation, but most peoples believe that by then the blood is so diluted that the power is considerably lessened. A few believe that the taint remains in the blood for ever.[186] Initiated smiths can almost never[187] be cleansed of this impurity even though they forsake their craft. Marrying a smith, a man popularly believed to be a sorcerer is, in addition, considered to be akin to marrying a medicine man whose "bad blood" is often similarly inherited.

The misfortunes arising from inter-marriage with smiths are similar to those arising from the smiths' curse. Infertility, sickness, general misfortune and death, which are thought to come by way of the smith and to a lesser extent by way of his tools, are believed to be the result of such a union. In one case[188] it is believed that a woman marrying a smith endangers not only herself and her children but also her more remote relations and ultimately her clan. To avert misfortune she is put to death. Generally it is believed that very few children

will result from such a union and those that do will be unhealthy and die young.[189] Some believe that the man marrying a smith's daughter will die as the result of a spear or arrow wound,[190] while others[191] believe that a woman who marries a smith causes the death of her brother. Sexual intercourse can cause similar but less severe misfortunes.[192] Smiths are often equally anxious to avoid inter-marriage or sexual relations with non-smiths, for outsiders bring pollution to the work; the smith ancestors are likely to be angered and cause the ironworking skills, which are proving so remunerative to the smiths, to deteriorate.[193]

In those societies where fear of pollution from smiths is strongest, contact with them in any form direct or indirect is avoided almost as much as sexual contact, for both are likely to cause misfortune. This fear prevents some peoples from shaking hands with smiths[194] and from taking newly finished products from them without first safeguarding themselves against the consequences.[195] They are also careful to avoid the smith's shadow for if it falls on them they will be polluted. In general a smith cannot strike or beat a non-smith for not only would the person struck suffer misfortune[196] but the smith might lose his mystical powers. Non-smiths, in any case, are far too terrified of the smiths' curse to beat or strike one.[197]

Smiths are not allowed to touch the food or food containers of non-smiths for fear of polluting them. If touched they may have to be destroyed, for anyone eating that food or food from that container is likely to become ill. It is for this reason that food cooked by a smith, or in a smithy, is avoided throughout Kenya and smiths will never allow food cooked in a smithy to be removed. It must all be eaten there.

Almost everywhere[198] smiths are kept out of non-smiths' houses and even compounds if possible, and if they enter, the place has to be ritually cleansed on their departure.[199] If a smith has to stay the night when he is on a journey he may either have to sleep in a special place on a special hide[200] or sleep on the reverse (i.e. the rough) side of a sleeping hide if he is given a bed.[201] Smiths whose own homes are filled with guests, sleep in the open in their compounds, or more usually in their smithies, as their non-smith neighbours will not welcome them.

Amongst peoples whose craftsmen are of low status it has been reported that smiths are not allowed to own or cultivate land or to own cattle.[202] This is an over-simplification of the position based on insufficient observation. The underlying reason is again fear of pollution for it is thought that contact with a smith will automatically render the soil, crops and animals infertile, or cause them to sicken and die. Since people might unknowingly eat crops or animals produced or otherwise contaminated by a smith, they too might be affected. In the days when land

was plentiful and agriculture was shifting this could be a real problem. The effect of eating crops produced by a smith is the same as that of eating crops cursed by a smith in order to protect them from thieves. For this reason crops used in harvest festivals must never be cut from a smith's field,[203] and a man who marries a smith's daughter may have to forfeit his share in his father's fields or livestock,[204] for it is believed that neither can prosper in the care of a man polluted by contact with a smith, or by his children in whose veins flow the "bad" blood of their smith grandfather.

In agricultural and some semi-pastoral agricultural societies, where their work is seasonal, smiths generally own small fields but they themselves often believe that crops will not prosper in their care, and they have the reputation of being very lazy agricultural workers who spend a lot of time drinking and allow even their fences to fall into disrepair. Since they are paid in agricultural produce as well as in animals, their attitude is usually "why bother to cultivate when we can live comfortably on the results of the work assigned to us by God."[205] As demand for their work lessens smiths are often forced to take to agriculture,[206] while in societies practising intensive agriculture, where there is a considerable demand for their products, smiths sometimes become wealthy enough to employ labour to work their fields. This happens in western Kenya.

Pastoralists generally inhabit lowland bush country unsuited to agriculture but when they live in highland areas suitable for cultivation their smiths sometimes take the opportunity to grow crops.[207]

Early reports that smiths were forbidden to own livestock are usually exaggerated. Seligman (1928: 432–3) pointed this out and cited the case of Bari smiths of the Sudan who were able to keep the few cattle and goats which they acquired in exchange for their products. In spite of reports to the contrary even Masai smiths kept some cattle[208] and still do.

Throughout Kenya, except in those pastoral communities where smiths live with patrons, livestock particularly small livestock and most commonly goats were the medium of exchange.[209] Smiths generally exchanged their products for goats and still do in most areas, but larger artefacts are exchanged for cattle. In agricultural communities they were prepared to accept a certain amount of agricultural produce in lieu of livestock, but they insisted on having both, and when they accumulated surplus foodstuffs they exchanged them for goats. Fines for breaking taboos and for incurring the smiths' curse are also paid in livestock although most of those animals are eaten after being sacrificed to purify the person who has wronged. Smiths also acquired animals in a number of other ways. Some[210] were given a share of the livestock captured on raids because they produced the weapons which made

the raid successful, and sometimes blessed the warriors before their departure[211] or put a curse on the enemy so that they would be the losers.[212]

One way and another, therefore, smiths everywhere acquire quite a lot of animals, but since breeding females are almost never used in barter they obtain only male, castrated, or barren animals which are of little use to them if they want to build up a herd. This is particularly true in pastoral societies where the notion of pollution is strongest. Pastoralists fear that their animals, which are their only means of livelihood in an environment generally unsuited to agriculture, will be contaminated by contact with those of a smith. They believe that their fertility will be reduced, their milk dry up, and they will become sick and not prosper. They are, therefore, careful not to herd (Merker 1910: 318, Hollis 1909: 37) or inter-breed (Hollis 1909: 37) their animals with those of a smith, and to purify any animal bought from a smith before adding it to the herd.[213] They avoid living near a smith, and in the vicinity of his smithy for it can affect animals adversely as well.

The smiths themselves are just as afraid of having female animals for they might be impure and pollute their ironworking. The smiths of agricultural peoples, who are not solely dependent on livestock for their livelihood and are not afraid of pollution in this way, often exchange foodstuffs or male large livestock for small-stock of either sex, but even they are generally very careful to see that they are given only "pure" females which have not yet given birth, for an animal whose offspring have died or been still-born will adversely affect the ironworking.

Pastoralists also believe that animals kept by smiths will not thrive because they will be polluted by them and their ironworking, and that, in any case, smiths are incapable of looking after livestock which are, therefore, only wasted on them. In nomadic pastoral societies where ironworking is a full-time occupation, smiths would, in any case, not have time to look after them properly, a fact which they are the first to point out. Pastoral smiths, and those of the semi pastoral agriculturists who supply their products to pastoralists,[214] do very well from their craft and do not, in fact, want to keep animals. They do not need to keep their capital on the hoof as their skill is their capital. They are perfectly satisfied with their way of life and have no desire to engage in animal husbandry which they consider a lot of bother and much harder work than their own. It is smiths who cannot make a living from their craft who take to agriculture and animal husbandry in their respective groups. With the importation of cheap commercially-produced iron goods and the break-down of traditional beliefs, this is happening more frequently nowadays.

The smiths themselves also believe that proximity to their iron-working is not good for animals[215] thus, when their work is full-time as it is in pastoral societies and they are assured of a continuous supply of animals, they eat them and have thus acquired the reputation of being enormous meat eaters. In popular conception most smiths are improvident people who rapidly squander all that they get. They have gluttonous feasts as soon as they are given animals,[216] and, now that they are sometimes paid in money they spend it on liquor as soon as they get it. For this reason peoples who regard livestock as wealth usually look on smiths as poor people who can never become rich.

These beliefs in pollution and the smiths' curse are also carried into the realms of inter-tribal warfare. Smiths never went to war or on raids, nor, in most cases where the notion of pollution is strong, could their sons, grandsons, or even outsiders married to their daughters,[217] for it is believed that the presence of a smith will result in defeat and also that any smith who engages in fighting will lose his ability to smelt and forge good iron. Since smiths are, so to speak, in a reserved occupation vital to the war effort, these are sensible beliefs. Weapons are normally the main products of pastoralist smiths, but they form only a small part of the output of agriculturalist smiths who, in periods of warfare, are suddenly called upon to abandon the manufacture of their usual products in order to concentrate on those essential to the outcome of the fighting.

At such times they became so important to their people that often very special precautions had to be taken to keep their ironworking pure,[218] and the smiths themselves were carefully guarded so that they did not fall into the hands of the enemy.[219] This was very necessary amongst agricultural peoples, for smiths were the first to be sought out by the enemy who either killed them in order to stop further weapons being produced for use against themselves,[220] or took the smiths prisoner in order to force them to work for them. In the former case if the smiths' families and property were found they were destroyed, but in the latter, they were spared as an incentive to the smith to work well for them.

This is quite contrary to the practice amongst pastoralists and semi-pastoral agriculturalists where raids and counter-raids to capture livestock are common, and fighting is, therefore, part of the normal way of life. Not only do their smiths not go to war, but because of the strong beliefs in the smiths' automatic curse, they are also inviolate[221] and so are their families and property for it is believed that some terrible wholesale calamity will befall any enemy group which harms a smith. Members of the smiths' own tribe even go so far as to feel pity for the enemy if one of them has

killed a smith, or a member of his family, or damaged or stolen his property.[222] It is very understandable that pastoralists without smiths should spare the smiths of their enemies on whom they rely for weapons,[223] but the inviolability of smiths is not restricted to such peoples, nor does it, as might be expected, apply only to enemies who belong to the same linguistic group, but also to those speaking totally different languages.

Where smiths are inviolate and enemy attacks are to be expected, smiths wear their insignia, and also sometimes carry the tools of their trade around with them, in order to be easily recognisable.[224] Where they do not live under the protection of a patron, they also congregate together for safety in an encampment or cluster of encampments,[225] or in large villages[226] which are known by the tribal enemies and avoided during warfare.

The status of Smiths

Kenya is an interesting area in which to study smiths for their status ranges from high to low. The attitude shown towards them is equally ambivalent for it varies in accordance with their status. When their status is high some peoples almost venerate them, but when it is low they may be regarded with disdain, contempt and disgust. Intermediate stages are also found in which the attitude towards them veers towards one extreme or the other.

Everywhere smiths form a separate occupational group standing apart from, but being an integral part of, the society in which they live and work, but in some cases they fall into a wider separate category of people of hereditary status of whom only a few follow the hereditary occupation. It is in these societies that their status is lowest and, in spite of their importance in ritual matters, their participation in tribal affairs is incomplete.

Amongst Kenya peoples status is generally a matter of wealth and respect. Wealth is necessary for a man to become a leader, and as a consequence of his position he is very often able to increase his wealth and power. Traditionally wealth is measured in the amount of cultivated land and/or livestock that a man possesses and in the number of wives and children that he has. These increase his influence for they increase the number of in-laws who are obliged to give him support and, if he is not mean, also increase the number of people who are likely to support him because they are indebted to him for loans of animals and/or grain and for hospitality in the form of beer parties and meat feasts. The older a man is and the more wealth and power that he has the more respect he can command especially if, like a medicine man, he happens to have, in addition, a mystical power which increases the awe and respect in which he is held.

The mystical power of smiths, derived ultimately from God and demonstrated by their curse, makes them feared, respected and held in awe throughout Kenya, even in those societies where they are of low status. Smiths, in addition, are suspected of sorcery and in some cases are also trained as medicine men. The knowledge of ironworking gives people superiority in agriculture, hunting and warfare, but for this superiority they depend entirely on the knowledge and ability of their smiths. Even when of low status smiths are potentially some of the most powerful people in society. If they can become indispensable to their society and are able to manipulate their mystical powers to their own advantage to maintain the exclusiveness of their craft and acquire wealth, they can attain the highest positions in society.

The status of smiths depends on how well they have succeeded in doing this, but this, in turn, depends to a large extent on the importance of their products to their society and the economy of that society which is dictated mainly by its environment. Uncertain and inadequate rainfall results in three quarters of Kenya being suitable only for occupation by nomadic or transhumatic pastoralists. Periodic famines, pestilences and raiding in this type of environment have caused continual small movements of peoples over countless generations, and often their assimilation of each other. There has been no settled way of life except in the areas of higher rainfall beside the coast and Lake Victoria, and in the well-forested mountain areas which have been populated intensively by agriculturists only comparatively recently. With the exception of the Interlacustrine Bantu, these agriculturists have formed isolated islands of settled population virtually separated from contact with other agricultural peoples by a sea of pastoralists who have had a predominant influence on their culture.

The influence of the pastoralists is particularly evident in the social and political organisation of the agriculturists which is not centralised but loosely organised into acephalous groups based on a system of age-sets and age-grades ruled, in each neighbourhood, by councils of elders drawn from the senior grade. The greatest pastoralist influence has been on the Highland Bantu. There is less evidence for it on the Coastal Bantu and little in the Interlacustrine area where environmental conditions have made a settled way of life possible over a longer period of time. There, tribal organisation is based on a lineage system. Local rulers began to emerge when the population expanded and one maximal lineage managed to gain ascendancy over the others. Only the Wanga succeeded in developing this centralisation to the point where they could form themselves into a small kingdom on the same model as the more powerful interlacustrine kingdoms of Uganda.

Throughout Kenya the traditional economy is a subsistence one whether it be pastoral or agricultural or a combination of both, but a more settled way of life over a long period led to an increase in productivity and population which gradually resulted in a more centralised form of government. The introduction of ironworking to peoples able to lead a sedentary existence in an environment suitable to agriculture led to this increase in productivity.

High status Smiths

To agricultural peoples smiths are vital, for the livelihood of the whole group depends on them. Iron tools are far more efficient than wooden ones for digging, weeding and harvesting and much better than burning and rotting for clearing bush and forest. Smiths provide the tools essential for intensive agriculture, the weapons necessary for hunting and defence, and the protective devices which keep people healthy and prevent misfortune. As agriculture intensifies the number of smiths increases in order to meet the growing demand for their products. They are the people to whom everyone ultimately has to turn for the basic tools with which to make a living, while in time of war they are especially valued, for agricultural peoples, unlike pastoralists, cannot move away with their wealth but have to stay put and defend it. The age-set systems of pastoral societies give rise to bands of armed ever-vigilant warriors but agriculturists are preoccupied with their crops and unprepared for defensive warfare. When an increasing population had no more room in which to expand wars became inevitable; when they occurred heavy reliance was placed on the smiths as their ability to produce weapons quickly was often one of the deciding factors.

War led to a further increase in their power and prestige. The additional demand for their products led to an increase in their number so that a master smith often had several smiths of his family working for him and became rich and powerful. Smiths were part of the lineage system of these more centralised societies and frequently belonged to the leading clans. Because they were so vital to the war effort they either worked in collaboration with the leader or themselves became leaders as, in addition, they already had the necessary supernatural powers to maintain themselves in high office. There are only rare instances of this happening in Kenya but the nearby ironworking inter-lacustrine kingdoms of Bunyoro, Buganda, Nkore, Karagwe and Ruanda were led by blacksmith rulers to whom ritual forging was an important duty, and in which the royal or state insignia included ritual anvils or hammers[227] as symbols of power. In the Pare mountains in north-eastern Tanzania the state of Ugweno, famous for its ironworking, also developed under blacksmith chiefs (Kimambo 1968: 18).

It is, therefore, in agricultural societies, which are more dependent on them than they are on society, that smiths have risen to positions of prestige. They have managed to become indispensable to the efficient production of food, and can become almost self-supporting, if they wish, as the seasonal nature of their work allows them to engage in the normal subsistence activities of the group. Since there is little fear of pollution from contact with them and their craft they are not avoided, so, instead of relying on the automatic curse as they do in those societies where the fear of pollution is great, they go to great lengths to use their mystic power to keep their craft exclusive to themselves. They keep non-smiths away from their ironworking by the imposition of strict taboos and impose the strongest and most feared curses of their society on those who break them. As their status increases and they become sure of their position they also use those curses on behalf of non-smiths in order to help maintain law and order in the whole society.

In societies smiths are often referred to as "holy" or "venerate"[228] and people pray for them to have long and fruitful working lives so that their communities can derive the maximum benefit from them. Ironworking is a highly prestigious craft and smithies are regarded as sacred places. In attaining positions of high prestige, however, they lost their right to invulnerability in war, which is enjoyed by smiths of pastoral and semi-pastoral agricultural groups, for they were the first people that an enemy sought to immobilise.

It was amongst the Interlacustrine Bantu in western Kenya that smiths attained their highest status. In that area of intensive agriculture, in spite of remaining a separate occupational group, they have been readily assimilated into society. The idea of pollution from close contact with them is minimal so it is easy for them to own and cultivate land and to own animals, and once they have acquired wealth and prestige there is no aversion to intermarriage with them. On the contrary, parents are often anxious to marry their daughters to smiths because they are considered important men who can provide well for them. During the period of greatest demand for their products (around the turn of the century) when they wished to expand their activities in order to benefit from their own products rather than allow middle-men to do so they themselves sought inter-marriage with the neighbouring sub-tribes who had no knowledge of ironworking, but once established there they attempted to re-impose the restriction on inter-marriage, although they found that they were able to keep themselves exclusive more by the power of their curse.

Luyia smiths are considered to be rich people. In some cases the leading clans are descended from a smith and smiths belong to all the leading clans. In many sub-

tribes they were regarded as being almost the peers of the head of the sub-tribe or leading tribal figure. They made the special anklet which was, in many cases, the insignia of that dignitary, and were the only other men allowed to wear it.[229] On ceremonial occasions they were amongst the few men allowed to wear the prestigious leopard skin cloaks. No matter what their age, they sat with the elders at council meetings and beer parties for they were automatically regarded as being members of the ruling generation by virtue of their mystical power, intelligence and skill. They also acted as advisers for they were thought of as being particularly wise men who were always right in their decisions.

Their prestige was acknowledged, in the same way as that of the tribal leader, by inviting them to all the elder's beer parties and giving them the privilege of drinking from the gourd before the rest of the guests, while, on ceremonial occasions, a special gourd of beer was reserved for them alone.[230] The elders always made sure of inviting them and allowing them to drink first because if they omitted to do so they were liable to find themselves cursed.[231] They were also honoured, in the same way as the head of the sub-tribe, by having gifts of food and beer taken to them, the donors no doubt hoping thereby to obtain artefacts at a reduced rate when they became customers and to obtain the smith's blessing rather than his curse. The smiths themselves provided the rulers with the artefacts they needed and in return were exempt from paying them taxes.

The notion of pollution from physical contact with smiths is minimal amongst the coastal Bantu whose smiths can also rise to positions of prestige, especially amongst the Giriama who are famous for their ironworking. Their smiths can become high ranking elders who play important roles in the ruling councils. One of them, Wanje, succeeded to the leadership on the death of Fungo, the legendary hero after whom one of their two fortified tribal capitals (*Kaya*) is named.

The position of smiths amongst the Highland Bantu is also good except amongst the northernmost Meru groups.[232] In the intensive ironworking area of Kikuyu, and in Embu and southern Meru, where smiths are regarded as vitally necessary and therefore important people, they became very wealthy, owned land and livestock and joined the elders in discussing tribal affairs and settling disputes. They attained positions of highest prestige amongst the Tharaka who liken them to the Mugwe, their tribal leader and prophet whose person is regarded is sacred. As such, smiths there are also regarded as elders no matter what their age.

Although the position of Highland Bantu smiths is generally good the notion of pollution from physical contact with them remains strong. The predominant attitude towards them is one of fear[233] which the smiths

themselves do all in their power to encourage. Vague feelings that crops and animals do not thrive in their care persist in certain areas but the notion of pollution is expressed most strongly in an aversion to intermarriage with them, and the smiths themselves actually prohibit it. The desire for separation has become mutual. Smiths encourage that aspect of pollution and the fear of their curse in order to discourage non-smiths from joining them, for their craft is so lucrative that they wish to keep its jealously guarded secrets to themselves and have no desire to abandon it in favour of an alternative means of livelihood.

In all these Bantu agricultural communities where the status of smiths is high, they have the same legal rights as other men particularly with regard to the compensation payable in the event of their murder. Whether a smith murdered a fellow tribesman or was murdered by one, the normal tribal compensation for homicide was paid by the murderer's clan. Smiths are also initiated into adulthood and admitted into age-sets on terms of equality with the other men of the tribe in those societies which have an age-set organisation. More important, as we have seen, they take part in decision making with the elders of their tribe, are often ranked as elders even if they are young men, and have the opportunity to become tribal leaders. They are, therefore, fully accepted as integral members of their society not only economically and ritually but socially and politically as well.

Although smiths form an exclusive occupational group they do not fall into a separate category of people of whom only a few follow the hereditary occupation, as amongst pastoral peoples. Smith families do not, therefore, live apart but are dispersed amongst the rest of the population although their smithies are always kept isolated.

Low status Smiths

Conversely amongst nomadic pastoral peoples the status of smiths is low. There are far fewer of them and ironworking is a full-time occupation as there is a constant and not seasonal demand for their produce; smiths are, therefore, entirely dependent on the pastoralists for their food but the pastoralists are not dependent on them for their livelihood. Pastoralists believe their way of life to be superior to that of agriculturists because it provides them with a subsistence and a great deal of leisure in return for the very minimum amount of manual labour for, in the absence of natural calamities, their herds increase with very little effort on their part. They therefore scorn agriculture and often hunting, so their only essential is a weapon usually a spear with which to defend their herds and to raid the herds of others in order to increase their own. These spears frequently serve as a multi-

purpose artefact equally useful as a weapon, general purpose knife, or woodworking tool. With so few iron requirements smiths, although useful to have, are not necessary to pastoralists if they can obtain their weapons, as they usually can, from the smiths of neighbouring agriculturists.

It is in these pastoral societies, where the position of smiths is a lowly one, that the taboos associated with ironworking apply only to the smiths themselves. They do not have to impose taboos on non-smiths and rarely have to resort to imposing a curse because fear of their automatic curse is sufficient to keep people away from their work, and where the fear of pollution from that is strongest the smiths are regarded as strange objects of unease who are best avoided by both men and animals. This deliberate avoidance is not encouraged by the smiths themselves.

To refer to these smiths as "despised" (Forbes 1950: 78, 98; Huntingford 1969: 37) is wrong. It is the role of ironworking which is despised not the ironworkers themselves. They are, however, regarded with disdain and contempt because they demean themselves by engaging in the dirty manual labour of ironworking, for any form of manual labour is despised and scorned by pastoralists who measure wealth and prestige in terms of the number of livestock a man owns, and believe that God gave cattle to them exclusively.[234] Smiths are also regarded with contempt by them because they do not fight, for these warrior herdsmen to whom prowess in fighting and raiding livestock brings prestige look on non-combatants as effeminate. Because they have the ability to act as sorcerers, and are suspected of doing so although they can never be condemned as such, smiths are also looked on with disgust.

Instead of forming an exclusive occupational group the smiths of these pastoralists fall into a separate category of people of hereditary status who by no means all follow the hereditary craft. They often appear to be so different from the rest of society as to raise questions as to whether they are of different origin and cultural identity, and as to the length of time that these groups have had the knowledge of ironworking.

Avoidance of smiths from fear of being polluted by contact with them is strongest, and their position lowest, amongst the pastoral Cushitic Somali and Paranilotic Masai groups whose fear of smiths is so great that both they and their animals avoid smiths. In those societies the greatest objection to any form of direct physical contact, whether from inter-marriage[235] or sexual intercourse, shaking hands, or striking or being struck by them, comes not from the smiths themselves, but from the non-smiths who wish to keep themselves separate. The same applies to indirect contact for it is in those societies that customers take the additional precaution of safeguarding themselves before accepting a tool from a smith although

they know that it will be blessed. It is they, too, who feel strongest about allowing smiths into their homesteads, and move as far away from them as possible in order to avoid pollution to themselves and their animals.

This attitude is slightly modified and the position of smiths slightly better amongst the semi-pastoral cattle-orientated agricultural Kalenjin to whom smiths are a little more necessary.

Thus it is in these previously cattle orientated societies that smiths and their families, and those of hereditary smith status who do not practise the craft, are found living in encampments or clusters of encampments apart from though still amongst the rest of the community. This does not mean that smiths are segregated and told where to live as has sometimes been inferred, but that proximity to them is assiduously avoided (Merker 1910: 111–2, 318). Generally they settle where they wish and other people, who feel that they might be sufficiently close to be affected by their mystical powers, move away in case proximity to them brings sickness and misfortune or infertility and death to their livestock. They also avoid living near a smithy and keep their animals away from it. This is not very difficult as, in such cases, smithies are built just outside the perimeter fence of the homestead of the smith group,[236] or close to their villages.[237]

The position of the smiths is low amongst all the Cushitic peoples of the north-east but amongst the Galla and Rendille, instead of living in separate encampments, they are attached to patrons. As this is a particularly interesting relationship I will describe that of Rendille smiths in some detail.[238] The Rendille have little fear of pollution, to themselves or their livestock, from physical contact with smiths. Although they do not inter-marry with them they allow them to live in their larger settlements often in positions of considerable prestige,[239] and permit them to construct their smithies just outside the perimeter fence.

These people occupy vast arid and semi-arid wastes where tribal boundaries fluctuate and rights over the limited grazing and water resources are jealously guarded. Although they keep some small-stock and a few cattle where conditions permit it is on camels that they depend for their subsistence, but the rate of increase of a camel herd is slower than that of other livestock and they are more prone to disease. Livestock raiding is also endemic. As a result men tend to be monogamous instead of polygamous. In such harsh conditions there is greater dependence on the group both because food has to be shared and because of the need of protection from raiders. Settlements are very large, in comparison with those of other pastoralists, and spaced far apart.

In such conditions it would be difficult for smiths to survive without protection. They are found only in the largest settlements under the personal protection of the

most influential man. They remain with those settlements and move only when they move. In such societies respect is not measured by wealth alone because life is so completely unpredictable that no man can be sure of retaining his wealth.[240] Rendille know that God gives and that he can just as easily take away, and they believe that men who are rich in one thing cannot expect to be rich in another as well. Smiths are regarded as being rich in a skill for which they were chosen by God, their poverty is therefore God's will. Although their position is a lowly one, and pastoralists cannot marry them because they have no animals for bride-wealth, they are highly respected because they are poor and because of their ability to pray to God for protection on behalf of the group, prayer being essential to a people to whom life is so uncertain.

Smiths are liked, not avoided by Rendille, because they are humble, make the few iron objects that such pastoralists need, and utilise their mystical power for the benefit of the group by providing indispensable protection in the form of prayer and protective iron devices. Those of the hereditary smith group who do not practise the craft provide the Rendille with other services such as slaughtering and butchering although they are only responsible for slaughtering and butchering animals for meat (never for killing animals for sacrifice on ceremonial occasions), woodworking,[241] making fences, and digging wells and graves. In return the pastoralists are prepared to provide them with security and feed them.[242] They know that if they fail to look after the smiths on whom they rely, God will punish them by way of the smiths' automatic curse.

Smiths obtain food by several means. On ceremonial occasions when animals are slaughtered *en masse* the legs[243] are set aside for smiths, and at the ceremony marking the end of the mourning period they take the whole of the carcase of the sheep which is killed on the grave.[244] The smith *group* obtain certain cuts of meat in exchange for their butchering services, but the *smiths* obtain their regular food supply in exchange for their products. Although they are nowadays sometimes paid in animals, before the 1920s they were paid entirely in meat and milk; if they wanted a live animal they could always threaten to make use of their curse in order to obtain one. Livestock owners are obliged to give smiths animals if they ask for them. They dare not refuse for fear that the smiths will withhold their blessings and the automatic curse of their ancestors will become operative through contact with their iron products. In those societies there need be no verbal curse.

The asking and giving of animals has, however, become more than just a means whereby smiths obtain extra food. Most pastoral societies maintain their cohesion and survival by an elaborate system of reciprocal relationships built up around the exchange of livestock

both within and outside the clan. Relationships with smiths cannot be established in this way as they do not have animals. Instead they are built up between smiths and pastoralists by means of an institutionalised form of exchange whereby the smiths give small iron gifts and beg an animal in return. They do this only to the wealthier members of society in turn. The gift of a smith is considered powerful protection so men who give a big animal in return can expect to obtain their next iron artefact from that smith without payment.

The method of obtaining an animal follows a regular pattern. The smith leaves a small iron gift, such as a knife, protective bracelet, bleeding arrow or branding iron, inside the house of the non-smith in the appropriate place for gifts. Often he ties a rope to the side of the door in the expectation that he will find an animal attached to it on his return, but usually he returns later to make a formal request. If it is refused due warning of his curse is given by leaving a maul-hammer, or anvil, outside the house to the right of the door near the water containers. Sometimes it is a smith's wife who makes a request. She does this only to a woman, indicating her request by sneaking into a house and throwing one of the hearth-stones on the fire.[245]

A smith may also enter a house when the owner is at home, taking a small gift with him and making a request for a specific animal. He then sits just inside the door near the firewood (in the most humble position in the house) waiting for it, or he might sit outside and take a small child on his lap presumably to indicate that the child might be harmed by the curse if the animal is not forthcoming. If the owner is reluctant to part with an animal, the smith will spend the night there and the animal is usually handed over to him in the morning.[246]

The smith group, rather than the smiths themselves, are now beginning to own animals. Stories are told of how they first obtained breeding animals by acting as herders for pastoralists[247] or as paid murderers for the Somali.[248] They can now ask for a female goat or sheep but never a female camel. Until recently they were only given male animals for slaughter, never female ones. They asked for small-stock or sometimes a bull or steer or even a camel for slaughter, and occasionally for a pack camel, but never for a female animal or for a camel that carried water.

Differences in the status of smiths are shown by their legal position and by the extent to which they participate in the social, political and religious life of the group. These smiths of low status may not share the legal protection offered to non-smiths.[249] Those attached to patrons usually rely on them for any support that they may need. The patrons are responsible for any damage that they may do, stand surety for them and are prepared to help them with their bride-wealth when they marry.[250]

Compensation payable on the murder of a smith may be nil,[251] or less than for a non-smith.[252] It must not be forgotten, however, that in those societies fear of physical contact with a smith is such that the murder of one is a rare occurrence because the smiths' automatic curse is a powerful deterrent; it can cause not only the death of the murderer, but some dreadful long-lasting misfortune to his whole clan. In an attempt to avert such calamity compensation is usually paid immediately,[253] and in at least one instance[254] the murderer was put to death to try to avert misfortune.

A smith killing a non-smith would be an even more unlikely occurrence, but if the murderer was a non-smith member of the smith caste, purification rights would have to be performed and several of the smith caste might be killed[255] as smiths have insufficient animals for "blood money" and those of a practising smith would, in any case, bring pollution.

Where the status of smiths is low their participation in tribal affairs is usually minimal but their mystical power enables them to perform functions of ritual importance to the community, especially in rites connected with birth, initiation and death. In some cases they are not regarded as full members of the tribe.[256] They may be segmented into their own small lineage groups and only allowed contact with the rest of society through their patrons.[257] Their opinions on tribal matters are completely disregarded and they are usually excluded from the age-grade systems.[258] Because of fear of pollution from the curse their sons are circumcised separately, usually by the smith group,[259] and make payment for their circumcision directly to that group,[260] not to non-smiths. Those becoming smiths then joined their fathers in their hereditary craft (Leakey 1930: 209) while initiates and those of the hereditary smith group who were not smiths built separate warrior camps in which they lived with the daughters of their own group.[261]

Although these smiths form a separate group within society, are of low status, and have little or no say in tribal affairs, they are nevertheless regarded as being integral members of that society because of their ritual and economic functions.

The attitude towards smiths described here, and their consequent low status, is generally confined to pastoral peoples and to semi-pastoral agricultural groups whose former life-style was probably pastoralism. The attitude is, however, also found amongst the Highland Bantu agriculturists who have been greatly influenced by pastoralists, especially by the Masai, but their smiths have utilised it to their own advantage and are of comparatively high status.

It does not appear to be possible to correlate this attitude towards smiths and their low status with a recent introduction of ironworking. The evidence afforded by oral history and linguistics suggests that, with the exception of the Galla, ironworking has been known to these peoples for some considerable time.[262] Moreover amongst the paranilotic pastoralists of the north-west who have no smiths there appears to be no fear of pollution from the few smiths who have settled amongst them, nor are they afraid of pollution to themselves or their animals from any initiated smiths who become pastoralists and settle amongst them. When those smiths occasionally practise their craft they do so well away from their own livestock for fear of harming them, but their neighbours show no signs of fear for their animals and do not try to keep them at a distance. Neither do they regard the smiths as of low status for they are not averse to intermarriage with them and smiths are initiated into the tribe and take full part in its social and political activities. The same applies to smiths who settle amongst agriculturists who have no smiths. Bajun smiths who recently settled amongst the Pokomo have great difficulty in keeping people out of their smithies as the Pokomo have no fear of pollution from smiths or their ironworking and no fear of their curse.

There are indications that the smiths of some of these groups are of different cultural origin[263] but this alone is unlikely to be the reason for the attitude shown towards them, for every Kenya tribe is ethnically mixed and outsiders are rapidly assimilated and fully integrated into tribal life. In pastoral societies, however, their integration depends to a large extent on their ownership of livestock, for people without animals are poor and without prestige and, if they engage in manual labour, they are also scorned. Pastoralists themselves, who lose their animals and are forced to become hunters or to work for nearby agriculturists, are viewed in the same light until they can build up their herds and return to their original way of life. Smiths are included in this category of poor people. It is possible that the ideas of pollution from contact with smiths, and their consequent lowly status, were diffused southwards from Ethiopia where manual labour in the form of craftsmanship in ironworking, leather-working, potting and to a lesser extent weaving, is despised by agriculturists and pastoralists alike. The same attitude is shown towards hunting as a means of livelihood. The position of craftsmen there has yet to be studied in detail but they have been loosely described as a separate submerged class who are much despised. They appear to form an endogamous caste apart, from but living in symbiotic relationship (often under the patronage of their superiors) with, the tribe with whom they live and work, but are not fully integrated into its social and political life. These attitudes could have been carried southwards into Kenya by the Cushites and by Cushitic-influenced peoples, such as the Masai and Kalenjin, whose basic

mode of livelihood is pastoralism. In Ethiopia its diffusion has been attributed to incoming Cushitic peoples, for it is said not to be found (Haberlund 1961: 202–3) amongst the older established peoples of south-west Ethiopia although, like everyone else, they also regard smiths as a group apart. Hallpike (1968: 268) came to the conclusion that the low status of craftsmen amongst the agricultural Konso indicated that their crafts must have been introduced "after the stabilization of the agricultural population and way of life".

Craftsmen are not of low status amongst Kenya agriculturists. Smiths are more frequently readily assimilated by them than by pastoralists. They have acquired a higher status and there is little fear of pollution from them. This may lend plausability to the theory that the ideas were diffused southwards by Cushitic and Cushitic-influenced pastoralists from Ethiopia. If that is the case, the idea of pollution diffused to the agricultural Highland Bantu, but not, as one would expect because of the influence of the Kalenjin on the easternmost section of their iron industry, to the Interlacustrine Bantu, probably because they have developed a more strongly centralised political organisation.

As has been shown, the status of smiths and the attitude shown towards them varies slightly amongst the Cushitic and Cushitic-influenced pastoralists even within the same language group. Thus the Somali have a greater fear of pollution from contact with smiths than the Rendille who speak an archaic form of Somali. This could be explained by the Rendille moving southwards before the attitude was diffused fully to their area, or by the way of life forced on them by their environment; more likely it is because they have not become Muslims like the Somali who believe that smiths were cursed for ever by the prophet Issa because the ancestral smith disobeyed him.[264]

Nowadays the status of smiths and attitude to them, in these pastoral and semi-pastoral communities, is beginning to change. In recent years many people have been converted to Christianity and no longer fear contamination from smiths either to themselves or to their animals and crops, and smiths themselves are no longer afraid of abandoning their craft for fear of mystical retribution from their ancestors. Also smiths are beginning to be superfluous amongst peoples who live closest to the developed areas. In those areas there is now little demand for weapons which were their most important products. This was because of the Pax Britannica in earlier days and because improved communications have made possible the importation of commercially-produced iron artefacts especially spear and sword blades made of superior unbendable steel.

There are now very few smiths left amongst the semi-pastoral Kalenjin, except among those groups who do a flourishing business supplying the smithless north-western pastoralists with weapons. The idea of pollution from contact with smiths, in the other groups, relaxed sufficiently for them gradually to be able to acquire the land and livestock necessary to enable them to abandon their craft completely, and for their children to intermarry with non-smiths and gradually be adopted into society on more equal terms.

Although the attitudes of most pastoralists to smiths remain virtually unchanged those of the Masai are beginning to alter. Many smiths have now forsaken their craft but Jacobs[265] found that it was not until 1967 that they were allowed to participate in the important Eunoto age-set ceremony on anything like equal terms with the rest of the Masai, and even now, although the majority of Masai are at last prepared to shake hands with them and there are rare cases of inter-marriage, they will still not eat with them and generally will not marry their daughters.

It is in these purely pastoral societies, which prize livestock above all else and where smiths occupy the most lowly position, that there is the greatest desire to abandon the craft for the more prestigious one of keeping animals, but it is most difficult to do so. Smiths cannot leave their caste by giving up their occupation, and they cannot give up their occupation because they cannot build up the herds which would enable them to do so, for the full-time nature of the craft and the necessity to remain within easy reach of ore, charcoal, and customers, makes it difficult to engage in animal husbandry even if they were able to obtain the necessary breeding animals. Generally the environment is unsuited to agriculture but it is interesting that in the areas where it is possible smiths often cultivate small fields[266] to give themselves more independence.

In agricultural societies, on the other hand, smiths have little desire to abandon ironworking for by being able to own and cultivate land and continue their remunerative craft they can achieve considerable wealth and prestige. Smiths are most likely to wish to abandon their craft, and to be able to do so, where they belong to a semi-pastoral agricultural people who regard livestock keeping as the more desirable way of life and live alongside a pastoral people of the same language group whom they supply with iron goods. Their status, while not quite as low as that of pastoral smiths, is low enough for some of them to want to improve on it, and the notion of pollution from contact with them is not so strong that they cannot eventually acquire animals and join the nearby pastoralists who have no objection to them because, with a readily available supply of iron products nearby, they do not need smiths. Such groups are usually evolving or recently evolved pastoralists, often new to the area,[267] who may themselves have derived from the nearby semi-pastoral agriculturists, or

be in process of assimilating them rather than being themselves assimilated by them.

There are indications that pastoralists who have no nearby agricultural group from whom they can readily obtain iron products, make sure that their own few smiths are more dependent on them than they are on the smiths.

Notes

1 e.g. the name *Il Kunono* used for Masai and Samburu smiths, or the name *Uvino* used for Luo smiths.
Johnston (1904:II:790) refers to the *Uvino* as a separate caste but Huntingford (1931: 269) says that the *Uvino* form a separate clan.
Gray (1963: 44) refers to the *Waturi* clan but *Waturi* is the vernacular for "smiths".

2 Members of the *Akiuru* and *Agaciku* clans of the Kikuyu could not become smiths according to Routledge (1910: 84) but according to Hobley (1922: 173) the *Agaciku* and *Eithaga* clans could not – the former could not be circumcisors either and the latter had to avoid smiths altogether. Some Kamba clans do not forge, and the *Kamurigi* clan of the Tharaka cannot be smiths because in the past when many of them were smiths they were surprised whilst at work and nearly exterminated, so they vowed never to return to the craft (Champion 1912).
Southall (1953: 171) mentions that several clans of the Alur (Uganda) were not allowed to work iron.

3 The *Athimba* clan of the Igembe (Meru), who are said to have been the first clan in the area, were the first to introduce ironworking to the Meru and are said to have dispersed throughout Meru and to have taught most of the other sub-tribes. The leading clans of the Teso and the Samia, Marachi and Hayo are all famous for their smiths, and only they are allowed to work iron amongst the Hayo. The Mwanziro clan were the first to introduce ironworking to the Giriama, and the Abangaale of the Samia are said to have done the same for the Luyia.

4 The Marakwet and Bukusu say that they teach only their eldest sons. The Bukusu think that it is a bad omen if the craft is passed on to any other son. If the first-born are twins then the first one to be born is taught. The Kamba teach the first-born son of the first wife, or the youngest son.
Merker (1910: 111) says that the Masai taught their eldest sons. A Pokot smith teaches his most obedient (and therefore trusted) son of his best-loved (usually his first) wife.

5 e.g. Somali smiths.

6 e.g. Kikuyu smiths.

7 This is particularly true of the Kamba and adjoining Bantu.

8 Bajun smiths have moved into the Tana river area and taken on Pokomo apprentices. The master smith, whose family originally came from Lamu, moved to Witu and from thence to Galole. He trained his eldest son who is now working at Garsen and has taken on a Pokomo apprentice as his own two sons are very young. The second son of the master smith is now being trained and will stay to help his father. His two other sons will later be trained and sent up-river to work in the Garissa area. i.e. all will then be working amongst the Pokomo.

9 This is what the only Turkana smiths I came across had done. The most famous case in Kenya is that of a Luo who married a smith's daughter from Tanzania. She took him back to her father in Tanzania to learn the craft which he then introduced to the Luo.
Smiths from some western Luyia groups like the Samia and Wanga taught ironworking to some eastern Luyia groups and to the Bukusu.

10 Tharaka smiths say that they do not have to ask permission to do so, and Tugen questioned on this point all said that they had to ask permission directly from their masters.

11 An example is given by Mwaniki (1974: 37) for the Embu.

12 This is common amongst the Luyia especially the Bukusu. The person is said to be suffering from *Kamusambwa* i.e. an illness caused by spirits, or more specifically from *Bubasi* after the name for a smith. It usually takes the form of small pus-filled ulcers all over the body (?? chicken pox). If two sons in a family are found to be suffering simultaneously, both will undergo purification but only the eldest will be taught the craft.
Amongst the Kamba it takes the form of an illness of unknown origin, which persists for a very long time, or of persistent general misfortune.

13 Wagner (1949:II:9) gives an instance of this amongst the Luyia.

14 The main sign amongst the Idakho (Luyia) and the Marakwet.

15 Goats are the most usual sacrificial animals. They must be "pure" see note 118, Chapter I. Chyme, taken from the first stomach (because there the process of changing plant matter into food, the means of life, has begun but has not yet become waste matter as it does later) is the purifying agent.

16 A Bukusu is given a smith's twisted iron bracelet *Sirere*, a plain iron ring bracelet with turned-back ends *Lusinga*, and a coiled iron ring *Limili*.

17 This is usual amongst the Samburu whose wives or daughters act as their bellows blowers, and are the only tribe in Kenya who do this regularly.

18 This test was used by the Isukha (Luyia).

19 Somali and Luo smiths do not pay for their apprenticeship. Kamba apprentices, from outside the family, paid only the goat of acceptance and the goat for initiation. They kept the money from any tools that they themselves made and sold, but those tools were always said to have been made by the master smith.

20 The Highland Bantu. Leakey (1977: 303) also mentions this for the Kikuyu; and coastal Bantu usually had fixed fees.

21 These are the fees which Giriama apprentices have to pay.

22 Leakey (1977: 303) gives the figures of 30 ordinary goats and sheep and 10 stall-fattened animals. Osogo (1972: 5) gives the figures of 10 cows and two bulls although he does not say to which Luyia group this refers.

23 The welcome of a Giriama apprentice. In the vernacular. *"Karibu mwanafundi, nyondo karibu kambini, upate kitu cha kukufaha maishani mwako, mulungu akupe nguvu amina"*. The apprentice is annointed on the head with water into which *Mkone* leaves have been put and squeezed. A Kamba smith welcomes his apprentice by spitting honey beer onto him and saying "May your hands become skilful at the work which I can do" (Hobley 1922: 174).
See also note 39 the Hammer.

24 Leakey (1977: 308) says that it was usual for Kikuyu apprentices to pick up a hammer or some other forbidden object.
At a certain stage in their training Bukusu apprentices defy the taboo on stepping over the bellows knowing that they will have to provide a goat. They deliberately step over them to demonstrate that they wish to proceed to the next stage of their training.

25 At this stage a Giriama apprentice only learns to pound holding the hammer with both hands.

26 A Giriama apprentice, finding his master already in the smithy, greets him by saying *"Fundi Nyundo"* = hammer craftsman, and the smith replies by saying *"Fundi chuma udzelemkadze dzalamuka!"* = iron craftsman (rest not translated).

27 Giriama smiths sing *"Kazi ya chanda ni kazi Ya fundi nyundo"* = work of the smithy is the work of the hammer craftsman. This is sung first by the smith and then by the apprentice over and over again. The smiths of other tribes have similar repetitive songs!

28 At this stage a Giriama apprentice learns to hold the hammer with only one hand.

29 Logoli smiths pay their apprentices two spears and a hen each
 month.

30 e.g. the Giriama. A Somali apprentice is not enthroned on a
 stool until his initiation. Generally it is taboo to sit on a smith's
 stool. Even the smith's wives and children are not allowed to do
 so for it is believed to be the seat of the ancestors. Even if a stool
 gets broken or discarded any substitute for it will automatically
 have the same power as soon as it is brought into the smithy and
 sat on by the smith.

31 Bukusu smiths must be married, so must Marakwet and Giriama
 smiths. The Giriama say that they would not teach a bachelor
 even if he were 50 years old!, and they do not allow a smith to
 have his own smithy until he is over 30 years old.

32 e.g. Kamba.

33 Embu and Mbeere smiths do not have other smiths at their
 initiation ceremonies. The Embu invite only the elders of the
 ridge on which the initiate lives.

34 Tharaka smiths are given only a hammer, Tugen smiths several
 hammers and the bellows, and most other tribes all their tools.
 A Somali smith is also given a stool and receives his hammer
 after his anvil and bellows. This is unusual as the hammer is
 usually given first.

35 The Kikuyu carefully skinned the sacrificed ram and passed it
 across the hearth to protect both the smithy and the smith from
 any evil or misfortune. Hobley (1922: 168) gives a somewhat
 different version of a Kikuyu smith's initiation.
 The Kamba place the hammer on one side of the tuyere in the
 hearth and some pig iron on the other, and pour honey beer
 over them all to protect the smith from the dangers to which he
 is exposed, in particular to burning.
 The Tugen rub the hammer with iron dust and flakes.

36 A Logoli initiate is taken to the swearing place and made to
 swear in front of the traditional swearing tree (*Umutembe*). The
 smith elders then face the tree and say "We have chosen you to
 be one with us and if you break any of our laws and customs you
 will die".

37 The oldest man is usually chosen to lead the blessing because he
 is considered to be the most "pure", and also closer to the
 ancestors.
 The initiate is frequently spat on in blessing. The other smiths
 chorus the blessing after the blesser e.g. the Marakwet say "Stay
 well with this thing" (= the hammer) and the others chorus
 "*Anyin Berur*" (= literally sweet blessing, sweet blessing,) mean-
 ing blessings be upon you.

38 See Attitude to iron in chapter on Iron Products.

39 When Kikuyu and Bukusu smiths are presented with their
 ornaments their senior wives are presented with theirs too. The
 first task of a newly qualified Kikuyu smith (Hobley 1922: 169),
 is to forge similar bracelets for his other wives if he has any. The
 first task of a newly initiated Embu smith is to forge his wife a
 protective bracelet. His second task is to forge one for himself.

40 The Luo.

41 The Marakwet.

42 No work is done in a Samburu smithy for four days after the
 initiation of a new smith.
 Rendille smiths liken the putting on of the twisted iron bracelet
 (presumably at their initiation) to a "baptism".

43 A *Giriama* smith cannot be buried until a ritual forging is done
 by his grave. A sheep is sacrificed for purification and its skin is
 used to dress the dead body. If those things are not done
 immediately, the whole of the smith's family is believed to die.
 Iron ore is ritually smelted by the grave of a *Bukusu* smith and
 the resultant core is buried with the smith together with his
 "male" hammer (i.e. the smaller of his two mauls) which is the
 one given to him at his initiation. Burying it with him is said to
 show that he worked hard during his life with great success. It
 is believed that if his relatives did not bury it with him he would
 feel that they had disliked him and would therefore haunt them,

cause their ironworking to fail and bring them general misfor-
tune. As soon as a smith is buried, a cow is slaughtered at the
grave and liquor is drunk on the grave whilst the mourners sing
special smith songs.
A *Tugen* smith is also buried with his hammer at a special
ceremony. It is said that it must be buried with him because it
is the symbol of his trade, given to him at his initiation: as the
mystic power is concentrated in it if it were not buried with him
it would bring misfortune to others.
On the day of a *Luo* smith's burial, all the metal tools in the
district which have been made by him have to be carried by the
mourners. Luo funerals are big affairs to which the whole
neighbourhood go.
Smiths are occasionally buried (e.g. *Tharaka*) wearing their
smith's bracelets.

44 Hinde (1901: 86) is one of the few authors who says that
 although Masai smiths are of low status they are respected.

45 Elsewhere in Africa it has been noted only amongst the Lango
 (Driberg 1923: 86ff), the Bakongo (Weeks 1914: 249), The
 Chagga (Guttmann 1912: 81–83), and amongst artisans of the
 Gurage (Shack 1964: 50–52). Most references to it come from
 Kenya particularly from the Highland Bantu group. They come
 from the Kikuyu (Routledge 1910: 84, Hobley 1922: 165ff,
 Kenyatta 1938: 26, Cagnolo 1933: 36), the Ndia (Orde Browne
 1925: 40, Mwaniki 1974: 272) and indirectly for the Chuka
 (Orde-Browne 1925: 40), the Kamba (Hobley 1922: 165), the
 Nandi (Hollis 1909: 37), the Kipsikis (Orchardson 1961: 138),
 and the Samburu and Rendille (Spencer 1973: 118). Lindblom
 (1920: 182), who lived with the Kamba for some time, does not
 mention the smith's curse and says that as far as he knows the
 use of curses is confined to the family circle, while Wagner
 (1949:II:9) who lived with the Luyia says "There are no magical
 powers attributed to the smiths or the art which they practice",
 yet the smith's curse is widespread and highly developed amongst
 the Luyia.

46 The most effective public curse is that of the leading elders
 which is almost always uttered by one of their number who is
 a medicine man.

47 Taita smiths.

48 Bajun smiths who went to work in the Tana river area in
 Pokomo territory comparatively recently say that the Pokomo
 have no fear of them at all and they have difficulty in keeping
 them out of the smithy.

49 Amongst the Rendille the Ibere have the power to curse but the
 curse of a smith is much stronger (Anders Grum personal
 communication). the Fithaga clan of Kikuyu, who cannot be
 smiths, are sorcerers and rain-makers but they are very afraid of
 smiths (Hobley 1922: 165, 731).

50 A Samburu smith told Elliott Fratkin this (personal communi-
 cation).

51 That of the Meru whose leader/prophet is the *Mugwe*. Meru
 liken smiths to the *Mugwe*.

52 e.g. Tugen and Marakwet.

53 A few do call on God, but his name when mentioned is usually
 mentioned after that of the ancestors.

54 A Tugen smith admitted that he might.

55 Igembe smiths will do so.

56 And to a lesser extent amongst the semi-pastoral agricultural
 Kalenjin.

57 No Tugen or Somali would dare to joke with a smith. The
 Somali believe that if they did so they would be haunted so
 badly that they would die.

58 e.g. Bukusu.

59 e.g. Igembe.

60 e.g. the Somali and Masai. The Keiyo and Marakwet often insult
 smiths behind their backs by calling them jackals, which are
 regarded as impure animals who bring misfortune, but they
 dare not do so to their faces.

61 Only the Somali seem to question a smith's honesty.

62 If a Masai inadvertently uses the word after dark enemies are likely to raid the homestead, or a lion attack it. Even utterance of the word in a livestock pen is believed to bring sudden disaster to the animals corralled there (Merker 1910: 112).

63 e.g. the Somali.

64 The Kalenjin group Pokot, Tugen, Kipsikis and Marakwet smiths all have to obtain permission, so do the Kalenjin-influenced Bukusu.

65 Pokot smiths can.

66 e.g. Tugen.

67 Tugen smiths say that they only meet together to curse if there is need to impose a very powerful curse.

68 e.g. Bukusu. They meet between the hours of 7 p.m. and 5 a.m. i.e. during the hours of darkness.

69 Tugen, Marakwet and Bukusu. The Bukusu use a black soil (Kumutobu) which they say was used by their ancestors.

70 Tharaka.

71 The Tugen say that these indicate the smith's magic powers and are very afraid when they see a smith with them. The Tharaka say that such spots (Kiugo) are not confined to smiths, but anyone cursed by a person with them will not recover.

72 It is usually a finished product which has not yet been handed over, or some scrap iron or other small object which is stolen.

73 The Giriama are not, as a rule, afraid to enter a smithy, but they believe that if they touch anything or sit on any of the smith's things they will become ill and die.
 Amongst many Luyia the curse is so greatly feared that it is usual for a man who has to go to a smithy when the smith is working, to bring with him a white hen (Jemakuti) as a sacrifice.

74 Many smiths of the Interlacustrine Bantu and Luo do this. If an Isukha smith wishes to leave his smithy he holds a piece of iron in his hand or bangs his small hammer on his anvil and says:
 "Mundu wivi shindu shianje vakuka vange, ajelele hango havo noho nehe murwi nukuhenzi munzu"
 "My forefathers, you who taught me to work and made me a hero before the whole sub-tribe as a result, let any person who steals my things return home when his/her head is facing towards his/her home."
 This last sentence means let him die in a place far from home. In this instance the victim is believed to die from incurable headache and bloody diarrhoea.

75 In Seme location of Luo they hang up birds heads and feathers, together with special dried leaves and bits of cloth.

76 The Idakho, Isukha, Logoli, and some others, seem to be particularly prone to bloody diarrhoea as a result of the curse.

77 Mbeere smiths use tongs.

78 Logoli smiths, for example, will only use the inyoli, the traditional unhafted pounder, not any of their other hammers.

79 A Logoli smith will strike the iron flakes, or a piece of iron on the anvil, and calling on his smith ancestors will cry "My knife (or axe, or whatever has been stolen) you burned me when I made you, I expended my strength on you and wasted my time. I poured out my sweat in making you because of the intense heat and now you have been stolen. Let the thief use you and bring you back." Most Logoli curses are slight variations of this, but one merely says "You clever one from the east (the east is life-giving) you have stolen things which are the life and support of the whole community thereby causing great trouble, however you will see." In no case does the smith mention what will happen to the man for it is believed that the curse will become operative through the thief touching and using the tools which he has stolen. An Imenti smith beats the iron pieces (mathegetha) on the anvil saying "Let the one who has taken my property be as dry (or hard) as these pieces of iron that I am hammering. Let him be as dry (or hard) as this hammer hitting them". Of a man who steals the Meru say "Akhgitirwa kiria" which means "The hammer will be cut for his case."

80 Cagnolo (1933: 33) says that a Kikuyu smith hammers a piece of iron saying "May members of the thief's family have their skulls crushed as I crush this iron with my hammer. May their bowels be seized by hyaenas (i.e. may they die as bodies are left out for hyaenas) as I seize this iron with my tongs. May their blood spurt from their veins as the sparks fly beneath my hammer".

81 Kenyatta (1938: 76) says that with his hammer and chisel a Kikuyu smith cuts a piece of red-hot iron on the anvil saying "May so and so (giving the name of the thief if it is known) be cut like this iron. Let his lungs be smashed to smithereens. Let his heart be cut off like this iron".

82 As an Isukha smith bangs the hammer he will say "The hammer should look for the person who stole my things. The craft of ironworking was given to us by our ancestors, we did not steal it. Because I am saying this, tomorrow I should hear the footsteps of the thief coming to confess to me. As the sun is sinking I will see". In a slightly different version of this curse (khiriavila), the smith says that he did not steal his craft, it was given to him by his father and his father's father before him, and the person who steals another's belongings has to suffer and die for the theft for already he has been condemned in heaven.

83 To both the Luo and Luyia.

84 Just as both the Logoli and Banyore hurl one into a sacred mulembe tree during boundary disputes, and are believed to die if ever they violate the agreed boundary. (Report of Commission on Native Land Tenure, Kavirondo. October 1930).

85 They are used by the Luo and by the westernmost Luyia i.e. the Marachi, Wanga and Samia, i.e. the people who use double bowl bellows with sticks.

86 Which the Nandi do (Hollis 1909: 37). Generally it is taboo for a non-smith to blow into a smith's fire.

87 While doing this Marachi smiths say "Whoever is being cursed and turns a deaf ear should not forget that one day he will have to come to the smithy with some iron tool for sharpening." Tugen and Pokot smiths say "Go in the Wind" as they blow their bellows.

88 The Marakwet do this and say "This person (naming him if known) or this thief who has done wrong will blow up as this bellows has blown up, and he will die."

89 e.g. the Luo. This is probably their most common method of cursing.
 To curse a wife who leaves him a Luo smith will say "Let her not get with child all her life."

90 Logoli who blew a horn called Ulwiga. The stomach and legs of the victim were supposed to blow up. His family would be affected likewise.

91 The Highland Bantu hang them up. Routledge (1910 Plate LVIII) Illustrates this.

92 e.g. Pokot smiths who say "I let my spit kill anyone who has stolen anything. Tell him to open his mouth to confess that he has stolen the thing." After three-four months the thief is thought to become ill and confess.

93 e.g. Igembe smiths do this saying "Muntu uria uthithitie untu buna na buna ta kuia kuthanga muturi, arothira ta kelwe" and hoping that the thief will perish like the tuyere.

94 Purko Masai smiths do this. The smith rubs his fingers inside a tuyere and then rubs the dust on them onto his forehead, his toe joints, his finger knuckles and his umbilicus, before rubbing them onto the tuyere itself and then onto the nozzle of the bellows. He then pronounces his curse whilst sitting firstly on the anvil and then on the clay humps of the hearth.

95 Marakwet smiths do this saying "May his mouth get dry. May he lose his possessions and be dogged by misfortune and poverty for the rest of his life." When cursing in this way smiths may also invoke lightning to stike down the thief.

96 e.g. Kikuyu. The owner of a stolen goat or stolen sugar cane approaches the smith who takes a sword or axe-head which he is making and uses this method whilst saying "May the body of

the thief cool as this iron cools." The victim is believed to develop a terrible cough and to become thinner until he dies (Hobley 1922: 171).

97 A Meru smith using this method says "Let the seeds of this thief be cooled as this piece of metal is cooled and made useless." Kamba smiths curse in the same way altering the words to suit the occasion.

98 An Mbeere smith who uses them puts *ira*, a white diatomaceous powder, (also employed by medicine men and reported incorrectly to come from "High up on Mt. Kenya" possibly because Mt. Kenya is snow covered) on the tongs and crushes the jaws together on a piece of iron uttering a curse to the effect that the thief will be bitten by a snake just as the tongs are biting the iron. Cagnolo (1933: 33) says that the Kikuyu also use tongs for cursing.

99 Some Mbeere smiths do. One uses a twisted circumcision knife and pours the beer through each of its seven loops.

100 Marakwet, Pokot, Keiyo, Tharaka, Luo, Tugen, and Bukusu smiths can all invoke lightning to strike an offender. A Bukusu smith strikes his anvil with his hammer to do this. A Tugen smith says "In the name of my ancestors I call you, lightning, to split this person open now." They assure me that it invariably happens!

101 See No. 98. A Samburu smith looks for a thief's footprint and takes some earth from it, throws it into his fire without saying a word and then rubs his fingers in some iron flakes which have flaked off during forging. He rubs those onto the anvil, onto his forehead, onto his mouth, and lastly onto his neck before looking heavenwards to intone the curse the gist of which is "May the thief be killed. If he meets an elephant may it trample him. If he meets a snake may it bite him." He then spits in the direction of the fire. Masai smiths do very much the same. In Tanzania Chagga smiths also take earth from a thief's footprint (Cline 1937: 12 quoting Guttmann).

102 See note 110.

103 Only Imenti smiths said that they could curse anyone taking personal belongings other than their own.

104 When doing this an Idakho smith says "I curse you by the power of my hammer. May this power work on you and cause you to die by scouring blood, for you cause other people to lament and make long journeys in search of their stolen property. May you also make long journeys in search of your life. If you cannot manage, just as the neighbour you robbed cannot manage, then die! die! die! No-one will have mercy on you, as you, yourself, had no mercy on your neighbour's property, and as my hammer will have no mercy on you." N.B. Both Luyia and Luo tether their cattle.
A Kikuyu smith called in to help someone who had been robbed would accompany him to the scene of the crime where he would bang his hammer on the spot from whence the things were stolen saying "*Avohehea aroinaiha mahuri*" which means "Get cold as when dead." Hobley (1922: 171) gives an alternate Kikuyu method; the owner of a stolen goat or of stolen sugar cane takes an amulet or necklet of a dead person to a smith who beats it and cuts it into two while cursing "May the thief be cut as I cut this iron".

105 Bukusu and Logoli smiths use this method a lot.

106 e.g. Bukusu.

107 This applies particularly to the Kikuyu of Muranga district, the Embu and Meru.

108 When asked to do this a Kikuyu smith heats some iron red-hot and then, without beating it, dunks it quickly into his quenching water so that it suddenly becomes cold. Taking this iron, together with some flakes and dust from the anvil, he walks seven times (the number seven is singularly dangerous and unlucky to the Kikuyu) around the area to be protected saying as he goes "If anyone dares to graze his animals on this land (or steal the crops if it is a field) may his body become as suddenly

cold as this iron, may he die by slow degrees." An alternative Kikuyu method (Hobley 1922: 172) is to cut an iron bracelet belonging to a dead person, into small pieces and bury them at the foot of a tree after encircling the area to be protected.

109 A smith of the Southern Kikuyu of Kiambu (Leakey 1977: 1226) protects a field by walking around it once counter-clockwise carrying his hammer, tongs and tuyere, then standing where he started he inserts his hammer into his tuyere seven times saying "May the person who steals from this field be consumed by this curse." He then hangs up the tuyere to show that the field is protected. If anything is stolen he digs up the root of the plant whose produce has been stolen, takes it back to his smithy and there burns a hole in it, and hangs it up in the rafters. Each morning he takes down any such roots and, in the presence of witnesses, either plunges a piece of red-hot iron into his quenching water or, using his hammer and chisel, cuts a bit into two on his anvil. At the same time he utters a curse to the effect that the person who stole from the protected area will sicken and die. An Mbeere smith walks around the field or animals to be protected three times clutching, in his right hand, a discarded tuyere through which he puts one handle of his tongs and the handle of his hammer (Fig. 36, No. 3). A Tharaka smith uses his hammer and bellows whilst planting a special "medicine" in the field. An Igembe smith carries his tuyere, or sometimes his tuyere and bellows, as he goes around the field. An Isukha smith protects fields or livestock by turning his tools upside down in the field or livestock pen, or by using his hammer to make three grooves in the ground there in several places usually across paths. A Bukusu smith protects crops by cursing publicly whilst digging the field with his hoe (*embako*). Pokot and Marakwet smiths tie a tuyere at the foot of the gateway of the livestock pen so that all animals passing in and out touch it and are protected.

110 In return for gifts of honey beer, Marakwet and Pokot smiths secretly bury a discarded tuyere in the middle of a strip field which has been wrongly taken by another man or from which crops have been stolen. The Pokot leave two or three inches of the tuyere sticking up out of the ground. Tugen smiths bury a hoe in the field. Luo smiths use a special "medicine", and Pokot smiths also put a mixture of coloured clay (*munyan*) around fields and animal enclosures.

111 To hang up a tuyere was common practice amongst the Kikuyu (Boyes 1911: 24; Hobley 1922: 172; Routledge 1910: 91). Smiths hung them up to protect their own property as well (Routledge 1910: 91: Plate LVIII.90b). Some Kikuyu smiths erect seven large posts ten to fifteen feet in height as a sign that a field has been protected, and tie to them some dried foliage of the crops growing there. Dried leaves are used to signify withering away and death so that they will act as a further deterrent to would-be thieves or trespassers. In a grazing area the dried leaves of *Muthakwa* (*Vernonia holstii*) are tied instead (the stems of this plant usually have seven forks. It is also used in oathing and by smiths to rub sparks off their bodies).

112 e.g. Isukha.

113 The Luo do. See also the revoking of the curse later in the chapter.

114 e.g. a Logoli who steals a cow wearing a protective bell provided by a smith, develops a persistent splitting headache if he touches the bell or holds it to prevent it making a noise as he leads the animal away.

115 A Kamba smith curses a man who has stolen a tool by saying "I curse him and if he eats this season's food he will die." (Hobley 1922: 174).
A Logoli who steals an agricultural tool is also not expected to live beyond the next harvest.

116 Kikuyu smiths may be called on to bury a piece of iron in the path of the advancing enemy. Before warriors set off for war a Bukusu smith takes his hammer and large spear (*Liswakilo*) and, standing before witnesses in his smithy, hits them on the anvil

whilst cursing the enemy and pronouncing words of victory which the spear symbolically is supposed to bring.

During periods of prolonged raiding Tugen smiths are called together to curse the cattle thieves.

117　N.B. Wives are usually divorced only because they have not produced children. This is very often because the husband is infertile!

118　e.g. Kikuyu.

119　e.g. If a young Kikuyu falls ill his father goes to consult a medicine man who asks him a number of penetrating questions while shaking his divining gourd and spilling out the contents to divine the cause of the illness. If the young man has stolen sugar cane, the medicine man says that he can see nothing but sugar cane so sugar cane must, in some way, be causing the illness. He suggests that the sick youth might have stolen sugar cane from a protected plot. The father returns home, confides in his wife and together they confront their son. The father never directly accuses his son of theft but tells him that he is going to die and asks him to try to remember if there was any occasion on which he ate sugar cane which might have come from a protected plot, or which he himself obtained from one. Because the youth believes that he is dying he always tells the truth; he either confesses to stealing, or divulges the name of the person from whom he obtained the sugar cane so that its provenance can be traced. Having discovered whose sugar cane was eaten, the father informs the owner that his son has stolen it (or inadvertently eaten it as the case may be) and is very ill as a result of the smith's curse, and asks what he can give as compensation. The owner expresses regret that the boy is ill but says that he was only endeavouring to protect his property. He asks the man to return on the following day. Meanwhile he reports to the smith with whom he discusses the removal of the curse and decides what penalty will be paid. For a rich man's son this could be very heavy.

120　Most Luyia and Highland Bantu groups do this.

121　A not uncommon state of affairs as the necessary negotiations can be long drawn out!

122　e.g. The Isukha return the stolen things plus a ram.

123　e.g. Luo and Marakwet.

124　This is general everywhere. Hobley (1922: 172) mentions it for the Kikuyu.

125　Amongst pastoral people such as the Masai, Samburu, Rendille and Somali whose smiths only curse on their own behalf never to help other people and only they can remove it.

126　e.g. Tharaka.

127　Meru smiths foregather at the home of either the thief or the smith who imposed it.

128　Amongst the Kalenjin group the smith alone generally cannot revoke the curse. He must obtain permission to do so from the elders who gave permission for it to be imposed in the first place. A Kipsikis or Pokot thief must confess in front of the leading elders of the community in the presence of the smith.

129　If the ceremony is to be held at the smith's home the sacrificial animal is often led there on the previous day e.g. Logoli.

130　See Note 142.

131　A Meru thief, who realises the cause of his illness or other trouble, may go directly to the smith to confess taking with him the stolen property whether it was stolen from the smith or from someone else, but usually he sends it with an intermediary who confesses on his behalf. If the ceremony is held in a Logoli smith's home he asks for the stolen objects to be brought before him and directs that, as soon as the thief has recovered sufficiently to be able to carry them, they be returned by him to the place from where they were stolen.

132　A Logoli thief, and his representatives, sit in silence while the smith elder stands up to address him. The smith says he presumes him to be the thief since it is he who has been smitten by the illness specified in the curse. The thief admits his guilt unless he is too

ill to answer when one of his people will answer for him. The smith asks the man what prompted him to steal and points out that people have gone to considerable trouble to arrange the present ceremony to remove the curse. The smith, whose articles were stolen, is then called on to cross-question the man to make quite sure that he is the thief. He is under no obligation to remove the curse. He tells those assembled that it was he who imposed the curse but when doing so he had no idea who was responsible for the theft; now that the thief has confessed, and his people have verified his guilt, he is prepared to forgive him.

133　The normal sacrifice is a he-goat (usually castrated) but the thief has to provide what the smith demands. It may be a ram, or even an ox if the theft is very serious. For cases of minor theft the Coastal or Interlacustrine Bantu sacrifice a hen. The Kipsikis and Pokot prefer an all-white goat but many smiths, particularly those of the Luyia group, prefer an all-black animal. The victim may also have to provide the smith with liquor and honey.

134　At a Logoli ceremony the oldest man present eats some of the meat before anyone else. The smith is given the right hind leg and the thief some of the internal organs. Some meat is always thrown around to appease the smith ancestors who are the real cause of the curse and are now responsible for forgiving. The Kikuyu often strangle the goat. All its meat must be roasted never boiled and, like all meat eaten in a smithy, none of it can be removed from there so whatever is not eaten on the first day is left there to be eaten the following day. Hobley (1922: 172) says that the thief was given the heart and lungs of the sacrificial ram which was walked round him three times by the smith before being killed.

Leakey (1977: 1228), says that in the case of theft from a protected field, a second goat was killed and its breast-joint was rubbed over with "magic powders" and then eaten by the thief, the smith and the plot owner.

135　Chyme is usually smeared all over a victim but the Kikuyu place some of it in the victim's mouth. Holding it there he has to walk around the fire seven times, then step over all the stones of the smithy and only then can he spit the chyme out into the hearth. In so doing, he spits out his sickness and is cleansed (Hobley 1922: 172).

136　This appears to be confined to the Interlacustrine Bantu and Luo. Idakho smiths say that the herbs are only activated by the payment and sacrifice of an animal. The smith makes several cuts, with a razor, on the victim's body in order to let out the "bad blood" thought to be causing the disease.

I am assured that the blood issuing from these cuts is always dark in colour. The herbal concoction (*Amanyasi*) is then rubbed into the cuts.

The Luo use *amanyasi* not only to wash the victim but also to wash out the bowls of the bellows into which the blood of the goat was poured when making the curse. An Isukha smith sprinkles a concoction of herbs, plus iron dust and flakes from his anvil, onto the hammer and bellows which he used for cursing and onto the arms and head of the thief who then has to drink some of it.

137　A Masai smith rubs his fingers on the iron flakes left on the anvil, then rubs them onto the forehead, onto the toe and finger knuckles, onto the umbilicus and, lastly, onto the tongue of his victim and then makes him swallow some. The tuyere, whose dust was originally used to curse the man, is then thrown away through the victim's widely straddled legs.

See also note 136.

138　Meru smiths rub some of the honey, brought by the victim, first onto the iron which was plunged into the quenching water during cursing and then onto the hammer. Blood of the sacrificed animal is smeared onto the iron and hammer and its tail fat is rendered down for the same purpose.

After purifying the thief the Kikuyu rub the rest of the chyme over the hammer, tongs and tuyere with which the smith

originally cursed "to make them cold and peaceful" (Leakey 1977: 1228).

See also note 136.

139 The Kikuyu of Muranga district.

140 Samburu smiths do this.

Tharaka, Tugen and Luo smiths also present their victims with protective iron bracelets, in certain circumstances, after removing the curse but I have no information on what this involves.

141 To remove the curse, a Marakwet smith puts his mouth to the nozzle of his bellows and sucks air out of it until the diaphragm subsides into the bowl. This is supposed to remove the evil from the man's stomach just as blowing into the bellows put it there in the first place.

142 Kamba smiths pour some of the blood from the sacrificed animal onto the ground as a libation to the ancestral smith spirits in the hope that they will help to forgive, purify, bless and heal the man so that he can be accepted back into the community.

Logoli smiths say:
"*Avaguga vakale numuyanza muvohoroli uyu wiyami gayakora yaga.*"
"My ancestors I ask you kindly to forgive this man who has confessed his shameful action."

Kipsikis elders, and their wives who are past the menopause, ask the ancestors and God to forgive the thief saying:
"*Kasich logoik* forgive him
Kasich logoik chebongolo, chebo namoni, chebo kipkoiyo".

Chebo Kipkoiyo is God, the others are his manifestations.

Their wives utter the following women's prayer:
Iteremian kut Chebokipkoiyo."

143 After anointing the victim, Meru smiths fill their mouths with a mixture of honey and water and spit it in blessing over the hammer and iron saying:
Cuti mantu Kairi, guti mantu kairi
No more trouble, no more trouble.

Then they bless the thief by saying:
Arociara, ja Kanua
ja kanoti
ja kairu
Akathithimara, ja Ntiira cia Nyambene
Akathunguka, Ja Kirimaara

Let him be as fertile as Kanua
as Kanoti
as Kairu
(these are all very productive plants)

Let him be as beautiful, as rich and as peaceful as Nyambene mountain (the mountain range on which the north Meru live)
Let him appear as beautiful as Mount Kenya appears in the morning.

They also sometimes ask for him to live "As long as a papyrus plant" for no papyrus has ever been known to be struck by lightning, a possibility which might befall even the longest-lived tree.

144 Hobley said (1922: 171) that the Kikuyu estimated that complete recovery will have taken place six weeks after the ceremony.

145 e.g. the Pokot. The Logoli also sacrifice the animal as dawn begins to break. God is thought to be able to hear prayers better at that time.

146 When removing his curse from a piece of forest that he had protected a Kikuyu smith sacrificed an ewe there. He then took up the pieces of bracelet, which he left there when cursing, and smeared chyme from the sacrifice on the place where they had been lying. If the smith had placed a tuyere on a stick in a field when cursing he had to remove both tuyere and stick, sacrifice a sheep and place its chyme in the hole left by the stick (Hobley 1922: 172). In southern Kikuyu (Leakey 1977: 1228) the stomach and entrails of a sacrificed he-goat were carried clockwise round the protected area. Then its chyme was smeared onto the

hammer, tongs and tuyere with which he originally cursed, while the rest was broadcast about the cultivated field.

An Mbeere smith performs a similar ceremony but circles the field three times holding the hammer, tongs and tuyere with which he originally cursed, but this time without the handle of the tongs placed through the tuyere (see Fig. 36, No. 3).

147 A Southern Kikuyu smith was given the produce of three yam plants if he protected a yam plot, three sugar cane roots if he protected a plot of sugar cane and three goatskins if he protected an area of bushland from grazing (Leakey 1977: 1228).

148 e.g. Logoli.

149 e.g. Luo and Tharaka can do this. This has also been reported from West Africa (Guebard 1911: 134) where Bobo smiths can stop quarrelling by banging two pieces of iron together.

150 There are very few references to the swearing of oaths in an African smithy. Forbes (1950: 84), who does not refer to a particular tribe, says that an oath sworn on an anvil "is said to be particularly binding". Cline (1937: 126) says that the Tiv and Fouta swear oaths on the smith's iron tools.

151 The Kipsigis regard their strongest oaths as those sworn before a smith's bellows.

152 A Kisa who is suspected of thieving but denies the accusation is marched off to a smithy where he is made to sit on the stone anvil (never on the iron one) and swear his innocence. No-one else is normally allowed to sit on a smith's anvil.

153 This is the common method of the Kamba and Giriama. If one person steals from another or is accused of sorcery by another, but vows that he is innocent, he is taken along, by the Giriama, to a smithy. The accused and accuser, each with a supporter, stand outside the smithy waiting for permission to enter. The smith usually guesses the reason for their coming and quickly reverses the position of his bellows, placing the right hand bellows where the left one normally works, and vice versa. He then blackens himself all over with soot or charcoal in order to frighten the guilty party. When the protagonists enter he fixes them with a long piercing stare which further terrifies them. Taking an axe he places it in the red-hot charcoal of his fire and covers it with embers. Whilst it is heating he pounds some leaves of *Kukone* and puts them in a pot of clean water. The accused is then instructed to say "*Kala mimi ni mutsai kiraho nona ela kala na henda kusingizirwa tuo kiraho enda shamba*" which means "If I am really a sorcerer (or thief) then let me be burned, but if he is accusing me because he dislikes me, then anything may happen". He then dips his hands into the mixture of water and ground-down *mukone* leaves before touching the red-hot axe which the smith removes from the fire. If he is not burned then everyone present will immediately conclude that the accuser is lying while he, well aware of the feelings against him, usually confesses without taking the oath. He has to pay the smith a large amount, plus an animal for his purification. A red-hot axe ordeal is also used by the Swahili, and by the Nyamwezi of Tanzania.

154 Orchardson (1961: 138) cites a case of false accusation from the Kipsigis, and says that it was followed by a series of disasters and deaths in the family of the accuser.

155 e.g. When the Mwimbe have a dispute over field boundaries and the boundary is finally settled they bury some pieces of iron (probably iron flakes), which come from the smithy, with the wooden boundary markers and some hair of the adjudicating elders.

If further disputes arise years hence they dig them up and the claimant, carrying a sacrificed sheep on his shoulders, scatters its chyme around the plot. If he dies within a year he is believed not to be telling the truth and the boundary is fixed accordingly. (Kenya Govt. Land Commission Report, Evidence 1929. Appendix A. 33, 36.)

156 Hobley (1922: 173) says that at a Kikuyu smith's court (*njama ya Aturi*) the smiths were each questioned as to whether they

had stolen the article. If no-one confessed the one most strongly suspected was made to take "the oath of the goat" (*Kuringa thenge*). If he did not confess to the whole assembly of smiths he was cursed "by the bracelet of a dead person."

They did this by heating a dead person's bracelet and then cutting it up.

157 Marakwet smiths read the future by looking in the fire.

Tugen smiths read omens by looking at the bubbles and lumps in pieces of slag.

Chagga smiths in Tanzania were said (Cline 1937: 12 quoting Guttmann) to do the same thing.

Samburu are said to be able to predict rain, enemies and wild animals or people dying, by the sound of the hammer, but cannot prevent these things happening.

158 This applies to smiths of most of the Luyia tribes except the Bukusu.

159 e.g. by Kikuyu smiths who can kill someone by grinding up the flakes and putting them in their victim's food. Within three days the victim is supposed to complain of stomach pains, then a severe headache, and within seven days he is supposed to be dead. The effects are irreversible.

Somali smiths are also particularly fond of using these iron flakes.

160 A Kikuyu smith with a grievance will also secretly bury the cut-up pieces of bracelet of a dead person at the gate of his victim's homestead, or at a watering place, so that anyone stepping over them will be afflicted with illness. The illness will continue until the bracelet is removed (Hobley 1922: 172). Another Kikuyu smith's method is to grind up the fused iron and stone (filled with bubbles) which result from a failed smelt, and place that in the victim's food.

Idakho smiths who are medicine men (*Ombila*) use *Bibira*, a medicine consisting of herbs and roots, whose power, like that of the smith's curse, depends on a combination of things; the magic of the plants themselves, the choice of the words used, and above all, the power of the *Ombila* helped by that of the smith ancestors. Another method of Idakho smiths is to plant two seedlings by the victim's homestead. One of them is believed to wither and die. When it does the victim too is believed to die.

They can also kill by obtaining dust from the footprints of their victims or fragments of material from their clothing which they wrap up in special containers (*Shidohi* or *Shimugi*).

Tugen and Somali smiths bury a spearhead or sword in the victim's path. One of the best known methods of a Pokot smith is to place a bulb of a special magic plant in the middle of a heap of stones, dry soil and the dry branches of some special magic trees and to leave it there for two days. On his return if he finds that the bulb is rotting he is sure that his victim will die, but if it is still fresh then he has to try some other method.

161 The northern Meru tribes who have a morbid fear of smiths.

162 Somali smiths are believed to have the evil eye.

163 e.g. as amongst the Pokot and Somali.

164 As amongst the Tugen and Luo.

165 As amongst the Kikuyu (Hobley 1922: 172) and Tharaka.

166 Tharaka and Tugen medicine men obtain them for use in protecting their patients from all manner of ills, the Tugen giving the smith a goat in exchange. Kikuyu smiths always save them and place them in a small container for medicine men. Their medicine men particularly value the flakes produced when a smith forges a new hammer; they use them to concoct *Kihoho*, a "medicine" with which they secretly protect homesteads from both human and animal marauders.

The "medicine" is buried in the gateway to the homestead after the medicine man has walked three times around the homestead with it (Hobley 1922: 172).

In Pokot they are ground down, mixed with water and put in the eyes to cure eye disease.

167 Within Kenya it has been mentioned for the Somali (Paulitschke 1893: 236–7; Dracopoli 1914: 150), the Masai (Hollis 1905: 330–331; Merker 1910: 112; Leakey 1930: 209: Eliot 1905: 148; Hinde 1901: 86–90), the Keiyo (Massam 1927: 51), the Kipsigis (Peristiany 1939: 174–5), the Nandi (Huntingford 1953: 34), the Samburu and Rendille (Spencer 1973: 118), and the Pokot (Beech 1911: 18).

168 In countries adjoining Kenya it has been mentioned from Ethiopia for the Borana (Haberlund 1961: 202–3), for the Konso (Hallpike 1968: 260), for the Gurage (Shack 1964: 50–51), for the Amaro-Burji (Mude 1969: 27). In Tanzania for the Chagga (Guttmann 1912: 89–90), for the Sonjo (Gray 1963: 77) and for the Pare (Kotz 1922: 138; Dannholz 1916: 76, 107).

It is especially well recorded for the Somali (Paulitschke op.cit.; Dracopoli op.cit; Wightwick-Haywood 1927: 22; Hinde 1901: 86–90, Ratzel 1897: 494; and Lewis (1961: 188).

169 Neither Masai (Merker 1910: 112; Hollis 1905: 330–331) nor Somali (Ratzel 1897: 494) could do so.

170 By the Masai (Merker 1910: 111–2).

171 The reports by Wightwick-Haywood (1927: 22) and Dracopoli (1914: 150) are only of the Somali doing so.

172 The Kalenjin group and the Highland Bantu group are very averse to intermarriage. It has been said that the Kamba and the Tharaka (Champion 1912: 79) of the latter group are not, but this is not true. The Coastal Bantu and the easternmost Luyia tribes (who are most influenced by the Kalenjin) are also against inter-marriage; the rest of the Luyia and the Luo generally have no objection.

173 The Masai, Somali, Borana, Tugen and Pokot are very emphatic about this.

174 e.g. the rest of the Kalenjin.

175 Peristiany (1939: 174–75) also mentions this for the Kipsigis.

176 M. Guillibrand (personal communication) said that the Keiyo have no objection to marrying a smith who has forsaken his calling but I found this to mean a smith's son who has not taken up his father's calling.

177 e.g. Keiyo girls do.

178 e.g. by the Marakwet, Keiyo.

179 Because smiths do not go to war see later on in this chapter.

180 Some Marakwet girls said this but most are very much against inter-marriage.

181 The Kalenjin and Highland Bantu groups have to do this. The only previous mention of it is in an unpublished manuscript of H.E. Lambert. I have no information from the Coastal Bantu but it is probable that they also do it.

182 This happens to Somali women. My information was from the Garissa/Wajir area.

183 The Samburu do this (Spencer 1973: 118) although the closely allied Rendille surprisingly do not (ibid: 63).

184 Adultery itself is a serious offence which requires purification and recompense.

185 Only the smith son or smith father of a Tharaka smith can do so. They believe that the smith's blood is black because it has been heated.

Guttmann (1912: 89–90) says that fear of the smiths' blood is also the main reason for aversion to inter-marriage amongst the Chagga of Kilimanjaro just over the border in Tanzania.

186 The Masai and Somali do.

187 Only the Tugen said that this might be possible with purificatory herbs but the informant was not very reliable.

188 e.g. Somali. Information from the Garissa/Wajir area.

189 Merker (1910: 112) says that a Masai smith's daughter is believed incapable of producing healthy children.

The Keiyo, Tugen and Pokot believe that very few children will result and that they will suffer misfortune all their lives.

190 The Masai (Merker 1910: 112). The Chagga, just over the Tanzania border, believe that the husband will die as the result of marrying a smith's daughter (Guttmann 1912: 89–90).

191 The Keiyo believe this (Massam 1927: 51).

192 Kotz (1922: 138) and Dannholz (1916: 67, 107) say that for Pare men of northern Tanzania such contacts result in an unusual illness.

193 Tugen, Pokot and Marakwet smiths are particularly afraid of this. The Dogon of west Africa are also reported (Griaule and Dieterlen 1954: 106) to have the idea that inter-marriage would harm the smith.

194 e.g. the Masai (Hinde 1901: 86–90) and Somali (Hinde ibid and Ratzel 1897:II:494), but this taboo also works both ways for smiths are loathe to shake hands with others in case they are impure and their impurity will affect the ironworking. Thus a Kamba smith will not shake hands with any woman in case she is menstruating, or with any strange man, in case he is ritually impure.

195 See chapter on smith's products.

196 In societies such as those of the Luyia where the fear of pollution from direct contact is not so strong, smiths can sometimes beat people without causing them mystical harm. The beating compensates for everything; it is said that it is far better to be beaten than to be cursed.

197 The only exception is that mentioned in the chapter on the exchange and distribution of products, but the beating is not done by an individual and is always carried out publicly in front of the tribal elders at a meeting of the council.

198 The Interlacustrine Bantu Luyia are the only people who do not seem to object to smiths in their houses.

199 Somali sprinkle the compound with holy water while they chant verses from the Koran. Tugen call in a medicine man to sprinkle the hut with holy water.

200 A Somali smith has to sleep in the compound beside the windbreak (*dash* or *buk*). Tugen smiths are given a special calf-skin on which they sleep beside the door. Rendille smiths sleep outside on the left of the door.

201 Masai do this but they do not normally grant hospitality to smiths (Merker 1910:III–2).

202 In the literature there are a number of references which state that the smiths of certain tribes, particularly in North East Africa, may not own or cultivate land or own or herd livestock. Haberlund (1961: 202–3) says that in Ethiopia at one time smiths could possess neither livestock nor land and were even forbidden to enter fields. Shack (1964: 50–51) verifies this for the Gurage and Hallpike (1968: 259) says that "Konso craftsmen own little or no land".

203 This has also been reported from the Pare of Tanzania (Guth 1939: 455) where sugar cane used in a ceremony to celebrate soil fertility must never be cut from the field of a smith.

204 A Somali loses his rights to inherit animals, a terrible thing to a pastoralist who has no other means of livelihood. A Tugen loses his rights to both fields and livestock. Kotz (1922: 138) and Dannholz (1916: 76, 107) say that the same applies to the Pare just over the border in Tanzania.

205 This same attitude has been recorded by Hallpike (1968: 260) amongst craftsmen of the Konso of SW Ethiopia.

206 This seems to have been particularly true of the Gusii.

207 Merker (1910: 318) mentions the Masai doing this, and they still do if the country is suitable (e.g. in the Narok area) but it is the smith group rather than the practising smiths who own the fields. The Samburu also do so.

208 Merker (1910: 111–113, 318) says that they had to give half of them to non-smiths but since non-smiths are very afraid of pollution from them he may be referring to members of the smith group who do not practice ironworking.

209 See Appendix VII.

210 e.g. Bukusu and Tugen. This custom of remunerating a smith after a raid was also followed by the Bedouin (Fettich 1929: 59). Merker (1910: 111) says that smith warriors back from a successful raid had their cattle booty confiscated by non-smiths. Since smiths did not become warriors or go raiding he can only be referring to members of the smith group who do not practise iron-working. Hollis (1905: 331) says that Masai smiths are not rich in cattle because they have no luck with them; 40 head, owned by one smith is considered to be a large number.

211 Bukusu smiths did this.

212 Tugen smiths did this.

213 Leakey (1930: 209) says that if Masai bought a sheep or cow from a smith they purified it by dipping it in a river before adding it to their herds.

214 e.g. Marakwet smiths.

215 See end of section on Low Status of Smiths.

216 Luo smiths also have this reputation perhaps because the Luo, who are now agriculturists, are a cattle-orientated people or because their smiths are comparatively new to the tribe. Hallpike (1968: 258–269) says that the Konso of South West Ethiopia have similar ideas about their craftsmen.

217 See early part of smith's automatic curse and the fear of pollution.

218 Bukusu smiths were strictly segregated in their forts. No-one was allowed near them, nor were they allowed to return home; food could only be brought to them by an older woman past the menopause. If these rules were broken the Bukusu believed that they would be defeated.

219 The Bukusu gathered their smiths together in their walled forts where they were set to work to make war weapons under orders from the elders. Isukha elders had to make certain that at such times smithies were well guarded. This was common practice amongst most of the Luyia group.

220 The Tharaka of the Highland Bantu tell how their Kamurigi clan, most of whom were blacksmiths, was at one time virtually wiped out by the enemy who made straight for the smiths and over-ran them at their work. As a result no member of the Kamurigi clan has since been allowed to be a smith.

221 The inviolability of smiths has, as far as I know, only previously been noted amongst the Bedouin (Fettich 1929: 59) the Chagga (Dundas 1921: 272) of Tanzania, the Hima (Yitzchak 1974: 166) and Lango (Driberg 1923: 86) of Uganda and the Jur of the Sudan (Crawhill 1933: 41–43).

222 The Somali believe this strongly.

223 e.g. Turkana sparing Marakwet smiths. Also pastoral Pokot, who do speak a related language, sparing Marakwet smiths. The smiths believe that it is because they rely on them for their weapons.

224 Both Keiyo (Information M. Guillibrand) and Marakwet smiths, who usually do not move far from home, carry the tools of their trade with them (although they are not going to use them) even when going to the nearest market two or three miles away. Marakwet also carry their bellows with them when they go home in the evenings in case raiders catch them on the path.

225 e.g. Masai and Nandi.

226 e.g. Marakwet.

227 Roscoe (1911: 524) mentions the house where the Muganda king did the smithying. D'Ertfelt and Coupezi (1964: 115–117) describe the ritual re-forging of the dynastic hammers in Ruanda. In Bunyoro the king had to hammer iron on the anvil four times at his accession to show that he was leader of the blacksmiths (Winyi 1936: 296). The Karagwe insignia were believed to have been forged by the monarch (Ford and Hall 1947: 8) and included anvils or hammers. Sassoon (1983: 93) mentions that some of these ritual objects have horn-like projections and suggests that this may reflect the importance of cattle to those states.

228 Wayland (1931: 197) also used this term in describing smiths of the Labwor of Uganda.

229 The Marama pointed out to me that no-one was in a position to stop them doing so for if the tribal head complained they could easily turn round and refuse to make the insignia for him!

230 Tharaka smiths, who hold the most prestigious position of any smiths of the Highland Bantu, were also accorded this honour. They are likened to the *Mugwe*, the tribal leader and prophet. Like a smith the *Mugwe*'s position is hereditary. He is set apart from the rest of society and may not have intercourse with outside women. He must be pure and is regarded as an elder when very young. He has the ability both to bless and to curse automatically and disobedience to him results in death. If a *Mugwe* spends a night in a house other than his own it must be burned down.

231 Samia, Banyala, Wanga and Marachi smiths were particularly liable to do this.

232 The northern Meru were so much influenced by the pastoralist tribes to the north that they regarded smiths as on a par with hunters (*mwathi*) and men who bury the dead (*Mwenji*). The notion of pollution from contact with smiths was strong there.

233 Cagnolo (1933: 36) summed up this attitude well by saying that a Kikuyu smith "is looked upon with some terror and fear almost involved in an atmosphere of mystery whence his ironworking power is derived" and is "surrounded with a veil of terror" by the Kikuyu who regard him as "an evil genius".

234 Almost every pastoral group has a myth to this effect. The Masai story tells how God sent cattle down to them from heaven on a strip of hide, the Pokot one tells how he sent all livestock down to them from heaven by way of a very tall tree. They therefore believe that in raiding cattle they are merely recovering their own property.

235 When the opportunity arises these smiths may try to marry outside their cast to better their position. e.g. Gray (1963: 77) wrote of the Masai-ised SonJo "The *Waturi* (smiths) try to marry outside their caste in order to better their position" (smiths) "themselves are quite willing to marry outside".

236 In the Masai group (Masai and Samburu) and some of the Kalenjin group (Nandi).

237 As with Kalenjin e.g. the Marakwet who live on the Kerio valley escarpment.

238 I am indebted to Anders Grum for most of this information.

239 See the Smithy note 11.
A smith's house within the *Gob* (encampment) is always in line with the others and comes immediately after those of the headman's immediate family, so it is usually house No. 5 in an encampment of 100–130 houses. In one case the headman had named his son after the smith. In Ethiopia, Borana smiths are also attached to the larger villages of an important man (Haberlund 1963: 110).

240 There is a very definite feeling that divine retribution is likely to fall on a man who has more than his fellows unless he is particularly generous in helping others.

241 They are never allowed to carve camel bells though.

242 The Rendille say of smiths "They are poor yet no-one has ever heard of them dying of hunger. When dogs bark people give them food". (Information Anders Grum).

243 Anders Grum reports that at a Soreo festival he watched the senior and most influential smith sprint from house to house in one settlement to collect seven legs, and then rush off to the next settlement to collect more. Presumably he was obtaining them for other smiths as well. Spencer (1973: 55) says that smiths are also given the whole of the goat and the flank of the camel sacrificed on the third night of the wedding, which is the day on which the bride is circumcised. Rendille smiths are not the only ones to obtain meat in this way for Samburu smiths can claim half the topside of the animal sacrificed at birth ceremonies and half the flank of the animal sacrificed at marriage and Ilmugut of the Oxen age-set ceremonies (Spencer 1973: 128–9). Somali smiths receive the intestines, stomach, head, hooves, heart and lungs of sacrificed cows in return for skinning them. Tharaka smiths are given the shoulder of a sacrifice as they are regarded as important men, and Bukusu smiths are given the right rear leg

because it is said to be the sign of energy and success for a smith. From Ethiopia, Shack (1964: 50–52) reports that Gurage Craftsmen are given the lower part of the back and the feet of any animal sacrificed during a festival.

244 Relatives hoist it onto the back of the widow of the deceased who carries it to the smith's homes.

245 This is done by Samburu smiths' wives. (Information Elliott Fratkin). When a Samburu grants the request for an animal he can beat the smith telling him never to return. This shows the difference between Samburu and Rendille attitudes towards smiths as Rendille would never do this.

246 One informant told Anders Grum how, in the 1960s, a smith came to the right of his father's door demanding a pack camel. His father was reluctant to give it so the smith settled down for the night outside the door on the left; in the morning the animal was handed over. When the donor later required spears he obtained a pair from that smith free.

247 An elderly Rendille related how early in the century a smith's wife came to his mother to beg for milk and was asked if she could spare a son to herd for them. The son worked for them for ten years. At his circumcision he was rewarded with two sheep and two goats which have since multiplied into a herd two hundred strong.

248 Another story tells how some Somali traders, who had settled in Rendille, discovered that one of their number was a government spy. They wanted him killed so asked a Rendille warrior if he would do so. He refused but two Rendille youths of the smith group agreed to do so on condition that they were given a pregnant cow from which they too were able to build up herds.

249 Haberlund (1963: 110) says that Borana smiths have no legal protection. He is referring to the Borana in Ethiopia.

250 This information comes from Goldsmith and Lewis (1958: 252) and refers to the Somali Sab bondsmen who include other craftsmen as well as smiths. It is presumed that the same applies to the Somali in Kenya but no anthropological study had been made of them. The Somali smiths I studied now work in small trading centres.

251 Merker (1910: 214) says that the murderer of a smith went unpunished as smiths had no legal rights.

252 Amongst the Southern Somali in Kenya, compensation paid for the murder of a smith is exactly half that paid for a non-smith. Goldsmith and Lewis (1958: 252) say that amongst the Northern Somali it was also less in the past but is now equal.

253 e.g. Somali and some of the Kalenjin e.g. Tugen.

254 The Tugen.

255 The Somali say that they would do this, and so did the Masai (Merker 1910: 214).

256 The Somali say that they do not regard them as such.

257 Goldsmith and Lewis (1958: 252) say this of Somali craftsmen including smiths, and also say that they are sometimes included in the *dia*-paying groups of their patrons but are now trying to set up their own.

258 Haberlund (1963: 110) says that the Borana give them no rights in the Gada system.

259 The Masai-influenced Chagga (just over the border in Tanzania) circumcised smiths' sons in their own homes. Neighbouring Pare smiths' sons were operated on as a separate group although their daughters were circumcised with the rest of the candidates.

260 e.g. The Somali.

261 Merker (1910:111–2) reports this for the Masai but does not make clear whether it is the sons of smiths or of the smith group. It can only be the latter.

262 See next chapter.

263 See next chapter.

264 The Somali believe that the ancestral smith, from whom all Somali smiths descend, was called Musa Sabil. Since he was cursed by the prophet Issa because of disobedience it is believed that no-one who smelts or heat forges will ever go to paradise.

265 Alan Jacobs personal communication.

266 See note 207.

267 The eastern Pokot, who became pastoralists when they split off from the western agricultural section and moved from the mountains to the plains approximately 150 years ago, still have no smiths but obtain their iron products from the agricultural Pokot and related Marakwet. The same is true of the Turkana who obtain their iron goods from the Labwor by way of the Jie and Karimojong, although a few practising smiths have now settled amongst them. Over the border in Uganda the same thing was happening in the eighteenth century amongst the evolving predominantly pastoral Jie whose iron needs were easily satisfied by smiths of the nearby emerging agricultural Labwor. The existing agricultural Paranilotic inhabitants of the area and other incoming agriculturists, all of whom had knowledge of ironworking, took to cattle herding when assimilated into Jie society, their smiths forsaking their craft to do likewise (Lamphear 1972: 314–316).

CHAPTER V

Summary and Conclusions

THE PRESENT IRONWORKING STREAMS AND REGIONAL INDUSTRIES

This study shows that throughout Kenya, there is great uniformity in the methods of iron production, particularly in the techniques of forging. A similar uniformity is observable in the mystical aspects of ironworking and in the rituals, symbolism, taboos and omens associated with the craft, but although smiths everywhere use basically the same few essential tools and make only a narrow range of products, those tools and products vary considerably in type. The status of smiths and the attitude shown towards them by the community, although always one of awe and respect, is equally variable.

In order to clarify the overall picture, in Table 1 an attempt has been made to tabulate this information. Thus it appears that the differences in tools and products are sufficiently well-defined for ironworking in Kenya to be tentatively separated into two distinct streams, an eastern and western, between which the Rift Valley acts as a dividing line. These streams are differentiated mainly by the type of bellows and furnaces that are in use. To the east of the dividing line bag bellows and bowl furnaces are used exclusively whilst to the west of it predominantly bowl bellows and dome furnaces are used.

The two major ironworking streams can themselves be subdivided into clearly recognisable regional industries. Details of the area and peoples covered by each industry; the industries main characteristics; affinities with other industries and probable connection with iron-working in adjacent territories (where information is available) follow.

The Eastern Stream

Within the eastern stream the following can be recognised:

The Coastal Industry which is confined to:

1. The coast and its immediate hinterland occupied by:
 a) the Bantu speaking Miji Kenda group of agriculturists of whom the Giriama are the most important,
 b) Swahili speaking Bajun who live by agriculture and fishing,
 c) the Swahili of the coastal towns and villages who are of mixed Arab/ Bantu descent.
2. The Tana river basin occupied by the Bantu speaking Pokomo group who live by agriculture and fishing and whose ironwork is produced mainly by resident Bajun smiths.
3. The Taita hills in south-eastern Kenya, one hundred miles inland, occupied by the Bantu speaking Taita who are agriculturists.

The greatest variety of tools and the most advanced tool types and techniques are found in this industry which uses only iron anvils and a range of well-designed long-handled hammers. The industry has no tradition of ever having used stone hammers, iron maul hammers, or split green-wood tongs.

The characteristic tools are whole-skin bag bellows with cone-shaped tuyeres, small square or round iron anvils set in wood, and the hammers already mentioned. Two of these tools, the whole-skin bag bellows, and the square iron anvils set in wood, are also found in the eastern branch of the north-eastern industry which is the only other industry to use a similar variety of tools and advanced tool types and techniques. In the westernmost and more isolated section of the industry in the Taita Hills some differences are to be noted. Instead of whole-skin bag bellows the triangular bag bellows characteristic of the neighbouring central highland industry are used. Their products (of which axes, hoes and arrows are the most important) are essentially the same but they also make swords, and unlike the rest of the industry, still use wooden digging sticks and hoes. They have a tradition also of once having used stone hoe-blades.

The riverine Pokomo, who are without smiths, use the same products as the rest of the coastal Bantu, but fix their hoe-heads to an elbowed haft by means of rings cut from a hard fruit casing. Although this method of hafting is typologically earlier than that of the rest of the industry where blacksmiths themselves fit the hafts for their customers, it may not be the relic of an earlier method but rather an indication that hoes are imported and are easier to carry without heavy hafts. Spears, not found elsewhere in this industry, are used. They are fish spears of typologically early tanged type which used to be made for them by Orma Galla smiths of the North-eastern Industry, but are now made by their resident Bajun smiths.

Indian Ocean trade appears to have had the greatest influence on this industry. The techniques used by the few remaining Swahili silversmiths of the coast are found from Morocco to Zanzibar wherever Islamic influence has penetrated. They cast, stamp patterns into an object by hammering it into a mould, draw wire with a drawplate, coil wire, make chain, and inlay non-ferrous metal. Trade in silverwork to the east African coast was mentioned in the Periplus of the Erythraen Sea (Schoff 1912) written in the first century A.D. so the knowledge of silver and possibly silver working is of considerable age. These techniques spread to smiths and ornament makers of the coastal Bantu who produced much cruder ornaments using copper, brass and later aluminium (the poor man's silver) which is regarded as being preferable to silver because it does not tarnish.

Simple casting in a groove spread quite far afield but the more complicated form of casting (into a one-piece or two-piece clay mould in the shape of the object) penetrated only as far as the nearby Kamba of the Central Highland Industry. Wire and chainmaking which was quickly learned by the Giriama, diffused inland from them. Other peoples make chain but only the Giriama and Taita of the Coastal Industry, and the Kamba and Tharaka of the Central Highland Industry, make the special chain with S-shaped links.

Inlay work also diffused inland only as far as the Kamba but the technique of stamping on designs although carried up the Tana river by Bajun smiths who learned it in the Lamu archipelago, has still not penetrated beyond the coastal industry.

The diffusion of techniques used in ornament making is more rapid than those used in ironworking, the craft being frequently in the hands of specialist ornament-makers who are not smiths and are not permitted to use smiths' tools. They are, therefore, not subject to the rituals and taboos which tend to make ironworking so conservative. Even though diffusion is more rapid, and personal ornaments (which are not worn for protective purposes) are subject to fashion and therefore more rapid change, there has still been very little diffusion of techniques and those that have occurred have penetrated very slowly.

The North-Eastern Industry

In the vast north-eastern region of arid desert and semi-desert the ironworking picture is somewhat confused, but as there are indications that the earlier ironworking of that region was more homogeneous it has been regarded as one industry which is divided into well-defined eastern and western branches. *The Eastern Branch* is confined to the western cushitic-speaking Somali and Galla pastoralists who are primarily camel keepers. Like the Coastal Industry it has a greater variety of smiths' tools; more sophisticated tools and techniques than elsewhere; the same whole-skin bag bellows and square iron anvils set in wood, but these last are of comparatively recent introduction and have been superimposed on more archaic elements similar to those of the Western Branch. The Somali and Orma Galla still use groove-less stone anvils, but the former also use iron maul hammers. The Somali generally use the more sophisticated tools and techniques found in the coastal region of Somalia where similar whole-skin bag bellows and small square anvils are found. Konso smiths working for the Borana Galla use only the more sophisticated tools and techniques. They came from south-western Ethiopia within the last hundred years to work for the Borana whom they had long supplied with metalwork. They brought with them from Ethiopia their tools and the techniques of *cire perdue* casting, inlaying and punching, but the whole-skin bag bellows they now use appear to have been adopted recently, for Konso smiths working in their Ethiopian homeland were observed to use a single large sewn bag bellows of a type not found in Kenya.

The Western Branch of the industry is confined to the eastern cushitic Rendille who speak an archaic form of Somali, and the eastern nilotic Samburu who are a branch of the Masai. Both are pastoralists but the economy of the former is based on camels while that of the latter is based on cattle. The industry still uses only stone anvils some with grooves and iron maul hammers; split green-wood tongs are not used nor is there any information on them having been used in the past. The triangular bag bellows are of the same type as those of the Central Highland Industry which also uses iron maul hammers and their hafted derivatives.

Spears are the main products of both eastern and western branches but differ in type. Those of the eastern branch often have flat or ogee cross-sectioned blades, short heads and butts and long shafts: they resemble Ethiopian types. Those of the western branch are long-butted with lanceolate heads with mid-ribs; they resemble those made by the Kalenjin of the Western Highland Industry of the western stream.

The Central Highland Industry

This industry, which occurs in the central highlands of Kenya (particularly round Mount Kenya), is confined to the kikuyu-speaking Kikuyu, Embu and Meru, and to the Kamba, all of whom are agriculturists belonging to the Kenya Highland Bantu linguistic group. Triangular bag bellows are used and there has never been a traditional iron anvil. Stone anvils, which often have grooves, are still in use and where iron anvils are found nowadays they are of scrap from commercially produced iron. Iron maul hammers are still used but their hafted derivatives predominate. Of the latter the slight variations of form, in the different tribal areas, can perhaps be placed in typological sequence. Kamba hammers show some affinity with those of the Coastal Industry. Split green-wood tongs, which were used until comparatively recently, are now no longer found. The characteristic products of this industry are axes which are of ritual importance particularly to the Kamba and swords from which digging knives with mid-ribs (Fig. 65, No. 6) appear to have developed. They are peculiar to this industry and take the place of hoes. Also peculiar to it are the long-handled wood chisels for making bee-hives (Fig. 74, No. 6) which may have been developed from an axe.

Spears are made and used by the kikuyu-speaking peoples but not by the Kamba who rely on bows and arrows but also use swords. The Kamba may have chosen arrows instead of spears as weapons because much of their country is dry bushland better suited to hunting than to agriculture. They have become famed as hunters; they are also famed as coastal traders so their choice of arrows could equally well be due to coastal influence. This influence shows itself most strongly in the adoption of a number of ornament-making techniques which were learned on coastal trading expeditions. These techniques, although few and adopted slowly, represent the greatest introduction of new ideas and metalworking techniques now traceable in Kenya. Ornament-makers, not smiths, were responsible for these innovations. As already mentioned they include casting of non-ferrous metals into one and two-piece clay moulds, inlay, wire-drawing, chain-making and also certain techniques of fastening ornaments. The wire drawplates closely resemble those used by coastal silversmiths but have far fewer holes, probably because such fine wire is not required by inland peoples. The chain-making pincers, which are quite different from blacksmiths' tongs and have a different name, are the same as those used by coastal silversmiths. Even the Kamba name for S-twist chain (*munyoo*) suggests its coastal origin as it is called *mnyororo* in Swahili. It retains the name *munyoo* when traded to the adjoining Kikuyu although the Kikuyu have their own name for their own simple-link chain.

The closest affinities of this industry are with the western branch of the North-Eastern Industry. The same triangular bag bellows and iron maul hammers are used and both use only stone anvils which may be either plain or grooved. Swords and branding irons are typical products of both industries. Triangular bag bellows are also found in the Taita Hills area of the Coastal Industry and on the nearby mountains of Kilimanjaro and Pare just across the Tanzania border. Further westwards in the Rift Valley on the Kenya/Tanzania border the Sonjo also use triangular bag bellows and hafted maul hammers identical to those of the Embu and Mbeere.

Western Stream

The western stream can be divided into the following regional industries.

The Western Highland Industry

This industry occurs in the western Kenya highlands where it extends from the Pokot hills in the north, southwards across the Trans-Nzoia and Uasin Gishu plateaus to the Tanzania border, and westwards from the Rift Valley to Mt Elgon and the Nandi hills. It is confined to the semi-pastoral agricultural Kalenjin group and to the purely pastoral Masai. Both are paranilotic groups: the former speaking southern nilotic languages and the latter eastern nilotic.

Dome furnaces and single wooden bowl bellows with valves are characteristic of the industry. Plain or grooved stone anvils are still used but tiny plain or grooved iron anvils (peculiar to this industry) are also used. Neither stone nor hafted iron hammers are found but iron maul hammers are utilised with extraordinary skill and delicacy. Split greenwood tongs were used until comparatively recently. In the southern part of the industry the Masai and probably the southern Kalenjin use carefully-cut round stone anvils (which are also found in the eastern branch of the Interlacustrine Industry), while the Masai have an enclosed smithy peculiar to themselves.

Spears are the characteristic products of the industry. In the northern area a long-butted short lanceolate-bladed throwing spear, exactly like that of the neighbouring western branch of the North-eastern Industry, is made, while elsewhere (particularly amongst the Masai) the long-butted long-bladed stabbing spear is typical. This, according to linguistic evidence (Ehret 1971: 53), was probably adopted by the ancestral Masai from the ancestral Kalenjin in the first millennium A.D.

The closest analogies to the tools of this industry appear to be in south-western Ethiopia where dome furnaces are used by the Dime and neighbouring peoples (Haberlund 1961: 196–197). These peoples also use

single bowl or pot bellows with valves (which are pumped in the same way but are made of clay instead of wood) and iron maul hammers.

The Interlacustrine Industry
This industry which has distinct eastern, western and southern branches, is found around the fertile shores of Lake Victoria where the agricultural Interlacustrine Bantu and the formerly largely pastoral, but now largely agricultural, Luo live. Fishing forms part of the economy of both. The two main Bantu groups are separated by the Luo who have the Luyia group to the north of them and the Gusii and Kuria to the south.

Common to the three branches are the use of large stone anvils, stone hammers, iron pounder hammers and split green-wood tongs. The products are also the same. Peculiar to the industry are bill-hooks, sickles and curved knives; bells made specifically for hunting dogs; double-pronged fish-spears and circular sharpened throwing discs for fighting, although the last two are rarely found in the southern area. Hoes, arrows and spears with ogee cross-sectioned blades and short butts are very characteristic.

The *Western Branch* retains the greatest number of archaic tool types and the most laborious and primitive methods of ironworking to be found in Kenya. A variety of stone hammers, stone chisels, simple massive stone anvils and split green-wood tongs are used. The double wooden bowl bellows pumped with long sticks are valveless, while the cumbersome long segmented pipe-like tuyeres (Fig. 25, No. 1) are found nowhere else in Kenya. A bowl furnace, with connecting trench, backed by a low wall; unhafted iron hammers of mandrel type; unhafted oblong tanged hammers (which are not found elsewhere in Kenya) and tiny oblong narrow iron anvils are also utilised.

From the little information available on smiths' tool types in territories adjacent to Kenya the closest analogies to this branch seem to lie directly to the north with the eastern Nilotic speaking Labwor of Uganda.[1] These people, who live mid-way between Lake Kioga and the Sudan border, are famous for their ironworking. From Wayland's (1931: 197) descriptions and illustrations the double bowl bellows pumped with sticks appear to be of exactly the same type although they are stated to be made of clay.[2] The tuyeres, consisting of three pipe-like sections joined by rounded humps of clay, are exactly the same, as are the stone hammers and split green-wood tongs. The unhafted iron hammer also appears to be of mandrel rather than maul type. Smelting is described as being done in a similar hut also specially built while clay is heaped up round its perimeter in the same way. Ore of apparently the same type is broken into the same-sized pieces before being smelted in an open furnace. The furnace itself, although placed

on top of a 1.2m solid clay dome, nevertheless bears some resemblance to the furnaces of this branch: it consists of a narrow groove reminiscent of the trench with its open end stopped by a stone slab reminiscent of the wall and is stone-lined like the hearths in the smithies of this branch.

This branch of the industry must also have been influenced from the west because the only traceable similar oblong tanged iron hammer (Fig. 6, No. 4) is from the famous ironworking kingdom of Bunyoro in western Uganda (Rosco 1923: 225). Valve-less bowl bellows pumped with sticks, usually of clay but sometimes of wood, (Roscoe 1923a: 220, 1915: 76) are also found there (and in the other interlacustrine kingdoms[3]) as are stone hammers, split green-wood tongs, and iron pounders although their type is not made clear. Simple bowl furnaces which are found in Toro and Karagwe are elsewhere surrounded by a low wall of mud brick while those of Bunyoro are covered over by a lid-like clay structure with a hole in its top (Roscoe 1915: 75 and Plate 11). Bells made specifically for hunting dogs are found in these Interlacustrine kingdoms (Roscoe 1915: 240; White 1969: 65) as they are in the Interlacustrine Industry but nowhere else in Kenya.

The Eastern Branch of the Interlacustrine Industry is obviously derived partly from the western branch and partly from the Western Highland Industry. The bellows are a strange combination of those of the two industries for the single bowl bellows of the latter (which have valves and are pumped directly by hand) are used as a pair in imitation of the double valve-less bowl bellows of the former, which are pumped by sticks whilst standing. Tuyeres are funnel-shaped. Split green-wood tongs and the occasional iron maul hammers are still to be found. Simple stone anvils are the type most commonly used, although round stone anvils of the type used in the southern district of the Western Highland Industry are also found. Otherwise the industry exhibits many recent features. With the exception of two instances, one in the northern area where dome furnaces were used,[4] there was no smelting tradition. The hafted iron hammers are copies of European types and the only iron anvils are of scrap from commercially produced iron.

The Southern Branch
This branch is found amongst the southern Luo, Gusii, and Kuria who extend over the border into Tanzania. It differs from the other two branches in its use of triangular bag bellows which are also found amongst the Sukuma in Tanzania who live to the south of the Kuria.

The Relationship of the Regional Industries
to Language and Tribal Groups
The study of the distribution of smiths' tools and products shows that these ironworking industries are

not confined to the territories of individual tribes but have a far wider distribution which encompasses a whole group of tribes. However, minor features of an industry are sometimes specific to a particular tribe. With rare exceptions these tribes share common elements of culture (both material and otherwise), speak mutually intelligible or related languages which descend from a common ancestral language and have traditions of origin from a common homeland. In most cases it is, therefore, reasonable to assume that they originate from the same stock. Occasionally, as in the case of the Samburu and more particularly the Luo, the tools and products of the industry, and indeed the material culture as a whole, succeed in masking their different language and culture, but it is significant that they follow the same mode of livelihood.

In attempting to identify a regional ironworking industry it is essential to consider the whole assemblage of characteristic tools and products as well as the significant omission of others for very few are peculiar to, and therefore diagnostic of, one industry.

A study of the distribution of smiths' tools is usually more useful in identifying a regional industry than a study of its products because products are seldom characteristic of the industry as a whole but are restricted to one or more of its component tribes. The smiths of an industry usually use the same type of tools but their products are regulated by the demands of their immediate group and those are dictated by the predominant mode of livelihood. Thus differences in individual products tell us more of the economy of the people who use them than of the industry which makes them. Pastoralists do not need hoes while hunters, and agriculturists without livestock to defend, can manage without spears.

Since smiths everywhere use the same basic tools the regional differences are more explicable in terms of typology. Some industries, such as the western branch of the Interlacustrine Industry, have a greater number of archaic tool types while others, such as the Coastal Industry, have a greater number of more recent types. This does not necessarily mean that one industry must be regarded as the oldest and the other as the most recent, but rather that the former has been less affected by innovation than the latter because it has not been so subject to recent and progressive outside influence.

Arranging the most essential products of smiths into typological sequence can, however, be helpful when trying to determine which features of an industry are older than others and therefore likely to form part of its cultural core.

Just as there is no 'pure' tribe in existence there is no 'pure' industry for in some cases the distribution of artefacts is greater than the distribution of the industry or culture of which they are characteristic. In border areas an industry sometimes extends into a surrounding culture or cultures. There is, however, surprisingly little diffusion of products from one industry to another unless the two industries belong to the same language group and/or have a similar economy, and are adjacent to each other. Thus the diffusion of the hoe across Uganda into western Kenya during the second half of the last century – first by short-distance trade and then by smiths acquiring the techniques of manufacture – was rapid but it did not greatly affect the Western Highland Industry as the greatest demand there was still for weapons and the smiths of that industry were not skilled in making hoes. The diffusion of the hoe progressed rapidly through an area where people spoke languages of the same group and followed the same mode of livelihood but it was halted by coming up against peoples whose language group and economy were different.

The tools essential to smiths are basically the same everywhere and do not vary with the economy of their society. Once each industry has developed its own characteristic tools there is little diffusion of them from one to another. A more advanced type of tool, leading to an improvement in forging techniques may be adopted very gradually, but this rarely happens in the case of a completely different type of tool.

If such a tool does cross a linguistic and cultural border to another industry it may develop into a strange mixture of two types as in the case of the bowl bellows of the eastern branch of the Interlacustrine Industry.

The present distribution of smiths' tools and products appears to show that they are diffused primarily within the same linguistic and cultural group of peoples but do occasionally cross linguistic and cultural boundaries although economic boundaries are crossed more frequently by smiths' tools than by their products. Thus the distribution of artefacts can give clues as to the possible origins and direction of diffusion of ironworking.

The Relationship between the Ironworking Industries and Ironworking Beliefs

Before investigating further evidence we must consider whether any relationship exists between the regional ironworking industries, the rituals and beliefs associated with ironworking and the status and attitude accorded to smiths.

The ironworking rituals observed by smiths are universal and bear no relation to their industry, status or background culture. Ore collecting and bellows-making rituals, however, are simplified by being reduced to a prayer in those industries where ironsand and bag bellows are used; the preparation of ironsand, unlike that of other ores, is generally not restricted to smiths; bag bellows take less time to make than bowl bellows and are not as long lasting.

The omens observed by smiths are sometimes related to those of their culture but the taboos observed *by the smiths themselves* are as widespread as their rituals and equally unrelated to their industry, status or culture. The only exception is the universal taboo on women which is completely relaxed in isolated, and apparently unrelated, instances in the Eastern Stream.[5] Throughout Kenya the taboos and omens associated with forging are more numerous than those associated with smelting.

Smiths everywhere also have the same supernatural powers but the great variation in how those powers are regarded by non-smiths, and in the degree to which smiths have managed to manipulate them to their own advantage, has considerable bearing on their status and is determined by the cultural and economic frame of their society.

Table 1, which shows the characteristics of each industry, demonstrates that the status of smiths and the attitude of the community towards them bears little relation to the types of tools they use or to the artefacts which they produce and therefore, to the regional industries. The idea of avoiding smiths for fear of pollution does, however, appear to be related to the movements of Cushitic and Cushitic-influenced peoples.

Smiths are poor and of low status in the purely pastoral groups of the North-Eastern and Western Highland Industries, of slightly higher status in the semi-pastoral agricultural groups of the Western Highland Industry, of high status in the agricultural groups of the Central Highland Industry and of highest status in the agricultural groups of the Coastal and Interlacustrine Industries.

Apart from the possible diffusion of the idea of avoidance of smiths, by Cushitic and Cushitic-influenced predominantly pastoral peoples, the differences in smiths' status (and in attitude shown towards them) appears to reflect the different modes of livelihood which are primarily dictated by environment, but more particularly the relative stage of political development of the background culture of which they form a part.

Having examined the evidence provided by the artefacts themselves in relation to regional differences, possible origins and direction of diffusion, it is necessary to turn to oral historical, linguistic, historical and archaeological sources for corroboration of the conclusions as well as for clues to the means of dissemination and reasons for diffusion.

Evidence for the Origins of the Regional Industries

Myths are generally an unreliable source of information but may have a historical core which can provide clues.

There are three different types of myth in Kenya. The first relates how ironworking was a direct gift from God.[6] The second tells of the accidental discovery of smelted iron in the domestic hearth or after firing the bush,[7] by an ancestral smith who may,[8] or may not, have been miraculously conceived, and was sometimes of different tribal origin.[9] The last explains how some miraculous feat of ironworking by a legendary smith hero resulted in the defeat of an enemy and the appointment of the smith as tribal leader.[10] Myths of the last type usually concern a known person and actual event to which oral historians are able to ascribe a date.

The Central Highland Industry and the Rendille of the Western Branch of the North-Eastern Industry have myths that ironworking was a gift from God, but myths of the Coastal Industry and the two industries of the Western Stream indicate that the knowledge came to them from elsewhere. As is to be expected, myths about legendary smith heros are restricted to the Coastal and Interlacustrine Industries where smiths have the highest status.

Oral history and linguistics considered in conjunction with the little information that the smiths themselves are able to give, throw further light on the contacts between the different regional ironworking industries, which are apparent from the study of the distribution of their artefacts, and afford clues as to their origins. The Bantu speaking peoples of the *Coastal Industry* (and some of the Highland Bantu) all have traditions of origin from Shungwaya,[11] an area identified as being in the hinterland of Port Durnford (Birgao) in Southern Somalia. They had earlier spread from the highlands of north-eastern Tanzania to as far north as the Webi Shebelli. In that coastal area of Somalia their ancestors evolved from a predominant mixture of Bantu with Cushitic pastoralists from the Horn and with some Arab (and possibly Persian and Indian) immigrants. They lived mainly by agriculture and appear to have had a highly organised society with local rulers and a paramount chief. Southward movement in the sixteenth century (or earlier) by the Galla, due to Somali pressure, forced these Bantu-speaking peoples southwards into Kenya where they became differentiated into their present groups. Some travelled inland to the central highlands while the rest occupied the coastal hinterland or penetrated inland to the Taita Hills. Some groups remained in those hills while others returned to the coastal area or moved on into Kamba country in the central highlands. Later many Taita expanded southwards to the Pare and Usambara mountains in north-eastern Tanzania.

Amongst the earliest immigrants in the coastal region were the Pokomo who having no smiths of their own (probably because no ore is available in the lower Tana river valley) relied for their ironwork on Swahili, Orma Galla and, later, Bajun smiths.[12] Otherwise smiths are found throughout the Miji Kenda area and amongst

the Swahili in the coastal towns and villages, but most of the ironworking is done by Bajun and Giriama smiths, the largest centre of ironworking being in Giriama country. Giriama smith traditions say that they could work iron before leaving Shungwaya but that it was re-introduced by a legendary leader who used it to forge weapons with which to defeat the Wakwavi Masai.[13] Traditions of the central highland Meru corroborate that iron was worked in Shungwaya.

Ironworking amongst the Taita is largely confined the Dabida group whose smiths claim to be of Kamba, Giriama, Shambaa[14] and Wakwavi Masai origin but say that ironworking originally came from the Malindi and Lamu areas of the coast.

The peoples occupying the area covered by the *North-eastern Industry* all speak eastern Cushitic languages with the exception of the Samburu who are a branch of the eastern Nilotic speaking Masai.

The *Western branch* of the *North-eastern Industry* is confined to the pastoral Samburu and Rendille who, although they speak totally different languages, are closely related and intermarry a great deal. According to linguistic evidence the relationship has probably been of long standing for eastern Cushites, who may have been ancestral Rendille, were in contact with the proto-Masai in the First millennium B.C. (Ehret 1974: 41). It is very rare for a regional industry to be produced by peoples of different language and culture but this close association offers an explanation.

The Rendille, who speak an archaic form of Somali and were probably once more widespread, have been longest in the area. They are believed to have migrated from the southern edges of the Ethiopian highlands east of Lake Turkana (L. Rudolf) at least a thousand years ago (Ehret 1974: 34). They maintain that they knew of ironworking before their migration and before the adoption of camels on which their economy has for so long depended.

The Samburu are an offshoot of the Laikipiak, one of the Wakwavi semi-pastoral agricultural Masai groups who became differentiated from the pastoral Masai after they had moved south from an area to the west of Lake Turkana. Their smiths insist that they learned ironworking from the Rendille.

The Orma Galla, of the *eastern branch* of the industry, expanded into Kenya from Ethiopia in the 16th and 17th centuries occupying territory between the Rendille and Somali as far south as the Tana River and beyond. They were followed by the Borana and Gabbra Galla. A resurgence of Somali from the beginning of the 19th century gradually pushed the Gabbra and Borana westwards and restricted the Orma to the Tana river area where they have had considerable influence on the Bantu Pokomo.

The more archaic elements of the industry appear to stem from Somali and Orma smiths. The Gabbra and Borana Galla of Kenya had no smiths until Konso smiths from south-west Ethiopia settled amongst them in the present century. It is possible that the few Orma smiths who used to work[15] in the Tana river area learned ironworking from the Somali who say that their knowledge came from the Barawa of the Benadir coast of Somalia but that it was originally introduced from Arabia or India.[16] The influence of the North-eastern Industry on the Coastal is seen in the *tanged* fish spears of the Tana river Pokomo which, before Bajun smiths settled amongst them, were made for them by Orma smiths whose typical products were tanged flat-bladed spears and daggers.

The *Central Highland Industry* is restricted to the Kenya Highland Bantu who were well established in their present territory by the sixteenth century and probably earlier. According to their oral history the central Meru, who were later arrivals, emigrated from the coast and probably ultimately from Shungwaya, the homeland of the coastal Bantu. They left their traditional homeland on the island of Mbwa, which has been identified as Manda island, probably as late as the 17th century (Fadiman 1970: 13). From their traditions it would appear that they knew of ironworking for some considerable time before their emigration from the coast and that they took this knowledge with them inland. They say that Mbwa was rich in ironsand and their smiths were much respected but after leaving there, and before arriving in their present homeland, they had difficulty in finding ironsand; an understandable statement as the lower Tana river valley up which they travelled has no ore. The fact that they practised ironworking at the coast suggests that the craft must have been known to the earlier people of Shungwaya as the Coastal Bantu maintain.

The Kamba, who are also of coastal origin, arrived in the central highlands by several different routes. Some came up the Tana river while others came by way of Kilimanjaro mountain or the Taita hills.

Smiths in the Kilungu and Mbooni hills in the southern part of Kamba country state that they brought the knowledge of ironworking with them from the Kilimanjaro/Taita hills area,[17] and many Taita smiths claim to be of Kamba origin. The use of triangular bag bellows by Taita smiths, instead of the normal whole-skin bag bellows of the rest of the Coastal Industry, is evidence of this interchange. Kamba iron-working, as we have seen, also differs in some respects from that of the rest of the Central Highland Industry in that it shows more coastal influence.

The Kikuyu and Embu groups and some of the southern Meru have no traditions of coastal origin. They maintain that they arrived in their dispersal centre of the Ithanga hills from an area to the north-east of Mount

Kenya (now occupied by the Igembe Meru[18]) where they appear to have derived from a Bantu speaking people known as Thagicu who inter-mingled with eastern cushitic speaking Gumba and nilotic speaking Il Tikirri.

On their arrival at the now famous ironworking centre of the Ithanga Hills, they found more Gumba and Thagicu groups of whom the latter also provided some ancestors for the Kamba (Muriuki 1974: 57), the Sonjo of northern Tanzania (Bennett 1967: 141) and the coastal Segeju (Spear 1978: 36). The Kikuyu moved on to their traditional homeland of Mukurwe wa Gathanga (near Muranga, Fort Hall) from where they gradually spread to their present territory.

Smith traditions corroborate the oral history. Smiths of the Igembe, the northernmost Meru tribe (from whom one section of the Kikuyu claim descent (Muriuki 1974: 57) maintain that the Athimba clan, to which they belong, were the first people in the area and that they spread the knowledge of ironworking to the other Mount Kenya peoples from their ironworking centre also called Ithanga in the Nyambeni hills.

To the south, Mbeere smiths, famous for their ironworking, believe themselves to have been the first smiths of the area. They say that they came from the Ithanga hills and whilst there taught the Masai, and later the Embu[19] and Kikuyu, the art of ironworking.

Kikuyu smiths say that they all came originally from the Ithanga hills (Hobley 1922: 167). From there the majority moved to Gaturi[20] near Mukurwe wa Gathanga,[21] the traditional Kikuyu homeland, while others went on northwards to the vicinity of Nyeri. These two areas became the main centres of Kikuyu ironworking. In the 19th century Gaturi was famous for its iron markets at Geitwa, Mukangu, Kanonero, Ngindu and Mukurweini which supplied the Embu and Chuka as well as the Kikuyu. The Kukuyu say that they learned the art of ironworking from the Gumba (Beech 1915: 40, Routledge 1910: 4) who could just conceivably have learned it from the Thagicu. It was certainly known before the arrival of the Kikuyu in the 16th century for excavations to the south and south-east of Mt Kenya at Gatung'ang'a (Siiriainen 1971: 205), the Ithanga Hills (Mahlstadt and Diblasi 1978: 192), Grand Falls in Meru District (Cummings 1978: 193), in Embu, Mbeere and Chuka areas (Soper 1976: 31) and elsewhere in the central highlands have yielded Gatung'ang'a ware (a late variant of Early Iron Age Kwale/Kwamboo pottery) in association with evidence for iron smelting. Gatung'ang'a was occupied between the 12th to 14th century A.D.

The ancestors of the eastern nilotic speaking Masai and the southern nilotic speaking Kalenjin group, to whom the *Western Highland Industry* is restricted, originally dispersed from the same general area in the Uganda/Kenya border region. There the Southern Nilotes (but not the Eastern Nilotes) were so strongly influenced by eastern cushitic-speaking peoples that they adopted many of their cultural traits including circumcision and a cyclical age-set system. Linguistic evidence (Ehret 1971: 29) shows that at the beginning of the Christian era (and probably earlier) the ancestral Southern Nilotes knew of iron and ironworking and shared the word for "to forge iron" with the ancestral Eastern Nilotes.

Oral history tells us that the Kalenjin peoples arrived on Mt Elgon early in the 17th century from an earlier homeland immediately to the north-west. Their second major dispersal led to the formation of the present-day groups some of whom remained behind on the mountain. The proto-Masai moved down the Rift Valley south of Lake Turkana (L. Rudolf) and gradually split into pastoral and agricultural sections. The pastoral agricultural Wakwavi moved into the highlands bordering both sides of the Rift Valley; the Laikipiak settled to the east while the Uasin Gishu shared the high plateau to the west with the Kalenjin.

Their predecessors on this plateau were earlier Kalenjin and Masai speaking peoples. Of those they remember the Ilgoolala Masai and the Serikwa who were probably also of Masai origin.[22] Both are said to have practised agriculture and to have been famed as ironworkers. One of the Serikwa ironworking centres appears to have been in the Cherangani Hills. They supplied ironwork to the Kalenjin who had remained behind on Mt Elgon. When the Serikwa were later dispersed by the arrival of the Masai proper some of their smiths moved to Mt Elgon where they continued to work for the Mt Elgon Kalenjin and for their Bantu neighbours whose tongue they adopted (Weatherby *et al.* 1964: 61–74). Others, who had gone southwards, were eventually over-run by the southern Kalenjin and became their smiths (Peristiany 1939: 160) or later went on to work as smiths for the pastoral Masai.[23] Those who remained behind worked for the Uasin Gishu Masai (Hinde and Hinde 1901: 86) and later Kalenjin. Masai smiths seem to have been attached to the Wakwavi agriculturists[24] rather than to the pastoral Il Masai (Ratzel 1897: 494) just as the present-day Pokot smiths are attached to the agricultural and not to the pastoral sections of that tribe.

Almost all Kalenjin and pastoral Masai traditions about the origin of ironworking tell of its introduction either by the Serikwa[25] or the Uasin Gishu Masai (Huntingford 1953: 37 and 1931: 265; Hollis 1909: 36; Johnston 1904: 876). Inter-tribal wars in the 19th century, between agricultural and pastoral Masai and between the different Masai agricultural groups, resulted in the Uasin Gishu being almost annihilated. The remnants, who were chased from their territory by advancing Nandi Kalenjin, were either assimilated by them or

sought refuge with other Masai or with the Interlacustrine Bantu. Some were smiths who took their craft with them, while others learned the craft because they had no other means of livelihood.[26] Some pastoral Masai smiths must have previously worked for the Kalenjin for there are references to them speaking Kalenjin (Hollis 1909: 330); their unique smithies resemble Kalenjin (or possibly Uasin Gishu) huts and appear to have a Kalenjin name; the name for their hammers is a Southern Nilotic loan-word (Ehret 1971: 168); and like the Kalenjin, they use juniper wood in their dome furnaces which are used for smelting ironsand instead of the bulkier ore normally smelted in that type of furnace.

The Interlacustrine Industry is confined to a fertile region which has long been the scene of continual migrations and movements of peoples of different language and culture who arrived there from different directions.

Both linguistic and archaeological evidence indicates that iron-working was introduced to the area well before the period covered by oral history. On linguistic grounds Ehret (1971: 32, 39, 42) considers that contacts had begun between ancestors of the Southern Nilotes, who already knew how to smelt iron (Ehret 1971: 29), and the first Bantu settlers in the area in about the first century B.C. Those contacts continued until the period at which oral history is able to take over (Ehret 1971: 47, 50, 63). Archaeological evidence in the form of pottery typical of the early iron age, and named after its type-site of Urewe, is found throughout the area.

Early Bantu groups, about whom oral history can tell us little, peopled the southern half of present Luyia and Luo country before the arrival of the Kalenjin who were already occupying Mt Elgon by the beginning of the 17th century. Some Kalenjin remained there while others spread into central and southern Luyia abandoning their own language and culture in favour of that of the Bantu.

The early 16th to the mid 18th century saw large-scale immigrations of Bantu speaking peoples mostly from Busoga country in eastern Uganda. Although they had become Bantu speakers they were of mixed Bantu and Nilotic descent, their ancestors coming originally either from the north and west by way of Bunyoro and Buganda or from Mt Elgon to the north east.

An expansion of Eastern Nilotic peoples in Uganda in the late 18th century started further emigrations from the same area. As a result the united Bugisu/Bukusu peoples divided, the former going northwards to settle on the western slopes of Mt Elgon whilst the latter moved eastwards to occupy its southern slopes in Kenya.

In the late 16th and early 17th centuries Wakwavi Masai (and sometimes Nandi) immigrants settled amongst the south-eastern Luyia peoples, adopted the Bantu tongue and formed their ruling clans. Later another group of Masai became the ruling clan of Nyala Luyia.

Among the ancestors of major Luyia clans to be found just across the present Uganda border[27] in the late 17th century were the Abafafoyo of Marachi; the Abaguuri of Hayo; the Abakhekhe of Samia and the Abashitsetse of Wanga (Were 1967: 189) all of whom are well known as smith clans. Of these the Abafafoyo clan, which is also found in Samia, Hayo and Wanga, claims to have come from Bunyoro (Were 1967: 232) the famous ironworking centre in western Uganda. They also claim to be closely related to the Abaguuri (Osogo 1966: 106), the ruling clan of the Hayo who are the only people in that tribe allowed to engage in ironworking. The Abakhekhe, the Abasamia (which is the other major clan of the Samia) and the Abashitsetse, are all partially of Kalenjin origin from the east.

These peoples settled in western Luyia within reach of the Samia hills which provide the richest source of ore in the area. The Abakhekhe, accompanied by the Hayo and Marachi (who were once one people), and the Abasamia, must have been able to work iron before their arrival in the area as Abakhekhe traditions maintain that they migrated because they had no iron ore for smelting while the Abasamia reported that they settled in Samia because iron ore and the wood necessary for smelting it were plentiful in the area. Their smith clans of Abang'aale,[28] (who pass as either Abasamia or Abakhekhe), and Ababonwe (who claim to belong to the latter) are also found in Marachi. The Abakhulo, who are the leading Samia clan as well as a smith clan, came from the west of Mt Elgon.[29]

The Abashitsetse clan, which is a smith clan, came from the east from a branch of the Tiriki kingly line.[30] About 1600 A.D. the Hima, from south-western Uganda, entered the predominantly Kalenjin-populated area of Wanga to form it into the independent state of Imanga under a Hima ruler. It was this state which was subsequently extended, reorganised and centralised into the kingdom of Wanga. This was accomplished by Wanga who deposed its ruler and started the Shitsetse dynasty.

Shiaya, the eponymous ancestor of the leading Amulembo clan of the Yala (neighbours of the Samia), also came from Tiriki from the same clan that gave rise to the Abashitsetse.[31] Before becoming ruler of the Yala he had sojourned in Marachi where he became famous as the legendary smith hero who saved himself by forging a spear from a skull.[32]

The ancestors of the Bukusu, the northernmost Luyia were driven from Serikwa (to the east of Mt Elgon) by the Kalenjin. After intermingling with Bantu to the south-west of the mountain, and adopting their tongue, they returned eastwards to settle in their present home

on its southern slopes. As has already been mentioned Serikwa ironworkers settled amongst the early Kalenjin (neighbours of the Bukusu) who remained on the mountain when the rest dispersed. Two of the clans to which Bukusu smiths belong, the Balako and Bamasaba originate respectively from the Bok group of those Kalenjin with whom they inter-married (Were 1967: 1. 179, Osogo 1966: 82) and the Bagisu with whom they formerly lived to the south-west of the mountain. For some time the Bagisu also lived in Hayo where it is recorded that they were manufacturing iron.

It must now be evident that although the Luyia represent the westernmost expansion of the large group of peoples (of similar language, culture and economy) known as the Interlacustrine Bantu, the northern and eastern-most Luyia groups have assimilated the greatest number of paranilotic speaking semi-pastoral agricultural Kalenjin and Masai. Amongst them were a number of smiths. This helps to explain the derivation of the different tools used in the eastern and western branches of the ironworking industry. There is, however, little ore to be found in eastern Luyia so only the Tiriki and Bukusu, whose ironworking is derived largely from the Western Highland Industry, have traditions of smelting. The rest of the eastern Luyia maintain that they learned ironworking from smiths of the western branch of the industry who live close to the rich ore deposits in the Samia hills near the Uganda border. This happened only in the last century. After the introduction of hoes the demand for them became so great that smiths responded by training more of their sons in the craft. Some remained in the western ore-producing area to meet the demand for more pig-iron by working in larger occupational groups, while others took additional wives from eastern groups without smiths and returned home with them to set up new smithies in the east. Their movement was greatly facilitated by the demand for their services; the dispersal of Luyia clans throughout the area; their membership of leading clans; and the fact that they were not moving outside their own tribal area which shared a common language, culture and economy.

To the south of the Luyia live the western nilotic speaking Luo. They began to arrive in Kenya early in the 16th century after expanding southwards, throughout Uganda, from their homeland in the Upper Nile region of the southern Sudan. They were preceded in their present homeland by various peoples of Bantu and Kalenjin origin, some of whom assimilated or were assimilated by the Luo, but most of whom were displaced northwards or southwards into their present territories.

While retaining their own language and culture, the Luo gradually adopted the agriculture and fishing economy of their Bantu neighbours and much of their material culture. They had no smiths of their own until the Walowa migrated from the west across lake Victoria to the northern part of Luo territory in the 18th century. The Walowa were allowed to settle because they were smiths, but only on condition that they supplied the Luo with iron products (Ochieng 1975: 22). They used the same tools and methods as the rest of the western branch of the industry. These were probably already familiar to them in their western (Uganda) homeland. A further group of Walowa sailed southwards to settle in Tanzania where they became known as *Waturi* (smiths) (Ochieng 1975: 22). While in Tanzania they must have adopted the triangular bag bellows used by the Sukuma and Sonjo for when ironworking was introduced from there to the southern Luo by a Luo who married a Mturi girl and was taught the craft by her father bag bellows were introduced with it.

The incoming Luo divided the bantu speaking Gusii and Kuria from the Luyia. They drove the Gusii south-eastwards where they came up against the southern Kalenjin and Masai. After a defeat by the Masai c. 1820 (Ochieng 1974: 40) the Gusii moved into their present homeland in the Kisii highlands. There they developed a thriving iron industry which exported goods northwards to the Luo because there were too few Luo smiths to satisfy the demand. The Gusii are said to have been working iron since the time of the eponymous ancestor Mogusii in the sixteenth century (Ochieng 1974: 213). Their smiths bear the same name as those of the Luyia but use mostly bag bellows which must have been introduced from the south.

Closely allied to the Gusii are their southern neighbours the Kuria who extend over the Tanzanian border. They originated in the west but arrived in their present homeland from different directions. Some came from the same direction as the Gusii, while the rest travelled from Uganda by way of the southern end of Lake Victoria. There they split, one group going eastwards before returning, and the other going directly northwards. Their smiths also use bag bellows which must have been introduced from the south after coming originally from the east.

Thus the oral history and smith traditions of this Interlacustrine Industry, like its artefacts, suggest a northern and western origin for its *western branch*; a more recent derivation of its *eastern branch* from the western branch with strong influence from the Western Highland Industry; and a mainly southern origin for its *southern branch*.

In the case of every ironworking industry the oral and linguistic history of the peoples and the traditions of their smiths appear to corroborate the evidence of interchange as seen from a study of the distribution of ironworking tools and products. Wherever there is a diffusion of artefacts there has also been a diffusion and usually an assimilation of peoples.

Artefacts are diffused easily only between peoples who belong to the same language group and share the same culture and economy. Regional ironworking industries are generally confined to such groups although, on rare occasions, an industry and indeed a similar material culture does mask a difference in language and culture. In that case, however, there is never any difference in the basic economy and there is always a history of mutual intermingling of the two peoples. A change in economy has usually been forced on one by a change in environment and that, in turn, has caused them to adopt from their neighbours a material culture more suited to their new way of life.

A study of oral history and linguistics confirms that on the few occasions when artefacts are diffused from one industry to another, people responsible for that diffusion speak the same language and share the same culture and economy because they are minority groups or disbanded peoples who have been assimilated by those with whom they sought refuge, and have adopted their language, culture and economy.

When a people with a flourishing iron industry is dispersed, many of their smiths are assimilated by those who disbanded them while others are welcomed and given refuge by neighbouring peoples who have already been obtaining iron artefacts from them by border trade. This happens when the neighbouring peoples have no smiths of their own or their smiths are too few to meet their demand for iron goods. The smiths of the dispersed group are quickly assimilated. They take their tools with them and, since their products always reflect demand, they adapt to making a different set of artefacts if the economy of the people with whom they have settled is different from their own.

The diffusion of smiths' products across borders does not mean that there has been a diffusion of smiths although it does imply an interaction of peoples usually by diffusion.

The diffusion of smiths' tools, however, almost invariably means a diffusion of the smiths themselves; this appears to take place only when the people to whom they belong are displaced by others, or when a surplus of smiths has been trained in response to a sudden increase in demand for their products and that demand has not been sustained. In addition smiths, as we have seen, are more readily assimilated into agricultural rather than into pastoral societies.

THE AFFINITIES OF THE REGIONAL IRONWORKING INDUSTRIES

The Eastern Stream

The affinities of the *Coastal Industry* are with the Tanzania coast immediately to the south and, more par-

ticularly, with the eastern branch of the North-Eastern Industry which shares the same more advanced tools and techniques. These obviously derive from the Indian ocean/Red Sea trading area from where they must have been introduced directly to the coast or indirectly by way of Ethiopia.

The *Central Highland Industry's* connections with the Coastal Industry are slight and generally late. It has affinities with ironworking in the Taita Hills, with Sonjo ironworking on the Kenya/Tanzania border and with ironworking in the mountains of north-eastern Tanzania where, until recently, the Pare Hills were renowned as an ironworking centre. Oral history confirms that there have been movements in both directions between the Kamba (of the Kenya Highland Bantu) and the Taita (of the Taita Hills); the Taita and the Pare (of the Pare mountains), Chagga and Wakwavi (of Mt Kilimanjaro); the Pare and the Chagga and Wakwavi; and probably between the famous ironworking areas of Mts Kilimanjaro and Pare[33] and the Sonjo. The Language of the Taita is closer to that of the Kenya Highland Bantu and the Bantu of the mountains of north-eastern Tanzania than to the Coastal Bantu, while some Highland Bantu languages are close to those of the Interlacustrine Bantu[34] on the Kenya/ Tanzania border among whom, as we have seen, the triangular bag bellows also appear. The earlier underlying connection between these groups may be the Thagicu (from whom many of the Kenya Highland Bantu descend and who are still to be found in Tharaka and Mbeere) who were dispersed southwards, for the Sonjo still speak a language belonging to the southern Thagicu group (Bennet 1967: 141).

There are obviously also very close affinities between the Central Highland Industry and the Western Branch of the North-Eastern Industry, but the connections are difficult to trace for they may be earlier than the period covered by oral history and virtually nothing is known of the oral history or linguistics of the Rendille. Eastern Cushitic traits borrowed by the Highland Bantu from the Masai were, according to linguistic evidence, assumed by the proto-Masai peoples in the first millennium, perhaps from the Rendille (Ehret 1974: 41), but this cannot be verified as so little is known of the latter people. There has been much intermingling between the Highland Bantu and the Wakwavi Laikipiak Masai, of whom the Samburu are an offshoot.[35] The earlier Thagicu must also have been in contact with the ironworking Ilgoolala Masai, who inhabited the Laikipia plateau probably before and contemporaneously with the arrival of the Laikipiak, and with their predecessors the Iltatua "Ilarinkon who are thought to be connected with, or to descend from, the Somali, Rendille, Borana or Meru or mixed groups of all four" (Jacobs 1972: 81). They could also have been in contact with Cushitic peoples in the

Igembe homeland area, and there are reports of some Kikuyu being of Ethiopian or Rendille origin (Muriuki 1974: 56). Thus the connections, whatever they were, between the peoples of the two regional industries have been of long-standing: the Central Highland Industry appears to derive mainly from the western branch of the North-eastern Industry which, itself, appears to derive from what might be described on the strength of its using bag bellows and bowl furnaces as the eastern ironworking stream of Ethiopia.

Thus the main influences on all the industries of the eastern stream appear ultimately to be those which have penetrated inland from the northern and eastern coasts.

The Western stream

Apart from the possible connection (noted in the chapter on smiths' products) with ironworking of the Tatoga of Tanzania, who originate from the same ancestral stock as the Kalenjin, the closest affinities of the *Western Highland Industry* are with the extreme south-west of Ethiopia where bowl bellows and dome furnaces are also used. Further evidence for the connection is provided by similarities in some of the names used in ironworking. Names used for a smith in south-west Ethiopia are *gita-manna* and *gito*; in Kalenjin *gitonghin* (or *kitonghin* as g and k are interchangeable) is used, and in Tatoga *gidangodiga*. The names for iron also appear to derive from the same source. Iron called *sibila* by the Ethiopian Galla, is called *sibila*, *sibil* and *sila* in south-west Ethiopia, names which are similar to *sibia*, *shiba* and *esiwya* used by the eastern branch of the Interlacustrine Industry which owes so much to the western Highland Industry where iron is called *ossiyai* or *asiyai* by the Masai but not by the Kalenjin.

The so-called "old people" who inhabit the mountainous region of south-west Ethiopia have been driven there by incursions of Cushitic and Amharic peoples from the north and east, and Nilotic peoples from the west and south-west. They speak closely related (but as yet not precisely classified) languages which are thought to be early Nilotic. Their ironworking, which differs from that found elsewhere in Ethiopia, closely resembles that of the Bongo west of the Nile and that of the intervening Nilotic peoples of the Sudan.

Ironworking in the Western Branch of the *Interlacustrine Industry*, as we have seen, is closely related to that of an eastern Nilotic people to the north, but also has close affinities with that of the Interlacustrine Bantu to the west to whom most of the peoples of the industry culturally belong, and from whom their ironworking terms are taken.

The Interlacustrine area of East Africa witnessed the emergence of a number of independent kingdoms in

which blacksmiths rose to positions of highest prestige as leaders of the state. Bunyoro, the earliest kingdom in Uganda, has no traditions about the introduction of ironworking, only of introducing it to other peoples. This points to an earlier establishment of the craft there than elsewhere. It also appears to be the only place recorded where ironworking developed so intensively that specialisation between smelters, pig-iron workers and forgers took place (Roscoe 1923: 217). Baganda oral traditions all indicate that ironworking was introduced from Bunyoro.[36] Ruanda traditions maintain that it was introduced in the late 15th or early 16th century by pastoralists from the north who had earlier formed the Bunyoro/Kitara empire. These same peoples, variously called Bachwezi, Bahima and Bahinda, also settled in Urundi (where ironworking was said to have been introduced in the 17th century by a legendary ruler), Ankole and Karagwe where they were not absorbed as in the north but established rule over sedentary cultivators with whom they formed a symbiotic relationship.

In Bunyoro these peoples were followed by the incoming western Nilotic Luo who established the Babito dynasty. The Luo-speaking peoples probably evolved in the south-east corner of the Sudan about 1000 A.D. From there the ancestors of the Nuer, Dinka and Shilluk moved northwards to their present Sudan homeland, while the Luo travelled southwards up the Nile arriving in Uganda about 1500 A.D. or earlier. Once there they divided into groups which spread throughout northern Uganda and penetrated into western Kenya. The western Nilotes were primarily pastoralists. Their traditions suggest that they first learned ironworking from people they encountered whilst moving north.

No detailed study has been made of traditional ironworking throughout the Interlacustrine area[37] but from what is known it appears that the tools are remarkably uniform. The same type of clay or wooden bowl bellows, stone hammers, unhafted iron maul hammers and split green-wood tongs are used. Bowl furnaces, occasionally covered over[38] and with or without a low surrounding wall, are common although in the southern part of the area high dome furnaces of mud or 'brick' or stone, resembling those of eastern Zaire, are also found.[39] In general, however, the tools resemble those of the equally little known iron industries of the adjacent areas of north-eastern Zaire and the southern Sudan.

Oral history does not extend back much before the rise of the kingdoms but it does suggest that the previous inhabitants of the area were Bantu who were primarily agriculturists organised on a clan basis with local chiefs and that they did, in fact, have a knowledge of ironworking (Katoke 1975: 11–12) before the coming of the Chwezi, Hima and Hinda.

PRODUCTS

WESTERN STREAM Interlacustrine Industry
Peculiar to this industry are bill-hooks in various shapes and sizes, and similarly curved knives and sickles, double-pronged fish spears, bells made especially for hunting dogs, and circular sharpened throwing discs for fighting.
Characteristic are short-butted spears with ogee cross-sectioned blades, and hoes.
Note. Since non-ferrous metals are rarely used except for the insignia of tribal leaders, there are no specialist ornament makers, so smiths make a greater variety of iron ornaments than elsewhere. Of particular note are miniature bill-hooks.

WEST HIGHLAND INDUSTRY
Most characteristic are spears which are made in a greater variety than elsewhere. Arrows, axes, bells and swords are also typical although swords are not made by the northernmost people. Peculiar – elephant spears.
Only a limited variety of products are made but they are of high quality workmanship.

EASTERN STREAM North-Eastern Industry
Characteristic. Short-butted spears either flat-bladed or with square or oblong cross-sectioned mid-ribs. Occasionally ogee. Often ridged sockets. Flat bladed daggers with non-ferrous metal handles. Tooled leather sheaths. Socketed adzes. Samburu. Long butted throwing spears with small leaf-shaped heads, swords, branding irons, bells.

CENTRAL HIGHLAND INDUSTRY
Peculiar. Digging knives with mid-ribs and a very long handled chisel for hollowing wood.
Typical. Swords which resemble the digging knives, long-bladed stabbing spears, branding irons, axes and adzes which are typical of the Kamba. Kamba do not use spears, or digging knives. They rely on arrows as weapons, and metal tipped digging sticks for agriculture.

COASTAL INDUSTRY
Typical. Axes, arrows, knives, and hoes. Axes are particularly important.
Note. The few fish spears used by the Pokomo of the Tana river are tanged otherwise spears, swords and bells are rarely found.

STATUS & ATTITUDE

Smiths are rich men of high status who own both land and livestock. Many of them belong to the ruling clans. There is no fear of pollution from contact with smiths only from their tools and products. They are therefore not avoided and do not live apart as a separate group although their smithies, as everywhere else, are always apart. Non-smiths welcome intermarriage with them.

Smiths are regarded as powerful sorcerers. Their automatic curse is not strong enough to exclude non-smiths so they impose powerful curses, often using their bellows, on those who break their taboos. They can curse on behalf of non-smiths for the good of the community.

The smiths have had to impose strict taboos on non-smiths. Those normally restricted to productive women are extended to little girls. Peculiar to this industry is a taboo on twins. Some categories of impure persons who have to enter can do so if they do something to counteract their impurity.

Of comparatively low status. Live apart as a group in separate villages. Fear of pollution from contact with smiths and ironworking strong. Intermarriage does not take place in first generation, only in second. Buyers safeguard themselves from products. Pollution affects crops and livestock and smiths believe animals will not thrive in their care. Smiths cannot fight and are inviolate in war. Non-smiths avoid smithy but strong curse also imposed often by using bellows. Cannot impose or revoke it without permission of tribal elders. Cursing people by invoking lightning peculiar to Kalenjin smiths. Taboos on non-smiths, particularly women, strict. Oath on bellows in S. Masai Status lower. Greater fear of pollution therefore avoided more and don't intermarry. Taboos on non-smiths unnecessary. Beliefs closer to those of Samburu smiths. Like them curse using tuyeres and flakes left on anvil after forging and invoke wild animals and snakes to harm people.

Poor and low of status. Separate caste. Fear of pollution from contact greater than elsewhere. Avoided and no intermarriage. Safeguard themselves against products. Fear of touching smith's things or smiths touching theirs or entering houses. Smiths don't fight and are inviolate in war. Taboos on non-smiths unnecessary. Rendille Chosen by God but poor. Separate caste but live with patron in larger camps. Given food and protection in return for work and prayer. Automatic curse so strong withdrawing prayer sufficient.

Rich and powerful especially in S. Separate caste but don't live apart. Fear of pollution from contact and avoidance encouraged by smiths themselves. Both sides averse to intermarriage. In N. Meru area pollution affects crops and livestock so smiths own neither but they do elsewhere. Automatic curse strong and great fear of imposed curse for which often use Tuyeres and bits of red-hot iron which are cut up or dunked in water. Regarded as powerful sorcerers. Curse regularly on behalf of non-smiths for good of community. Very strict taboos on non-smiths approaching ironworking.

Comparatively high status. One of famous leaders was a smith. Separate but do not live apart. Fear of pollution from contact not very strong therefore some intermarriage takes place but smiths not allowed to sleep in non-smith houses. Automatic curse strong and powerful curses imposed using hammers and bellows. Smiths administer most powerful oath of group on axe in smithies. Taboos on non-smiths entering smelting place or smithy. Smiths wives and daughters can blow bellows.

Data table

TRIBE & LANGUAGE	ECONOMY	SMITHY	HEARTH	FURNACE	HAMMER	ANVIL	BELLOWS	TUYERE	TONGS
I/L BANTU									
Logoli	A.	A	A	A	C3	A2a, B5	A2b	A	A,B
Isukha	A	A	A	?	B1,C3	A3,B2 B5	A2b	A	A,B
Idakho	A	A	A	?	C3	A2a B5	A2b	A	A,B
Tiriki	A	A	A	?	C	B5	A2b	?	? B
Hayo	A	A	A	A	C	A3 ?	A1	A	A,B
Marama	A	A	A	A	C3	A2a	A1	A	A,B
Kisa	A	A	A	A1	C3	A2a, B5	A1	A	A,B
Sania	A	A	A	A1	A,B1b,B2	A2a,A3,B2,B4	A1		C
Marachi	A	A	A	A1	A,B1b,B2	A2a,A3,B2,B4	A1		C
Wanga	A	A	A	A1	A,B1b,B2	A2a,A3,B2,B4	A1		C
Bukusu	A	A	A1	?	A,B1b	A2a	A1		C
W. NILOTIC									
Luo	A/F	A/F	A	A	C3	A2a	A1	A	A,B
S. NILOTIC									
Kipsikis	SPA	A		B	B1a	A2a	A2	A	? B
Nandi	SPA	A		B	B1a	A2a	A2	A	𝒜,B
Tugen	SPA	A		B	B1a	A1 ,B3	A2	A	𝒜,B
Keiyo	SPA	A		B	B1a		A2	A	𝒜,B
Marakwet	SPA	A&D	A	B	B1a	A1,A2b,B4	A2	A	𝒜,B
Pokot	A&P	A	B		B1a	A1 B3	A2	A/C	𝒜,B
E. NILOTIC									
Masai	P	A	B	B	B1a	A1,A3	A2	A	B
Samburu	P	C	B,A	BA	B1a	A2a,A2b	B1	A	B
CUSHITIC									
Rendille	P	C	B,A	B,A	B1a,C3	A1			B
Somali	P	C	A	A	B1a,C3	A1,B1a	B2	A	B
Borana	P	C	A	A	?	B1a	B2	A	B
Orma	P	C	A	A	?	A1	?	A	B
H. BANTU									
Kikuyu	A	A	A	A	B1a,C1b	A2a,A2b B5	B1	A	𝒜,B
Embu	A	A	A	A	B1a,C1	A2a,A1	B1	A	𝒜,B
Mbeere	A	A&C	A	A	C1	A1 B5	B1	A	𝒜,B
Igembe	A	A&C	A	A	C1	A2a B5	B1	A2	? B
Tharaka	A	A	A	A	B1a,C1	A2a B5	B1	A2	𝒜,B
Chuka	A	A	A	A	C1	A2a	B1	A	𝒜,B
Kamba	A	A	A	A	C1a,C1	A1, A2a B5	B1	A	? B
C. BANTU									
Taita	A	A	A	A	C2	A2a B1a	B1		B
Giriama	A	A	B	A	C2	B1a	B2		B
Digo	A	B	A&B	?	C2	B1a,B1c	B2		B
Swahili	A	B	A	?	C2	B1a,B1b	B2		B
Bajun	A	B	A	A	C2	B1a,B1b	B2		B

𝒜 = used formerly A = Agricultural SPA = Semi pastoral/Agricultural
A (underlined) = variant P = Pastoral F = Fishing

UGANDA PEOPLES

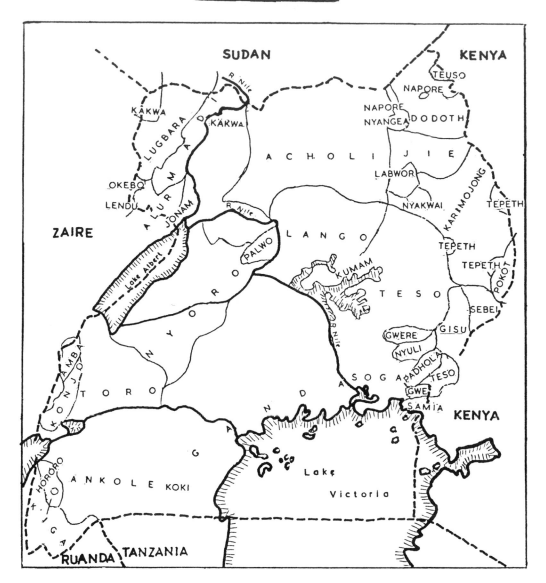

- - - - Territorial boundary

Ironworking in the Interlacustrine region exhibits a number of archaic features which appear to have changed little since its introduction. Archaeological discoveries of furnaces[40] confirm this fundamental continuity which is to be expected in view of the conservative nature of the craft and the general immoveability of smiths.

CONCLUSION

A study of smiths' tools and products does make it possible to distinguish regional ironworking industries in Kenya. They can generally be correlated with a group of tribes of similar culture and economy who belong to the same language group, although occasion-

ally an industry can mask differences in language and culture but usually not economy. These industries can be divided tentatively into two distinct streams to the east and west of the Rift Valley.

By reference to oral history and linguistics it is possible to equate the movements of peoples with the expansion of ironworking industries; make suggestions as to their origins; and outline routes by which the knowledge of ironworking may have been introduced.

Although separate industries can be recognised from an ethnographic study of ironworking tools and products, archaeologists would be unable to determine them by this means unless by some miracle they were able to find the total assemblage of tools and products

KENYA PEOPLES GROUPED ACCORDING TO LANGUAGE

(The most convenient method of Grouping them)

CUSHITIC SPEAKERS (Hamites)

(Afro–Asiatic family)

Eastern Cushites

Galla Group		Somali Group	
Orma)		Somali)	
Borana) Pastoralists) Pastoralists	
Gabbra)		Rendille)	
Boni			

NILOTIC SPEAKERS

(Nilo–Saharan family. Eastern Sudanic Branch)

NILOTES PARANILOTES (Nilo–Hamites)

WESTERN or RIVER–LAKE NILOTES	SOUTHERN or HIGHLAND NILOTES	EASTERN or PLAINS NILOTES

Luo: Agriculture and fishing with "cattle cult"

Kalenjin
Pokot Agricultural and
 Pastoral sections
Nandi)
Kipsigis) Semi–
Keiyo) pastoral
Marakwet) agriculturists
Tugen)
Sebei Agric. & Hunting
Ogiek Dorobo – Hunters

Masai Group
Masai) Now all
Samburu) pastoralists

Il Camus Mixed ecomomy
(Njemps) with fishing
El Molo Fishing

Karimojong Group
Turkana – Pastorists

Teso – Agriculturists

BANTU SPEAKERS

(Niger–Congo family)

ALL AGRICULTURISTS

INTERLACUSTRINE BANTU HIGHLAND BANTU COASTAL BANTU

Luyia Group

Samia	Gusii
Marachi	Kuria
Wanga	
Banyala	
Banyore	
Hayo	
Holo	
Tsotso	
Fafoyo	
Tachoni	
Kisa	
Kabras	
Bukusu	
Idakho	
Isukha	
Tiriki	

Kikuyu Group **Pokomo Group**

Kikuyu Kamba
 Kikuyu Upper Pokomo
 Ndia
 Gicuga Lower Pokomo

Embu
 Embu
 Mbeere
Meru
 Cuka
 Tharaka
 Muthambi
 Igembe
 Imenti
 Mwimbe
 Igoji
 Miutoni
 Tigania

Miji Kenda Group

Giriama	Taita
Duruma	
	Taveta
Digo	
Chonyi	
Kauma	
Kambe	
Jibana	
Ribe	
Rabai	
Bajun	

THE LUYIA GROUP OF INTERLACUSTRINE BANTU

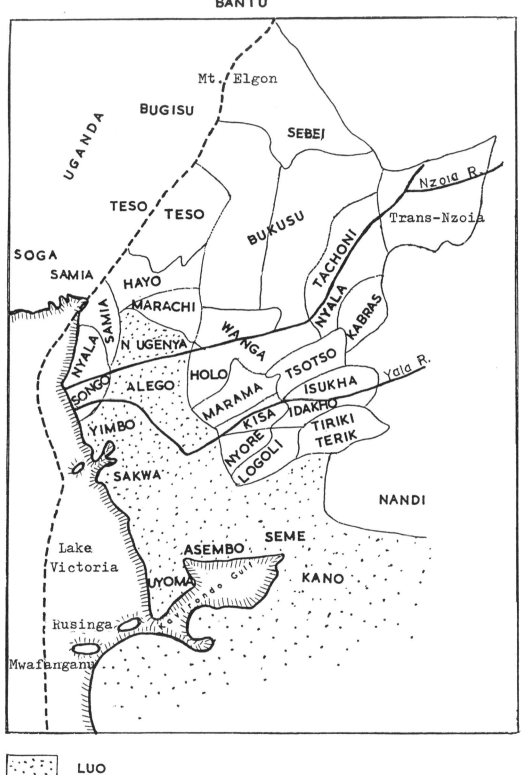

LUO

Territorial boundary

THE EMBU MERU GROUPS OF KENYA HIGHLAND BANTU

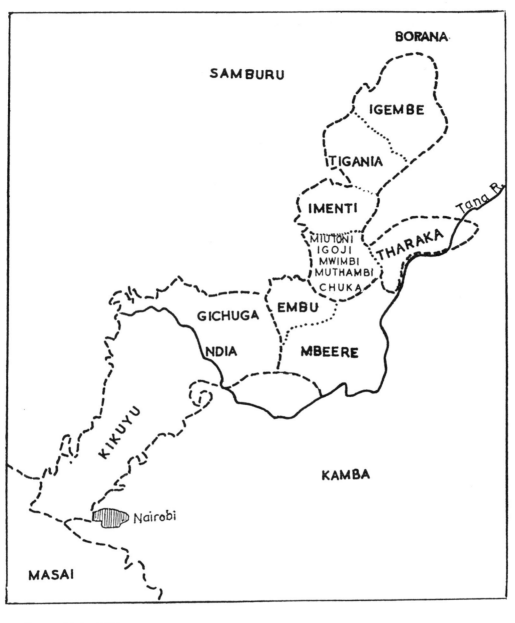

- - - - Main tribe
........ sub tribe

which are necessary to define an industry. Single artefacts are only diagnostic in those rare instances in which an industry has developed an artefact peculiar to itself. Archaeologists would, therefore, be left to fall back on the recognised method of differentiating an industry mainly on the basis of its pottery.

The examination of pottery appears to be as reliable a method as any for distinguishing the *regional industries* of the two ironworking streams for, with the exception of the two branches of the North-eastern Industry whose pottery is clearly differentiated, there is a distinct pottery type associated with each industry, although within each there are minor differences by which the pottery of the component tribes can be easily recognised. There is, however, an extension of the pottery associated with the Central Highland Industry to the Taita of the Coastal Industry, whose ironworking shows influence from the same direction, and a comparatively recent extension of the pottery associated with the Interlacustrine Industry to the southern part of the West Highland Industry.

Differentiating the two ironworking *streams* on the

basis of pottery would, however, be impossible because the dividing line between Kenya's two main pottery types of rouletted and un-rouletted ware does not coincide with the dividing line between the eastern and western streams of ironworking, but falls instead between the Interlacustrine and Western Highland regional industries between which there are also marked linguistic, economic and cultural differences.

The physical remains of ironworking can tell us a lot about the type of artefacts produced and the type of tools used to produce them. They can also provide clues as to the technology, trade, subsistence economy and perhaps the sources of iron ore, but they can tell us little about the number of smiths available; their training; their industrial organisation; the extent to which they are fully employed or are able to partake in the normal subsistence activities; their methods for exchanging their products; their status; or their supernatural powers and the beliefs associated with ironworking.

The ethnographical study does not bear out some of the assumptions made by archaeologists about smiths and ironworking. It shows that full-time smiths are to be found in subsistence economies but only in those based on pastoralism and not in those based on cultivation: in pastoral, unlike agricultural, societies there is no fluctuation in demand for their products, and there are no sanctions to prevent them from collecting ore, smelting, or forging during certain seasons of the agricultural cycle, nor is nomadic pastoralism an economy which can be indulged in as a spare-time activity. Pastoral societies also require fewer smiths and they work both as smiths and ornament makers for pastoralists have no specialists in working chain and non-ferrous metals as do many agricultural groups.

Cultivators are always more dependent on their smiths than the smiths are on the community, but the reverse is generally true of pastoralists whose smiths are largely dependent on them for their food.

Although the beliefs associated with smiths and their ironworking set them apart as a separate occupational group, smiths are always integrated into the culture in which they live and work. The extent of this integration can be correlated with their status and with the stage of political development reached by their society which is, in turn, dependent on its mode of livelihood. Thus smiths in the more centralised agricultural societies are fully integrated into the life of the tribe and are of high status, whilst the integration of smiths of the more acephalous pastoral groups is incomplete as they often do not have the same legal and political rights as non-smiths, and they are of low status.

In Kenya there is no such being as a free travelling itinerant smith; the nature of the work, the availability of raw materials, the method of exchanging products, the firm integration of the smiths into their cultural context and the beliefs of the smiths themselves make sure that, under normal circumstances, smiths remain static.

Only by the use of ethnographic parallels to provide them with inspiration for possible explanations for their data can archaeologists hope to be able to begin to reconstruct such details of past ironworking. Provided that they are related to their own particular cultural, linguistic and economic context, the use of such parallels in Kenya is more justifiable than usual because they are taken from the same geographical area and, although they are separated by time, they are obtained from similar peoples living in similar ecological conditions in the same environment, following the same way of life that they have pursued for countless generations; and producing ironwork in a manner which appears to have remained virtually unchanged since its first introduction.

Notes

1　Further proof of the connection between the two areas is given by Ogot (1967: 188) who says that it is not unreasonable to conjecture that the Luo of the Kano plains were one of the many Labwor clans.

2　According to Frobenius (1933: 197), who mapped them, clay bowl (pot) bellows extend across savannah country from Senegal through the Sudan to the Nile and Lake Victoria while wooden bowl bellows are found in the more forested zone of west and central Africa.

3　The other Interlacustrine kingdoms are Buganda, Nkore (Ankole), Karagwe and Ruanda.

4　By the Bukusu.

5　Merker (1910: 114) says that Masai women sometimes blow bellows. Rendille women occasionally do and Samburu women do so regularly. Giriama women do so in the absence of an apprentice. Arkell-Hardwick (1903: 238) reports that Tharaka smiths wives do although I have never seen this. In Pare (in Tanzania) Baumann (1891: 233) reported that the smelters were said to be women.

6　The Rendille believe that God gave them their livestock but omitted to give animals to some men. Instead he picked up a handful of earth and gave it to those men telling them that they could transform it into iron. The smith craft is therefore believed to derive directly from God.
　　Some of the Bukusu of Mt Elgon say that God imparted the knowledge of ironworking to one of their prophets in a dream. A Kikuyu myth reported by Kenyatta (1938: 70-72) relates how God told men to take sand from a river bed and burn it in order to make tools that would kill animals cleanly, for women had been killing theirs with wooden knives and spears which caused them a painful and lingering death. In consequence their animals ran away. The men consulted God because they did not want theirs to do likewise.

7　The Pokot say that their smiths came from the Mtia (Serikwa) and tell how, when burning the bush at the end of the dry season to provide green grass for their animals, they burned down a huge acacia tree under whose roots were found lumps of iron. When hit it was noted that these changed shape, but no-one bothered until this happened a second time. They then tried burning the soil from that place and produced iron but at

that time they did not use bellows. Those were only introduced later by other people.

8 A Kikuyu myth reported by Cagnolo (1933: 227) tells of the miraculous birth of a smith and how he discovered iron. A stranger arrived in Kikuyuland. He developed a swollen knee which burst open giving birth to three children destined to become a pastoralist, an agriculturist and a blacksmith respectively. One day when tending the domestic hearth the third son uncovered from the ashes a hard heavy black lump. After examining it carefully he threw it into the air but it fell without breaking. He replaced it in the fire to see if it would become soil again, but it turned as red as the glowing charcoal. He tried striking it, first with a piece of wood, then with a stone which broke and, finally, with an identical hard black stone. To his astonishment the red-hot stone changed shape until it became as thin as a knife, whereupon he tried to use it to cut a piece of sugar cane and found that it was a perfect tool. His father and brothers were so overjoyed with his discovery that they called him *Muturi* (blacksmith) and he became the ancestor of all Kikuyu blacksmiths.

9 See notes 6 and 7 above.
 The Idakho Luyia say that they were taught the art of ironworking by the Wanga who, they believe, discovered how to smelt. The original smith found an unusual lump of hard soil which he placed in a fire. To his surprise the heat transformed it into a very hard substance which changed shape when he hit it. He hammered it until he had forged a spear-head and then went in search of more raw material to heat and forge into tools.

10 *Giriama* traditions say that they could work iron before leaving their traditional homeland of Shungwaya in the coastal area of southern Somalia, but that ironworking was re-introduced by their legendary leader Masha Makalungu who, after constant Giriama defeats at the hands of the Masai, taught them a way of overcoming their enemies by heating ironsand from Chilulu about two miles NE of Kaloleni, the present centre of Miji Kenda ironworking. (Note there is a place called Msanga near Mukunumbi in the Lamu hinterland which may indicate the presence of iron ore and smiths.) He smelted the ironsand in a small bowl furnace round which he placed *Mavuo* leaves pounded in water in order to ensure a successful outcome. From the resulting iron he forged arrowheads with which he armed his followers. He built a closely fenced homestead, afterwards named *Boma ra Mitsanga* (the ironsand enclosure) into which the Giriama retreated when warned of the next enemy approach. Through the gateway, in single file as was their practice, came the Wakwavi. The arrow which Masha let fly penetrated the whole line of warriors coming to rest in the belly of the last man and killing them all. This victorious battle was called *Viha vya Chembe* (the battle of the arrow) and its hero was renamed Beshembe i.e. the father of the arrow, or alternatively *Msanya* (blacksmith) by which name blacksmiths are known to this day. He taught his followers the craft of ironworking which rapidly expanded. When Fungo, the legendary leader, died he succeeded him and instituted the most feared of all Giriama trials i.e. oathing by a blacksmith on an axe in a smithy, after first washing the hands in water in which magical *Mavuo* leaves are pounded.
 Several *Luyia* tribes have the story of a smith variously called Shirikhaya, Sirikhaya, Saywa or Shiaywa, who either has to forge a spear from a skull or forge a skull. The Tiriki story tells how Shirikhaya was a famous smith who invented several artefacts. He deserted his family and moved westwards where he encountered Masai raiders who demanded that he make a man's skull for them in three days. This he succeeded in doing. In Marachi they also tell the story of Sirikhaya for it was to Marachi that he moved when leaving Tiriki. He is said to have been of the Ababonwe clan himself and to have married a girl from the Abang'aale clan. Both are smith clans. He turned a

human skull into iron and then forged it into a spear for some Masai raiders who were seeking an excuse to kill him.
 Another version of the same story is given by Osogo (1966: 115) who calls him Saywa son of Murwa. In Marachi, where he became famous as a smith, some Masai came to him with a skull saying that if he was as skilled as he was reported to be, he would be able to forge the skull into a spear. Knowing that they were looking for an excuse to kill him he asked them to wait while he fetched his tools. His brother suggested that he should secretly place pieces of iron in through the sockets of the skull. This he did and successfully produced a spear. The Masai were so astounded by his achievement that they presented him with a bull which proved to be so fierce that wherever he went he was forced to move on rather than kill it. Finally he came to Bunyala where there was a bad drought. He succeeded in making rain and as a result the Bunyala made him their tribal leader.
 In Idakho, adjoining Tiriki, a somewhat related story is told by Enock Guvundo, born between 1882 and 1885, who claims to have been a witness of the events. An old man called Amukune, who lived there and was well-known as a sorcerer, smelted iron using a human skull. People were generally too frightened to ask him how he did this but Enock's grandfathers, Yambasa Ngoli and Visaho, also knew how to smelt in this way. Enock witnessed them all doing this and said that he was particularly terrified of Amukune. The skull, filled with "iron", was placed on a wood fire which was covered with soil as when making charcoal. The bone of the skull was reduced to a rock-like charcoal and the iron ore inside was smelted to a lump. On removal the skull and its contents were fired in the open air which caused the skull to burn off leaving a conveniently shaped iron bloom. This was reheated, hammered to remove the slag, and then forged into a lump of pig iron.

11 It is generally only the leading clans who trace their origins to Shungwaya. The people who lived there were called "Kushuru". Bunger (1973: 10) wonders if this has any connection with the Kush of the ancient Egyptians.

12 Bajun smiths say that Orma smiths stopped work soon after their arrival as they were not very skilled. The Orma now obtain their ironwork from the Bajun. Baron von der Decken (1871) mentions smiths, probably Swahili or Bajun, amongst the lower Pokomo at Kau.

13 See note 10.

14 The Shambaa inhabit the Usambara mountains in north-eastern Tanzania which extend southwards from the Pare mountains. When the Kilindi arrived there in the 18th century the Shambaa were ruled by a lineage of smiths about whom it was said "God gave them the gift of working iron and skill in war and that is how they got the country" (Hemedi 'lAjjemy 1963).

15 See note 12.

16 Somali smiths in Kenya are said to belong to the Muhammed Zubeir whose name Rer Bahar means "The people who came from the sea".
 Information Muhammed Wasa.

17 The Chyulu range, on which the Kamba have lived in the past, provided a natural stopping place between either Mt Kilimanjaro or the Taita Hills and the Kilungu and Mbooni Hills. Soper (1976: 112) concluded that sites he excavated in the Chyulu Hills were occupied by Proto-Kamba on their way towards their present lands. Jackson (1972) says that the Kamba migrated from Kilimanjaro about 1450-1550 first settling in the Chyulu and later in the Kilungu Hills. In the Kilungu Hills sites occupied by iron producing communities yielding Gatung'ang'a ware (a late variant of Early Iron Age Kwale/Kwamboo pottery) have been found (Soper 1980: Collett 1983) plus a later derivation of that ware "which could be ancestral" to modern Kamba pottery.

18 The Kikuyu told Dundas (1908: 137) that they came from two tribes called Shagishu and Ngembe.

19 When the Embu left Ithanga for their present homeland after warring with the Masai at the end of the 17th century, they are said (Mwaniki 1973: 21 and 1969: 64) to have taken with them superior iron weapons which enabled them to defeat the Gumba. Their neighbours, the Chuka, had no iron in their country so obtained most of their iron goods from the Mbeere (Mwaniki 1974: 242) and Tharaka. The smiths that they did have were said (Orde Browne 1925: 129) not to be as skilful as those of the Kikuyu, and not to have such an assortment of tools.

20 The name indicates ironworking as the Kikuyu name for smiths is *aturi*.

21 This name, like that of the Ithanga hills, also indicates ironworking, as *muthanga* is the Kikuyu name for sand but is taken to mean ironsand. Elsewhere in East Africa place-names are similarly derived e.g. Sanga, Mtanga, Sangi, also meaning ironsand, are found as names at the coast and in the famous ironworking centre of the Pare hills in north-eastern Tanzania.

22 Pokot informants believed the Serikwa to have been Masai. Blackburn (1974: 152) records an Ogiek informant saying that the Serikwa were Masai. Sutton (1973: 26-32) records oral traditions which give equal weight to a S. Nilotic or Masai origin for the Serikwa. Jacobs (1970) says that most archaeological and oral historical evidence indicates that the Serikwa were basically a Masai-speaking people.

23 Merker (1910: 112) also says that there were Kipsigis smiths amongst the Masai, and Orchardson (1961: 138) verifies that some of the Kipsigis smiths were of Masai descent. Others appear to be of Gusii descent. The Kipsigis captured two sons of Gusii smiths in an intertribal war and they began to practise their father's craft. The clan which they founded is called Babasik which probably comes from *Omubasi* an Interlacustrine Bantu name for smiths.

24 Masai smiths in the region of Eldama Ravine, who must have been Wakwavi, were said (Wakefield 1870: 328) to produce both agricultural tools and weapons.
Merker (1910: 275) tells how ironworking was brought to Masai country by a smith who married a Masai girl.

25 Pokot smiths say that they arrived in Pokot from Serikwa territory. Some say that they taught the Marakwet, others that the Marakwet taught them. The Keiyo are said not to have known of ironworking until they had conquered the Serikwa and driven them from the plateau but "kept the ironworkers as slaves" (Galloway 1934: 500).

26 When the Uasin Gisu Masai lost their cattle and split up, some wandered into Nandi and were hospitably received by the only Nandi smith who taught them the craft.

27 The old Uganda border came well into present-day Kenya, up to Naivasha.

28 The Abang'aale clan are also found in Wanga to where they came from Tiriki (Were 1967: 120) and in Kabras where many of the people are of *Serikwa* origin.

29 i.e. from the Busoga who were also of mixed descent.

30 They had adopted the practise of circumcision from the Kalenjin and were for some time the only clan in Wanga who circumcised (Were 1967a: 109). When they first moved to Wanga they obtained hoes from the Hayo (Were 1967b: 101). This does not mean that they did not know how to work iron as hoes were only gradually introduced from the west to people who already knew how to make spears.

31 Amulembo oral traditions say that they originally came from Mt Elgon and went to Tiriki (Were 1967b: 10-11) where they belonged to the same clan as the Abashitsetse. Abashitsetse oral traditions tell how their ancestors once lived in the Sudan as part of the Nubian community (Were 1967a: 109). For some time they travelled with the Baganda but then moved eastwards into Busoga and thence into Kenya where they settled in Tiriki and mixed with the Kalenjin. They have the custom of killing their king when he is ill, a custom which is similar to that of the Bunyoro (Were 1967a: 114).

32 See note 10. Shiaya was called Amulembo because he was constantly moving (Were 1967b: 46). On his travels he found the Abafafoyo clan in Marachi and the Abakhulo clan in Samia. Both are smith clans.

33 In these areas of intensive ironworking smiths also reached high status. The Washana clan in Pare are remembered as smiths and as the first rulers of the country (Kimambo 1969: 47). Traditions claim that people settled *around them* because of their ability to supply iron goods.
French-Sheldon (1892: 284) said that the most renowned smiths of the Chagga all had been or were celebrated chiefs or Sultans. She cites Mireali of Marangu and Mandara of Moshi as amongst the most famous.

34 Notably to the Gusii and Kuria. Gusii traditions maintain that long ago they and the Kikuyu were one people (Ochieng 1974: 11).

35 Jurg Mahner, researching amongst the northern Meru, found some clans to be of Samburu origin and traditions linking the northern Meru with Lake Baringo.
Meinertzhagen (1957: 42) reports that he was told of ancestors of the Kikuyu coming from Lake Rudolf (Turkana).

36 Kimera, the great-grandson of Kintu, who became the third ruler of Buganda (Roscoe 1911: 163, 215, 387) was trained as a smith whilst in exile in Bunyoro and was reputed to have introduced iron tools to Buganda (Roscoe 1911: 376-9).
Another tradition tells how a Kisimba smith came from Unyoro to make weapons for the ruler Kintu (Roscoe 1911: 171). During the coronation of the Baganda ruler Kisimba smiths make the king's spear and present him with it and the hammer with which it is made (Wainwright 1954: 129). Other traditions tell how when Buddu was annexed by Buganda in the 18th century, its smiths - who originally came from Bunyoro - became smiths to the ruler (Roscoe 1911: 225).

37 Although recently Schmidt (1980a and 1986) has observed Haya and Barongo smelting. Until recently three different types of furnace were said to have been used in Buhaya (*Tanzania Zamani* No. 4 Jan. 1969: 18).

38 Bunyoro furnaces were (Roscoe 1923a: 220) 18" – 2' deep, 1' wide and covered over with a clay cover like a lid with a hole in its centre. This just protruded above the ground.

39 From the area of Eastern Zaire where similar furnaces are to be found, iron was also imported (Czekanowski 1911: 155, 162).

40 These were dug in Buhaya province on the shores of Lake Victoria in the Western Lake Region of Tanzania by Schmidt (Schmidt and Avery 1978: Schmidt 1980b, 1981, 1983: and Childs Schmidt 1986) who concluded that the makers had developed a preheating technology nearly two million years before present. Similar furnaces have been excavated in Rwanda/Burundi (Van Grunderbeek *et all* 1983a, 1983b; Van Noten 1977, 1983, 1988; Hiernaux and Maquet 1960).

APPENDICES

Appendix I

ACKNOWLEDGEMENTS

First I would like to thank Professor Stuart Piggott for the help and guidance which he has given me for so many years.

This work was carried out whilst I was Research Fellow in Charge of the Material Culture Project of the Institute of African Studies of the University of Nairobi. I have to thank Professor Alan Ogot for his encouragement, and the Rockefeller Foundation for a grant to pay for my salary and to collect metalworking artefacts for the Kenya National Collection. For the funds which made this research possible, I am everlastingly grateful to my dear friend, the late Mrs Hester Ayers of Florida, who made me a personal grant channelled through the Urgent Anthropology Programme of the Smithsonian Institution, and to the Deans Committee of the University of Nairobi.

For the majority of photographs in the original thesis I am indebted to my Peace Corps assistant, Mr Richard Beatty, and to Miss Irene Sedgwick who gave her services voluntarily. For the printing I have to thank the photographic staff of the Department of Prehistoric Archaeology in the University of Edinburgh.

Last, but not least, I wish to thank all the blacksmiths and other metalworkers who were so interested and anxious to have their crafts recorded for posterity that they gave their help and information willingly. Unfortunately, I omitted to record all their names but I am as indebted for information to those who are not listed as I am to the following who are either metalworkers, metalworkers' children or field researchers.

Name	Information about	Name	Information about
Opondo Aginya	Luo	Johnson Kanyoro Gichore	Kikuyu
Monica Agola	Luo	Anton Gitau	Kikuyu
Charles Agonga	Samia	Father Godina	Tharaka
Omar Ahmed	Bajun	Mick Gramly (Dr.)	Borana
Nelson Akarangus	Idakho	Anders Grum	Rendille
Rod Blackburn (Dr.)	Ogiek/Dorobo	Michael Guillibrand	Keiyo
Robert Bunger (Dr.)	Giriama	Yusuf Hassan	Somali
Yusuf Bute	Bajun	Bernt Heine (Prof.)	Mukogodo
Ali Buya	Malakote (pokomo)	Ngate Ichira	Kikuyu
Edward Charo	Giriama	Alfred Igunza	Logoli
Cheranange	Giriama	Lusambini Indigi	Isukha
Joseph Cheturo	Marakwet	John Chimba Irungu	Kikuyu
John Irungu Chimba	Kikuyu	John M. Irungu	Kikuyu
Jeff Fadiman (prof.)	Central Meru	Philip Ngenge Itumange	Kamba
Elliot Fratkin	Samburu	Oroche Jula	Luo
Muhammed Fumo	Swahili	Gilbert Kabaya	Giriama
Benjamin Gachagua	Kikuyu	Kache	Konso working for Borana
Caciriga	Kikuyu	Josphart Kadenge	Giriama
Gastola	Kamba	Stanley Kahindi	Giriama
Isiah Gatama	Kikuyu	Wandugi Kiiri	Kikuyu

Name	Information about	Name	Information about
Willis Kamiyay	Luo	Alfred Mwanga	Bukusu
Harrison Karisiti	Giriama	H.S.K. Mwaniki	Embu
John Kariuki	Kikuyu	Naaman Mwirichia (Chief)	N. Imenti
Simbano Ole Kialolo	Masai	John Barasa Nsangali	Bukusu
Samueli Kibindo	Giriama	Simon Ndichu	Kikuyu
Kirumba	Kikuyu cold forger of arrows	Mogo Nduku	Kikuyu
Wilson Kitsao	Giriama	Raphael Ndingi (Bishop)	Kamba
Kongelai	Pokot	Jeremy Newman	Kamba
Laetekerich	Samburu	Kaara Ngahu	Kikuyu
Landere	Samburu	E.N. Ngondi	Embu
Louis Leakey (Dr.)	Kikuyu	Nikibo	Konso working for Borana
Lokoma	Pokot	Wanjohi N]oroge	Kikuyu
Iguel Lokwali	Turkana	Nuyo	Konso working for Borana
Hudson Lomosi	Logoli	Pius Nyan]a	Giriama
J.A.K.A. Loyatum	Pokot	Nyenze	Kamba
John Lyayuka	Idakho	Peter Nzuki	Kamba
David MacOmega	Logoli	Oumah Ochieng	Kayo
Saimon Mahina	Idakho	Moses Ochola	Luo
Simon Maina	Idakho	Richard Ochuonyo	Marama
Nginyane Makururu	Giriama	Musa Odoma	Luo
John Manners	Gusii	Mbaruk Omar	Bajun
Wanje Masha	Giriama	Muhammed Bara Omar	Bajun
Jotham Masinde	Gisa	Stanley Ominde	Logoli
Gaciingu Samuel Matahe	Kikuyu	Safari Paul	Giriama
Robert Mberia	Tharaka	Stuart Reynolds	Kamba
Kaara Mgahu Mihuti	Kikuyu	Thomas Rimbui	Imenti/Igembe
Musera Mtengo	Logoli	Ripokomar	Pokot
Kamau Mucemi	Kikuyu (Chainmaker)	Cordelia Rose	Samburu
Mujumbe	Giriama	Gatiti Rukenge	Mbeere
Charo Mujuwi	Giriama	Stanley Sheldon (Prof.)	Kisa, Kikuyu
Mwange Mukope	Kamba	Patrick Simiyu Sichangi	Bukusu
Ngole Mulanda	Giriama	Henry Sitawa	Yala
Josek Mumosi	Kisa	Edward Kipsang Tangus	Kipsigis
Mathias Mukuko	Idakho	Peter Kirigwi Waithaka	Kikuyu
Gilbert Muruli	Isukha	Mathuba Wambira	Kamba
Mutondia	Giriama	Muhammed Warfa	Somali
Muthula Mutuwa	Kamba	Wambulwa Wekesa	Bukusu
Sebastian Mwakasi	Giriama	Isiah Were	Warachi
Emmanuel Mwakuwanda	Giriama	John Yaa	Giriama

Appendix II

Vernacular Names for Smithy

Tribe	Name	Tribe	Name
Isukha	*Lirumbi*	Wanga	*Etumbi, Mutumbi* or *Esirumbi*
Idakho	"	Samia	"
Logoli	*Ilitumbi* or *Iritumbi*	Marama	*Mwirumbi* or *Lirumbi*
Bukusu	*Lirumbi*	Luo	*Theth* or *Thethi*
Gisa	*Lirumbi*	Igembe	*Kiganda*
Hayo	"	Tharaka	" or *Gathunu*
Marachi	*Etumbi, Mutumbi* or *Esirumbi*	Embu	*Kituoni*

Tribe	Name		Tribe	Name
Mbeere	Chanda		Samburu	Il Kokwet, also given Loipolongunei
Kikuyu	Kuwanda		Masai	Olkokwet
Kamba	Kituoni		Somali	
Taita	Chanda		Rendille	Ngunei (?)
Digo	Kuwanda		Borana	Gadis
Swahili			Gabbra	Gass
Bajun	Kibanda		Konso (working for Borana)	Hoss tumtu or Hosa tumtu
Kipsigis	Kapkitany			
Nandi	Kapkitanyit		Elsewhere in East Africa	
Pokot	Kapkitany			
Marakwet	Kokwa Kitony		Wolamo (Ethiopia)	Bacha

Vernacular Names for Hammers

Tribe	Iron Hammers	Stone Hammers
Isukha	Inyoli, Inzarulu (shop-bought called Inyundo)	
Logoli	Tsinyundo, Viduyiru, Enyuli	Ingomago
Bukusu	Enyuli	
Kisa	Inyoli	
Hayo	Inyundo	
Marachi	Enyundo ya Nisiri	Likina
Wanga	Enyundo ya Nisiri	
Samia	Enyundo ya Nisiri	
Luo	Nyatieng, or Ratieng, or Nyol	Kidi or Resuagi
Igembe	Kiria gia Nkundi	
Tharaka	Kiriba	Ngomango
Embu	Kiriva	
Mbeere	Kiriba	
Kikuyu	Kiriha kia Ngundi (large)	
	Kiriha kia muti (small)	
Kamba	Kiiva	Nganza
Taita	Kichano (beater) Kilingo	
Giriama	Nyundo	
Digo	Nyundo	
Swahili	Nyundo or Nudo (?)	
Bajun	Nyundo	
Kipsigis	Kirisuet; also given Koitabai	Tanganguliet
Nandi	Kirisuet	
Pokot	Kriswo	
Marakwet	Kiriswa	
Samburu	Lkiriset or Sobwa	
Masai	01 Kirisiet	Osoit
Somali	Dube	
Rendille	Yondi or Iunti* (a European type hammer is called Khadim**)	
Borana	Buris	Buris
Orma	Madosa	Burusa
Konso	Burusha	Burusha

Elsewhere in East Africa

Tribe	Iron Hammers	Stone Hammers
Wolamo (Ethiopia)	Dilinua, Narika (small)	
Labwor (Uganda)	Kidi	

* Means a walking stick
** Means a mallet

Vernacular Names for Anvils

Tribe	Stone Anvils	Iron Anvils
Isukha	*Lijina* or *Lichina*	*Ikhomajilu*
Logoli	*Elituliru*	*Engomacilu* or *Incomagiru*
Bukusu	*Likhupilo*	
Idakho	*Ikhutu*	
Hayo	*Elikina*	
Kisa	*Rijina*	
Marachi	*Likina*	*Isivia*
Samia	"	*Sichuma*
Wanga	"	*Esikoko*
Luo	*Kidi* or *Pong*	
Igembe	*Iiga*	
Kikuyu	*Ihiga ria Uturi*; also given *Kigera*	
Mbeere	*Ihiga*	*Thigaria uturi*
Embu	"	
Kamba	*Ivia Yiuma*	
Taita	*Igo*	*Igo*
Giriama		*Fulawe*; base called
Swahili		" " *Munyamawe*
Digo		"
Bajun		*Fwai*
Kipsigis	*Kirisuet* or *Kotapai*	
Nandi	*Topet* (Top- sing.)	
Pokot	*Koii go Kitonghin*	*Top*
Marakwet	*Koiibo kitonghin*	*Top*
Turkana		*Amuru*
Samburu	*Soit oiber* or *soyet*	*Soit engunei*
Masai	*Soit* or *Soyet* or *Soyondet*	*Ngi*
Somali		
Orma	*Maraja*	
Rendille	*Daga**	*Daga*
Konso	*Tuput*	*Daga*

Elsewhere in East Africa

Wolamo (Ethiopia)	*Hoga*	
Kiga (Uganda)	*Oruhiiga*	

* Means a stone

Vernacular Names for Bellows

Tribe	Bellows Bowl Bellows	Nozzle	Stick	Diaphragm	Bowl
Isukha	*Mukuba* or *Mukuva*	*Mikoba*		*Lisero*	
Idakho	"				
Logoli	*Umuguvu*	*Umudalimbo, Lidulele* or *Amahiga*		*Kisero che Ligondi*	
Bukusu	*Kumukuba* or *Chikhelu*		*Chisala*	*Enyubo Openingis Endombi*	
Hayo	*Ebifuriro* or *Esifuriro*				

Vernacular Names for Bellows (cont.)

Tribe	Bellows/Bowl Bellows	Nozzle	Stick	Diaphragm	Bowl
Samia	Omukuba	Amolu	Esala	Ekosi	
Marachi	"		Silendi	Esero	
Wanga	"		Tsisala	"	
Marama	"		Emikhono Chomukuba	Lisero	
Kisa	Mukwa			Risero	
Luo	Buk or Buge		Pion		
			APERTURE		
Kipsigis	Kubanda	Chepkutma		Magatetap, Kirgit	Kenut
Nandi	Kopanda	Rupeitit	Kutit or Kalil	Makatet	Kelet
Pokot	Kopan	Rupai		Sera (Skin)	Otupa
Marakwet	"	Kareng	Kuti	Sombrir or Sira	"
Turkana	Otuba	Ndogole		Ello	Otuba
Masai	Engunei	Erubetit	Engaluk	Endabana	Enjata

Tribe	Bag Bellows	Nozzle	Slats	Strap
Samburu	Engunei (pl.) Engunata (sing.)	Lmoti or Lmotio	Il Barwai	Engenei
Rendille	Nip	Sup (where the nozzle joins is = gaz)		Sap
Somali	Bufuma		Kabsin	
Borana	Bufa	Sala	Muk (where aperture = Afambura)	Farro
Orma	Bufa			
Igembe	Mubua or Muvua		Mikumbati ya Njari	
Imenti	Nkunii			
Tharaka	Miura, also given Migua			
Embu	Migua	Kioru	Miamato or Mitumbi	
Mbeere	Mugwa	Kiura	Mikumbati	Mikwa
Kikuyu	Miura (pl.) Mura (sing.) also given Kihuruti			
Kamba	Mua	Kyuu	Mukumbati	
Taita	Mvurudo			
Giriama	Mivuo	Der. (Michewa?) (between nozzle and bellows = Murevi)	Mbamba	
Digo	Kiriba			
Swahili	"	There	Mbamba	
Bajun	Kiriba, Viriba	Kasiba goes into Mbere = wider part	Mbambo	Shipa

Elsewhere in East Africa

Tribe		Nozzle
Kigezi (Uganda)		Omuzhuba (bowl bellows) or Omucunga "
Ruanda		Amuvuba

Vernacular Names for Bellows (cont.)

Tribe	Bellows/Bowl Bellows	Nozzle	Stick	Diaphragm	Bowl
Pare (Tanzania)	*Mvuo* (bag bellows)				
Sagara (Tanzania)	*Mwuo*				
Gogo (Tanzania)	*Mjua*				
Nyatura (Tanzania)	*Mewa*				
Yao (Tanzania)	*Muhwa*				
Chagga (Tanzania)	*Mfua* (bag bellows)				
Bena (Tanzania)	*Mvua*				
Ngoni (Tanzania)	*Mvua*				

Vernacular Names for Tuyere

Tribe	Name of Tuyere
Isukha	*Isholo*
Kisa	*Ishero*
Marachi and Wanga	*Ishero* or *Ekhero*
Hayo	*Tsikhero*
Luo	*Sero, Haro, Ngalowo*
Bukusu	*Ekhombi*
Logoli	*Induhu, Mukondu, Irdundu*
Kikuyu	*Ngerwa* or *Ngerua*
Embu	"
Mbeere	"
Igembe	*Nkelwe*
Giriama	*Chewa*
Bajun	*Tcwa*
Digo	*Kewa*
Swahili	"
Nandi	*Soiyet*
Kipsikis	"
Pokot	*Soyon*
Marakwet	"
Masai	*Osoyondet*
Samburu	*Engunei*
Rendille	*Emoti*
Borana (Konso)	*Hilnto*

Elsewhere in East Africa

Tribe	Name of Tuyere
Labwor (Uganda)	*Churu*
Kigezi (Uganda)	*Echuru*
Konso (Ethiopia)	*Makukuta*
Pare (Tanzania)	*Mkerwa*
Kinga (Tanzania)	*Ngela*

Vernacular Names for Tongs

Tribe	Iron Tongs	Wooden Tongs
Logoli	*Kikabo, Imbaisi, Inchindo, Ichondo* and *Edzingaga* (Wagner), *Inindi.*	*Iviliva* (for (i)) *Isira* (for (v))
Isukha	*Makasi*	*Viliva, Imbafi*
Bukusu	*Embano, Luani*	
Idakho	*Makamata* (sing. *Likamata*)	

Vernacular Names for Tongs (cont.)

Tribe	Iron Tongs	Wooden Tongs
Hayo	*Ebidiriro*	
Samia	*Ebidiri*	
Wanga	*Oluwana*	
Marachi	*Ebaki, Olanga* and *Sirungu*	
Kisa	*Makhana*	
Marama	*Amahana*	
Luo	*Ramaki* (also use *Mahana*)	
Igembe	*Mugwati*	
Tharaka	*Mugwadi*	
Embu	*Mivato*	
Mbeere	*Mwibato*	
Kikuyu	*Miihato*	*Gatandara*
Kamba	*Mwiyeto* (large) and *Ngolia* (small)	
Taita	*Mwibado*	
Giriama	*Mkwatto* (large) and *Kweleo* (small)	
Digo	*Koleo*	
Swahili	*Kweleo*	
Bajun	*Kweyo*	
Kipsikis	*Kanamayuek, Kanameito* and *Konomoi*	
Pokot	*Konomoi*	
Marakwet	*Kanamai*	
Samburu	*Ramet*	
Masai	*Oramet*	
Turkana	*Akan*	
Somali	*Gamba*	
Rendille	*Khadaba*,* also *Ramet* and *Hradara*	
Borana	*Khadaba*	
Orma	*Kwabdu*	

Elsewhere in East Africa

Tribe	Iron Tongs	Wooden Tongs
Konso (Ethiopia)	*Kalaptota*	
Wolamo (Ethiopia)	*Kapia*	
Labwor (Uganda)		*Okake*

* Khadaba - from the word to touch

Vernacular Names for the Smiths other Tools

Tribe	Chisel	Mandrel
Isukha		*Muluhu*
Idakho		
Logoli	*Itindo* or *Usumendo*	*Muruhu*
Bukusu		
Kisa	*Ishitetik*	
Hayo	*Esidedero*	
Marachi	*Endemo*	*Lubango*; stone ones *Eskoko* or *Esiboko*
Wanga	*Endemo*	
Samia	*Endemo* or *Okhanga*	*Lubango*
Luo	*Chen* or *Ndemu*	*Nyatieng* (same name as for hammer) or *Nyadhuru* or *Ng'ado Chuma*
Igembe	*Ntemi*	*Kiau kia Matumo*
Tharaka		
Embu	*Ngeca*	
Mbeere		

Vernacular Names for the Smiths other Tools (cont.)

Tribe	Chisel	Mandrel
Kikuyu	*Gakwiro*	
Kamba	*Ngesa* or *Ithoka*	*Ivia*
Taita		
Giriama	*Temo* or *Tindo*	
Bajun	*Tindo*	
Kipsigis	*Boreito* (stone)	
Nandi	*Laita*	
Pokot	*Chesileit*	*Blich*
Marakwet	*Oiwo* (means axe)	
Samburu	*Il bunet*	*Udet*
Masai		*Esenkenkei*
Somali	*Goya*	
Rendille	*Il bunet* (Samburu name)	*Utet* (Samburu name)
Borana	*Chirtu*	*Kabato* (a wooden one)
Orma		
Turkana		*Aswat*

Elsewhere in East Africa

Wolamo (Ethiopia)	*Kileshia*	

Wire Drawplate

Kikuyu	*Uta*	
Kamba	*Uta* or *Nzile*	
Giriama	*Kombe*	
Masai	*Engauo*	

Vernacular names for Smith

Tribe		Tribe	
Isukha	*Muruli* or *Viranyi*	Pokot	*Kitonghin*
Idakho	*Mwiranyi*	Marakwet	"
Logoli	*Umuturi*	Turkana	*Ekitiran*
Bukusu	*Omubasi* or *Omubangali*	Samburu	*Lkunono*
Kisa	*Omuranyi*	Masai	*Ol Kunono*
Hayo	*Amwiranyi*	Rendille	*Tumal*
Marachi	*Omutuli* or *Omwiranyi*	Somali	*Tumtu*
Wanga	"	Borana (Konso)	*Tumtota*. Also use *Harmich*
Samia	*Aberanyi*		
Marama	*Omwiranyi* or *Omuruli*	*Elsewhere in Africa*	
Luo	*Jathethi*		
Igembe	*Muturi*	Wolamo (Ethiopia)	*Wogace*
Tharaka	*Muturi*	Dime (Ethiopia)	*Gitsu*
Embu	*Muturi*	Basketto (Ethiopia)	*Gita - manna*
Mbeere	*Muturi*	Male (Ethiopia)	*Gito*
Kikuyu	*Muturi*	Ankole (Uganda)	*Mugabe*
Kamba	*Mutwii*	Kigezi (Uganda)	*Omuheezi*
Taita	*Mshani*	Tatoga (Tanzania)	*Gidangodiga*
Giriama	*Msanya*	Pare (Tanzania)	*Mshana*
Digo	?	Iraquw (Tanzania)	*Karasemo*
Swahili	*Muhunzi* (Whitesmith = *Sonara*)	Irangi (Tanzania)	*Vachana*
Kipsigis	*Musogindet*	Dinka (Sudan)	*Yotheth*
Nandi	*Kitonghin*	Kakwa (Sudan)	*Marshia* or *Masanik*

Vernacular names for apprentice

Tribe	
Isukha	*Bwiriany*
Logoli	*Umwiji. Umwiga, Omuhuzi* – bellows blower
Hayo	*Omweka*
Marachi	*Omuuchi. Obwirany*
Wanga	*Omuuchi*
Luo	*Jabuk* (bellows blower) or *Japuonji mer Thethi*
Kikuyu	*Muhuruti* (*Ahuruti* pl) or *Mugucia*. Also given *Muruguti*.
Kamba	*Auuti*
Marakwet	*Toretin*

Some Vernacular Names for Iron

Tribe	
Isukha	*Shivia*
Bukusu	*Sibia*
Kisa	*Esiwiya* or *Nyinyo*
Samia	*Nyinyo*
Wanga	*Shivia*
Marachi	*Nyinyo*
Luo	*Nyinyo*
Kamba	*Kilea, Kiaa*
Taita	*Kizia*
Giriama	*Chuma*
Kipsigis	*Marabayat*, also given *Kdita*.
Nandi	*Karna* (sing), *Karin* (Plur.)
Pokot	*Karun*
Marakwet	*Karun*
Masai	*Segengei, ossiayi*
Samburu	*Segengei, ossiayi*
Rendille	*Sengei*
Somali	*Birr*
Borana	*Sibila*
Orma	*Sibila*

Elsewhere in East Africa

Chagga (Tanzania)	*Menya* or *Minya*
Taveta (Tanzania)	*Menya*
Pare (Tanzania)	*Minya*
Iramba (Tanzania)	*Isanyenge*
Tatoga (Tanzania)	*Bugusta*
Sindja (Tanzania)	*Ekiwha*
Karagwe (Uganda)	*Edzioma*
Labwor (Uganda)	*Apora*
Jie (Uganda)	*Apuru*
Dodoth (Uganda)	*Athuwat*
Acholi (Uganda)	*Nyonyo*
Lango (Uganda)	*Nywenyo*
Wolamo (Ethiopia)	*Wogacha*
Jur (Sudan)	*Ny'eng* or *niihny*

Appendix III

Kenya Tuyere Measurements in cm
Class 1 = Funnel shaped; 2 = Cone shaped; 3 = Straight pipe

Class Tribe	Max. Length	Diameter in centre end	Diameter of funnel end	Diameter of bore at nose	Diameter of bore at mouth	Depth of funnel flare
1. ISUKHA	15	6	8	2.5		5
1. SAMBURU	17.5	5		2.5	5.5/6	5
1. RENDILLE	18.5	5	9	1.75	6	5
	24	7	10.25	2.5	6.5	8
1. KIKUYU	36	7	12.5	2.5	9.5	10
	14 (broken off)	7.5	14.5	2.25	11	10
1. EMBU	13	4.5	6.5	2	4.5	3
1a THARAKA	31	8 x 7	12 x 6.5	5 x 3.75	9.5 x 6	9.5
1b KISA	22	6.5	9.5	4	6	5
2. BAJUN	19.75	5.7	9.6	2.5	6.5	5.5
3. WANGA	49	11	11	5.5	5.5	nil
3. MBEERE	26	5	5	2.5	3	nil
3. POKOT	26	6.75	6.75	2.75	2.75	nil

These were the only ones measured, the rest were judged by eye.

SAMBURU						
Bellows	14	5	7.25	1.75	2.5 where it fits bellows	nil
Nozzle						

Appendix IV

Trees used for making charcoal by smiths

BUKUSU
Kumukhonge
Kumusemwa

KISA
Mutaragwa. *Juniperus procera*

SAMIA, MARACHI, WANGA
Olulando. *Hymenocardia acida* Tul. *Euphorbiaciae*
Olichuta. *Combretum molle* G. Don. *Combretaceae.*
Olukhonswe. *Terminalia mollis* Lawa. *Combretaceae.*
Amakhoni
Omudede

Amsangula. *Rhus* sp
Omukhonge

KIKUYU
Mutamayu. *Olea chrysophylla*
Mutarawa. *Juniperus procera.*
Mukoiigo. *Bridelia micrantha* Mull. Arg.
Muthiaga. *Warburgia ugandensis.*
Muathathia. *Olinia usambarensis* Gill.
Muhutu. *Erythrina tomintosa* R.BR.
Mutundu. *Croton macrostachys*
Mukoe. *Syzigium guineense*
Banana. *Musa sapientum*

THARAKA
Muthigira. *Acacia mellifera.*
Mukima
Mukome

IMENTI
Miukuro. *Olea* sp

EMBU
Muthigira. *Acacia mellifera.*
Mukome
Muthura. *Ocotea usambarensis* Engl. *Hyparrhenia.*

KAMBA
Muselelu
Musaa. *Cassia longiracemosa*
Matheu. *Rhus* sp
Musemei. *Acacia nilotica*
Mukuu. *Juniperus procera*
Kioa
Mupa

MBEERE
Muraci. *Lannea stuhlmanii* Engl.
Mururuku. *Terminalia kilimandscharica* Engl.
Mugaa. *Acacia* sp.

MARAKWET
Koloswo. *Terminalia brownii* Fresen

Reberwo. *Syzigium guineense*
Mutungwa

KEIYO
Juniperus procera

SAMBURU
Iltarakwa. *Juniperus procera*
Iltepes. *Acacia* sp.
Ilngerioroi
Bili

SWAHILI
Mkoma. *Hyphaene coriacea*
Coconut shells

BAJUN
Mkoma. *Hyphaene coriacea*

GIRIAMA
Mkoma. *Hyphaene coriacea*

TAITA
Mukalamke

BORANA
Ejers. *Olea africana*

SOMALI
Agag

Appendix V

Vernacular Names for Iron Ore and Sources of Supply

Tribe	Name	Type	Obtained from
Isukha	*Luralo*	Murram and a hard stone	Some obtained on the slopes of the Nandi escarpment. But they mostly obtained pig-iron from the Wanga who obtained their ore from Iluteko near Mumias, or Samia
Idakho	*Vuvalo*	Ironsand and murram	Obtained from Tiriki district, and some from Bungoma. Iron-sand found in river beds and valleys
Logoli	*Uvuhalo* or *Butara*	murram	Some obtained from murram from Tiriki district, but mostly imported pig-iron from the Wanga of Mumias area
Bukusu	*Burale*	Ironsand, murram and Samia haematite	Ironsand from river beds. Murram local. Other ore from Tororo, just over the Uganda border and from Samia
Hayo	*Amasengeri*	? Murram	Dug at Ndafumbwa in Kisoka (means axe) sub-location of Bukhayo in Busia district
Tiriki		Murram, a little ironsand	From Tiriki itself
Kisa	*Esiwiya*	Hard rock	
Samia	*Oburale*	" " (haematite)	Samia Hills

Vernacular Names for Iron Ore and Sources of Supply (cont.)

Tribe	Name	Type	Obtained from
Wanga	*Obdurale*	(haematite)	Samia Hills
Marachi	"	" " " and also murram	" "; murram found locally in Marachi
Luo	*Otaro* also given *Nyinyo*	Hard rock, some murram	They mostly imported pig-iron from Samia, but also collected ore from there, and dug some from the Bunyala/Samia boundary and from Yimbo location, Siaya. Haematite also from Homa mountain
Gusii			From S.W. Nyanza, N.W. of Kisi
Igembe		Ironsand, also murram	In stream beds especially on the plains below the Nyambeni Hills
Imenti (N)	*Nkanka*	murram and ironsand	From pockets in local hill-side and at Kithangari
Imenti (S)	*Maiga* or *Muthanga*	Ironsand	From pockets in local hill-side and at Kithangari
Tigania	*Inga*	Ironsand	From Gikunjwa, Muthanga mountain
Tharaka	*Muthanga uria Mujiri*	Ironsand	Locally in rivers and streams
Embu	*Muthanga*	Ironsand	Mostly from Mbeere, but some from lower Embu
Mbeere	*Igero*, *Ithiga*	Quartzite rocks veins of metal and ironsand	Kiambere Hill
Kikuyu	*Nganga*, *Muthanga*	Ironsand, and murram (particularly in S. Kikuyu)	Area east of Mukurwe wa Nyagathanga called Gaturi (between Muranga and Nyeri). Also from the Ithanga Hills, Mbuini, and Kiambu (murram)
Kamba	*Kilea*	Ironsand and murram (often thought to be the best)	Lot of murram in the Kilungu Hills and east of them, and at Kithanafathini Mukuyu below Uvete. Muthome in Machakos district
Taita		Ironsand	In the Taita Hills
Giriama	*Mtsanga wa Fulawe*	Ironsand	Main source just north of Malindi but also some at Kaloleni and Tsakakorolovu
Swahili		Ironsand	N. of Malindi
Digo		Ironsand	Shimba Hills
Bajun		Ironsand	Kipini, Mukunumbi, Mtanga-wanda on Manda island
Kipsigis	*Menet*, as told *Marabak*	Murram	Local
Nandi	*Ngoriamuk*	Murram	Kaptilol in Engwen, S.W. and S.E. Nandi
Pokot	*Punot*, also given *Mano* (means clay)	Murram	Lomut mountain, and Kapartong near headwaters of Marich river (Beech, 1912, 18)
Marakwet	*Bunit* or *Chirerei*	Murram	Mainly local from top of scarp
Keiyo		Murram	Some dug in valley (Massem 1927, 51) also in Highlands and on scarp
Tugen	say they have no name for it!	Murram	In Kamasia Hills
Samburu	*Song'ai orok*	Ironsand	River beds in Baragoi area and in desert E. of the Matthews Range
Masai	*Sengei O-sekengei*	Ironsand	Narok area but not Loita Hills. Matapato River (Hollis 1905: 330)
Rendille		Ironsand	E. of the Matthews range
Borana		Ironsand	A lot came from Yavello in S. Ethiopia but also from Sololo in N. Kenya on the Ethiopian border
Somali	*Bir-lab*	Murram ? ironsand	

Appendix VI

Main Smith Clans

N.B. These clans have not been checked with anthropologists working in the area.

ISUKHA	Aburuli (who came from Wanga) Avashikholwa (who started ironworking in the tribe) Abateheli Abasulwa		Muthanga or Akanga Ekombi (spelt by Hobley Eombi) Muyini Some clans don't forge at all.
IDAKHO	Abasukani Abakobe	GIRIAMA	Mwaziro introduced ironworking Amwakombe Amwamwemi
LOGOLI	Avagisisi Avamoi		Amwabayamwaro
BUKUSU	Basefu Balako Bamasaba	TAITA	Wanya Waikumi
HAYO	Abaguuri = the *ruling clan* and *no-one else is allowed to carry on the craft*	KIPSIGIS	Babasiki Toiyoi (according to Peristiany (Peristiany 1939:148) but the Kipsigis say that most clans have always had smiths). Original clans said to be of Uasin Gishu Masai origin.
KISA	Wambaria Emtoli	POKOT	Silokwa (Silokot pl.) particularly sub-clan of chepochesunto.
N. TESO	Karwoko said to be the *leading clan*	SAMBURU	Smiths in Lmosiat Masala section and Loisilate Pisikishu section (personal communication Elliot Fratkin). I found that others belonged to clans of Rendille origin.
SAMIA	Abakhulo = *leading clan* Abakhekhe Abasamia (Abangaale)		
WANGA	Ababwino and others Abasitsetse	MASAI	Kipuyoni (Hollis 1905: 330) and others.
MARACHI	Abafafoyo = *leading clan* Ababwino Ababonwe	SOMALI	The low class SAB to which smiths belong are said to derive from Somali lineage groups which are weak numerically. According to Goldsmith and Lewis (Goldsmith and Lewis 1958: 252) many *Tumaal* (smiths) say that they are descended from Darood the founder of the Darood Somali.
BUNYORE	Abamang'ali		
TACHONI	Babuhya Bangaachi		
GUSII	Ababuria	RENDILLE	*Tumaal* (smiths) claim origin from all nine clans. Original ironworkers said to be Bille family from Kurage in Likorum. Stromat, Nangole and Nkure are of smith caste but do not practice ironworking. They do woodworking and odd jobs. Most of the ironworkers said to be of Samburu origin.
LUO	Agoro Ulomo Asayi		
IGEMBE	Athimba = First clan in the area. Introduced iron-working and it spread throughout the area of N. Meru.		
MBEERE	Mwendia Mucera	GABBRA BORAN	Their smiths are all of Konso (a S.W. Ethiopian tribe) origin.
KIKUYU	All except Agaciku and Eithaga		
KAMBA	Anzunzo originally		

Appendix VII

Exchange Values

Animal	Number	Tool	Tribe
COW (sex specified)	1 for	6 hoes	Banyala (Barnett 1965: 54
	1 for	1 hoe	Gusii
			Gusii to Luo
			Luo to Luo
	1 for	30 hoes	Luyia (Hobley 1929: 248)
	1 for	25 hoes	Luyia (Hobley 1929)
	1 for	1 spear	Bukusu from Samia (Barnett 1965: 55)
	1 for	1 spear	Gondiek (Sebei)
	1 for	pair spears	Pokot from Marakwet (1975)
	1 for	pair spears	Turkana (1974)
BULLOCK (Young)	1 for	large spear	Samburu (Spencer 1973: 119)
	1 for	stealing a spear	Nandi (Hollis 1909: 76)
HEIFER	1 for	1 hoe	Marama
	1 for	hammer	Embu (only to another smith)
GOAT (Sex unspecified)	1 for	bracelet	Logoli from Wanga
	1 for	10 digging tools	Wanga
	1 for	Sword with sheath	Logoli from Tiriki
	1 for	1 hoe	Luyia (Hobley 1929)
	1 for	2 hoes	Giriama (recent)
	1 for	1 axe	Nandi (Hollis 1909: 76)
	1 for	Quiver full of arrows	Nandi (ibid)
GOAT	1 for	1 hoe	Banyala (Barnett 1965: 54)
	1 for	1 hoe	Bukusu from Samia (ibid)
	1 for	1 spear	Pokot (Beech 1912: 18)
	2 for	1 spear	Pokot to Marakwet (present)
	2 for	1 spear	Masai (Merker 1910: 115)
	1 for	Sword	Masai (ibid)
	1 for	1 axe	Masai (Merker 1910: 115)
	1 for	10 barbed arrowheads	Masai (ibid)
	1 for	big cowbell	Masai (ibid)
	3 for	1 spear	Kikuyu say people
	2 for	1 sword	Kikuyu thought this
	1 for	1 barbed arrowhead	Kikuyu cheap circa. 1900-10
GOAT	1	to make broken sword smaller	Kikuyu
	1 for	long digging knife	Kikuyu
	1 for	1 spear	Kikuyu (different area)
	1 for	1 spear	Kikuyu

N.B. A Goat was the equivalent of payment for three months field labour (Routledge 1910: 87-88)

	2 for	large iron neck-ring given to daughter, when she marries, by wealthy father (Routledge 1910: 131)	Kikuyu
	1 for	Branding iron	Igembe
	1 for	small brass bead apron	Kamba (Gregory 1896: 349)

Exchange Values (cont.)

Animal	Number	Tool	Tribe
HE-GOAT	1 for	Five foot length of brass chain worn across chest	Taita (1939)
	1 for	eight circumcision knives	Tharaka paid Tigania
	1 for	1 spear	Turkana (1974)
SHE-GOAT	1 for	theft of spear	Nandi (Hollis 1909: 76)
SHEEP Sex unspecified	1 for	1 spear	Turkana (1974)
EWE	1 for	small spear	Samburu (Spencer 1973: 119)
	2 and a lamb for	large spear	Samburu (ibid)
CHICKEN	1 for	1 axe	Bukusu from Samia (Barnett 1965: 55)
	1 for	1 cowbell	Bukusu from Samia (ibid)
	1 for	1 spear	Logoli from Tiriki (present)
	1 for	1 hoe	Samia and Marachi (present)
	1 for	1 spear	Samia and Marachi (present)
FOOD	6 bowls maize for	1 hoe	Giriama (recent)
	2 basketfuls grain (about 50lb) for	1 sword	Logoli from Tiriki
	Sack of Maize for	1 hoe	Idakho (present)
	2 calabashes of food (yams, potatoes or bananas) for	1 woman's knife	Kikuyu
	Small basket of millet for	small knife	Kikuyu (Kenyatta 1938: 61)
	2 small baskets of beans for	small knife	Kikuyu (ibid)
	Sack of maize, millet or beans for	slasher	Luo
	Sack of maize, millet or beans for	axe	Luo
	Sack of maize, millet or beans for	spear	Luo
	5 gourdsful of honey beer for	smith's twisted iron bracelet	Mbeere (present)
	Beer (large amount)	1 axe	Taita (present)Exchange Values (cont.)
MONEY	10/- – 12/- for	large bell	Kikuyu (1974)
	10/- – 12/- for	large bell	Mbeere (1974)
	8/- for	medium sized bell	Mbeere and Kikuyu (1974)
	5/- for	small bell	Kikuyu (1974)
	3/- for	small bell	Mbeere (1974)
	40/-for	spear	Masai to Kikuyu (1972)
	5/- for	bracelet (mourning)	Masai to Kikuyu 1972
	20/- – 25/- for	1 spear	Pokot to Marakwet 1973

Appendix VIII

Time taken to manufacture various artefacts

Artefact		Hours
Spears		
Kikuyu working for Masai		
elder's spear	head and butt	4
warrior's spear	" " "	8
Pokot " " "		8
Turkana makes four spear*heads* at a time which takes eight hours		2
Samburu spear*head*		2
Samia		3-3½
Masai (Merker 1910: 115) smith and Asst. make a spear and a butt		1 day
Sword		
Kikuyu		2
Hoes		
Tharaka to make eight hoes takes		6
Samia 1 hoe		3-3½
Slashers		
Kisa 2 slashers alternating in fire		5
Marachi 1 slasher		3½
Tharaka 1 arrowhead without final burnishing		1
Bajun metal walking stick		1
In six hours two Marakwet smiths made	1 awl	
	2 knives	
	a twisted iron bracelet	
	an iron neckring (from a heavy gauge wire)	
	a spearhead and butt.	

In one hour a Kamba smith (who had been traditionally trained but had then worked for the railway) rivetted new blades onto two hoes; lengthened the prongs of a hoe-fork; made ferules for several handles. He said that in his prime he could make several hoes, about 10 digging sticks (with flat leaf-shaped blades) or 20 feet of chain in one day. An Embu smith boasted (Mwaniki 1974: 38) that he prospered because he could make two swords, four knives and an axe in one day.

Bibliography

Abrahams, R.G., 1967. Peoples of the greater Unyamwezi, Tanzania. International Africa Institute. *Ethnographic Survey of Africa, East Central Africa*, Part XVII. 37.

Achinard, M.L., 1884. La Fabrication du fer dans le Sudan, *Revue d'Ethnographie 3*, 249–55.

Aitchison, L. 1960. *History of Metals*. Two vols.

Alpers, E. 1969. "The Coast and the Caravan Trade". In I.N. Kimambo and A.J. Temu (Editors). *History of Tanzania*. 1969, 35.

Ambrose, S.H. 1984. Excavations at Deloraine, Rongai. *Azania 19*, 79–104.

Ambrose, S.H. 1983. Archaeology and linguistic reconstruction of history in E. Africa. In Ehret, C. and M. Posnansky (Eds.) *Archaeological and Linguistic reconstruction of African History*, pp. 25–40.

Andrée, R. 1889. *Ethnographische Parallelen ... Der Schmied*. 15, 23–24.

Andrée, R. 1884. *Die Metalle bei den Naturvolkern*. Anfray, F. 1963. Une Campagne de fouilles a Yeha. *Ann. d'Eth. V.*

Anfray, F. 1967. Matara. *Ann. d'Eth. VII.*

Anfray, F. 1968. Aspects de l'Archéologie Ethiopienne. *J.Af.Hist. IX.* (3). 345–366.

Ansorge, W.J. 1899. *Under the African Sun*. 66, 69, 77.

Arkell, A.J. 1961. *History of the Sudan to 1821.*

Arkell, A.J. 1966. The Iron Age in the Sudan. *Current Anthropology*. 7. 451.

Arkell-Hardwick, A. 1903. *An Ivory Trader in North Kenya.*

Ascher, R. 1962. Analogy in archaeological interpretation. *Anth.* 17. (4). 317–326.

Ascher, R. 1962. Ethnography for Archaeology. *Ethnology I.* (3). 360–69.

Atherton, J. and Milan Kalous. 1970. *Namoli. J.Af. Hist. XI.* 3. 303.

Avery, D. and P.R. Schmidt, 1979. A Metallurgical study of the iron bloomery, particularly as practised in Buhaya. *Jnl. of Metals, 31*, 14–20.

Baker, Sir S. 1877. *Albert Nyanza.* 165, 205.

Balfour, J. 1930. *Jnl. Inst. Metals. 43.* 350.

Barber, J. 1968. *The Imperial Frontier.* 68.

Barnes, H.B. 1926. Iron smelting among the Ba-Ushi. *J.R.A.I. 56.* 189–194.

Barnett, Guy. 1965. *By the Lake.* 13, 55, 67.

Barrett, W.E.H. 1911. Notes on the Customs and Beliefs of the WaGiriama etc. British East Africa. *J.R.A.I. 41* 20.

Barth, F. 1969. *Ethnic Groups and boundaries.*

Baudin, N. 1884. Le Fétichisme. *Missions Catholiques XVI.* 249.

Baumann, H. 1944. Zur Morphologie des Afrikanischen Ackergerates, Koloniale *Volkerkunde I.* 201–2.

Baumann, H. and Westermann D. 1948. *Peuples et Civilisations de l'Afrique*. Paris. 220, 259, 278, 281, 431, 498.

Baumann, O. 1891. *Usambara und seine Nachbargebiete.* 40, 190, 200–207, 216, 232–3, 291.

Baumann. O. 1894. *Durch Masailand zur Nilquelle.* 186, 207, 211, 232, 247.

Baumstark, P. 1900. Die Warangi. *Mitteilungen von Forschungsreisenden und Gelehrten aus den Deutschen Schutzgebieten XIII.* 45–60.

Beck, L. 1891. *Geschichte des Eisens.* Braunschweig. I, 317.

Beech, M.W. 1911. *The Suk. Their Language and Folklore.* 18.

Beech, M.W. 1913. *MAN XIII*, 4.

Beidelman, T.O. 1962. Ironworking in Ulaguru. *T.N.R.* 58/59. 288–9.

Bennett, P.R. 1967. Dahl's Law and Thagicu. *African Language Studies* 8. 127–59. University of London.

Bernhard, F.O. 1962. Two types of Iron smelting furnaces on Ziwa Farm. Inyanga. *S.Af.Arch. Bull.* 17. 68, Dec. 1962. 235–6.

Bey, Emin; 1882. Zeitschrift für Ethnologie 14. 160, 164.

Binford, S.R. and L.R. (Eds.). 1968. *New Perspectives in Archaeology.*

Binford, L.R. 1972. *An Archaeological Perspective.*

Birch, J.P. 1937. Madi blacksmiths. *Uganda J.* 5.(1).

Blackburn, R.H. 1974. The Ogiek and their History. *Azania IX.* 139–157.

Bland-Sutton, Sir J. 1933. *Men and Creatures in Uganda.* 105.

Bleeker, S. 1963. *The Masai.* 74–7.

Blohm, W. 1931. *Die Nyamwezi. Land und Wirtschaft.* Sv.I.22, 161–4, 166, 168, 236, 138.

Bohannen and Dalton (eds.). 1963. *Markets in Africa.*

Boyes, J. 1911. *King of the Wakikuyu.* 89, 246.

Bourgeois, R. 1957. Banyarwanda et Burundi. Tome I. *Ethnographie.* Bruxelles. 538–539.

Brelsford, W.V. 1949. Rituals and Medicines of the Chisinga Ironworkers. *MAN 49.* No. 27, 28–9, 38.

British East Africa. 1897–8. *Report of Sir A. Hardinge on the British East Africa Protectorate.*

Brock, B. and Brock P.W.G. 1965. Ironworking amongst the Nyiha of south-western Tanganyika. *S.Af. Arch. Bull. XX* 97–100.

Browne, G. St.J.Orde. 1925. *The Vanishing Tribes of Kenya* 40, 129–131, 143–149.

Browne, G. St.J.Orde. 1916. *Mt Kenya and its peoples.* Jnl.Af.Soc. *15.* 59, 225.

Bugeau, F. 1943. Les Wakikouyous et la guerre. *Annali Lateranensi VII.* 205.

Bunger, R. 1973. *Islamisation amongst the Upper Pokomo.* Maxwell School of citizenship and Public Affairs. Syracuse University.

Buschan, G. 1922. *Illustrierte Volkerkunde.* Sv.I 536. Stuttgart.

Burgt, J.M.M. 1903. *Un grand peuple de l'Afrique Equatoriale.* 51–2. Bois-le-Duc. Holland.

Burton, Sir R.F. 1860. *The Lake Regions of Central Africa.* II Appendix I (395). 261, 269, 231.

Cagnolo, C. 1933. *The Akikuyu.* Nyeri, Kenya. 32, 37–41, 188, 226–8.

Cagnolo, C. 1952. Kikuyu Tales, *African Studies II.* 12–14, 37.

Calvocoressi, D. and N. David. 1979. A new survey of radiocarbon and thermoluminescence dates, for W. Africa. *Jnl. of African History 20* 91–100.

Cameron, V.L. 1877. *Across Africa*. Sv. 2, 44, 238, 328.

Carnell, W.J. 1955. Sympathetic Magic among the Cogo of Mpapwa District. *Tang. Notes and Records*. No. 39, 31.

Cellis, G. and E. Nzikobanyanka. 1976. La Métallurgie Traditionnelle au Burundi. Téchnique et croyances. *Mus. Roy. de l'Airique centrale*. Tervuren. Archives d'Anthropologie 25.

Cerulli, Ernesta. 1957. The African Smith, a cult hero. *Stud. e Mater storia relic*.

Cerulli, Ernesta. 1956. Peoples of south-west Ethiopia and its borderland. *Ethnographic survey of Africa. North-east Africa*.

Cerulli, Ernesta. 1964. *Somalia III*. 98.

Champion, A.H. 1912. *J.R.A.l. 42*. 70–1, 77–80, 90.

Chanler, W.A. 1896. *Through Jungle and Desert*. 253–254, 318–407.

Chaplin, J. 1961. Notes on traditional smelting in N. Rhodesia. *J..Af.Arch.Bull. XVI*. 53–60.

Chapman, S. 1967. Kansyore Island. *Azania II* 115–191.

Childe, V.G. 1930. *The Bronze Age*. 4, 10.

Childe, V.G. 1936. *Man Makes Himself*.

Childe, V.G. 1939. *The Dawn of European Civilisation*.

Childe, V.G. 1940. *Prehistoric Communities of the British Isles*. 163, 166.

Childe, V.G. 1950. *Prehistoric Migrations in Europe*. 166.

Childe, V.G. 1954. Ed. *New Light on the most Ancient East*.

Childs, S.T. 1984. Clays to artefacts: resource selection in African Early Iron Age iron making technologies. Paper read at the 83rd Annual Meeting of the American Anthropological Association (Denver).

Childs, S.T. and P. Schmidt. 1986. Experimental iron smelting: the genesis of a hypothesis with implications for African Prehistory in *African iron-working, ancient and traditional* (Eds. P. Shinnie and R. Haaland. Bergen).

Chittick, H.N. 1967. Discoveries in the Lamu Archipeligo. *Azania II*. 55.

Chittick, H.N. 1968. Kilwa: a Preliminary Report. *Azania I*. 1–36.

Chittick, H.N. 1974. Kilwa: an Island trading city on the E. African coast. *The British Institute in Eastern Africa. Memoir I*.

Chittick, H.N. 1984. Manda. *The British Institute in Eastern Africa. Memoir 9*.

Clark, J.G.D. 1952. *Prehistoric Europe - The Economic Basis*, 197–9, 257.

Clarke, D.L. 1968. *Analytical Archaeology*. 223, 238–9.

Clarke, J.D. 1944. *MAN. 44*. 25.

Clarke, J.D. 1970. *The Prehistory of Africa*. 214–5.

Clarke, J.D. 1970. African Prehistory - opportunities for collaboration between archaeologists, ethnologists, and linguists. In Dalby and David (Eds.) *Language and History in Africa*.

Claus, H. 1911. Die Wagogo. *Bassler Archiv. Beiheft II*. 33–34 Leipzig Berlin.

Clement, P. 1948. Le Forgeron en Afrique Noire: quelques attitudes du groupe à son egard. In *Revue de Géographie humaine et d'Ethnologie*. No. 2 April-June 1948. 35.

Cline, W. 1937. *Mining and Metallurgy in Negro Africa*.

Clist, 8., R. Osisly and B. Peyrot. 1986. Ancient Ironworking in Gabon. *MUNTU. Revue Scientifique et Culturelle du CICIBA* No. 45.

Coghlan, H.H. 1941. Prehistoric iron prior to the dispersal of the Hittite Empire. *MAN* Nos. 59 and 63.

Coghlan, H.H. 1956. Notes on the Prehistoric and early iron age in the old world. *Pitt-Rivers Occ. Paper on Technology*. No. 8. Oxford.

Cole, Sonia. 1964. *Prehistory of East Africa*. 278–9, 301.

College, P. 1913. *Les Baluba*.

Collett, D. The Spread of Early Iron Producing Communities in Eastern and Southern Africa. *PhD. thesis University of Cambridge*.

Collett, D. 1983. Models of the spread of the early Iron Age: in Ehret and Posnansky (Eds.) *Archaeological and linguistic Reconstruction of African History* 182–198.

Collett, D. and P. Robertshaw. 1980. Early Iron Age and Kansyore pottery: finds from Gogo Falls, S. Nyanza. *Azania* 15: 133–145.

Collett, D. and P. Robertshaw: 1983a. Problems in the interpretation of radiocarbon dates; the Pastoral Neolithic in E. Africa. *African Archaeological Review* I, 57–74.

Cooke, C.K. 1966. An Account of iron smelting techniques once practised by the Manyubi of the Matobo District of Rhodesia. *S. African Archaeological Bulletin* 21: 86–87.

Coupland, R. 1938. *East Africa and its Invaders*. II. 4.

Coy. M.W. (Jr.) 1981. The Social and Economic relations of blacksmiths in Baringo District. *Seminar Paper Dept. of Sociology Nairobi*.

Crawhill, T.C. 1933. Ironworking in the Sudan. *MAN XXXIII* March 1933. No. 28. 41–43.

Crawshay, R. 1902. Kikuyu. Notes on the country, people, and fauna. *Geog.J. XX*. 29, 34.

Culwick, A.T. and C.M. 1935. *Ubena of the Rivers*. 293–295.

Cummings, H. 1976. Two Iron Age Sites in the Grand Falls area, Meru district. *Azania XII* 193–4.

Cunningham, J.F. 1905. *Uganda and its Peoples*.

Czekanowski, J. 1911. *Forschungen im Nil-Kongo-Zwischen-gebiet. III* (Wissenschaftliche ergebnisse der Deutschen zentral Afrika-Expedition 1907–8. VII). 9–10, 26, 154–6, tab. 12–13. 1917. 156.

Dalby, D. 1975. The Prehistorical Implications of Guthries Comparative Banta Part 1. Problems of Internal Relationship, *J.Afr. Hist. 16* (4): 481–501.

Dannholz, J. 1916. *lm Banne das Geisterglaubens*. 76, 107.

Dart, R.A. 1931. The Ancient Iron smelting cavern at Mumbwa. *Trans. R.Soc*. 19. 379–427.

David, N., Paul Harvey and C.J. Goudie. 1981. Excavations in the S. Sudan 1979 *Azania XVI* 21–31.

Davies, Oliver. 1966. Comment on the Iron Age in Sub-Saharan Africa. *Current Anthropology* 7. 470–1.

Decken, Baron K. von der. 1871. *Reisen in Ost-Afrika in den Jahren 1862-1865*. Sv.2, 17, 19.

Dempwolff, O. 1916. *Die Sandawe*. 105–6, 108.

Di Blasi, M. I980. Kwamboo: An Early Iron Age occurrence in the eastern highlands of central Kenya. Paper presented at the 79th annual meeting of the American Anthropological Association, Washington.

Diesing, E. 1909. Uber eine Reise im Gebiet des Rukwa im Jahre 1899. *Globius* 95. 327.

Dieterlin, G. 1973. A Contribution to the study of blacksmiths in W. Africa in Pierre Alexandre. French Perspectives in African Studies. *Int. Af. Inst*. 40–61.

Diop, L.M. 1968. Métallurgie et l'Age du Fer en Afrique, *Bull. IFAN* (Serie B) *30*: 10–38.

Doutte, E. 191Z. *Ethnographie, magie et religion de l'Afrique du Nord*. 40. Paris.

Dracopoli, I.N. 1914. *Through Jubaland to the Lorian Swamp*. 150, 309.

Driberg, J.H. 1923. *The Lango*. 86, 391, 399.

Dugmore, Radclyffe, A. 1900. *Camera adventures in the African Wilds*.

Dundas, Hon. Charles. 1908. Notes on the Origin and History of the Kikuyu and Dorobo tribes. *MAN* 8. 137.

Dundas, Hon. Charles. 1913. History of Kitui. *J.R.A.l. 43*. 503, 504, 495–496.

Dundas, Hon. Charles. 1915. Organisation and Laws of some Bantu tribes of East Africa. *J.R.A.I. 45*. 270.

Dundas, Hon. Charles. 1921. *Kilimanjaro and its People*. 176–77, 270–274.

Dundas, Hon. Charles. 1921a. Laws of some Bantu tribes of E. Africa *J.R.A.l. 51*. 217.

Dundas, Hon. Charles. 1955. *African Crossroads*. 48.

East African Annual, 1939–40. Craft of the Blacksmith. 37.

Echard, N. (Ed.). 1983. Métallurgies Africaines: nouvelles contributions. *Memoire de la société de Africanistes* 9.

Edrisi (ldrisi), Abu 'Abdalla Muhammad ben Muhammad al; 1936–40. *Geographie d'Edrisi*. Trad. par P.A. Joubert. Paris 58.

Ehret, C. 1971. *Southern Nilotic History*. 18, 29, 32, 39, 42, 45, 47, 50, 53, 63.

Ehret, C. 1974. *Ethiopians and East Africans*. 41, 34, 56.

Ehret, C. and Merrick Posnansky. 1982. *Archaeological and Linguistic Reconstruction of African History*.

Eichorn, A. and Karassek, A. Beitrage zur Kenntnis der Waschambaa. Nach Hinterlassen Aufzeichnungen von. A. Karassek hrsg. von A. Eichorn. *Bassler archiv. 8* 1923–24. 80. *Bassler Archiv. I.* 1911. 168.

Elam, Yitzchak. 1974. The relationships between Hima and Iru in Ankole. *African Studies 33.* (3). 166.

Eliade, M. 1936. Metallurgy, magic, alchemy. *Cahiers de Zalmoxis* Vol. I.

Eliade, M. 1962. *The Forge and the Crucible*. 57.

Eliot, Sir Charles. 1905. *East Africa Protectorate*. 148.

Elliot, J.R.M.D. 1924. *The Graphic*. Nov. lst.

Ellis, H.B. 1894. *The Yoruba speaking people of the Gold Coast*. 113.

Ende, L. von. 1889. Die Baduwis von Java. *Mitteilungen der Anthropologischen Resellschaft im Wien. XIX* 10.

Fadiman, J. 1970. Oral Traditions of Meru, Mwimbe and Muthambe on Mt Kenya: The Migration from Mbwa, *University of Nairobi Cultural Division Seminar June 1970*.

Fagan, 8. 1961. Pre-European Ironworking in Central Africa with special reference to N. Rhodesia. *J.Af.Hist. II.* 199–201.

Fagan, B. 1965a. *Southern Africa During the Iron Age* 47–49, 56–57 plate 44.

Fagan, B. 1966. Iron Age in Zambia. *Current Anthropology 7.* 453–462.

Fagan, B. 1969. Early Trade and Raw Materials in central Africa, *J.Af.Hist. X* (1). 1–13.

Fagan B. and R. Oliver. 1975. *Africa in the Iron Age*.

Fagg, B.E.B. 1956. The Nok Culture in Prehistory. *Jnl. of Af.Soc. Nigeria I.* 4.

Fagg, B.E.B. 1969. Recent work in West Africa. New light on the Nok Culture. *World Archaeology I.* (I). 41–50.

Ferrand, G. 1913. *Relations des voyages et textes géographiques Arabes, Persans et Turks relatifs a l'Extreme-Orient du VIII au XVIIe siècles*. Trad. par G. Ferrand. 274.

Fettich, N. 1929. Bronzeguss und Nomadenkunst. *Skythia II* 59.

Fischer, G.A. 1885. *Das Massai-land*.

Fitzgerald, W.W.A. i898. *Travels in the coastland of British East Africa and the islands of Zanzibar and Pemba*. 97.

Fleming, H. 1964. Baiso and Rendille: Somali Outliers. *Rassegna di Studi Etiopici XX* 83–90.

Fontaine, J. la. 1959. *The Gisu of Uganda*. 23.

Foran, W.R. 1937. *African Odyssey*. 179–80, 199–200.

Forbes, R.J. 1950. *Metallurgy in Antiquity*.

Forbes, R.J. 1964. *Studies in Ancient Metallurgy. VIII.* 105, 176– 180.

Ford, J. and R. de Z. Hall. 1947. The History of Karagwe (Bukoba District). *Tang. Notes and Records.* 24. 3–27.

Forde, C. Daryll. 1934. *Habitat, Economy and Society*. 298–9.

Fosbrooke, H.A. Richard Thornton in East Africa. *Tang. Notes and Records* 1962 *56* 43.

Foy, W. 1909. *Zur Geschichte der Eisentechnik, insbesondere der gebläse Ethnologica*. 142.

Foy, W. 1910. *Globus Bd XCVIl*. 142.

Francis-Boeuf, C. 1937. L'Industrie autochtone du fer en Afrique occidentale française. *Bull. du Comité Histoire et Scientifique de l'A.O.F. XX.* 448.

Franklin, H. 1945. The native ironworkers of Enkeldoorn District and their art. *NADA 22* 5–10.

Frazer, J.G. 1920. *The Golden Bough. 1.* 349. *111.* 237.

Frazer, J. 1911. *Taboo and the Perils of the Soul*. 224–39.

French-Sheldon, M. 1892. *Sultan to Sultan*. 284.

Friede, H. and A. Hejja and A. Koursaris. 1982. Archaeo-metallurgical studies of iron smelting slags from prehistoric sites in Southern Africa. *Jnl. of the S. Af. Inst. of Mining and Metallurgy 82* 3848.

Frobenius, L. and Wilm Ritter. 1929. *Atlas Africanus*. Heft 1. Blatt 4.

Frobenius, L. 1898. *Ursprung der Kultur*.

Frobenius, L. 1904. *Geographisch Kulturkunde*. 864.

Frobenius, L. 1933. *Kulturgeschichte Afrikas*. Das Unbekannte Afrika.

Frobenius Institute. Dime ironworking film text.

Fulleborn, F. 1907. *Das Deutsche Njassa und Ruwama-Gebiet*. 166–168, 172–3, 198, 507. Berlin.

Galloway, A. 1934. A Note on the iron-smelting methods of the Elgeyo Masai. *S.A.F. Jnl.Sc. XXXI* Nov. 1934, 500–504.

Gand, F. 1911. *Les Mandja*. 225, 230.

Garland, H. and C.O. Bannister. *Ancient Egyptian Metallurgy*. 85–112.

Gedge, E. 1892. Recent Exploration up the Tana to Mt Kenya. *Proc. Roy. Geog. Soc. 14.* 513.

Goldschmidt, W. 1976. *The Culture and Behaviour of the Sebei*, 94, 190– 193, 317–318.

Goldsmith, K.L.G. and I.M. Lewis. 1958. Preliminary Investigation of Blood groups of the Sab bondsmen of N. Somalia. *MAN 58.* 252.

Goody, J. 1971. Technology, Tradition and the State in Africa, *Int. Af. Inst.*

Gramly, R.M. 1978. Expansion of Bantu-speakers versus development of Bantu language and African culture in situ: an archaeologist's perspective. *S. African Archaeological Bull. 33* 107–112.

Grant, J.A. 1864. *A Walk across Africa*. 78, 87–8, 293–295.

Gray, Sir J. 1957. *The British in Mombasa* 1824–26.61.

Gray, R. 1963. *The Sonjo*. 44–5, 77–8.

Greenburg, J. 1955. *Studies in Linguistic classification*.

Greenburg, J. 1972. Linguistic Evidence regarding Bantu origins. *J.Af.Hist. Xll* 189–216.

Gregory, J.W. 1896. *The Great Rift Valley*. 34, 310, 349.

Greig, R.H. 1937. Iron smelting in Fipa. *T.N.R.* No. 4. 77–81.

Griaule, M. 1948. *Dieu d'Eau Entretiens avec Ogotemméli*.

Griaule, M. and G. Dieterlen. 1965. Le Renard Pâle. Vol. 1. Le Mythe cosmogonique No. 1. *Travaux et Mémoires de l'Institute d'Ethnologie* Vol. *LXXll*.

Groube, L.M. *The Hazards of Anthropology*.

Guebard, P. 1911. Notes Contributives a l'étude de la religion des Moers et des coutumes des Bobo du Cercle de Konny. *Revue d'Ethnographique et de Sociologie 11.* 134.

Guillain, M. 1856. *Documents sur l'Histoire, la Géographie, et le Commerce de l'Afrique Orientale*. Premier Partie 224–5.

Gulliver, P.H. 1952. Bell-oxen and ox names among the Jie. *Uganda Jnl. 16.* 72.

Guth, W. 1939. Der Bodengott der Asu. *Africa 12.* 56, 455.

Guttmann, B. 1912. Der Schmied und seine kunst im animatischen denken. *Z. für Ethnologie 44.* 81–93.

Haaland, R. and P. Shinnie (Eds.). *African Ironworking*. Bergen.

Haberlund, von Eike. 1961. Eisen und Schmiede in Nordost-Afrika. *Mus. Volkerkunde XI.* 191–220.

Haberlund, von Eike. 1963. *Galla Süd-Äthiopiens*. 110, 131, 140–1, 776.

Haden, J. 1970. Okebu ironsmelting. *Uganda Jnl. 34* 163–170.

Halkin, J. 1911. *Les Ababua*. 233.

Handbook of Kenya Colony 1920. 113, 392, 451.

Hallpike, C.R. 1968. The status of Craftsmen among the Konso of S.W. Ethiopia. *Africa XXXVIII.* (3). 258–269.

Hallpike, C.R. 1972. *The Konso*.

Hardinge, Sir A. 1897–8. Report of Sir A. Hardinge on British East Africa Protectorate for the year 1897–8.

Hatton, J.S. 1967. Notes on Makalanga Iron Smelting. *NADA 9:* 39–41.

Hawkes, C. 1940. *The Prehistoric Foundations of Europe*. 285 379–80.

Heinzelin, J de. 1959. Metallurgie primitive du fer dans la region de la Basse-Semliki. *Bull. Séances Académie Roy.Sciences Colon. 5.* (3) 673–698.

Hemedi, 'lAjjemy, Abdullah bin. 1963. *The Kilindi*. ch. 36.

d'Hertefelt, M. and A. Coupez. 1064. La Royautée Sacrée de l'Ancien Rwanda. *Series in 8° Sciences Humaines No. 54.*(Musée Royal de l'Afrique Central). 115–7.

Heusch, L. de 1956. Le Symbolisme du forgeron en Afrique, in *Reflets du Monde* No. 10. July 1956. 57–70.

Heunglin, M. TH. von. 1869. *Reise in das Gebiet des Weilsen Nil und seiner westliche Zuflusse*.

Hiernaux, J. and E. Maquet. 1957. Cultures prehistoriques de l'age des métaux au Ruanda-Urundi. *Bull. de l'Académie Roy. des Sciences Coloniales n.s.* II (6). 1126–1149.

Hiernaux, J. and E. Maquet. 1960. *Académie Roy. des Sciences d'Outre Mer. Classe des Sciences nat. et med.* New Series LX. 2 I–I02.

Hiernaux, J. and E. Maquet. 1960. Un haut-fourneau prehistorique au Buhunde, Kivu. Congo Belge. *Zaire 61.* 5–9.

Hiernaux, J. 1968. Bantu expansion. The evidence from Physical anthropology confronted with linguistic and archaeological evidence. *J. Afr. Hist.* 9 (4): 505–15.

Hildebrandt, J.M. 1878. Ethnographische Notizen über die Wakamba und ihre Nachbarn. *Zeit. f. Eth.* 10 (5). 372.

Hillman, J. and S. Hillman. 1984. Archaeological observations in Banangai Game Reserve, South-Western Sudan: *Azania XIX* 115–120.

Hinde, S.L. and Hinde, H. 1901. *The Last of the Masai.* 86–90.

Hobley, C.W. 1902. Eastern Uganda. An Ethnological Survey. *Anthropological Institute Occasional Paper.* No. 1. 16, 18, 19, 27, 38–9.

Hobley, C. 1905. Anthropological Studies in Kavirondo and Nandi. *J.R. A.1.* 33. 325.

Hobley, C.W. 1910. *The Ethnology of the Akamba and other East African Tribes.* 51, 29–30.

Hobley, C.W. 1913. The Evolution of the Arrow. *J.E.Af. Nat. Hist.Soc.* III (6) 31.

Hobley, C.W. 1922. *Bantu Beliefs and Magic.* 165–176, 182.

Hobley, C.W. 1929. *Kenya: From Chartered Company to Crown Colony.* 247–8.

Hodgson, A.G.O. 1933. Notes on the Achewa and Angoni of the Dowa District of the Nyasaland Protectorate. *J.R.A.I. 63.* 163.

Hofmayr, W. 1925. *Die schilluk.* 230. Fig. 22b.

Hohnel von. 1894. *The Discovery by count Teleki of Lakes Rudolf and Stefanie.* Vol. 1. 356. Vol. II. 310.

Holas, B. 1968. *Craft and Culture in the Ivory Coast.*

Hollis, A.C. 1905. *The Masai.* 330–331.

Hollis, A.C. 1909. *The Nandi.* 9, 36.

Holy, L. 1957. Iron-smelting and Iron techniques among E. African Bantu. *Ceskoslovenska Ethnographie V.* (3). 273.

Holy, L. 1958. Eisengewinnung und Eisenbearbeitung bei den Ostafrikanischen Bantu. *Ceskoslovenska Ethnographie 6* 144–162.

Holy, L. 1959. Die eiseninindustrie der Pare-Swead Aus: *Opuscula Ethnologica Memoriae Ludovico Biro Sacra.*

Huiiman, T.N. 1970. The Early Iron Age and the spread of the Bantu. *S. Afr. Archaeological Bulletin.* 25. 3–21.

Huffman, T.N. 1979. African Origins. *S. African Jnl. of Science 75* 223–237.

Huffman, T.N. 1978a. The origins of Leopard's Kopje: an llth Century difaquane. *Anoldia* (Rhodesia) 8: 1–23.

Huffman, T.N. 1982. Archaeology and ethnohistory of the African Iron Age. *Annual Review of Anthropology 11* 133–150.

Housden, J. and Armor, M. 1959. Indigenous iron smelters at Kalambo. *N. Rhodesia Jnl. 2.* (4). 135–8.

Huard, P. 1966. Introduction et diffusion du fer au Tchad. *Jnl. Af. Hist.* 3. 377–404.

Huart, C. 1895. Documents persans sur l'Afrique, in *Receuil de Memoires Orientaux.* 87–115.

Hulst, J. van der and F. Steffens. 1975. Small lndustries in the W. Lake Region, Tanzania. *Scriptie.* Aug. 1975. Eindhoven University of Technology. 47, 49, 96–7, 100.

Huntingford, G.W.B. 1931. Free hunters, serf tribes and submerged classes in E. Africa. *MAN.* 31. 262, 263, 265.

Huntingford, G.W.B. 1950. *Nandi Work and Culture.* 80–83. 270 H.M.S.O. Col. Off. Section 302.

Huntingford, G.W.B. 1953. *The Nandi of Kenya.* Tribal Control in a Pastoral Society. 34.

Huntingford, G.W.B. 1955. The Economic Life of the Dorobo. *Anthropos L.* (4/6). 602–34.

Huntingford, G.W.B. 1961. The Distribution of Certain Culture elements in E. Africa. *J.R.A.I. 91* (2) 261–4. Map 294–5, 251.

Huntingford, G.W.B. 1969. *The Southern Nilo-Hamites. Int. Af. Inst.* 37, 52, 73, 89, 109, 123.

Jackson, Sir F. 1930. *Early Days in East Africa.* 175.

Jackson, K.A. 1972. *An Ethnohistorical study of the Oral Traditions of the Akamba of Kenya.* Unpub. PhD. dissert. Univ. of California L.A.

Jacobs, A.H. 1972. The Discovery and oral history of the Narosara site. In K. Odner, Excavations at Narosara, a stone Bowl Site in the southern Kenya highlands. *Azania VII.* 79.

Jacobs, A.H. 1970. *New Light on Interior Peoples - the Serikwa Phenomena.* Unpubl. Seminar paper. Univ. of Nairobi.

Jager, F. 1913. Das Hochland der Reisenkrater. *Mitteilungen aus den deutschen Schutzgebieten* Erg. Heft. No. 8. Berlin.

Jeffreys, M.D.W. 1948. Stone Age Smiths. *Archiv. fur Volkerkunde III* Band. 1.7.

Jeffreys, M.D.W. 1962. Some Notes on the Kivaja Smiths of the Bamenda. *MAN 62.* (236). 152.

Jensen, A.E. 1959. *Altvölker Süd Äthiopiens.*

Job, A.L. 1967. Mining in Uganda. *Uganda. Jnl. 31.* (1) 52.

Johnston, Sir H. 1886. *The Kilimanjaro Expedition.* 277, 297, 414–5, 439, 545.

Johnston, Sir H. 1902. *The Uganda Protectorate.* Vol. *I.* 102, 304.

Johnston, Sir H. 1904. *The Uganda Protectorate.* Vol. *II.* 664, 745, 790, 834–5. 846.

Johnston, Sir H. 1908. *George Grenfell and the Congo.* II.

Johnston, Sir H. 1919. *A Comparative Study of the Bantu and Semi-Bantu languages. I.* 62, 102, 118, 330, 354, 712, 757. *II.* 331.

Kagwa, Sir A. 1934. *The customs of the Baganda.* Translated 1934 from Ekitabo kye Mpisa za Baganda.

Kamuhangire, E.R. 1972. The Pre-Colonial Economic and Social History of E. Africa with special references to S.W. Uganda salt Lakes Region. E. Af. History Conference.

Kandt, R. 1904. Gewerbe in Ruanda. *Zeitschrift für Ethnologie 36.* 359, 365.

Kannenberg, C. 1900. Reise durch die Hamitischen Sprachgebiete um Kondoa. *Mitteilungen aus den deutschen Schutzgebieten 13.* 162.

Katoke, Israel K. 1975. *The Karagwe Kingdom.* II-l2, 14, 32, 59, 78, 150–1, 157–9, 163.

Kay, G. and Wright, D. 1962. Aspects of the Ushi iron industry. *N. Rhodesia Jnl.* 5. 28–38.

Kenya Land Commission Evidence. 1929. Appendix A. 33, 66.

Kenyatta, J. 1938. *Facing Mount Kenya.* 72–6, 85–7, 89–92.

Kersten, O. 1869–71. Quoted in von der Decken. *Reisen in Ost-Afrika.*

Kestler, H. (translator). 1963. An Account of a journey through N.W. German East Africa, *Tang. Notes and Records,* 60, 210.

Kieran, J. 1975. The period after 1000 A.D. *East Africa and the Orient Seminar.* Brit. Institute in Eastern Africa. Ed. N. Chittick.

Kimambo, I.N. 1968. *The Pare in Tanzania before 1900.* Ed. Roberts. 18.

Kimambo, I.N. 1969. *A Political History of the Pare people to 1900.* 5–6, 15, 32, 47–51.

King, K. 1977. *The African Artisan.*

Kiwanuka, M.S.M. 1968. Bunyoro and the British. *J.Af.Hist. IX* (4). 603–619.

Klusemann, K. 1924. Die Entwicklung der Eisengewinnung in Afrika und Europa. *Mitteilungen der Anthropolocischen Gesselschaft in Wien.* 54. 120–129.

Kohler, O. 1950. *Die Ausbreitunc der Niloten. Beiträger zur Gesellungs und Volkerwissenschaft.* Prof. R. Thurnwald zu seinem achtzigsten Geburtstag gewidmet. 161–2. Berlin.

Kohl-Larsen, L. 1943. Auf den Spuren des Vormenschen. Stuttgart 1. 210–211, 266–7. Illus. 208.

Kollmann, P. 1898. *Der Nordwesten unserer ostafrikanischen Kolonie.* 27, 34, 63–4, 71, 78–9, 111.

Kollmann, P. 1899. *The Victoria Nyanza.*

Kootz-Kretschmer, E. 1926. *Die Safwa.* Sv. I. 180–1. 138.

Kotz, E. 1922. *Im Banne der Furcht.* 138–40.

Krapf, J.L. 1860. *Travels, Researches and Missionary Labours during 18 years residence in East Africa,* 142, 302, 353, 357–8.

Krause, A. 1903. *Die Pariavölker der gegenwart.* 31.

Krauss, H. 1908. Hausgeräte der deutsch-ostafrikanischen küstenneger. *Globus 93.* 362.

Lambert, H.E. Unpublished Mss.

Lamphear, J. 1970. The Kamba and the North Mrima coast. In *Precolonial African Trade.* Ed. R. Gray and D. Birmingham. 83.

Lamphear, J. 1972. L.I.H.R. Thesis. 156, 257, 314–20, 359, 364, 409, 511.

Lanning, E.C. 1954. Genital symbols on smith's bellows in Uganda. *Man 54*. No. 262.

Lanning, E.C. 1956. Shafts in Uuganda and Toro. *Uganda Jnl.* 1956. 216–7.

Lanning, E.C. 1958. An iron mining tool from Uganda, with a note on Rhodesian parallels. *MAN58*. (40). 43.

Last, J.T. 1882. A visit to the Wa-Itumbi ironworkers and the Mangaheri near Mamboia-Nguu. A journey into Unguru country from Mamboia. *Proc. Roy. Geog. Soc. IV.* 520–1. *V* (1883) 581–592.

Last, J.T. 1886. *Polyglotta africana orientalis.* 190, 219.

Last, J.T. 1894. Iron making in East Africa. *Jnl. Iron and Steel Inst. 46.* (2). 400–402.

Laughton, W.H. 1944. *The Meru.* 8, 16. C.M.S. Nairobi.

Lauren, W. 1968. Masai and Kikuyu: An Historical Analysis. *J.Af. Hist. IX* (4). 578.

Leakey, L.S.B. 1930. Some Notes on the Masai of Kenya Colony. *J.R.A.I. LX* 209.

Leakey, L.S.B. 1935. *Stone Age Races of Kenya.* 97–8.

Leakey, L.S.B. 1977. *The Southern Kikuyu before 1903.* 303–309.

Leakey, M.D., W.E. Owen, and L.S.B. Leakey. 1945. Dimple-based pottery from Central Kavirondo, Kenya Colony. *Occasional Papers of the Coryndon Memorial Museum,* Nairobi No. 2.

Leared, A. 1876. *Morocco and the Moors.* 273.

Leclant, J. 1956. Le Fer à travers les Ages. *Annales de l'Est Memoire* 16.

Lewis, l.M. 1961. *A Pastoral Democracy.* 14, 188, 263.

Lindblom, G. 1920. *The Akamba.* 372, 528–9, 530–33.

Lindblom, G. 1939. *Wire Drawing especially in Africa.* Stockholm. Livingstone, D. 1865. *Narrative of an expedition to the Zambesi.* 536.

Livingstone, D. 1899. *First Expedition in East Africa.* 412.

Louis, H. 1929. Iron Manufacture and heat generation. *Nature 123.* 762.

Loupias, H. 1908. Les Touissi-Hima en Ruanda. *Anthropos.* 39.

Low, D.H. 1963. The Northern Interior 1840–1884. In Oliver and Mathew (eds.) *History of East Africa. I.* 297–351.

Lucas, A. 1948. Ed. *Ancient Egyptian Materials and Industries.* 202–5, 274.

Lugard, F.D. 1893. *The Rise of our East African Empire. I.* 274.

Luschan, F. von. 1898. *Beiträge zur Ethnographie des abflusslosen Gebietes von Deutsch Ostafrika. 33,* 341. Berlin.

Luschan, F. von. 1909. Eisentechnik in Afrika. *Zeitschrift für Ethnologie.* 41.

Lwanga-Lunyiigo, S. 1976. The Bantu problem reconsidered. *Current Anthropology 17* 280–286.

MacDonald, J.R.L. 1899. Notes on the Ethnology of the Tribes met with during the progress of the Juba expedition of 1897–99. *J.R.A.l. 29.* (2). 226.

MacKenzie, D.R. 1925. *The Spirit Ridden Konde.* 35, 107, 148.

Maes, J. 1930. La Métallurgie chez les populations du Lac Leopold II-Lukenie. *Ethnologica* 1. 82. 88–90. 100–101.

Mahlstedt, T. and M. Di. Blasi. 1978. Archaeological survey of the Ithanga Hills, Eastern Highlands of Kenya: preliminary analysis. *Azania 13* 192–193.

Mair, L.P. 1934. *An African People in the 20th Century.* London. 129.

Maquet, Emma. 1965. Utils de Forge du Congo de Rwanda et du Burundi. *Musée Royal de l'Afrique Centrale. Tervuren. Human Science series. No. 5.*

Maret, P. de. 1984. A Kikuyu-Ingombe Ilede Connection? *Azania XIX* 132–134.

Maret, P. de. 1980. Les trop fameux pots a fossette basale du Kasai. *Afrika - Tervuren 26* 13–19.

Maret, P. and F. Nsuka. 1977. History of Bantu Metallurgy: some linguistic aspects. *History in Africa 4* 43–65.

Maryon, H. 1938a. The Technical methods of Irish smiths in the Bronze and Early Iron Ages. *Proc. R.I.A. XLIV.* sect. C. 181.

Maryon, H. 1938b. Some Prehistoric Metalworkers Tools. *Antiquaries Jnl.* 243.

Maryon, H. 1949. Metal Working in the Ancient World. *A.J.A. LIII.* 93–125.

Mason, R.J. 1973. First Early Iron Age Settlement in S. Africa: Broederstroom 24/73, Brits District, Transvaal. *S. Afr. Jnl. of Science 69* 324–325.

Massam, J.A. 1927. *The Cliff Dwellers of Kenya.* 50.

Mathew, G. 1967. The East African Coast until the coming of the Portuguese. In *The History of East Africa: The Early Period.* Ch. 4.

Mauny, R. 1952. Essai sur l'Histoire des Métaux en Afrique Occidentale. *Bull. d'I.F.A.N. XIV* (2). 545–95.

McBrearty, Sally, S.A.C. Waane and G. Wynn. 1984. Archaeological Survey in Mbeya Region, Southern Tanzania *Azania XIX*: 128–132.

McCaughley, W.J. 1936. Ethiopian Blast Furnaces. *Metal Progress. 29.* (1) Jan. 1936. 62–3.

McConnell, R.E. 1925. Notes on the Lugwari tribe of Central Africa. *J.R.A.I. 55.* 467.

McDermott, P.L. 1895. *British East Africa.* 416–7, 422–3.

Meinertzhagen, R. 1957. *Kenya Diary.* 1902–1906.

Melland, F.H. 1923. *In Witchbound Africa.* 136–38, 159.

Mennell, F.P. and R.F.H. Summers. 1955. The Ancient Workings of S. Rhodesia. *Occ. Pap. Nat. Mus. S. Rhod.* No. 20.

Mercer, p. 1971. Shilluk Trade and Politics. *Jnl. Af. Hist. 12.* 407–426.

Merker, M. 1910. *Die Masai.* 47, 57–8, 110, 114–116, 246, 265–267.

Merritt, E.H. 1975. *A History of the Taita of Kenya.* PhD. thesis. Indiana University.

Meyer, H. 1916. *Die Burundi.* 83–85.

Mude, K.A. 1969. The Amaro-Burji of S. Ethiopia. In Ngano: *Nairobi Historical Studies I.* Ed. B. McIntosh. 27.

Muriuki, G. 1974. *A History of the Kikuyu 1500–1900.*

Murphy, J.H. Blackwood. 1926. The Kitui Akamba. Further Investigation on certain matters. *J.R.A.l. LVI.* (56). 195.

Mwaniki, H.S.K. 1969. Institute of African Studies, Nairobi. Seminar Paper 35.

Mwaniki, H.S.K. 1973. *The Living History of the Embu and Mbeere.* 138–9.

Mwaniki, H.S.K. 1974. *Embu Historical Texts.* 21, 37, 76.

Musil, A. 1927. Arabia Deserta. *Amer. Geog. Society*

Musil, A. 1928. Manners and Customs of Rwala Bedouins. *Amer. Geog. Soc.*

Nauta, Dick. 1971. The Traditional Spears of Kenya. Inst. Af. Studies, Nairobi. Research Seminar Paper No. 22. May 1971.

Nauta, Dick, 1972. Swoger: the ritual Spear of the Marakwet and Endo. *MILA 111.* (1). 43–52.

Neumann, A. 1898. *Elephant Hunting in Equatorial East Africa.* 92.

New, C. 1973. *Life, Wandering and Labours in East Africa.* 117.

Obst, E. 1912. Die Landschaften Issansu und Iramba. *Mitt d. Geog. Ges. in Hamburg.* 108–32.

Obst, E. 1913. Der Ostliche Abschnitt der grofsen ostafrikanischen Storungszone. *Mitt der geog. Ges. In Hamburg.* 27. 166–67, 359–61.

Ochieng, W. 1974a. *A Pre-Colonial History of the Gusii of W. Kenya from A.D. 1500 to 1914.*

Ochieng, W. 1974b. *An outline history of Nyanza up to 1914.* 59–60, 62, 67.

Ochieng, W. 1975. *A History of the Kadimo Chiefdom of Yimbo in W. Kenya.*

Odner, K. 1971. Usangi Hospital and other Archaeological Sites in the North Pare Mountains, North-Eastern Tanzania. *Azania VI.* 89–130.

Ogot, B.A. 1967. *History of the Southern Luo.*

Oliver, R. 1966. The Problem of Bantu Expansion *J. Af. Hist. VII.* (3). 361–376.

Orchardson, l.Q. 1961. *The Kipsigis.* Ed. A.T. Matson, 117, 138.

Osogo, J. 1966. *A History of the Baluyia.* 115, 125.

Osogo, J. 1972. *Kenya's Peoples in the Past.* 5.

Oswald, F. 1923. *Alone in Sleeping Sickness Country.* 37, 50–51. 176.

Otunga High School. 1970. *B.O.S.S. African History and culture Quarterly of Bishop Otunga High School.* No. 2. April 1970. 9.

Overbergh, C. van. 1908. *Les Basonge.* 224.

Overbergh, C. van. 1909. *Les Mangbetu.* 265–7, 269.

Patterson, J.H. 1909. *In the Grip of the Nyika.* 189.

Paulitsche, K. 1893. *Ethnographie Nordost-Afrika; Die Materielle Kultur der Danakil Galla und Somali.* 202, 236–7.

Peake, H. 1933. The origin and early spread of iron-working. *Geog. Review.* 23. 639–52.

Peake, H. 1965. *S.A.A.B. XX.* June 1965.

Pechuel-Loesche, E. 1907. *Volkskunde von Loango.* Stuttgart. 170.

Peristiany, J. 1939. *The Social Institutions of the Kipsigis.* 148, 160, 174–5.

Petrie, W. Flinders. 1909. *Arts and Crafts of Ancient Egypt.*

Phillips, J.A. 1959. Thoughts on Ancient Mining and Metallurgy. *Arch. J. XVI.* 12.

Phillipson, D.W. 1964. Excavation of an Iron Smelting furnace in the Livingstone District of N. Rhodesia. *MAN 64.* No. 216, 178.

Phillipson, D.W. 1970. C14 Chronology of E. and S. Africa. *J.Af.Hist. II.* 5.

Phillipson, D.W. 1975. The Chronology of the Early Iron Age in Bantu Africa. *Jnl. of African History 16* 321–342.

Phillipson, D.W. 1976. The Early Iron Age in East and South Africa. A. Critical Re-appraisal. *Azania XI.* 1.

Phillipson, D.W. 1976a. Archaeology and Bantu Linguistics. *World Archaeology 8* 65–82.

Phillipson, D.W. 1977. *The later Prehistory of Eastern and Southern Africa.* London. 228.

Phillipson, D.W. 1979. Some Iron Age sites on the Lower Tana river. *Azania 14* 155–162.

Phillipson, D.W. 1981. A Preliminary archaeological reconnaissance of the S. Sudan. 1977–8. *Azania XVI* 1–6.

Phillipson, D.W. 1985. *African Archaeology.* New York. C.U.P.

Pickering, C. 1854. *Races of Man.* 199.

Plas. J.V.D. 1910. *Les Kuku.*

Plog. F. 1974. *The study of Prehistoric Change.*

Pole, L.M. 1974. Iron-smelting procedures in the Upper Region of Ghana. *Bull. Hist. Metall.* Group 8.

Pole, L.M. 1975. Iron-working apparatus and Techniques: Upper Region of Ghana. *W. Af. J. Archaeol.* 5, 11–39.

Pole, L.M. 1976. Iron smelting procedures in the upper Region of Ghana. *J. Hist. Met.*

Posnansky, M. Prelude to African History. 89. *Jnl. Af. Soc. 8.* (1). 21.

Posnansky, M. 1966. Kingship, Archaeology, and Historical Myth. *Uganda Jnl. 30.* (1). 2.

Posnansky, M. 1968. Bantu Genesis – Archaeological reflections. *J.Af.Hist. IX* (I). II.

Poutrin, L. 1910. Notes Ethnographiques sur les populations M'Baka du Congo Français. *L'Anthropologie 2.* 49.

Prins, P. 1952. The Coastal Tribes of the North eastern Bantu. *Int. Af. Inst.* 15, 111.

Prinz, A. and Laku Heke, 1986. Ironworking and Oral Tradition. *MUNTU. Revue Scientifique et Culturelle du CICIBA* No. 4-5.

Pritchard, E.E. Evans. 1929. *Sudan Notes and Records.* 12. 4. 11–12.

Pritchard, E.E. Evans, 1940. *The Nuer.* 86.

Quiggin, A.H. 1949. Trade routes, Trade and Currency in East Africa. *Occ. Paper. No. 5. Rhodes-Livingstone Museum.*

Rattray, R.S. 1916. The Ironworkers of Akpafu. *J.R.A.I. 46.* 41.

Ratzel, F. 1897. *A History of Mankind.* 2. 494.

Raymaekers, J. and F. van Noten. 1986. Early Iron Age furnaces with "bricks" in Rwanda. Complementary evidence ifom Mutwarubona. *Azania 21* 65–84.

Read, F.W. 1902. Iron smelting and Native blacksmithing in the Ondulu country S.E. Angola. *Jnl. Af. Soc. 2.* (5). 44–49.

Reche, O. 1914. Zur Ethnographie des Abflusslosen Cebietes Deutsch-Ostafrikas. *Abhandlungen des Hamburgischen Kolonial Instituts 17.* 58–9, 84, 98, 103, 124.

Rehse, H. 1910. *Kiziba.* 80, 83, 86–89.

Renfrew, C. 1969. Trade and culture process in European Prehistory. *Current Anthropology 10.* 153–4, 160. Fig. 2.

Reynolds, B. 1966. *The Material Culture of the Peoples of the Gwembe valley.* 93. Kariba Studies. IIIa.

Richardson, H.C. 1934. Iron Prehistoric and Ancient. *Amer. Jnl. Arch. XXXVIII.* (4). 566.

Rickard, T.A. 1926. Notes on Ancient and Primitive Mining Methods. *Eng. Min. Jnl. 122* (2). 40.

Rickard, T.A. 1932. *Man and Metals.* Vol. 1. 148–9, 244–5, 253–4.

Richter, F. 1900. Aus dem Deutsch Ostafrikanishcne Schutzgebiete. *Mitteilungen aus den deutschen Schutzcebieten.* 22. 123.

Roberts, A. 1968. *Tanzania before 1900.* Intro. p. xiv, 101, 123.

Robins, F.W. .1953. *The Smith.* 60.

Robinson, V.R. 1961. Iron smelting furnaces from Hibi Native Reserve *S. Rhod. S. Af. Arch. Bull. 16.* (6). March. 20–22.

Rodd, F.R. 1926. *Peoples of the Veil.* 229, 452–56.

Roosevelt, T. 1910. *African Game Trails.* 348–9.

Roscoe, J. 1911. *The Baganda.* 51, 163, 170–1, 220, 215, 378–82, 387.

Roscoe, J. 1915. *The Northern Bantu.* 74–76.

Roscoe, J. 1921. *Twenty-five years in East Africa.* 13, 117, 220–1.

Roscoe, J. 1923a. *The Bakitara.* 5, 10, 217–225.

Roscoe, J. 1923b. *The Banyankole.* 105–7.

Roscoe, J. 1924. *The Bagesu* 66, 172.

Roscoe, J. 1924. Immigrants and their influence in the Lake Region of Central Africa. Frazer Lecture for 1923.

Rosemond, C.C. de. 1943. Ironsmelting in the Kahama district. *Tang. Notes and Records.* 16. 79–84.

Routledge, W.S. and K. 1910. *With a Prehistoric People.* 16, 40, 79–97.

Rowlands, M.J. 1971. The Archaeological Interpretation of Prehistoric Metalworking. *Archaeology 3.* 210–222.

Russell, W. (Ed.). 1962. *Natural Resources of East Africa.*

Sassoon, H. 1963. Early sources of Iron in Africa. *S. Af. Arch. Bull. 18.* 72. 176–80.

Sassoon, H. 1964. Iron smelting in the hill village of Sukur, N.E. Nigeria. *MAN 64.* Nov-Dec. (215). 174–8.

Sassoon, H. 1971. The collection of Metalwork from the Kingdom of Karangwe and its relationship to the Insignia of Neighbouring territories. Thesis submitted to Oxford University for the Degree of D. Phil.

Sassoon, H. 1975. Metals, Mining and Metallurgy as evidence for cultural links. Paper published in *East Africa and the Orient.* Ed. N. Chittick.

Sassoon, H. 1983. Kings, Cattle and Blacksmiths: Royal Insignia and Religious Symbolism in the Interlacustrine states. *Azania. XVIII.* 93.

Savory, H.N. 1958. The Late Bronze Age in Wales. *Archaeologia Cambrensis. CVII.* 34.

Sayce, R.U. 1933. Primitive Arts and Crafts quoted in Forbes 1950: 81.

Schmidt, P.R. 1975. A new look at the interpretation of the Early Iron Age in E. Africa. *History in Africa 2* 127–136.

Schmidt, P.R. 1977. Steel Production in Prehistoric Africa. Insights from Ethno-Archaeology. Resumé from 8th Pan African Congress on Prehistory.

Schmidt, P.R. and D. Avery. 1978. Complex iron smelting and prehistoric culture in Tanzania. *Science 201* 1085–1089.

Schmidt, P. 1978. *Historical Archaeology: a structural approach to an African culture.*

Schmidt, P.R. 1980a. Steel production in prehistoric Africa: Insight from Ethnoarchaeology in W. Lake, Tanzania. In Leakey, R.F.F. and B.A. Ogot (Eds.). *Proceedings of the 8th Pan. African congress of Prehistory and Quaternary Studies* p. 335–340.

Schmidt, P.R. 1980b. Early Iron Age settlements and industrial locales in West Lake. *Tanzania Notes and Records 84–85:* 335–340.

Schmidt, P.R. 1981. The origins of iron smelting in Africa: a complex technology in Tanzania. *Research Papers in Anthropology, Brown University 1.*

Schmidt, P.R. 1983. Further evidence for an advanced prehistoric iron technology in Africa. *Jnl. of Field Archaeology 10:* 421–434.

Schmidt, P.R. 1986. The Barongo iron smelters of Biharamulo. *Tanzania. Notes and Records.*

Schoeller, M. 1901–4. *Aquatorial Ost-Afrika 1896–7.* 3 vols.

Schoff, W.H. 1912. *The Periplus of the Erythraen Sea.* 24, 28. 151.

Schurtz, H. 1900. *Das Afrikanische gewerbe.* 79.

Schweinfurth, G. 1872. Linguisticsche Ergebnisse einer Reise nach Zentralafrika. *Zeit. für Ethnologie 4.* 62.

Schweinfurth, G. 1874. Im Herzen von Afrika. Sv. *I* 206. 225–7, 267, 277, 304–5.

Schweinfurth, G. 1875. *Artes Africanae.* Plate VI. 277.

Seligman, C.G. and B.Z. 1928. *The Bari. J.R.A.I. LVIII.* 428–434.

Seligman, C.G. and B.Z. 1932. *Pagan Tribes of the Nilotic Sudan.* II-12, 37, 138, 257, 466.

Semenov, S.A. 1964. *Prehistoric Technology.*

Shack, W.A. 1964. Notes on the Occupational castes among the Gurage of S.W. Ethipia *MAN 64* (54). 50–52.

Shaw, Thurstan. 1969. On Radiocarbon chronology of the Iron Age in Sub-Saharan Africa. *C.A.* 10. 226–30.

Shinnie, P. 1967. *Meroe.* A Civilisation in the Sudan. 166.

Shinnie, P. (Ed.). 1971. *The African Iron Age.*

Shinnie, P. 1971. The Legacy to Africa. *In The Legacy of Egypt.* 434–455.

Shinnie, P. and F. Kense. 1982. Meroitic iron working. *Meroitica 6.* 17–28.

Shinnie, P. and R. Haaland (Eds.). 1986. *African iron working, ancient and traditional.* Bergen.

Shorter, A.E.M. 1967. Rock Paintings in Ukimba. *Tanz. Notes and Records 67.* 50, 53–54.

Siiriainen, A. 1971. The Iron Age Site at Gatung'anga, Central Kenya. *Azania VI.* 199.

Simoons, F.J. 1965. Some questions on the economic prehistory of Ethiopia. *J.Af. Hist. VI.* 1–13.

Singer, C., Holmyard, E.J. and A.R. Hall (Eds.). 1958. *A History of Technology.* Vol. *1.* 575, 578, 582, 591.

Smith, W. and A.M. Dale. 1920. *The Ila speaking peoples of N. Rhodesia.* 203–5, 209–10, 212, 214.

Sonsberghe, H. de. 1955. Forgerons et fondeurs du fer chez les Ba-Pende et leurs voisins. *Zaire 9.*

Soper, R. 1967a. Kwale; An Early Iron Age site in S.E. Kenya. *Azania II.* 1–17.

Soper, R.C, 1967b. Iron Age sites in north-eastern Tanzania. *Azania II* 19–36.

Soper, R. 1971a. A General Review of the Early Iron Age of the Southern half of Africa and Early Iron Age Pottery Types from East Africa: Comparative analysis. *Azania VI.* 5–39.

Soper. R.C. 1971b. Early Iron Age pottery types from East Africa: comparative analysis. *Azania VI* 39–52.

Soper, R.C. .1976. Archaeological sites in the Chyulu Hills. *Azania XI:* 83–116.

Soper. R.C. 1979. Iron Age archaeology and traditional history in Embu, Mbeere and Chuka areas of central Kenya. *Azania 14:* 31–59.

Soper, R.C. 1980. Iron Age pottery assemblages from Central Kenya. In Leakey, R.E.F. and B.A. Ogot (Eds.). *Proceedings of the 8th Pan-African Congress of Prehistory and Quarternary Studies* 342-343.

Soper, R.C. 1983. Bantu expansion into Eastern Africa: Archaeological Evidence. In Ehret, C. and M. Posnansky (Eds.) 223–244.

Southall, A. 1953. *Alur Society.* 12, 81, 173.

Spear, T.T. 1978. *The Kaya complex. A history of the Mijikenda Peoples of the Kenya Coast to 1900.* Nairobi.

Spencer, Paul. 1973. *Nomads in Alliance.* 55, 63, 118–119, 128.

Spriggs, M. (Ed.). 1977. Archaeology and Anthropology. *B.A.R. Supplem. Series 19.*

Stafford, D.N. 1955. The Casting of Metals by Africans. *Uganda Jnl. 19.* 208–9.

Stahl, K.M. 1965. Outline of Chagga History. *Tang. Notes and Records.* No. 64. 41.

Stahl, K.M. 1966. *History of the Chagga Peoples.* 101–2.

Stam, P.N. 1908. The religious conceptions of some tribes of Buganda. *Anthropos V.* 216.

Stam, P.N. 1919–20. Bantu Kavirondo of Mumias district. *Anthropos.* XIV-XV, 968–980.

Stanley, H.M. 1872. *How I found Livingstone.* 545.

Stanley, G.G. 1931. Some products of Native Iron smelting. *S.Af.Jnl.Sc. 28.* 131-4.

Stannus, H. 1910. Notes on some tribes of British Central Africa. *J.R.A.I. 40.* 331.

Stannus, S.N. 1914. Nyasaland: Angoni Smelting Furnace. *MAN 14.* (65). 132.

Stayt, H.A. 1931. *The Bavenda.*

Stern, R. 1910. Die Gewinning des Fisens. In Stuhlmann's *Handwerk und Industrie in Ostafrika.* 152, 154–58.

Stigand, C.H. 1909. *The Land of Zinj.* 218.

Stuart-Watt, Fva. 1930. *Africa's Dome of Discovery.* 52.

Stuhlmann, F. 1894. *Mit Emin Pasha ins Herz von Afrika.* 117, 484, 527, 627, 697, 717–8, 816.

Stuhlmann, F. 1910. Handwerk und Industrie in Ostafrika. *Abhandlungen des Hamburgischen Kolonialinstituts 1.* 51. 57, 49–80, 697, Appendix 152.

Summers, R. 1963. *Zimbabwe. A Rhodesian Mystery.*

Summers, R. 1966. The Iron Age of Southern Rhodesia. *J.A. 1.* 470–71.

Summers, R. 1969. Ancient mining in Rhodesia. *Nat. Mus. Memoir No. 3.* xv. 236.

Sutton, J. (Ed.). 1969. *Tanzania Zamani.* No. 4. Jan. 1969. 14–22.

Sutton, J. 1972. Iron Working in Tanzania and Traditional salt production. *KWALE.*

Sutton, J. 1973. The Archaeology of the Western Highlands of Kenya. *Memoir No. 3. British Institute in Eastern Africa.*

Sutton, J. 1974. The Aquatic civilisation of middle Africa. *Jnl. of African History 15:* 527–546.

Tadao, Umesao. 1969. Hunting Culture of the Pastoral Datoga. *Kyoto Univ. Af. Studies 3.* 80.

Tanzania Zamani. No. 4. Jan. 1969. 13–22.

Tate, H.R. 1904. Further notes on the Kikuyu tribe of British East Africa. *J.R.A.l. XXXIV.* 257–8.

Tate, H.R. 1904. *Journey to Rendille Country.*

Taylor, B.K. 1962. The Western Lacustrine Bantu. *Ethnographic Survey of Africa, E. Cent. A:. Part XIII.* International Africa Institute. 105.

Taylor, G. 1926. Native iron-workers. *NADA 4:* 53.

Tessmann, G. 1913. *Die Pangwe. I.* 236.

Tessmann, 1934. *Die Baja.* 166–187.

Tew, M. 1950. *People of the Lake Nyasa Region.* 28.

Thompson, H.O. 1956. Geology of the Malindi area. *Geol. Survey of Kenya. Report No. 36.*

Thomson, J. 1885. *Through Masailand.* 177, 290–91, 440.

Torday, E. and T.A. Joyce. 1922. Les Bushongo. 235.(Notes Ethnographiques sur les populations habitants les basins du Kasai et du Kwango oriental. *Annales du Musée du Congo Belge. Ethnographie Anthropologie Series 3. 1922.* Documents ethnographiques concernant les populations du Congo Belge. Vol. 2 Pt. 2. 350.

Trigger, B.G. 1969. The Myth of Meroe and the African Iron Age. *Af. Historical Studies.* 11 No. 1. 23–50.

Trowell, M. 1941. Some Royal Craftsmen of Buganda. *Uganda Jnl. 8.* (2). 48–51.

Turnbull, C. 1973. *The Mountain People.* 80.

Tylecote, R.F. 1965. Iron smelting in pre-Industrial communities. *Jnl. of Iron and Steel Institute.* April. 340.

Tylecote, R.F. 1970. Iron working at Meroe. *Sudan. Bull. Hist. Met. 4.* No. 2.

Tylecote, R.F. 1975a. The origin of iron smelting in Africa. *W. Af. Jnl. of Archaeology.* 5. 1–9.

Tylecote, R.F. 1975b. Taruga Iron Smelting. *Historical Metallurgy 9.* No. 2. 49–56.

van Grunderbeek, M-C., E. Roche and H. Dutreleport. 1983a. *Le Premier Âge du Fer au Rwanda et au Burundi: archéologie et Environement.* I.F.A.Q. Brussels. C.Q.S.

van Grunderbeek, M-C., E. Roche and H. Dutreleport. 1983b. La métallurgie ancienne au Rwanda et au Burundi. *Journées de Palaéométallurgie 22-23.* Fevrier. Compiègne.

van Noten, F. lg77. Resumé of paper read at the 8th Pan-African Congress of Prehistory.

van Noten, F. 1979. The Early Iron Age in the Interlacustrine Region: the diffusion of Iron Technology. *Azania 14* ,61–80.

van Noten, F. 1982. *The Archaeology of Central Africa.* Akademische Druck-und Verlagsanstalt.

van Noten, F. 1983. Histoire archéologique de Rwanda. *Musée Royale de l'Afrique Centrale Annales Sciences Humaines* 12. Tervuren.

van Noten, F. 1988. Histoire archéologique du Rwanda. *Ann Kon. Mus. Mid. Air., Mens. Wet.* Serie in -8°, 112, Tervuren.

van Noten, F. and J. Raymaekers. 1988. Early Iron Smelting in Central Africa. *Scientific American 258* No. 6 (June).

van der Merwe, N.J. 1980. The advent of iron in Africa. In Wertime, T.A. and J.D. Muhly (Eds.). *The Coming of the Age of Iron.* 463–506.

Vansina, J. 1961. Chronologie des regnes du Rwanda. *Africa Tervuren I.* 1.22.

Vansina, J. 1980. Bantu in the crystal ball, 11. *History in Africa I* 293–325.

Vossen, R. 1978. Notes on the territorial History of the Maa-speaking peoples of Kenya and Tanzania. *Kenya Historical Review 6* 34–52.

Wagner, G. 1949. *The Bantu Kavirondo.* Vol. *II.* 9.

Wainwright, G.A. 1936. The Coming of Iron. *Antiquity X.* 19–23.

Wainwright, G.A. 1942a. Early records of Iron in Abyssinia. *Man XLII.* (43). 9.

Wainwright, G.A. 1942b. The Coming of Iron to some African Peoples. *MAN 42.* (61). 106.

Wainwright, G.A. 1943. The Coming of Iron to an African People. *MAN 43.* Nos. 67 and 87.

Wainwright, G.A. 1945. Iron in the Napatan and Meroitic Ages. *Sudan Notes and Records. XXVI.* 5–36.

Wainwright, G.A. 1950. The Coming of Iron to the Bantu. *MAN 50.* 19.

Wainwright, G.A. 1953. Supressed Classes among the Bari and Bari speaking peoples. *Sudan Notes and Records XXXIV.* 265.

Wainwright, G.A. 1954. The Diffusion of -uma as a name for iron. *Uganda Jnl. 18.* 113–136.

Wainwright, G.A. 1955. The Jaga and their name for iron. *MAN 55.* No. 62.

Wakefield, T. 1870. Routes of Native caravans from the coast to the interior of East Africa. *J. Roy. Geog. Soc. XL.* 317, 328.

Wayland, E.J. 1931. Preliminary studies of the tribes of Karamoja. *J.R.A.I. LXI.* 197, 199–200.

Weatherby, J., B. Kipkorir, and J. Sutton. 1964. The Serikwa. *Uganda Jnl. 28.* No. 1. 61–74.

Weatherby, J. Thesis. *Aspects of Ethnography and Oral Traditions of the Sebei of Mt Elgon.* Makerere. Uganda.

Webster, H. 1942. *Taboo - A Sociological Study.*

Webster, H. 1948. *Magic.* 165–67.

Webster, J.B. 1973. *The Itesyo during the Asonya.* 100.

Weeks, J.H. 1914. *Among the Primitive Bakongo.* 249.

Weiss, M. 1910. *Die Volkerstamme im Norden Deutsch Ostafrikas.* Tab. 20. 415–7.

Wembah-Rashid, J. 1969. Iron workers of Ufipa. *Bulletin of the International Committee of Urgent Anthropological Research 11* 6572.

Were, G.S. 1967a. *A History of the Abaluyia of western Kenya. C. 1500–1930.*

Were, G.S. 1967b. *Western Kenya Historical Texts.*

Were, P.O. 1973. Origins and growth of the Iron Industry and trade in Samia. B.A. dissertation. Dept. of History. University of Nairobi.

Werner, A. 1906. *The natives of British Central Africa.* 88, 201.

Werner, A. 1914. The Galla of E. Africa Protectorate Part 1. *Jnl. Af. Soc. 13* 121–142, 262–287.

Werth, E. 1915. *Das deutsch-ostafrikanische Kustenland und die vorgelegten Inseln.* Sv. 1. 281.

Werther, W. 1898. *Die mittleren Hochländer des nördlichen Deutsch-ost-Afrika: Wissenschaitliche Ergebnisse der Irangi-Expedition 1896–1897 nebst Kurzer Reisebeschreibung.* Berlin. 199.

Westermann, D. 1943. *The Shilluk people.* 298.

Westermann, D. 1952. *Geschichte Afrikas. Staatenbildungen südlich der Sahara.* 327–8, 338, 340–1.

Whisson, M. 1965. *Change and Challenge.*

White, R.G. 1969. Blacksmiths in Kigezi. *Uganda Jnl. 33.* Pt. 1. 65.

Whitehead, G.O. 1928. Quoted in C.C. and B.Z. Seligman The Bari *J.R.A.I. 58* 428–434.

Whitehead, C.O. 1929. Social change amongst the Bari. *Sudan Notes and Records.* 12. 93.

Widemann, A. 1899. *Die Kilimandscharo-Bevölkerung, Anthropologisches und Ethnologisches aus dem Dschaggalande.* 84.

Widstrand, C.G. 1958. African Axes. *Studia Ethnographica Upsaliensia XV.* 77, 98, 87, 132, 162.

Wightwick-Haywood, C. 1927. *To the Mysterious Lorian Swamp.* 22, 24.

Willis, R. 1968. The Fipa. In Roberts (Ed.) *Tanzania before 1900.*

Willoughby, J. 1889. *East Africa and its Big Game.* 75, 82.

Wilson, M. 1959. *Communal rituals of the Nyakusa* 142, 153.

Wilson, M. 1977. *For Men and Elders.* International African Institute.

Winyi, Sir Tito (K.W.). 1936. The procedure in Accession to the throne of a nominated King in the Kingdom of Bunyoro-Kitara. *Uganda Jnl 4.* (4). 289–299.

Wise, R. 1958. Iron smelting in Ufipa. *Tang. Notes and Records 51.* 27, 106–111, 232–238, 288–289. No. *4.* 50. 77.

Wrigley, C.C. 1960. Speculations on the economic Prehistory of Africa. *Jnl. Af. Hist. 1.* 97.

Wyckaert, R.P. 1914. Forgerons paiens et forgerons Chrétiens au Tanganyika. *Anthropos. 9.* 371–380.

Yitzchak, E. 1974. The Relationships between Hima and Iru in Ankole. *Uganda African Studies. 33.* (3). 166.

Young, R. and H. Fosbrooke. 1960. *Land and Politics among the Luguru of Tanganyika.* 31.

Zahan, D. 1973. Towards a History of the Yatenga Mossi. In *Perspectives in African Studies.* Ed. P. Alexandre. Int. Af. Inst.

Zimmer, G.F. 1916. The Use of Meteoric Iron by Primitive Man. *Jnl. Iron and Steel Inst.* 316.

Cambridge Monographs in African Archaeology

General editor: John Alexander

All those volumes still in print may be ordered from
Oxbow Books, Park End Place, Oxford, OX1 1HN
(Phone: 01865–241249; Fax: 01865–794449)